Reporting the Siege of Sarajevo

Reporting the Siege of Sarajevo

Kenneth Morrison and Paul Lowe

BLOOMSBURY ACADEMIC
LONDON • NEW YORK • OXFORD • NEW DELHI • SYDNEY

BLOOMSBURY ACADEMIC
Bloomsbury Publishing Plc
50 Bedford Square, London, WC1B 3DP, UK
1385 Broadway, New York, NY 10018, USA
29 Earlsfort Terrace, Dublin 2, Ireland

BLOOMSBURY, BLOOMSBURY ACADEMIC and the Diana logo
are trademarks of Bloomsbury Publishing Plc

First published in Great Britain 2021
Paperback edition published 2022

Copyright © Kenneth Morrison and Paul Lowe, 2021

Kenneth Morrison and Paul Lowe have asserted their right under the Copyright, Designs and Patents Act, 1988, to be identified as Author of this work.

For legal purposes the Acknowledgements on p. viii constitute an extension of this copyright page.

Cover Design: Ben Anslow
Cover image: A woman runs across an intersection on Sniper alley, Sarajevo June 1992; © Paul Lowe VII Photo

All rights reserved. No part of this publication may be reproduced or transmitted in any form or by any means, electronic or mechanical, including photocopying, recording, or any information storage or retrieval system, without prior permission in writing from the publishers.

Bloomsbury Publishing Plc does not have any control over, or responsibility for, any third-party websites referred to or in this book. All internet addresses given in this book were correct at the time of going to press. The author and publisher regret any inconvenience caused if addresses have changed or sites have ceased to exist, but can accept no responsibility for any such changes.

Every effort has been made to trace copyright holders and to obtain their permissions for the use of copyright material. The publisher apologizes for any errors or omissions and would be grateful if notified of any corrections that should be incorporated in future reprints or editions of this book.

A catalogue record for this book is available from the British Library.

Library of Congress Cataloging-in-Publication Data
Names: Morrison, Kenneth, author. | Lowe, Paul, 1963- author.
Title: Reporting the Siege of Sarajevo / Kenneth Morrison & Paul Lowe.
Description: [New York] : Bloomsbury Academic, 2021. | Includes bibliographical references and index.
Identifiers: LCCN 2020035921 (print) | LCCN 2020035922 (ebook) | ISBN 9781350081741 (hardback) | ISBN 9781350202849 (paperback) | ISBN 9781350081789 (ebook) | ISBN 9781350081796 (epub)
Subjects: LCSH: Sarajevo (Bosnia and Herzegovina)–History–Siege, 1992-1996–Journalists. | Sarajevo (Bosnia and Herzegovina)–History–Siege, 1992-1996–Press coverage. | Yugoslav War, 1991-1995. | War correspondents–Bosnia and Herzegovina–Sarajevo–History–20th century. | Foreign correspondents–Bosnia and Herzegovina–Sarajevo–History–20th century. | Journalism–Bosnia and Herzegovina–Sarajevo–History–20th century.
Classification: LCC DR1313.32.S27 M67 2021 (print) | LCC DR1313.32.S27 (ebook) | DDC 070.4/49949703–dc23
LC record available at https://lccn.loc.gov/2020035921
LC ebook record available at https://lccn.loc.gov/2020035922

ISBN: HB: 978-1-3500-8174-1
PB: 978-1-3502-0284-9
ePDF: 978-1-3500-8178-9
eBook: 978-1-3500-8179-6

Typeset by Integra Software Services Pvt. Ltd.

To find out more about our authors and books visit www.bloomsbury.com and sign up for our newsletters.

Contents

List of illustrations	vi
Acknowledgements	viii
Abbreviations	ix
Maps	xiii
Chronology of the siege of Sarajevo	xv
Introduction	1
1 The political context of the siege	7
2 The early months of the siege	33
3 The emergence of a reporting infrastructure	55
4 Operating in a city under siege	89
5 Reporting daily life	119
6 The troubles we've seen	141
Conclusion	161
Notes	170
Bibliography	212
Index	225

Illustrations

0.1	Sarajevo panorama	2
1.1	Peace demonstrators outside the Bosnian Parliament, 6 April 1992	26
1.2	Demonstrators take cover from shooting from the Holiday Inn, 6 April 1992	29
2.1	Ismet 'Ćelo' Bajramović in Sarajevo, July 1992	34
2.2	Citizens of Sarajevo waiting in line to fill plastic jerry cans of water, Summer 1993	36
2.3	Foreign journalists en route to Split following the evacuation from Ilidža	43
2.4	Cameraman Nigel Bateson films from the BBC's Vauxhall Carlton, Dobrinja, July 1992	51
3.1	François Mitterrand and General Lewis MacKenzie at the PTT building during the French President's visit to Sarajevo on 28 June 1992	56
3.2	A Hercules C-130 on the tarmac at Sarajevo Airport	57
3.3	Citizens of Sarajevo prepare to cross an intersection, July 1992	61
3.4	'Welcome to hell!' graffiti on Sniper Alley, July 1992	64
3.5	Opasna zona (dangerous zone), the Holiday Inn, Winter 1994	67
3.6	Jonathan Landay, Martin Dawes, John Burns and Chris Helgren in the Holiday Inn, Summer 1993	72
3.7	Kurt Schork in the Sarajevo TV station, Winter 1994	74
3.8	UNPROFOR Warrior APC outside the TV station in Sarajevo	79
3.9	UN press briefing at the PTT building, Winter 1993	86
3.10	UN 'Blue Card'	87
4.1	The BBC's Kate Adie doing a piece to camera in Sarajevo, Summer 1995	90
4.2	Photographers at a funeral in Sarajevo	94
4.3	Sean Maguire, Kurt Schork and Corrine Dufka with the SAP armoured car	96
4.4	One of the BBC's armoured fleet in Sarajevo	99
4.5	Gary Knight at work in Sarajevo, Summer 1993	106
5.1	Chris Helgren with satellite phone in the Holiday Inn, Summer 1993	121
5.2	The feet of a young female casualty in the Sarajevo morgue, Summer 1993	124
5.3	Charlotte Eagar in the Holiday Inn, Summer 1993	130
5.4	The 'Don't Let Them Kill Us' banner held aloft by 'Miss Sarajevo' contestants, December 1993	132
5.5	Susan Sontag with the Sarajevo cast of *Waiting for Godot*, August 1993	137

5.6 Bill Tribe looking through the window of a UN plane during one of his many visits to the besieged city ... 140
6.1 The body of Nermin Divović lies on the ground as UNPROFOR peacekeepers attempt to get transport to take him to hospital, November 1995 ... 151
6.2 Chris Morris photographing bodies in the Sarajevo morgue, Winter 1993 ... 154

Acknowledgements

The authors would like to thank the following people, all of whom have been invaluable in the completion of this book: Boba Lizdek, Neven Andjelić, Abdallah El Binni, Edina Bećirević, Remy Ourdan, Gordana Knežević, Martin Bell, Jeremy Bowen, Ron Haviv, Gary Knight, Charlotte Eagar, Colm Doyle, Milan Trivić, John F. Burns, Nigel Bateson, John Simpson, Martin Dawes, David Rust, Charlotte Eagar, Jelena Zindović-Grujić, John F. Burns, Allan Little, Joel Brand, Martin Dawes, Myriam Schmaus, Pierre Peyrot, Sean and Dina Maguire, Dina Neretljak, Samir Korić, Sabina Ćosić, Marcel Ophuls, Tim Judah, Kevin Weaver, Samir Krilić, Steve Ward, Zrinka Bralo, Gigi Riva and Hajrudin Rovčanin. Thanks also to Elma Hodžić at the History Museum of Bosnia and Herzegovina, David Cutler at the Reuters Archive in London, Nejra Veljan, Mirza Buljubašić, Shikha Chopra and all others who have been interviewed, read and commented on early drafts or have contributed in other ways to this book. It has been a pleasure to work, once again, with Rhodri Mogford and Laura Reeves at Bloomsbury Academic. Thanks also to Sebastian Ballard, who produced the maps, and to Deborah Maloney and Lesley Wyldbore for their copy-editing and attention to detail. Of course, this book would never have been realized without the love and support of Amra, Amil, Emir-Max, Helen and Hannah.

Abbreviations

ABC	American Broadcasting Company
AFP	Agence France-Presse
AP	Associated Press
APC	Armoured Personnel Carrier
APTN	Associated Press Television News
APTV	Associated Press Television
ARBiH	Army of Bosnia & Herzegovina
ARD	*Arbeitsgemeinschaft der öffentlich-rechtlichen Rundfunkanstalten der Bundesrepublik Deutschland*
BBC	British Broadcasting Corporation
BiH	Bosna i Hercegovina.
CBS	Columbia Broadcasting System
CIA	Central Intelligence Agency
CNN	Cable News Network
CSCE	Commission for Security and Cooperation in Europe
DPA	Dayton Peace Agreement
EBU	European Broadcasting Union
EC	European Community
ECMM	European Community Monitoring Mission
EPA	European Press Agency
EU	European Union
FTNA	Frontline Televison News Agency
GRAS	*Gradski saobraćaj Sarajevo* (City Transport (of) Sarajevo)
HDZ	*Hrvatska demokratska zajednica* (Croatian Democratic Community)
HDZ-BiH	*Hrvatska demokratska zajednica Bosne i Herzegovine* (Croatian Democratic Community of Bosnia and Herzegovina)

HOS	*Hrvatske obrambene snage* (Croatian Defence Forces)
HRW	Human Rights Watch
HVO	*Hrvatsko vijeće obrane* (Croatian Defence Council)
ICMP	International Commission on Missing Persons
ICRC	International Committee of the Red Cross
ICTY	International Criminal Tribunal for the Former Yugoslavia
IEBL	Inter-Entity Boundary Line
IFOR (NATO)	Implementation Force
IMF	International Monetary Fund
IOC	International Olympic Committee
ITN	Independent Television News
JNA	*Jugoslovenska narodna armija* (Yugoslav People's Army)
JRT	*Jugoslovenska radiotelevizija* (Yugoslav Radio Television)
KSHS	*Kraljevina Srba, Hrvata i Slovenaca* (Kingdom of Serbs, Croats and Slovenes)
MUP	*Ministarstvo unutrašnjih poslova* (Ministry of Internal Affairs)
NATO	North Atlantic Treaty Organization
NGO	Non-governmental organization
OHR	Office of the High Representative
OIC	Organisation of Islamic Countries
OSCE	Organization for Security and Cooperation in Europe
PEN	Poets, Essayists and Novelists
PIC	Peace Implementation Council
PL	*Patriotska liga* (Patriotic League)
PTSD	Post-Traumatic Stress Disorder
PTT	*Pošta, telegraf i teleefon* (Postal, Telegraph and Telephone)
RAF	Royal Air Force
RPG	Rocket-propelled grenade
RS	*Republika Srpska* (Serb Republic)
RTB	*Radio televizija Beograd* (Radio Television Belgrade)

RTBiH	*Radiotelevizija Bosne i Herzegovine* (Radio Television Bosnia & Herzegovina)
RTL	*Radio Télévision Luxembourg* (Radio Television Luxembourg)
RTS	*Radio Televizija Srbije* (Radio Television of Serbia)
SAO	*Srpska autonomna oblast* (Serb autonomous region)
SAP	Sarajevo Agency Pool
SAS	Special Air Service
SDA	*Stranka demokratske akcije* (Party of Democratic Action)
SDP	*Socijaldemokratska partija* (Social Democratic Party)
SDS	*Srpska demokratska stranka* (Serbian Democratic Party)
SFOR (NATO)	Stabilisation Force
SFRJ	*Socijalistička Federativna Republika Jugoslavija* (Socialist Federal Republic of Yugoslavia)
SIJA	Sarajevo International Journalists Association
SIPA	State Investigation and Protection Agency (Bosnia and Herzegovina)
SK-BiH	*Savez komunista Bosne i Herzegovine* (League of Communists of Bosnia & Herzegovina)
SKJ	*Savez komunista Jugoslavije* (League of Communists of Yugoslavia)
SKS	*Savez komunista Srbije* (League of Communists of Serbia)
SOF	Soldier of Fortune
SRJ	*Savezna Republika Jugoslavija*
SRS	*Srpska radikalna stranka* (Serbian Radical Party)
SRSJ	*Savez reformskih snaga Jugoslavije* (Alliance of Reform Forces of Yugoslavia)
TO	*Teritorijalna odbrana* (Territorial Defence)
TVSA	*Televizija Sarajevo* (TV Sarajevo)
UCSB	University of California Santa Barbara
UKRBAT	Ukrainian Peacekeeping Battalion in Bosnia and Herzegovina
UN	United Nations
UNHCR	United Nations High Commission for Refugees

UNICEF	United Nations Children's Fund
UNPROFOR	United Nations Protection Force
UPI	United Press International
US	United States
VOPP	Vance–Owen Peace Plan
VRS	*Vojska Republike Srpske* (Army of Republika Srpska)
WHO	World Health Organization
WTN	World Television News

Maps

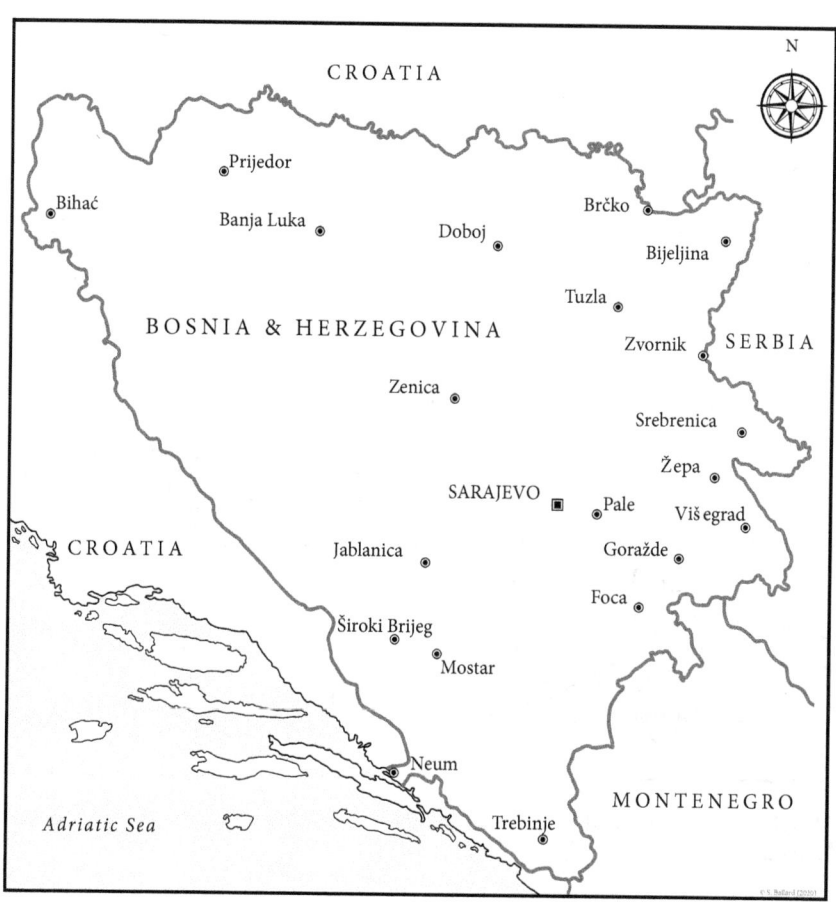

Map 1 Bosnia and Herzegovina (1992). © Sebastian Ballard.

xiv

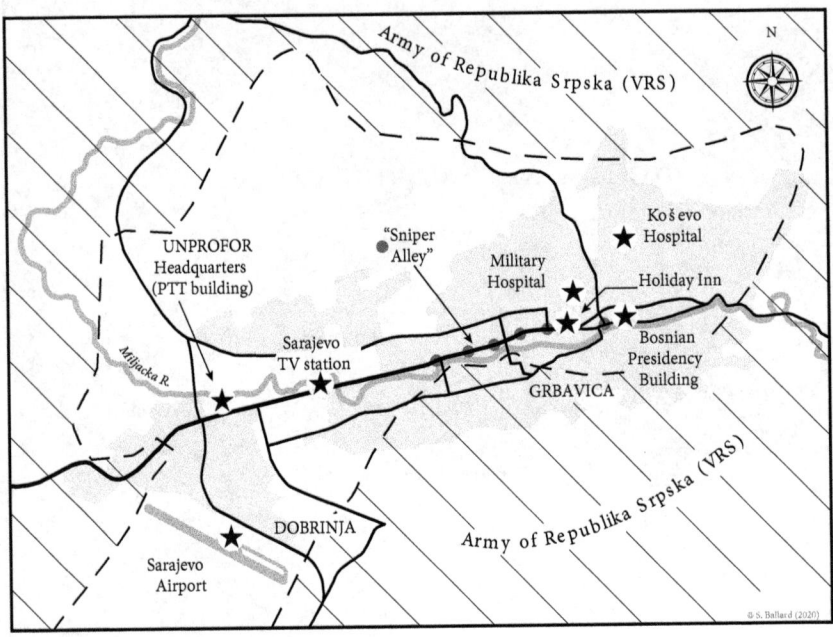

Map 2 Key buildings and routes used by journalists in besieged Sarajevo. © Sebastian Ballard.

Chronology of the siege of Sarajevo, 1992–96

This chronology outlines key events during the siege. It is necessarily brief, by no means exhaustive and is not a detailed chronology of the Bosnian war. It is, rather, an outline of the most important events that took place within the city over a four-year period and is intended to contextualize the authors' historical analysis of the role and work of foreign correspondents in Sarajevo during the siege.

1992

February/March

'Referendum Weekend' held after European Community (EC) insist referendum must be scheduled as a condition for recognizing independence of Bosnia and Herzegovina. Serbian Democratic Party (SDS) call for boycott of the referendum and majority of Bosnian Serbs do so. Murder of Nikola Gardović, a Bosnian Serb who was attending the wedding of his son, heightens tensions in Sarajevo. The first SDS barricades are erected in Sarajevo. Demonstrators succeed in having barricades dismantled. The government of Bosnia and Herzegovina declare independence after confirmation of the result of the independence referendum. Peace demonstrations in front of the Parliament – largest ever gathering in Bosnia-Herzegovina – organized by 'Omladinski Program Radio Sarajevo' – and entitled *Mi smo Valter* (We are Walter). UN peacekeeping forces – based in Sarajevo to administer the ceasefire in Croatia – arrive in the city and establish their headquarters in retirement home in Nedžarići.

April

Anxiety in Sarajevo caused by what citizens fear is a military encirclement of the city by the Yugoslav People's Army (JNA) and the armed supporters of the SDS. Further peace demonstrations. Olga Sučić and Suada Dilberović shot dead on the Vrbanja Bridge as demonstrators move toward the area of Grbavica. Demonstrators break into the parliament building and establish 'All People's Parliament'. Shots fired from the Holiday Inn hotel by gunmen from SDS killing six. The EC recognizes Bosnia and Herzegovina as an independent state and the siege of Sarajevo begins. The EC's recognition is shortly followed by the United States (US). Shelling of Sarajevo by the JNA. Curfew introduced in the city. Armed clashes begin in the vicinity of the Ilidža hotel complex, where most foreign journalists are based. The shelling of the city increases, with many of the city's key buildings under attack. Among them is the Olympic Museum which is destroyed by shells fired from Bosnian Serb positions.

May

The 'Battle for Sarajevo' – JNA and armed SDS militias attempt to push into the centre of Sarajevo but are held back at the Skenderija intersection. The Sarajevo Post Office is destroyed from within by JNA sappers, bringing down most of the city's telephone communications. Bosnian President, Alija Izetbegović, taken hostage by JNA on return from peace talks in Lisbon. Freed following day after a botched exchange in which seven JNA soldiers are killed by members of the nascent ARBiH. The JNA relinquishes command of its estimated 100,000 troops in Bosnia and Herzegovina, effectively creating the Bosnian Serb Army (VRS). The majority of foreign journalists temporarily depart Sarajevo along with most European Community Monitoring Mission (ECMM) staff and UNPROFOR personnel. Bosnia and Herzegovina becomes a full member of the UN. The 'Zetra' sports centre is destroyed by heavy artillery fire and many other buildings in Sarajevo – among them the Bristol Hotel, the *Sarajka* department store, the *Elektroprivreda* building, the Bosnian parliament and the Holiday Inn – are badly damaged by mortar and shell fire. Heavy fighting in Pofalići. A VRS mortar attack on a bread line in Vaso Miskin street in Sarajevo kills seventeen people and over 140 wounded. Days later, the United Nations (UN) imposes sanctions on the new Federal Republic of Yugoslavia – comprising Serbia and Montenegro – for fomenting war in Bosnia and Herzegovina and Croatia. Heavy shelling of Sarajevo continues.

June

The heavy shelling of Sarajevo continues unabated, with many of the city's key buildings targeted. The Presidency of Bosnia and Herzegovina declares a state of war and general mobilization. The last JNA soldiers from the Maršal Tito barracks leave Sarajevo. The Holiday Inn hotel re-opens to become the main base for foreign correspondents, who begin to return to the city in larger numbers. Muslim and Croat citizens are evicted from the Sarajevo district of Ilidža by VRS and paramilitaries. The *Oslobođenje* building is burnt down after heavy artillery attack by the VRS. Bosnian government issues instructions to Sarajevo citizens about sniper fire, shelling and how to best move around the city. All communications with the outside world are severed. French President François Mitterrand makes a surprise visit to Sarajevo. By the end of the month, UN peacekeepers hoist flag at Sarajevo Airport after agreement over control over the airport concluded.

July

International airlift – 'air bridge' – operation to Sarajevo commences. UN humanitarian aid is distributed but some ends up on the black market where it is sold for highly inflated prices. Fewer than half of all communities in Sarajevo receive aid. Heavy shelling of the city continues. Artillery attacks kill twelve in Sarajevo including three waiting in line for humanitarian aid. A convoy of mothers and children, organized by the 'Children's Embassy' leaves Sarajevo for Italy. Four power transmission lines leading into Sarajevo are dynamited by VRS cutting off city's electricity and water

pumps. Very little water in the city as surrounding reservoirs are held by the VRS. 'The Republic of Herceg-Bosna' proclaimed by Mate Boban. Shelling and sniping remains a daily occurrence in Sarajevo. Bosnian defenders launch offensive against Serbs in hills around Sarajevo; at least forty Bosnians killed as they fight with light weapons against heavy weapons of Serbs.

August

Attack on a convoy of children from the Ljubica Izević children's home. Two young children – Vedrana Glavaš and Roki Sulejmanović – are killed. The mother of the former, Ruža Glavaš, is subsequently targeted at her son's funeral. UNPROFOR headquarters in Sarajevo shelled, wounding four French soldiers. CBS journalist David Kaplan killed near Sarajevo Airport while reporting on the visit of the Federal Republic of Yugoslavia's Prime Minister, Milan Panić. The UN Security Council adopts two resolutions on Bosnia and Herzegovina: Resolution 770 – approving the use of armed force to conduct humanitarian missions – and Resolution 771 – which condemns violations of human rights. The Europa Hotel in Baščaršija goes up in flames after grenade attack by VRS forces. A shell lands in a market in Alipašino polje killing eight and wounding more than fifty. Sarajevo Airport temporarily closed after shots fired at British Royal Air Force (RAF) Hercules C-130. The National Library in Sarajevo is gutted by fire after attack – with incendiary shells – by the VRS. Mortar attacks hit main Sarajevo hospital and Bosnian parliament building. Sarajevo Airport intermittently closed because of fighting in the environs of Dobrinja, Butmir and Sokolović kolonija. Koševo Hospital shelled. Five Bosnian journalists wounded in the shelling of the ruined *Oslobođenje* building.

September

Clashes in the Sarajevo district of Stup – VRS launches a fierce offensive in the area. Heavy fighting continues in Sarajevo. Sustained VRS shelling of the Hrasno district. Four people killed by mortar shells in Alipašino polje. Italian plane carrying UN aid crashes near Sarajevo. Water completely cut off. Citizens of Sarajevo begin chopping down trees and removing park benches for firewood in anticipation of a winter under siege. Citizens of Muslim and Croat nationality are permitted to leave Serb-held Grbavica but are ordered to pay for their departure by the VRS and Serb paramilitaries. The *Zora* chocolate factory is destroyed by shells.

October

UN Security Council Resolution 781 leads to the banning of all military flights above Bosnia and Herzegovina except UN aid flights – which begin operating again. The Sarajevo City Bakery suffers heavy shelling. Intensive shelling of the city. A shell lands on the Ljubica Ivezić orphanage killing three children. The Presidency building among those hit. More than thirty shells fall on Koševo Hospital, killing one nurse. Electricity supplies in the city are completely cut off for three weeks as winter approaches.

UNICEF campaign 'A Week of Silence for Children' – a convoy of trucks carrying milk, blankets and winter clothes, arrives in Sarajevo. Irregular water, electricity and communications in the city.

November

A convoy of Slovenians from Sarajevo leave the city following an agreement with the Association of Slovenians and the Slovenian government. Aid flights into Sarajevo halted; city is without water and electricity again. Ceasefire declared – 2,000 refugees allowed to leave Sarajevo; convoys halted by VRS. The Sarajevo Post Office reconnects some of the city's telephone links, but only for those people who are prioritized. Banks are re-established in the city. Some intermittent electricity but no water. First snow of winter falls in Sarajevo. Elie Wiesel briefly visits the city.

December

VRS launches another heavy attack in the Sarajevo suburb of Otes. The ARBiH is forced to withdraw and evacuate citizens. The ARBiH win a strategic victory by taking a crucial part of Mount Žuč, which had been used by the VRS as a position from which to shell Sarajevo. UN headquarters in Sarajevo – PTT building – is shelled by the VRS. UN aid convoys still manage to get into Sarajevo with 220 tons of food despite artillery shelling. Sarajevo Airport temporarily closed and aid into the city becomes increasingly limited leading to inflated prices on the black market. Bread in short supply because of lack of oil and water. UN suspends airlift to Sarajevo for two days after US plane hit by small arms fire. Heavy snow falls in Sarajevo as winter takes hold. The temperature in the city is -13°C and there is regularly no electricity, gas or water. UN commander General Philippe Morillon claims his home in Sarajevo was shelled by a mortar from ARBiH positions.

1993

January

UN Secretary General, Boutros Boutros-Ghali arrives in Sarajevo; citizens mobilize to protest against UN policy and for his comment that the situation in Sarajevo was 'better than in ten other places in the world'. International mediators Cyrus Vance and Lord Owen unveil plan to divide Bosnia into ten provinces, mostly along ethnic lines. Bosnian Deputy Prime Minister, Hakija Turajlić, killed by VRS soldier in UN armoured vehicle near Sarajevo Airport. Peace conference begins in Geneva. VRS offensive against Sarajevo. VRS fires shell into a crowd of citizens waiting to fill water containers in the vicinity of the Sarajevo Brewery, killing eight people. The City Assembly of Sarajevo, on behalf of citizens of Sarajevo, passes motion to reject humanitarian aid in solidarity with those starved of aid in eastern Bosnia – as a consequence of the VRS blocking UNHCR aid convoys.

February

UN Security Council establishes the International Criminal Tribunal for the Former Yugoslavia (ICTY) to be based in The Hague. Alija Izetbegović signs Vance–Owen peace plan in New York. Conflict between Bosnian Croats and Muslims over the 30 per cent of Bosnia not seized by Bosnian Serbs continues. A Muslim funeral in Sarajevo fired upon by anti-aircraft machine guns killing one. VRS mortar hits line of people waiting for water in Sarajevo, killing three. UN aid flights to Sarajevo resume. ARBiH launches attack against Serbs in Ilidža. Sarajevo's last operating bakery temporarily shuts doors due to lack of fuel. The daily newspaper *Oslobođenje* is named 'World Newspaper of the Year'. The first wartime cinema *Obala* begins working – films are screened in basements. New fighting in Sarajevo – VRS shell Serb suburb of Stup. One – Egyptian – UNPROFOR soldier killed by sniper fire.

March

The shelling of Sarajevo intensifies along with VRS tank assaults on western part of city. Water and electricity cut off again after heavy bombardments of the city, though they are restored soon after. *Oslobođenje* publishes its 'European Issue'. The rock concert 'Help Bosnia Now!' takes place in Sarajevo. The clement weather in Sarajevo means that citizens venture outside. Two children are killed – one by sniper fire, the other succumbing to shrapnel wounds.

April

Citizens of Sarajevo mark one year of the siege. The Koševo cemetery is reopened – twenty-seven years after the last person was buried there – due to lack of space to bury the dead. Easter Mass held in the Sarajevo Cathedral. NATO jets begin to enforce UN no-fly zone over Bosnia and Herzegovina. Susan Sontag and Joan Baez both visit Sarajevo.

May

Following Serb assault on Srebrenica and dramatic crisis of refugees arriving in Tuzla, UN Security Council declares six 'safe areas' for Bosnian Muslims: Sarajevo, Tuzla, Bihać, Srebrenica, Žepa and Goražde. Bosnian Serb leader Radovan Karadžić signs Vance–Owen plan in Athens, Greece; the Assembly of Republika Srpska later rejects it. In a referendum, Bosnian Serbs overwhelmingly reject Vance–Owen plan in favour of an independent Bosnian Serb state (Republika Srpska). Thirteen people killed in artillery attacks on Sarajevo.

June

Thirteen people killed on a playground in Dobrinja. The VRS targets people in prayer during the funeral and eight people die at the Budakovići cemetery. The UN Security

Council adopts resolution on establishing 'safe areas' in Bosnia and Herzegovina. In accordance with this resolution, Sarajevo, Žepa, Srebrenica, Bihać, Tuzla and Goražde are deemed to be 'safe afeas' in which UNPROFOR peacekeepers will be authorized to 'repel' any attacks on these areas.

July

Utilities again cut off in Sarajevo. In Dobrinja, thirteen people are killed while they queue for water. VRS intensify assault on Mount Igman, breaking through ARBiH defences in three places. VRS say they will no longer allow Sarajevo to be supplied through international organizations. Fighting intensifies on Mount Igman. Renewed VRS shelling of Bosnian government positions outside Sarajevo. VRS fires artillery rounds at French UNPROFOR base in Sarajevo destroying four vehicles, damaging others. After threat of air strikes, VRS retreat on the condition that the UN move in to the positions they hold on Mount Igman.

August

VRS withdraws from Mount Igman but 'digs in' to mountain positions around Sarajevo. Launches 'air bombs' into centre of the city. Irma Hadžimuratović hit by a sniper – after significant media coverage and pressure from the international public, she is relocated to the United Kingdom for treatment. Susan Sontag premieres her production of the Samuel Beckett play 'Waiting for Godot' at the Sarajevo Youth Theatre.

September

The school year begins with children being taught in cellars and basements. Numerous incidents of firing on planes flying into Sarajevo. The airport is intermittently closed throughout the month resulting in smaller volumes of humanitarian aid entering the city and inflated prices for basic goods on the black market.

October

Continued and sustained shelling of Sarajevo. First evacuation of civilians from Sarajevo since May begins. The Sarajevo bakery ceases operations because of lack of gas and oil. ARBiH mortar attack on Sarajevo suburb of Vogošća results in heavy VRS shelling of Sarajevo. The Sarajevo 'air bridge' becomes the longest of its kind in history – beating the Berlin airlifts of June 1948 to September 1949. The Sarajevo Film Festival launches, though numerous guests remain in Ancona, Italy, unable to be transported by UN planes. The slogan of the festival is 'We can't promise you anything'. Aid flights to Sarajevo suspended after French UNPROFOR officer fired upon at the airport.

November

The city has no electricity, water, gas or humanitarian aid for several weeks. A VRS shell kills Fatima Gunić, a teacher, and three of her students outside a school in Alipašino

polje. Consequently, classes are suspended until protection measures are adopted – thereafter, it is determined that school lessons last for fifteen minutes and pupils will be absent from school from 24 December to 1 March. Five are killed and ten injured on an attack on a bridge in Dobrinja. Koševo Hospital targeted. French UNPROFOR battalion assists the citizens of the Sarajevo district of Alipašino polje to repair their homes and drain water from their basements. They also provide the materials for the construction of gas installations. Electricity is, however, in short supply in Sarajevo and supply is extremely irregular. Three children are killed in the centre of Sarajevo while playing in the snow.

December

Bosnian Serb leader Radovan Karadžić vows to bring about complete military defeat of the Bosnian government forces if VRS positions around Sarajevo are attacked. Fighting around and shelling of Sarajevo continues throughout the month. Sarajevo Airport is frequently closed and aid flights are limited due to heavy fighting. The city has little electricity and is short of water and salt. *Oslobođenje* wins the 'Sakharov Award' from the European Parliament. Eight people are killed on the *Drvenija most* (wood bridge) in Sarajevo.

1994

January

Bosnian President Alija Izetbegović appeals for UN intervention against VRS to stop shelling of Sarajevo. Shelling of Sarajevo continues keeping airport closed for long periods. Shell kills six children playing in snow in 'Phase C' of Alipašino polje. Announcement of the despatch of a French 'anti-sniping' unit to Sarajevo – they are predominantly deployed along so-called 'Sniper Alley'.

February

Sixty-eight people killed and some 200 wounded as a mortar shell fired into Markale marketplace in Sarajevo – the worst single incident of the siege. This followed a similar attack at a football field in Dobrinja the previous day in which ten civilians were killed. After initial investigation, UNPROFOR establish that the round fired into Dobrinja was from a VRS position, but it had not been possible to locate the source of the attack on Markale market. NATO 'ultimatum' gives VRS ten days to withdraw heavy weapons from Sarajevo and its environs or face air strikes. Radovan Karadžić agrees to withdraw heavy weapons on the proviso that Russian peacekeepers are deployed. Russian peacekeepers arrive and NATO deadline expires; UN states that VRS heavy weapons are being removed. US (NATO) F-16 fighters shoot down four Bosnian Serb warplanes violating the no-fly zone. The shots were the first fired by NATO in Bosnia and Herzegovina. Juan Antonio

Samaranch, the former President of the International Olympic Committee (IOC) visits Sarajevo ten years after the 1984 Winter Olympics.

March

For the first time since the siege began, citizens of Sarajevo are permitted to cross the Miljacka River. Under UNPROFOR protection, the first buses from the centre of the city arrive in the Hrasnica district. The US Secretary of State, Madeleine Albright, visits Sarajevo.

April

UN states that the VRS have 'mostly' complied with the terms of the NATO ultimatum. UN accuses VRS of 'orchestrated campaign' against UN observers/military personnel for airstrikes including Serb sniper wounding French soldier in Sarajevo. British Embassy opened in Sarajevo.

May

The VRS attempt to recover 122 mm cannon from a UN checkpoint at Poljine, where VRS weapons are held. UNPROFOR requests NATO assistance – NATO planes fly low over VRS positions around Sarajevo. The 'Contact Group' announce new peace plan, including a four-month ceasefire and eventual – internal – partition of Bosnia and Herzegovina. Mortar hits Sarajevo Airport.

June

Mozart's *Requiem*, conducted by Zubin Mehta, is played in the building of the gutted National Library in tribute to the victims of the siege of Sarajevo and the war in Bosnia and Herzegovina. One person is wounded on a tram near the Holiday Inn hotel after the UNPROFOR armoured vehicle that was supposed to protect it withdrew – though it was later replaced by another armoured vehicle.

July

US and French Embassies opened in Sarajevo. British Foreign Secretary Douglas Hurd and the Minister of Foreign Affairs of France Alain Juppe arrive in Sarajevo on the occasion of the opening of the French Embassy. Bosnian Serbs reject Contact Group Plan and close 'blue roads' around Sarajevo. Explosions in Jewish cemetery and at Vrbanja Bridge in Sarajevo. UNPROFOR says VRS moved five tanks and three artillery weapons into the Sarajevo exclusion zone. Sniper fire in Sarajevo forces police to close centre to traffic. UN accuses VRS of violations and attacks on peacekeepers. French UN troops fire on Serb snipers in Sarajevo. 'Survival gardens' have become commonplace in Sarajevo. Eleven people are killed after a water queue is targeted in Dobrinja. The airport is again temporarily closed after a Hercules C-141 is targeted.

August

Serbian President Slobodan Milošević severs ties with the Bosnian Serbs for rejecting Contact Group Plan. Attacks, especially by snipers – despite an anti-sniping agreement – escalate in frequency. Attacks occur in the city centre and the suburbs, directed on many occasions, at residential buildings, pedestrians and moving vehicles – such as busy trams – packed with people. UNPROFOR personnel targeted – UNPROFOR call in NATO warplanes to strike VRS heavy weapons violating the exclusion zone around Sarajevo. Fighting around Sarajevo's Jewish cemetery.

September

Airlift again suspended after Hercules C-130 hit by bullet at airport. UN officials confer with Bosnian Serb leadership and the VRS about restoring power to Sarajevo. UN commanders tell VRS they must remove guns from exclusion zone by next day or face air strikes. VRS restores utilities to Sarajevo, but continues to enforce airport closure and limit UN movements. Sniping on the increase in Sarajevo.

October

NATO threatens the VRS over the continuing obstruction of Sarajevo, citing this as a clear justification for further air strikes. The tram system is halted again after another tram is targeted in Sarajevo – the driver is killed and twelve passengers are injured.

November

VRS attacks Sarajevo, drawing retaliation from the ARBiH. Fifty NATO jets and support planes respond by targeting VRS airfield. VRS detain fifty-five – Canadian – UN peacekeepers as a protection against further air strikes. Eventually more than 400 peacekeepers are held across Bosnia and Herzegovina by the VRS. NATO attempts air strike on Serbs near Bihać. Mission called off after UN fails to pinpoint targets. Another tram is hit in Sarajevo, with one killed and six injured.

December

VRS hijacks UN fuel shipment as it tries to enter Sarajevo, also taking two vehicles with satellite communication equipment. UNPROFOR officials refuse to call for air strikes or overflights for fear of the VRS killing UN soldiers. VRS continues to fire on civilians, harass UN forces and block aid convoys to Sarajevo despite promises to do otherwise. Former US President Jimmy Carter visits Sarajevo on a mediating mission which ends with announcement of ceasefire covering the period between 1 January and 1 April 1995.

1995

January

Start of 'truce' – negotiated by Jimmy Carter – for a three-month period. Missile fired from Bosnian Serb side hits Holiday Inn hotel. Sarajevo Airport closed – this time because of bad weather. Sarajevo officially marks 1,000 days of the siege. Relief flights into Sarajevo suspended for first time since truce came into effect after two planes were hit by gunfire. UN spokesman Alexander Ivanko says they may have come from Bosnian Serbs celebrating Orthodox Christmas. The cellist, Walter Deshpal, together with the Sarajevo Philharmonic Orchestra, plays a concert at Sarajevo's National Theatre.

February

Trams are frequently targeted by snipers near the Holiday Inn hotel, leading to occasional cessation of service. A strain of flu called 'Influenza Type A' arrives in Sarajevo – apparently from China. Further attacks on the Sarajevo tram system. First railroad transport in Sarajevo Bosnia in two years. Serbs fire shells at government bunkers in Sarajevo; small arms fire exchanged around Jewish cemetery. Sniper fire a daily occurrence.

March

The UN Secretary General's Personal Representative Yasushi Akashi's aeroplane is hit by gunfire as it approaches Sarajevo Airport. Two people killed by snipers in Sarajevo. VRS renews attacks on airport firing on French air transport causing UNPROFOR troops to return fire.

April

US aid plane hit by gunfire; all UN aid flights to Sarajevo cancelled. The people of Sarajevo begin fourth year of war. Some fifteen citizens gathered in Sarajevo to place flowers on the grave of Suada Dilberović, who was killed on the Vrbanja Bridge on 5 April 1992. VRS shell government-held Sarajevo suburb of Hrasnica with 120 mm mortars killing two and wounding three. A young girl, Maja Djokić, is the latest victim of sniper fire in Sarajevo. US C-130 relief plane hit by ten bullets at Sarajevo Airport by Serb snipers damaging hydraulic system, hitting cockpit. The UN again suspends flights to and from Sarajevo Airport. The UN declares that the VRS have used 120 mm mortars in violation of the ceasefire agreement in Sarajevo killing three. The UN accuses the VRS of targeting Sarajevo's civilian neighbourhoods with 'big guns', which are supposed to be banned from around the capital; they request a NATO air presence over the city. French UNPROFOR peacekeeper killed in Sarajevo while driving through Dobrinja. Three French soldiers are killed in Sarajevo in the month of April.

May

Shortage of oil in Sarajevo – buses cannot function and trams run only between Čengić Vila and Alipašino polje. Serbs shell Sarajevo suburb of Butmir killing eleven and injuring forty near tunnel under airport. Battles around Jewish cemetery – mortars and rockets hit the Holiday Inn. A French UNPROFOR soldier is killed near the Unis towers and the Holiday Inn. Humanitarian aid reaching Sarajevo reduced to half as the VRS intensify their attacks on the city – as a consequence, there is little public transport, low gas pressure and limited water supplies. Heavy fighting between the VRS and French 'anti-sniping teams' on Vrbanja Bridge after a UN observation post was seized by the VRS. Two French soldiers are killed in the exchanges. UN orders VRS to submit heavy weapons to UN control and remove all heavy weapons from around Sarajevo. Bosnian Serbs ignore UN order. NATO attacks VRS ammunition depot. VRS respond by shelling 'safe areas', including Tuzla, where seventy-one people are killed and over 150 injured. NATO warplanes attack more ammunition depots. Serbs take UN peacekeepers hostage. Eventually more than 370 are seized. Bosnian government says UN no longer feels competent to defend Sarajevo after Serb shelling which killed eleven. Heaviest fighting in two years hits Sarajevo with hand-to-hand fighting in trenches, mortars, rockets and heavy artillery; at least five killed, and twenty-six civilians and two UNPROFOR peacekeepers are wounded. VRS seize more hostages bringing total to over 200 peacekeepers. VRS soldiers disguised as French peacekeepers capture twelve French UNPROFOR peacekeepers at Vrbanja Bridge in central Sarajevo, then get in firefight with UN reinforcements – one French soldier and four VRS soldiers are killed.

June

Heavy fighting in Sarajevo. Artillery being used again in city. Seven citizens waiting in line for water killed. First aid shipment in several weeks reaches Sarajevo brought in by government drivers escorted by Bosnian Serb police after Akashi approves scaled-back UN operations in exchange for allowing aid into Sarajevo. NATO defence chiefs, meeting in Paris, agree on rapid reaction force to bolster UN peacekeepers in Bosnia and Herzegovina. VRS release 111 more UN hostages. All but the last twenty-six UN hostages are released. Bosnian government launches offensive to break siege of Sarajevo. Offensive gradually stalls; VRS intensify shelling of Sarajevo. Last twenty-six UN hostages released. In retaliation for the ARBiH offensive, a VRS 'modified air bomb' hits TV building in Sarajevo and adjacent apartment block. Five are killed and dozens wounded.

July

UNPROFOR headquarters – the PTT building – in Sarajevo shelled by the VRS. Shelling of Sarajevo intensifies. VRS attacks and overruns the 'safe area' of Srebrenica. The Bosnian Serb wartime capital of Pale attacked by NATO warplanes. A total of 300 British and 500 French soldiers move onto Mount Igman to establish artillery and light tank positions. French UNPROFOR peacekeepers start to use 120 mm mortars – biggest calibre weapon used against the VRS since the beginning of the war – on road into Sarajevo.

August

VRS shells Sarajevo region, killing six and wounding thirty-eight – including six Egyptian UNPROFOR peacekeepers – after ARBiH shells VRS arms factory. VRS fire shell into a Markale marketplace in Sarajevo, killing thirty-seven and wounding scores. NATO planes, supported by ground troops of the UN rapid reaction force, launch massive airstrikes to silence Bosnian Serb guns around Sarajevo. VRS shell Sarajevo in response. ARBiH fires fourteen mortar rounds at Serb ammunition factory in Vogošća – Sarajevo suburb – killing two civilians. VRS retaliates by shelling Sarajevo, killing six and wounding thirty-eight. VRS fires on UN observation post in Sarajevo wounding six Egyptian peacekeepers. Three US diplomats, Robert Frasure, Joseph Kruzel and Nelson Drew, killed when armoured personnel carrier slips off Mount Igman road. Three other Americans and three French injured. NATO planes begin attacks on Serb positions – sixty planes launch strikes on air defence radar installations, SAM batteries, communication facilities, ammunition factories and dumps.

September

NATO resumes attacks to force withdrawal of VRS heavy weapons around Sarajevo. NATO suspends attacks. Slobodan Milošević pledges that Bosnian Serbs will withdraw guns from around Sarajevo. NATO suspends air strikes, but VRS General Ratko Mladić rejects UN demand to remove guns around Sarajevo unless ARBiH does likewise. Seven wounded by VRS rocket-propelled attack in Sarajevo. VRS refusal to move heavy weapons causes NATO to renew bombing around Sarajevo. In the presence of the Serbian President Slobodan Milošević, an agreement is signed – by Radovan Karadžić, Ratko Mladić and Richard Holbrooke – on the withdrawal of VRS heavy weapons deployed around Sarajevo. The agreement also binds the ARBiH to refrain from offensive actions in and around Sarajevo. VRS allow for the reopening of Sarajevo Airport. In a joint statement, UN and NATO commands state that the VRS had withdrawn heavy weapons to within twenty kilometres from Sarajevo before the set deadline, and that UN and NATO commanders had agreed that air strikes 'need not be resumed for the time being'.

October

Warring parties agree to a sixty-day ceasefire. Guns fall silent in the hills around Sarajevo. After a seven-month blockade, gas and electricity flow into Sarajevo. Western road out of Sarajevo opened by UNPROFOR after being cleared of landmines.

November

Peace talks begin at the Wright-Patterson Air Base in Dayton, Ohio. Bosnian Serb leader Radovan Karadžić and General Ratko Mladić, his military commander, indicted for war crimes by the ICTY for their alleged roles in Srebrenica massacres. Leaders initial peace accord, granting 51 per cent of Bosnian territory to Muslim – Bosniaks –

and Croats; 49 per cent to Serbs. Dayton Peace Agreement – Bosnia and Herzegovina to be integrated state with two entities – the Muslim-Croat Federation and *Republika Srpska* – and common institutions. Sarajevo remains undivided. Part of UNPROFOR to withdraw, but some within UN force will join the NATO 'Implementation Force' (IFOR). Jacques Chirac seeks security guarantees for the Serb population in Sarajevo. UN votes to end peacekeeping mission by 31 January 1996.

December

NATO authorizes deployment of 60,000 troops to Bosnia and Herzegovina; appoints Javier Solana as secretary general. Presidents of Serbia, Bosnia and Herzegovina, and Croatia sign Dayton peace plan in Paris, setting stage for deployment of NATO troops. Bosnian and Serbian governments agree to formal diplomatic recognition. UN Security Council transfers peacekeeping duties to NATO – which subsequently takes over command of Bosnia peace mission. Thousands of Serbs begin to flee Sarajevo suburbs, many carrying coffins of relatives. French NATO troops extend control in Sarajevo. Government and VRS troops pull back from area around Sarajevo to meet first deadline of peace accord. Lights return in Sarajevo as new electricity line paid for by Germany is turned on. ARBiH and VRS pull back from frontline positions near Sarajevo according to Dayton deadline.

1996

January

Tram in Sarajevo hit by projectile – one person killed, nineteen passengers injured. The 'air bridge' is formally closed after three and a half years, the longest such airlift in history, during which over 13,000 flights deliver nearly 168,000 tons of humanitarian aid into Sarajevo. Civilian flights, albeit a very limited number, resume. IFOR takes control of the city's water, electricity and gas infrastructure. The departure of Serbs from Sarajevo continues. Many set fire to their properties before they leave.

February

The 'Brotherhood and Unity Bridge' is opened during the day. The process of the 'peaceful reintegration' of Sarajevo and of hitherto Serb-held areas in the city begins. At the end of the month, siege of Sarajevo formally lifted – exactly four years since the 'Referendum Weekend' in 1992.

Introduction

The 1992–96 siege of Sarajevo, the capital of Bosnia and Herzegovina which, until April 1992, had hitherto been one of six republics within the Socialist Federal Republic of Yugoslavia (*Socijalistička Federativna Republika Jugoslavija* – SFRJ) remains one of the most shocking events of late twentieth-century European history. A specific theatre within the wider Bosnian war, the city was militarily encircled and subjected to a siege that lasted for over three and a half years – 1,425 days[1] – longer than the sieges of Medina, then Arabia, now Saudi Arabia during the First World War (1916–19), Madrid during the Spanish Civil War (1936–39) and both Leningrad (St Petersburg) and Stalingrad (Volgograd) during the Second World War (1941–44 and 1942–43 respectively). The siege of Sarajevo began on 6 April 1992 – though the lines of the siege were not fully consolidated at that point – and lasted until it was formally 'lifted' on 29 February 1996. The human cost of the longest siege in modern European history was significant, with an estimated 11,541 individuals, more than four times as many people killed in the city in a relatively short period than thirty years of 'The Troubles' in Northern Ireland, losing their lives.[2] During that period, Sarajevo – the city known globally as the place where Archduke Franz Ferdinand was assassinated by Gavrilo Princip on 28 June 1914 and where, seventy years later, in 1984, it hosted the fourteenth Winter Olympic Games – was almost entirely encircled and its citizens exposed to daily shelling, mortar and sniper fire, while being starved of basic essentials such as water, electricity and sufficient food supplies.[3] Sarajevo, built around the Miljacka River and located on an elongated valley, is surrounded by hills. The southern side of these hills – Trebević, Poljine and Mojmilo – and, at the beginning of the siege, parts of the northern side – Špicasta stijena and Žuč – were held by the besieging Bosnian Serb forces who had placed heavy weapons which were used to shell and mortar the city.[4] Many of the city's most important cultural institutions, historical monuments, religious buildings, sporting venues and the wider social and economic infrastructure were destroyed or seriously damaged during a sustained campaign by the army of the breakaway 'Serbian Republic of Bosnia and Herzegovina' – later *Republika Srpska* (RS) – whose aim was to 'strangle' the city into submission, or to divide the city into eastern and western parts, as Radovan Karadžić's 'Serbian Democratic Party' (*Srpska demokratska stranka* – SDS) had stated was their primary objective.[5]

For the vast majority of those *Sarajlije* (Sarajevans) who were unable to leave the city in the early weeks of the siege, few options were available to them once the

frontlines had been consolidated in the early summer of 1992. Indeed, they could do little other than to defend the city – for those that either volunteered or were compelled to fight – and learn to adapt to the harsh realities of living under daily shell and sniper fire, often running across streets and intersections in the hope that they would not be the target of a sniper's bullet. They had to survive without consistent water supplies, electricity or gas and had to rely on United Nations (UN) humanitarian aid – much of which would often find its way on to the city's thriving black market and thus subject to the inflationary forces and broader dynamics of a siege economy.[6] Even today, twenty-five years since the signing of the 'General Framework Agreement for Peace in Bosnia and Herzegovina' – known more commonly as the Dayton Peace Agreement – in 1995, which brought the war in Bosnia and Herzegovina to an end, it seems almost unimaginable to generations born since the war that a capital city in Europe could be subject to such a sustained and protracted siege for almost four years, with the international community seemingly unable, or unwilling, to end the agony.

The siege of Sarajevo became worldwide news, though the media focus on it ebbed and flowed, determined by events 'on the ground' and interest in the story. The late Michael Nicholson, a veteran ITN reporter, noted that 'Sarajevo quickly won its reputation as a lethal place to work and yet the world's press came to cover it eagerly'.[7] In the international media, the siege was cast as a dramatic and visceral struggle between David and Goliath; the lightly-armed, rag-tag defenders of a city encircled by the might of the remnants of the Yugoslav People's Army (*Jugoslovenska Narodna Armija* – JNA) and, later, the Army of the Serb Republic (*Vojska Republike Srpske* – VRS). Compounding this was the visceral imagery of ordinary citizens not only caught in the crossfire but deliberately targeted by shell and sniper fire. As the *New York Times* correspondent John Fisher Burns, in an interview with the filmmaker Marcel Ophuls, noted, 'If you are a newspaper reporter, inappropriate as it might be to say this, this is a story that has *everything*.'[8] As a consequence, foreign journalists began to arrive in the city in April 1992, with their numbers growing throughout the summer. Within a matter of months, their presence in the city was almost permanent, with most major media agencies establishing bureaus and offices, primarily – though

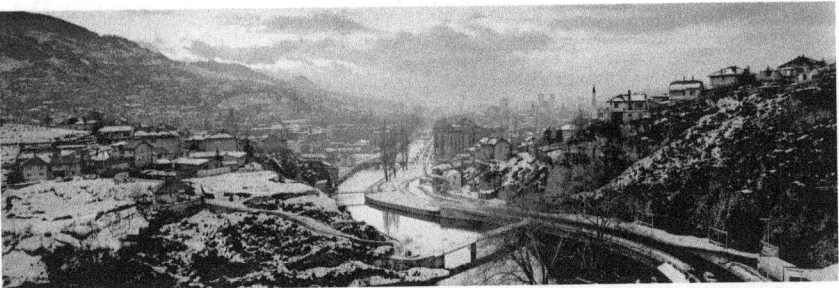

Figure 0.1 Sarajevo panorama (Paul Lowe/VII).

not exclusively – in the Holiday Inn hotel and the TV building. Many had covered previous conflicts – in Slovenia and Croatia – and were aware of the considerable risks. The war in Croatia, which preceded the conflict in Bosnia and Herzegovina, had been a particularly dangerous one for journalists – twenty-five were killed during the relatively short war there – in comparison to the figure of sixty-three during the entire Vietnam War, which is widely acknowledged as the first 'televised war'. In total, 142 journalists were killed, and many more injured, in the wars – in Slovenia, Croatia, Bosnia and Herzegovina and, later, in Kosovo – that accompanied the violent disintegration of the Yugoslav state, almost all of them journalists from the region, with a few notable exceptions.[9]

From 1992 until the signing of the Dayton Peace Agreement – and, to a lesser extent, the subsequent lifting of the siege and the implementation of that peace agreement – Sarajevo would become something of a second home for many foreign correspondents. Foreign TV crews, in particular, were located in and focused largely on Sarajevo.[10] Bureaus of most of the leading international press agencies were established in the city and, thus, at the expense of other cities, towns and villages in Bosnia and Herzegovina – such as Prijedor, Banja Luka, Zvornik, Višegrad, Brčko, Tuzla, Zenica and Mostar (the UN 'safe areas' of Srebrenica, Goražde and Žepa received slightly more coverage)[11] – Sarajevo was the primary focus of the international media covering the war.[12] As Charles Ingrao noted, 'As the largest city [in Bosnia and Herzegovina] and capital claimed by both sides, as well as the home to the 1984 Winter Olympics, it became the focus of media attention.'[13] Their presence ensured that the story of the siege was sustained and largely 'kept alive' throughout the duration of the Bosnian war – though it was the early months of the siege that received the most media attention. Indeed, Bosnia and Herzegovina – and within it Sarajevo – was, unlike many war zones, relatively accessible to journalists and photojournalists, whether they were employed by a wire service, TV station or newspaper, or were working in a freelance capacity. According to Robert Donia, Sarajevo became 'the lens through which most outsiders viewed the conflict; the agony of Sarajevo became the embodiment of the Bosnian war's savagery and senselessness'.[14] Much of this was merely 'urban bias' but it was also an issue of the relative ease of access for journalists.[15] As Peter Andreas notes, a city under siege 'by its nature should be a particularly inaccessible and dangerous place for international actors' and that Sarajevo was 'certainly violent and dangerous, as one would expect of a besieged city'; he adds that 'it was also the most accessible war zone and viable working environment for international actors in Bosnia – which helped turn Sarajevo into a global media spectacle'.[16]

Some of the conflicts that immediately pre-dated the Yugoslav wars of disintegration – the 'First Gulf War' being a case-in-point – had been characterized by 'hotel journalism', where foreign correspondents were often far from the frontline and largely reporting on US Army press briefings held in the hotels where the media were concentrated or being 'embedded' with US or other coalition troops engaged in the conflict that followed Iraq's invasion of Kuwait in August 1990.[17] There were,

of course, exceptions to this rule, with the major American networks – such as CBS, ABC, NBC and CNN, the latter of which was the only 24-hour news channel in the US – and the BBC reporting from inside Baghdad, albeit often from their hotel, the Al Rasheed, though they were, initially, forbidden by the Iraqi government to use satellite phones. Generally, however, the US government and military, and indeed their Iraqi counterparts, maintained a restrictive policy vis-à-vis the mobility and access of journalists. Conversely, the wars in Slovenia, Croatia and Bosnia and Herzegovina – though with a significant presence of international agencies such as the European Community Monitoring Mission (ECMM), the United Nations High Commission for Refugees (UNHCR), the International Committee of the Red Cross (ICRC) and, subsequently, the United Nations Protection Force (UNPROFOR) – afforded foreign correspondents a degree of freedom that had been impossible during the Gulf War and many subsequent wars. They were able, albeit not without significant risk or difficulty, to move across frontlines and operate without the restrictions often imposed in war zones – though they would increasingly rely on UN flights and transport in and out of the city and the wider UNPROFOR infrastructure within it.

Though a besieged city, Sarajevo could, albeit not without difficulty or danger – and depending upon whether the airport was open, as weather and security conditions on the ground could determine whether or not it operated – be accessed by plane on UN aid flights from Ancona in Italy or Split and Zagreb in Croatia, which came to be known as *Maybe Airlines*. It could also be reached by car via various routes – via Pale-Lukavica, Kiseljak-Ilidža and later by the rugged and exposed Mount Igman road. Once in the city, Sarajevo was relatively well equipped to deal with the large numbers of journalists that came to the city during the siege. Indeed, as Andreas further notes, 'An important legacy of the 1984 Winter Olympics was that the city also possessed the physical and technical infrastructure and support services to host a substantial media presence.'[18] That was undoubtedly the case, yet this existing infrastructure developed significantly throughout the siege and under adverse conditions. Despite the relatively easy accessibility and basic infrastructure, reporting from *within* the confines of a besieged city that had no consistent electricity and no regular supply of water – while food and fuel would often have to be bought on the black market, their cost thus subject to the specific economic dynamics of the siege – this work could not be conducted without some difficulty. These conditions brought their own very significant challenges, not least to establish and maintain an infrastructure that would allow for the siege to be reported. As the logistical operations that supported the reporting infrastructure developed, however, the access that foreign journalists had in the first year of the Bosnian war gradually diminished; crossing the lines between Bosnian government-held territory and Republika Srpska became more challenging and they were thus restricted to reporting from within relatively limited geographical areas, sometimes to merely the length and breadth of the narrow city of Sarajevo.

The accessibility, in the early days of the war in Bosnia and Herzegovina, to Sarajevo in particular attracted a younger generation of foreign correspondents, some of whom were relatively inexperienced. Among them were a significant number of freelancers, some fresh out of university. Indeed, the wars of Yugoslav succession were not considered, on

the whole, as significant or important as more important 'geopolitical' stories; many of the more senior, well-established journalists continued to focus on events in the Middle East – with, of course, some notable exceptions – rather than cover the events unfolding in the Balkans. Thus, the wars in what became known as the 'Former Yugoslavia' presented an opportunity for a younger generation of journalists and photojournalists – and some of the local stringers, translators and fixers who worked alongside them – to 'take ownership of the story', learn their trade and build their careers.[19]

These journalists also enjoyed relative autonomy and a semblance of editorial control, though the 'tyranny of the two-way' and the advent of digital communications began to change the way that they operated. As the BBC's Martin Bell has noted, the Bosnian war and the related siege of Sarajevo, fell within the twilight years of what he described as 'the high noon of electronic newsgathering'[20] and what Christiane Amanpour of CNN described as 'one of the last old-fashioned war reporting and storytelling opportunities before 11 September 2001 and the subsequent dangers for journalists in places like Syria that made it impossible to report on the ground in any meaningful way as we were in Sarajevo'.[21] Moreover, and unusually in a profession that is notorious for a high level of competitiveness, journalists in Sarajevo cooperated with one another in a rather uncharacteristic and anomalous manner, the creation of the 'Sarajevo Agency Pool' (SAP), an ad hoc organization created to limit the dangers for, in particular, TV crews, being the most tangible manifestation of such cooperation.

This book does not aim to document the siege of Sarajevo, nor is it an attempt to write a narrative history of it, though the siege is, of course, the wider context within which the main focus of the book – foreign correspondents in besieged Sarajevo – is located. Similarly, this is not a book about the arguments that journalists made with regard to the events within, and the trajectory of, the Bosnian war – though this is briefly addressed in later chapters – nor is it one that focuses on the role of local journalists, such as those working for the daily newspaper *Oslobođenje*, which continued publication throughout the siege.[22] It is, rather, a unique and detailed account of *how* the siege was reported by foreign correspondents and how they became part of a media infrastructure – be they journalists, photojournalists, cameramen, stringers, translators, filmmakers, technical staff or satellite engineers – that developed and consolidated inside the city and how that infrastructure functioned within siege lines.[23] As Peter Andreas noted, 'There was nothing automatic about the ability of the foreign press to keep Sarajevo in the global media spotlight ... getting the siege story out and sustaining it over an extended period required infrastructure and supplies.'[24] In part, this book provides an analysis of how that infrastructure was built and how it developed, with a particular, though not exclusive, focus on the first year of the siege – 1992–1993 – as this infrastructure developed and subsequently consolidated.

Though there has been much ink spilled and many books written about the war in Bosnia and Herzegovina and, to a lesser extent, the siege of Sarajevo – many written by foreign journalists – this book represents the first detailed account of how individual journalists, photojournalists, stringers, translators, satellite engineers and others from myriad international media organizations, operated in the besieged city. It seeks to

explain how those that reported in the early months of the Bosnian war adapted to the environment around them and how they overcame significant logistical barriers in order to convey their stories about Sarajevo and its people to the outside world from within and across siege lines. Equally, it provides a detailed account of how the infrastructure that was used by journalists evolved in the first year of the siege. As such, it describes in some detail the processes that led to the 'armourization' of the foreign press corps and how the use of armoured cars, flak jackets and helmets became part of the wider process of securitization that took place within the context of the war in Bosnia and Herzegovina and, specifically, the siege of Sarajevo. This, in turn, led to the wider development of 'hostile environment' training courses for journalists, with the lessons of Sarajevo being channelled into what is now standard practice for foreign correspondents across the industry.

Those journalists who reported from within the city throughout the duration of the siege also witnessed something of a revolution in the way that they functioned. At the onset of the Bosnian war, many still relied heavily on an existing communications infrastructure – telephone lines – and on the traditional 'bush telegraph', that required intimate knowledge and strong local contacts. As the esteemed Italian journalist, Gigi Riva, noted, the beginning of the Bosnian war was still in the immediate period before 'the technological revolution that changed the way we do journalism arrived'.[25] As the war dragged on, however, the inexorable ascent of digital technology – more portable satellite phones, laptops and the emergence and increase of 24-hour news cycle – determined a significant change in how they operated 'in the field'.[26] The reporting by foreign journalists was, moreover, oft regarded by critics as biased, lacking objectivity and underpinned by a failure to sufficiently understand the historical, political and structural complexities of Bosnia and Herzegovina and the wider region. The latter chapters therefore deal with the moral and ethical dilemmas faced by journalists in their role of 'self-appointed conscience of an otherwise oblivious world' and, therein, the debates over the so-called 'journalism of attachment' and the criticism that some had become advocates or campaigners rather than journalists.[27]

The book draws upon extensive primary and secondary sources: documents, correspondence, books, diaries, memoirs and hitherto unpublished excerpts from lengthy interviews that the authors conducted with journalists, photojournalists, producers and cameramen working – either as staff or as freelancers – for a number of printed publications, TV companies, newswire services and who were based in Sarajevo for long periods; local stringers, translators and fixers who provided invaluable knowledge of the city, its culture, its history and its politics; and satellite engineers and news editors that provided technical and/or logistical support for the media infrastructure that developed and consolidated in Sarajevo. Collectively, these sources, gathered over a six-year period by the authors, not only reveal much about the experience of operating within a city under siege, but have provided broader insights into the challenges of reporting from a besieged city and how the changing nature of journalism as digital technology and the 24-hour news cycle inexorably impacted on their work.

1

The political context of the siege

The foreign correspondents who had covered the wars in Slovenia and Croatia arrived in Bosnia and Herzegovina gradually, after the suspension of hostilities in Croatia in January 1992 following the 'Sarajevo Agreement', which allowed for the United Nations Protection Force (UNPROFOR) to administer the implementation of a ceasefire. Based primarily in Belgrade and Zagreb, they tended to come to Sarajevo for relatively short periods, though numbers increased significantly during the independence referendum of 29 February and 1 March 1992 – the so-called 'referendum weekend' – which ended with the subsequent 'war of the barricades'. Almost no foreign correspondents were based in Sarajevo at this time, though many who were there to cover the referendum would return to make the city a more permanent base after armed conflict broke out in April 1992. Thereafter, the encirclement and subsequent siege of Sarajevo by the Yugoslav People's Army (*Jugoslovenska Narodna Armija* – JNA) and, after May 1992, by the Army of the Serb Republic (*Vojska Republike Srpske* – VRS) became a major international news story.

The path to Yugoslav disintegration

The war in Bosnia and Herzegovina was the result of deteriorating relations between three nationalist parties that formed a governing coalition following Bosnia and Herzegovina's first multi-party elections in November 1990. Indeed, this coalition of uncomfortable bedfellows held very different views vis-à-vis the future status of Bosnia and Herzegovina and of the Socialist Federal Republic of Yugoslavia (*Socijalistička Federativna Republika Jugoslavija* – SFRJ). The latter was in the midst of a painful process that would culminate in its violent disintegration – one that was gradual, complex and multidimensional. There is no single causal factor – and thus insufficient scope to address, in detail, the myriad factors that led to the SFRJ's disintegration in this book.[1] The death of Josip Broz Tito on 4 May 1980 was, however, a pivotal event. The Yugoslav system that Tito – the partisan hero of the Second World War, the 'man who challenged Stalin' and the figurehead of the SFRJ on the international stage – had played such an important role in creating was, by the time of his death, becoming increasingly fragile. Constitutional changes, including the wide-ranging, decentralizing reforms of the '1974 Constitution', that had vested more power in the SFRJ's republics – Serbia, Croatia, Slovenia, Montenegro,

Macedonia, and Bosnia and Herzegovina – and two autonomous provinces – Kosovo and Vojvodina – had ensured stability throughout Tito's twilight years. However, in the years following his death, the Yugoslav League of Communists (*Savez komunista Jugoslavije* – SKJ) would endeavour to maintain the status quo – the slogan, *I poslije Tita, Tito!* (And After Tito, Tito!), underpinning their strategy of continuity.

Even before Tito's death, however, the SFRJ had begun sliding into an acute economic crisis that would, in turn, generate a crisis of legitimacy for the SKJ. In the immediate years after Tito's death, however, it was the economy that presented the greatest challenge. Loans were called in, as investors became nervous about the SFRJ's ability to pay its debts. The economy laboured under a growing trade deficit, a significant balance of payments deficit, and a burgeoning foreign debt. By 1983, the International Monetary Fund (IMF) demanded that the Yugoslav government initiate 'shock therapy' and endeavour to restructure the economy in an attempt to contain the worsening crisis. Such conditions were reluctantly accepted by a government only too aware of the potential social and political consequences that could result from further austerity in a context of pre-existing declines in living standards.[2] Nevertheless, in an attempt to rescue the economy, the government took drastic measures, closing down unviable enterprises while reducing manpower costs in others. Redundancies, growing unemployment and rising inflation dictated that ordinary Yugoslavs, after long periods of economic stability, began to feel the economic privations that had hitherto been unfamiliar to them, while the Yugoslav League of Communists (*Savez komunista Jugoslavije* – SKJ) seemed unable to effectively tackle the economic crisis.

The economic crisis did not *cause* the Yugoslav crisis, but it created the social, economic and political conditions whereby nationalism, long taboo, could be resurrected. The SKJ, already toiling with economic problems would, equally, prove impotent when faced with a rising tide of nationalism, which re-emerged as the dominant political ideology, first in Serbia and, as a consequence, throughout the SFRJ. The first politician to understand and exploit the opportunities presented by the shifting political currents, while simultaneously undermining the SKJ's mantra of *Bratstvo i jedinstvo* (Brotherhood and Unity), was Slobodan Milošević. A seemingly unremarkable party *apparatchik,* he had risen through the ranks of the League of Communists of Serbia (*Savez komunista Srbije* – SKS) through the mid-1980s, largely as a result of his close relationship with Ivan Stambolić, his friend and political mentor. Milošević's visit to Kosovo in April 1987, whereupon he told Serbs that they 'would not be beaten again' was a pivotal moment. Following the Eighth Session of the Central Committee of the SKS in 1987, Milošević used the issue of Serb rights in Kosovo to politically assassinate Stambolić; thereafter, Milošević quickly became the undisputed leader of the SKS and, increasingly, cast as the 'saviour of the Serbs'. Promising to revise the 'anti-Serb' 1974 constitution and stem the 'counter-revolution' in Kosovo, Milošević wrested control of four of the eight Yugoslav federal presidency votes – and rendered it dysfunctional – by sending the Yugoslav People's Army (*Jugoslovenska Narodna Armija* – JNA) into Kosovo and revoking Kosovo's autonomous status, as well as undermining – and eventually displacing – the existing local communist leaderships in Vojvodina which, like Kosovo enjoyed autonomy, and Montenegro, which was one of the six Yugoslav federal republics.

The instrument used to achieve this objective became known as the 'anti-bureaucratic revolution'. Ostensibly demonstrations about the status of Serbs and Montenegrins in Kosovo, the real aim was to discredit, undermine and eventually force out, the tottering communist leaderships there – to be replaced, of course, by Milošević loyalists. The 'politics of the streets', were used with some efficacy in Vojvodina, where a series of well-organized rallies in Novi Sad, dubbed 'The Yoghurt Revolution', brought the province's leadership to its knees. In Montenegro, 'Meetings of Truth' – ostensibly focused on the issue of Serbs and Montenegrins in Kosovo – took place across the republic.[3] Seeking to capitalize on the popular discontent fuelled by Montenegro's grim economic situation, they took their demonstrations to Titograd – now Podgorica, the republic's capital. A series of rallies outside the parliament building placed increasing pressure on Montenegro's ageing communist authorities. By January 1989, this 'old guard' within the League of Communists of Montenegro (*Savez komunista Crne Gore* – SKCG) had resigned and were quickly replaced by the *mladi, lijepi i pametni* (young, handsome and intelligent) troika of Momir Bulatović, Milo Djukanović and Svetozar Marović, all – at that point, at least – loyal to Milošević.[4]

These developments were observed with growing anxiety in Slovenia and Croatia, and in January 1990, amidst increasing tension between the Yugoslav republics, Slovenian delegates – whose proposals for reform had been dismissed – left the 'Fourteenth Special Congress' of the League of Communists of Yugoslavia (*Savez komunista Jugoslavije* – SKJ), held in the Sava Centre in Belgrade. They were followed thereafter by the Croatian delegation. In the spring of 1990 multi-party elections were held in both Slovenia and Croatia. In the former, Milan Kučan, the former leader of the Slovenian League of Communists (*Zveza komunistov Slovenije* –ZKS), became president, while in the latter, Franjo Tuđman of the nationalist Croatian Democratic Community (*Hrvatska demokratska zajednica* – HDZ) triumphed over Ivica Račan's Social Democratic Party of Croatia (*Socijaldemokratska partija Hrvatske* – SDP) in the Croatian presidential elections. Slovenia held an independence referendum on 23 December 1990, resulting in an overwhelming majority in favour of leaving the SFRJ.

Slovenia and Croatia declared independence on 25 June 1991, resulting in a short conflict between the Slovenian Territorial Defence (*Teritorijalna obramba Republike Slovenije* – TORS) and the JNA, before the latter departed Slovenian territory. Croatia seceding from the SFRJ was, however, a more complicated matter. Croatia's Serb community, particularly those inhabiting the Krajina region, watched these developments with growing alarm, with Milošević's government in Serbia only too happy to stoke their fears. History weighed heavily on the Serb population there. The experience of the area's Serbs between 1941 and 1945 when the Krajina was part of the Ustaša-led Independent State of Croatia (*Nezavisna država Hrvatska* – NDH), during which they were subject to mass persecution, murder and expulsion, resonated strongly with them. In response to the Croatian government's apparent moves towards independence following the victory of Franjo Tuđman's HDZ, Croatia's Serbs – the vast majority of which were located in the Krajina – embarked upon a rebellion following the announcement of a new constitution—which relegated Serbs to the status of a 'constituent people'. In December 1990, the Krajina Serbs established the Serbian Autonomous Region of Krajina (*Srpska autonomna oblast Krajina* – SAO Krajina),

set up roadblocks – the so-called 'Revolution of the Logs' – and three months later declared the region's separation from Croatia.[5] An organized rebellion by the Krajina Serbs soon turned into a full-scale war, and conflict intensified in both Krajina and Eastern Slavonia during the spring and summer of 1991. It would culminate in a full-scale war pitting hastily organized Croatian government forces and paramilitaries against Serb rebels, Serb paramilitaries and the JNA, during which the town of Vukovar was destroyed with heavy weapons and the medieval walled city of Dubrovnik was pounded with heavy artillery.

The 1990 multi-party elections in Bosnia and Herzegovina

Bosnia and Herzegovina was not, of course, immune from the events taking place in Slovenia and neighbouring Croatia. Indeed, it was in an unenviable situation as the SFRJ disintegrated. The most multi-ethnic of the SFRJ's republics, Bosnia and Herzegovina comprised a mixed population of Muslims, Serbs and Croats; thus, the disintegration of the SFRJ would have significant consequences for the republic. According to the 1991 Yugoslav census, 44 per cent were Muslims – a majority, though a relative majority only – 31 per cent were Serbs and 17 per cent Croats; the city of Sarajevo mirrored this ethnic mix to some extent, its population being 49 per cent Muslim, 30 per cent Serb and 7 per cent Croat.[6] Sarajevo developed significantly after the Second World War, with industrial development driving an increase in the population of the city and its physical expansion westward towards Ilidža. As a consequence, Sarajevo became an attractive place to settle for different ethnic groups from across Bosnia and Herzegovina and from other parts of the SFRJ.[7] Mixed marriages were common in the cities of Bosnia and Herzegovina, in places such as Sarajevo and Mostar, though far less common in rural areas. Sarajevo, in particular, was multi-ethnic, multi-religious and a place with an urban mindset, where one's ethnic or religious identity was relatively of little importance.

The challenge that Bosnia and Herzegovina faced as the SFRJ began to disintegrate began, however, to challenge the assumptions of many *Sarajlije* (Sarajevans) that their city was somehow immune from the rising tide of nationalism that had emerged in other Yugoslav republics. In any event, as multi-party elections were scheduled in every republic of the SFRJ, new political parties would emerge to challenge the League of Communists of Bosnia and Herzegovina (*Savez komunista Bosne i Hercegovine* – SK-BiH), then led by Nijaz Duraković – who would, in 1992, form the Social Democratic Party (*Socijaldemokratska partija* – SDP). Political parties were first registered in Bosnia and Herzegovina in early 1990, the first being minor ones emerging in Mostar, none of which were of any real significance.[8] In Sarajevo, however, parties that would become powerful, even destructive, forces in Bosnian politics would soon emerge. Problematically, they were of a predominantly, though not exclusively, mono-ethnic character and organized along ethnic lines.

The first of the significant parties to form was the – predominantly Muslim – Party of Democratic Action (*Stranka demokratske akcije* – SDA), who held their first

meeting in the Holiday Inn hotel.[9] One of the most iconic buildings in Sarajevo, the Holiday Inn hotel, with its somewhat unusual exterior of yellow, ochre and brown, was designed by the Bosnian architect Ivan Štraus and built in advance of the 1984 Winter Olympics. It was not only a distinctive building from an aesthetic perspective but, given its large atrium and numerous dining rooms, conference halls and location directly across from the Bosnian parliament, a place where the republic's political elite would regularly gather.[10] The SDA was, according to Izetbegović, 'a political union of Yugoslav citizens belonging to the Muslim cultural and historical traditions, as well as other citizens of the country', but Izetbegović had a history, and the SDA never transcended beyond a predominantly Muslim party. The SDA was ostensibly led by its then de facto leader, Alija Izetbegović, a Muslim lawyer and scholar who had, as a member of *Mladi Muslimani* (Young Muslims), been jailed in 1946. He was imprisoned again in 1983 during the so-called *Sarajevski proces* (The Sarajevo Process) for writing and disseminating 'hostile propaganda' and engaging in 'counter-revolutionary acts'.[11] A key part of the accusations directed against Izetbegović was that he had propagated the idea of a Muslim-dominated Bosnia and Herzegovina – in which Islamic law could be practised – in his *Islamska deklaracija* (Islamic Declaration), which had originally been published in 1970. The book made no specific reference to Bosnia per se, but this made little difference.[12] He was sentenced to fourteen years in prison but released in 1988.

Izetbegović, flanked by the core members of the SDA, read out the 'Statement of the Forty', the programmatic underpinning for the party.[13] Two months later, on 26 May 1990, the 'Constituent Assembly' of the SDA was again held in the Holiday Inn, and this time the numbers in attendance had increased significantly.[14] The party's programme was still in its infancy and not clearly articulated at this stage, but the SDA essentially brought together key Muslims – businessmen, intellectuals and assorted nationalists – under its banner. Izetbegović, an intellectual and political activist, was clearly the leading figure in the party, though also in attendance was Adil Zulfikarpašić, a wealthy Bosnian Muslim exile living in Switzerland since the late 1940s.[15] He would, in the coming weeks and months, emerge as an alternative and potentially competing centre of power within the SDA. Thus a 'liberal' wing of the party emerged that was essentially supportive of Zulfikarpašić, who had become increasingly concerned by the direction in which Izetbegović was taking the SDA.[16] Gradually, it became evident that a bifurcation of sorts was taking place within the SDA leadership, which would soon crystallize into two competing factions heading inexorably towards conflict.[17] In the early days, the more conservative factions – led by Izetbegović in Bosnia, Sulejman Ugljanin in Serbia and Harun Hadžić in Montenegro – were in the ascendancy, and many Muslims gravitated towards parties and institutions – the SDA and the Islamic Community (*Islamska zajednica* – IZ) – that claimed to be their protectors. The conservative wing of the SDA would achieve primacy and Zulfikarpašić, claiming he was unable to find common ground with Izetbegović, would later leave the SDA to create the Muslim Bosniak Organisation (*Muslimanska bošnjačka organizacija* – MBO) with Muhamed Filipović – though the latter would eventually return to the SDA fold.

Also present at the SDA meeting was the Chairman of the Croatian Democratic Union (*Hrvatska demokratska zajednica* – HDZ), Dalibor Brozović. Though based in Zagreb, he was Sarajevo-born and came with a message that Croatia respected

Bosnia's borders and their government would not accept 'possible offers concerning the division of Bosnia', but that 'this standpoint should not provoke any suspicion or anxiety' among Bosnia's Serb community.[18] But, of course, the sight of Muslim and Croat leaders sharing the same platform jarred with nationalistic elements within that – Bosnian Serb – community.[19] In August, two months after the May SDA meeting, the Bosnian branch of the HDZ, known as the Croatian Democratic Union of Bosnia and Herzegovina (*Hrvatska demokratska zajednica Bosne i Hercegovine* – HDZ-BiH) held their launch event at *Dom mladih* in Skenderija. There, delegates reiterated their commitment to a unified Bosnian state in which Croats would enjoy equal status with Serbs and Muslims.[20] The party was originally led by Davorin Perinović but he was soon replaced by Stjepan Kljuić, a well-known Sarajevo journalist and a moderate with a pro-Bosnia orientation, a position that would bring him into conflict with the more nationalist strands within the HDZ-BiH and, equally, the 'Herzegovinan lobby' within the Croatian HDZ. Kljuić would eventually be sidelined and replaced as leader of the HDZ-BiH, in January 1992, by the more hardline Mate Boban, a Herzegovinian Croat who would become the architect of the *Hrvastska republika Herceg-Bosna* (Croatian Republic of Herceg-Bosna).[21]

The Serbian Democratic Party (*Srpska demokratska stranka* – SDS) was formed in July 1990 and led by the psychiatrist – and amateur poet – Radovan Karadžić, a Montenegrin by birth.[22] Karadžić was, according to Neven Andjelić, the 'last-ditch choice' after other respected Serbs – such as the then Rector of Sarajevo University, Nenad Kecmanović – had declined an invitation to lead the party.[23] Like the HDZ-BiH, the SDS held their launch event at *Dom mladih*. The audience, which included prominent Muslims such as Alija Izetbegović and Muhamed Filipović, heard Karadžić inform the crowd that his party was both 'social democratic' and 'patriotic'.[24] Karadžić, the man who would come to personify the SDS would, soon after, become their bitter rival and the political leader of the Bosnian Serbs throughout the subsequent war.

Born in June 1945 in the small village of Petnjica, in the present day municipality of Šavnik – traditionally one of the poorest municipalities in Montenegro – he hailed from a well-known family in the area.[25] His father, Vuk, had fought for both the (Serb) Chetniks and the communist-led partisans during the 1941–45 war that ravaged Yugoslavia, but had been arrested by the communists in 1945 and sentenced to fifteen years in prison – though he would serve only five.[26] Thus Radovan Karadžić was brought up without his father for the first five years of his life, and he developed a much stronger bond with his mother, Jovanka, who would remain a central figure in his life. In 1956, the Karadžić family moved to Nikšić – Montenegro's second largest city – where Radovan attended *srednja škola* (middle school).[27] Bright and tenacious, he proved to be an excellent student, and at the age of just sixteen he left Nikšić to embark upon studies in psychiatry at Sarajevo University – he would also later study in both Norway and the United States. While there, he surrounded himself with a small group of like-minded young Serb students with nationalist leanings. Within this social milieu, he revelled in his Montenegrin roots. Montenegro was, he believed, the *Srpska Sparta* (Serbian Sparta), and Montenegrins 'the best of Serbs'; those who had tenaciously fought the Turks for centuries while carving out a meagre but proud existence in the rocky crags around *Stara Crna Gora* (Old Montenegro) in the environs

of Montenegro's ancient capital, Cetinje. The Montenegrins thereby preserving the flame of Serbdom, Orthodoxy and freedom while building their nascent state under the Petrović dynasty.[28] In the tradition of some of the great Montenegrin leaders, such as Petar II Petrović 'Njegoš' (*Vladika*) and author of the epic poem *Gorski vijenac* ('The Mountain Wreath'), Karadžić developed a love of poetry, which he began to write while a student in Sarajevo.[29]

His one-time friend, the writer Marko Vešović – a fellow Sarajevo-based Montenegrin – described the young Karadžić as 'charming, bright and popular – always at the centre of everything' though he seemed to be 'a man in a hurry – the first to marry and first to start a family'.[30] And Karadžić did indeed marry relatively early for a man of his educational background. While still at Sarajevo University, he wed Ljiljana Zelen, a medical student from Sarajevo, in 1967 and their first daughter, Sonja – who, as an adult, would run the 'Press Centre' in Pale during the Bosnian war – was born in the same year. Marriage did not, however, inhibit his growing interest in, or engagement with, politics. His activities while as a student included involvement with the 1968 student protests in Sarajevo – smaller in scale than the so-called 'June Events' in Belgrade and, to a lesser extent, Zagreb, but no less significant.[31] After graduating from university, however, Karadžić seemed to drift from his political interests; he began working in the psychiatric clinic within Koševo Hospital and settled into a seemingly stable and comfortable middle-class life in Sarajevo.

While practising his profession, Karadžić also developed a number of business interests unrelated to his work, and it was these interests that led to legal troubles in the early 1980s. In November 1984, he and his friend and business partner, Momčilo Krajišnik – who would later become a key figure within the SDS – went on trial and were eventually sentenced to three years for misappropriating funds from the Sarajevo-based *Energoinvest* firm – of which Krajišnik was an employee.[32] Karadžić always maintained his innocence, claiming that the case against him was 'politically motivated'. In any event, upon his release from prison, he left Sarajevo and moved to Belgrade, where he became an acquaintance of – among others – Dobrica Ćosić, widely regarded as the 'Father of Serb Nationalism'. Details of the relationship between the men are sketchy, but Karadžić's friendship with Ćosić meant that he was closely monitored by Bosnian authorities upon his return to Sarajevo in 1988.

Though he briefly flirted with environmental politics, Karadžić became one of the founders of the SDS – in 1990 – and would, after a rather protracted search, become the party's leader, selected by party oracles as the right man to lead Bosnian Serbs through 'historic times'.[33] Though the SDS was explicitly a nationalist party, staunchly defending Serb interests in Bosnia and Herzegovina, there was little in Karadžić's early public pronouncements to suggest that either he or the SDS were capable of the crimes they would subsequently commit.[34] In an interview for the Belgrade weekly *NIN*, Karadžić assured voters that the SDS was 'a party of peace and tolerance' but was 'committed to [the continuation of] a federal Yugoslavia'.[35] As Edina Bećirević noted, however, 'Karadžić's rhetoric towards Bosnia's Muslims [in particular] was to change dramatically after the [November 1990] elections'.[36]

The SDS operated from offices on *Ulica Titova* (Tito's Street) in central Sarajevo and from there they ran their campaign for the November 1990 elections – in March 1991

they also established an office on the tenth floor of the Holiday Inn. Lacking much in the way of political experience, the SDS and the other newly formed nationalist parties were not expected to perform particularly well in the elections and, moreover, Nijaz Duraković's League of Communists of Bosnia and Herzegovina (*Savez komunista Bosne i Hercegovine* – SK-BiH) and Nenad Kecmanović's Alliance of Reform Forces of Yugoslavia (*Savez reformskih snaga Jugoslavije* – SRSJ) were both expected to win. Indeed, pre-election polls suggested that the SK-BiH and SRSJ's share of the vote would far outstrip that of the nationalist parties.[37] It wasn't to be. The citizens of Sarajevo voted, in the main, for those parties, though the percentage of those voting for non-nationalist parties was higher there than throughout Bosnia.[38] As a result, seven members of the nationalist parties were elected to the republic's 'presidium': two Bosnian Muslims – Alija Izetbegović and Fikret Abdić; two Bosnian Serbs – Biljana Plavšić and Nikola Koljević – both respected academics who held posts at the University of Sarajevo; two Bosnian Croats – Franjo Boras and Stjepan Kljuić; and an 'other' – SDA member Ejup Ganić – a Muslim originally from Novi Pazar in the Sandžak region of Serbia, who had run as a 'Yugoslav'. Alija Izetbegović became the 'president of the presidium', after Fikret Abdić, who had won more votes than any other candidate, agreed to stand aside. In any event, the SDS/SDA/HDZ-BiH coalition – the so-called 'government of national unity' – that was formed after the elections comprised unlikely and uncomfortable bedfellows.

Rising tensions

Problems were evident from the outset, particularly because the new government had little in the way of a clearly defined political programme. Serious conflicts soon arose between them, due in large part to fundamental disagreements on Bosnia and Herzegovina's future trajectory and, ultimately, its state-legal status in the wider context of the process of the disintegration of the SFRJ.[39] The SDS were absolutely committed to the preservation of the Yugoslav state, while the SDA and HDZ-BiH were less so – though neither publicly expressed, at this point, a desire for independence. This was, of course, hardly a sound basis for a stable governing coalition. Relations within the coalition soon became both strained and increasingly manifest. Indeed, opposition parties attempted to 'moderate' in an attempt to bridge the growing divides.[40] Regardless of such initiatives, however, each party began clandestinely preparing for war. The SDS had begun, in early 1991, distributing arms – and confiscating them from Muslims and Croats – in areas largely under their control. The SDA, for their part, had initiated the formation of the 'Council for the National Defence of the Muslim People', who thereafter created the 'Patriotic League' (*Patriotska liga* – PL) in the summer of 1991.[41]

As the Yugoslav state was plunged into a deeper crisis, the brittle coalition began to break apart. The short – ten-day – war following Slovenia's declaration of independence on 25 June 1991 – that led to the withdrawal of the JNA from Slovenia – and the growing Serb rebellion in Croatia – which intensified after Croatia's declaration of independence on the same day – poisoned the political atmosphere in Bosnia and

Herzegovina. By this time, the SDS had begun a process whereby they asserted control in a number of Bosnian municipalities. Serbian Autonomous Regions (*Srpske autonomne olbasti* – SOAs) were established, without the consent of the Bosnian parliament, first the 'Community of Bosanska Krajina municipalities' – in April 1991 –then the SAO Herzegovina – in May 1991 – and finally, the SAO Krajina – in September 1991.[42] Thus political tensions, already evident, became increasingly acute; and that political matters had reached a very serious juncture was manifest during a session of the Bosnian parliament on 14 October 1991, whereupon HDZ-BiH and SDA deputies proposed a declaration of sovereignty and stated their intention to hold a referendum on independence. Karadžić's now notorious response was that such actions would put Bosnia and Herzegovina on 'the same highway to hell and suffering that Slovenia and Croatia have already taken', warning SDA delegates that 'if there is a war, the Muslim people will not be able to defend themselves'. At approximately 2.00 am on the morning of the 15 October 1991, the SDS delegates then left the parliament and the motion was passed in their absence.

On 24 October 1991, following their boycott of the parliament – the SDS moved their operations across the street to the Holiday Inn – they announced that the previously created SAO's would be united to form the 'Serbian Republic of Bosnia and Herzegovina'. In response to the HDZ-BiH declaration of sovereignty, the SDS organized and scheduled a plebiscite which, when it took place on 9 and 10 November 1991, asked – Serb – voters whether they wished to 'remain in a common state of Yugoslavia with Serbia, Montenegro, the SAO's of Krajina and Slavonia, as well as Baranja, Western Srem and all others wishing the same?' The subsequent result confirmed that the majority of Serbs wished to remain in Yugoslavia, in whatever form it may subsequently take.[43]

By this time, Haris Silajdžić – who would become Bosnia's Foreign Minister – aware that armed conflict was now a serious possibility, appealed for a United Nations (UN) peacekeeping force to be deployed across Bosnia and Herzegovina.[44] A Central Intelligence Agency (CIA) report in the same month echoed these concerns, claiming that Bosnia and Herzegovina was 'on the edge of the abyss'.[45] The Commission on Security and Cooperation (CSCE) were, however, already in Sarajevo, their delegation led by the senior German diplomat, Geert Hinrich Ahrens and Professor Thomas Fleiner, a constitutional expert based at the University of Fribourg. They met with Karadžić and other members of the SDS leadership in the Holiday Inn and found that although they could establish a cordial relationship within which common ground could be found, their political resolve was 'somewhat alarming'.[46] And that resolve was not merely rhetorical. According to Edina Bećirević, the – increasingly Serb-dominated – JNA had already begun 'to distribute weapons to areas with majority Serb population via the SDS party structure'.[47] On 9 January 1992, in the Holiday Inn, the SDS proclaimed that the 'Serb Republic of Bosnia and Herzegovina' – later *Republika Srpska* – would be activated in the event of the international community's recognition of an independent Bosnia and Herzegovina.[48] As well as having boycotted parliament, the SDS largely vacated their offices in Tito Street and instead rented offices on the seventh floor of the Holiday Inn, from where they directed their Sarajevo operations.

With the formal recognition of Slovenia and Croatia by the European Community (EC) on 15 January 1992, the seemingly inexorable downward spiral gained even greater momentum. The Bosnian government were now faced with a dilemma: stay in a 'rump' Yugoslav state dominated by the Serbs or opt to hold an independence referendum. Despite the increasingly dire warnings emanating from the SDS leadership, a referendum was scheduled, on the suggestion of the EC, for the weekend of 29 February and 1 March 1992. This would determine whether independence was the will of the majority of the citizens of Bosnia and Herzegovina. Karadžić's response was that the scheduled independence referendum was not 'of all citizens, only the Muslim and Croat communities' and that Serbs had already expressed their will through their own plebiscite.[49] In advance of the 'referendum weekend', the SDS held numerous meetings at the Holiday Inn to discuss the referendum and its potential implications. On 28 February 1992, the day before the referendum voting began, the SDS 'Club of Parliamentary Representatives' assembled in the Holiday Inn.[50] Though Karadžić and Nikola Koljević informed the delegates of the progress – or lack thereof – made during the Lisbon negotiations, the main purpose of the meeting was the ratification of the 'Constitution of the Serbian Republic of Bosnia and Herzegovina', which was adopted by the SDS just hours in advance of the referendum weekend.

The referendum weekend and the 'war of the barricades'

The first day of 'referendum weekend', though tense, passed without major incident.[51] The Holiday Inn would be at the centre of events throughout the referendum weekend; fully booked and bringing together, in close proximity, the most unusual 'bedfellows' – EC election monitors, foreign journalists and a growing number of armed SDS men, who could be seen stalking the lobby, bars, corridors and stairwells of the hotel.[52] SDS leaders could often be seen drinking coffee and chatting, surrounded by their bodyguards – who closely monitored who entered and exited the building – on the first-floor mezzanine level.[53] The Sarajevo daily *Oslobođenje* noted that the hotel, despite the presence of EC election monitors and growing numbers from the international press corps, remained the nerve centre for the SDS in Sarajevo, as the referendum votes were being cast and counted.[54]

Given the seriousness of the situation, the referendum attracted a large contingent of foreign press. Most of the international journalists were staying in the Holiday Inn, though many had travelled down to Sarajevo from Belgrade, where the majority had a semi-permanent base. Among them was a young American freelancer, Joel Brand, who would, though he was unaware then, spend most of the next three years living in, and reporting from Sarajevo. Brand made an unlikely war correspondent, but was not untypical of the kind of young, ambitious freelancers that were to make their careers during the Bosnian war. As a student attending the University of California Santa Barbara (UCSB), his main interest had been surfing, not journalism. Prior to his arrival in Yugoslavia in 1991 he had no previous experience as a journalist – notwithstanding his work for his university's student

newspaper – the *Daily Nexus*. In 1991, having failed to secure an internship at a US newspaper, he took a 'sabbatical' from his studies and went travelling around Europe, writing short despatches but with little hope of publication. Enthused by this trip, he opted to further postpone his studies and join a small group of students form his alma mater who had started an English-language newspaper in Prague. Before reaching the Czechoslovak capital, however, he called upon the offices of some of the leading US news organizations. He briefly met the Paris bureau chief of the *Los Angeles Times*, who told him he should go to Yugoslavia as a freelancer and write for anyone that offered to publish his work. It sounded, said Brand, 'quite romantic and heroic; I pictured myself sitting, leaning against a battle-scared concrete wall, a hail of bullets sailing inches over my head, and scribbling in my notebook – on the edge of death, and writing about it' – though in hindsight he acknowledged that this was 'rather naïve'.[55]

By November 1991, Brand had travelled to Budapest, from where he bought a ticket for a 'largely empty' train to Zagreb. The war in Croatia was nearing the end, but rumours were abundant within the press corps, many of whom were already departing their hotels in Zagreb, that war in neighbouring Bosnia and Herzegovina was, perhaps, inevitable. Many, he discovered, were heading for Sarajevo to assess the situation there and Brand did likewise, arriving in the city in late January 1992 to cover the period leading up to the independence referendum. Though still relatively inexperienced when he arrived in Sarajevo, he would subsequently become *The Times* of London's resident correspondent in Sarajevo, while simultaneously stringing for *Newsweek*. Moreover, he would become one of very few foreign correspondents permanently based in the city throughout the siege.[56]

During the referendum weekend, foreign journalists filed stories from wherever they could. Few had knowledge of the city beyond the Holiday Inn and east towards Baščaršija. The TV Sarajevo (TVSA) and YUTEL studios in the TV building in Alipašino polje to the west of the Holiday Inn towards the airport were known to them, but many preferred – particularly after the appearance of the first barricades on 1 March 1992 and the de facto (temporary) division of the city – the studio of *Dobre vibracije* (Good Vibrations). The first private TV station in Sarajevo, it was established in 1990 and owned by Slobodan Svrzo – a TV director and presenter who would later work for Voice of America. It was conveniently located in Marindvor, near the Vrbanja Bridge, the Bosnian parliament building and the Holiday Inn. Samir 'Krila' Krilić, who would later go on to work for Associated Press (AP), worked at Good Vibrations and recalled that 'During the referendum weekend many foreign journalists used our office to file. It was a perfect location for them because of the proximity to the Holiday Inn, where most of them were based.'[57] The offices of Good Vibrations thus became a hub for foreign journalists reporting on the events that would unfold during the referendum weekend – one of high drama.[58]

The majority of Serbs, though by no means all, boycotted the referendum – as instructed by the SDS – while the vast majority of Muslims and Croats voted in favour of independence. On Sunday 1 March, the tension was already palpable in Sarajevo even before a Serb wedding party was fired upon outside the Serbian Orthodox Church in the Baščaršija area of the city. Nikola Gardović, the father of

the bridegroom, was killed and a Serbian Orthodox priest, Radenko Mirović, injured in the attack. The SDS leadership immediately blamed the SDA for organizing the shooting, which they alleged to have been carried out by a Sarajevo underworld figure, Ramiz Delalić 'Ćelo', originally from the Sandžak region – which straddles the border between Serbia and Montenegro, and where tensions between Serbs and Muslims were also acute[59] – who, they argued, was under the protection of the SDA.[60] The murder was, according to Rajko Dukić, the SDS's de facto spokesman in Karadžić's absence, evidence that Serbs in Sarajevo were in mortal danger, and would be further so in an independent Bosnia.[61] This, however, was rejected by Šefer Halilović, who in 1991 had formed the paramilitary group, the Patriotic League (*Patriotska Liga* – PL), who claimed it 'wasn't really a wedding' but a provocation, and that the wedding party were SDS activists. They wanted, he said, 'to go through Baščaršija with the cars, with the flags, with the banners, to provoke us and to see how we would react'.[62]

On the evening of 1 March 1992, the Italian journalist Gigi Riva, who was reporting on the referendum for the Milan daily *Il Giorno* – he later worked for *La Reppublica* – took the elevator up to his room on the fifth floor with four of Radovan Karadžić's bodyguards. They began engaging in conversation. Riva recalled that

> One of them, dressed in a long white raincoat, asked me who I was and what I was doing in Sarajevo. I replied that I was an Italian journalist in the city to cover the referendum. He then advised me that I should leave because 'hell will happen here'. When I got out of the elevator, I realised that he had been hiding a machine gun under his coat.[63]

The Baščaršija shooting had indeed further fuelled tensions, and early the following morning, within a few hours of the completion of referendum voting, barricades appeared at key transit points across the city – among them Pofalići and Grbavica – manned by armed and masked SDS supporters, who, due to their mask or stocking-covered faces, became known as *čarapari* (essentially 'sock-heads').[64] According to a report by the CSCE, the blockade of the city 'turned from spontaneous protests provoked by the wedding incident to an SDS-controlled effort'.[65] Thus the barricades appeared not simply to 'protect Serbs' in the wake of the Baščaršija shooting but to demonstrate that the SDS would not accept lightly a declaration of independence in the event of a 'yes' vote. According to a report by the Bosnian MUP on 6 March 1992, 'Snipers were provided to protect the SDS crisis staff, who were stationed on top of the Holiday Inn hotel before the setting of the barricades'.[66] And while the SDS spokesman Rajko Dukić would claim that the erection of the barricades was 'a spontaneous event',[67] the same report stated that '[from] the fact that most of the barricades organized by the Serbs were set up on strategic locations in Sarajevo' and 'the weapons and radio equipment available, the organized distribution of weapons and food to the people at the barricades, the time and manner of setting and withdrawing the barricades, it can be concluded they were not a spontaneous reaction'.[68] Likewise, Kemal Kurspahić, the editor-in-chief of *Oslobođenje* observed that,

It was obvious that such a comprehensive blockade of a city of half a million people had not been conjured out of the thin night air without prior organisation and planning – there was not a whiff of spontaneity about it. All of Sarajevo was to be held to ransom not to avenge the murder at Baščaršija, but to prevent Bosnia's separation from Serbia.[69]

Alija Izetbegović learned of the barricades while at SDA party headquarters in Sarajevo. A decision now had to be made – should they use force to dismantle the SDS barricades? He and his closest advisers came to the conclusion that they should not because the SDA 'wanted to avoid street fighting in the parts of the city where we did not have enough forces'.[70] In the interim, however, two large groups of demonstrators – one gathering at the Café Dubravka near the Catholic Church in the city centre, the other coming from the western suburbs of Sarajevo – converged and made their way towards the parliament building directly across from the Holiday Inn.[71] The peace demonstrators achieved their objective only after shots were fired over their heads from a barricade – next to the Maršal Tito barracks – manned not by SDS gunmen, but by JNA soldiers.[72]

Tensions were running high in the Holiday Inn as the results of the referendum began to filter through. Soon after 08.00 pm, a group of around twenty people, who had been participating in the demonstrations against the barricades, entered the hotel to use the public telephones – located in the atrium. They were immediately identified by the armed SDS security, who watched them closely from their positions on the first-floor mezzanine level, as unwelcome guests. Just below them, the large atrium was still relatively busy with foreign journalists and EC monitors, the latter of whom were learning of the appearance of barricades manned by armed SDS supporters and keen to organize their departure from the city.[73] The group who had entered the hotel did little to attract the attention of the journalists, but they did not go unnoticed by the SDS gunmen. At the time, Karadžić,[74] Koljević and Krajišnik were not in Sarajevo but in Belgrade discussing developments with the Serbian President, Slobodan Milošević.[75] Nevertheless, the hotel was, according to Florence Hartmann of the French daily *Le Monde*, 'evidently entirely under the control of the SDS, many of whom were armed and carrying Motorolas; obviously to communicate with those manning the barricades' and the group had, unwittingly, walked into a dangerous situation.[76] As a warning to them, one of the SDS guards fired a shot into the air, shattering suspended roof lamps and showering the atrium with glass.[77] While the journalists and other guests in the atrium bar threw themselves to the ground or behind the furniture, the group were chased from the lobby of the hotel by a number of SDS gunmen before fleeing in different directions with shots being fired over their heads.[78] The Bosnian daily *Oslobođenje* quoted Florence Hartmann, who had been standing just outside the hotel entrance as the group entered. Her observations confirmed what many already knew: that armed SDS gunmen were using the hotel as a base for their operations – organizing the erecting and manning of barricades – in Sarajevo. Evidently, the SDS gunmen had been angered by the group of those who were demonstrating against the roadblocks entering 'their' hotel. In an interview for *Oslobođenje* she described the events that unravelled on the evening of Sunday 1 March 1992:

> It all began somewhere around 9.30 pm, when a group of men arrived at the hotel … they were mostly very young people. I was standing at the entrance gate, I passed them and I could see that they were not armed. I thought maybe they came to have a drink or something. When I went outside, I approached one of the two police cars that were parked in front of the hotel and started to talk to one of the policemen. At that moment, I heard gunfire in the hotel, so I entered the car to get away. Then the group of civilians that I had passed came running out of the hotel and immediately behind them were several armed men who were firing over their heads. Part of the group escaped to the left of the exit while the rest ran across the parking lot and turned left. As they escaped, the armed men continued to fire and I saw one of them climbing on to a large flower pot from where he continued to fire over the heads of those who were fleeing. I quickly re-entered the hotel, where I found a large number of frightened people.[79]

Gigi Riva of *Il Giorno* watched from the fifth floor of the Holiday Inn while these events unfolded.

> I saw a colleague of mine, Giancarlo Del Re from the newspaper *Il Messaggero*, who was at the lobby bar drinking a whiskey. I was afraid that the SDS gunmen would kill him but he looked untroubled and continued to sit and drink. He later told me that he wasn't afraid because he had been wearing a tie and that 'militiamen have respect for the tie'.[80] But while Del Re seemed unfazed by these events, others were less sanguine. Shaken by the appearance of the barricades and the actions of the armed SDS gunmen in the hotel, the EC election monitors gathered in the Holiday Inn's atrium, awaiting permission to leave Sarajevo. A Bosnian government translator, Senada Kreso (who was tasked with liaising with the EC monitors) did her utmost to provide assurances (and, in turn, receive assurances from the JNA general, Milutin Kukanjac) that the monitors would be safely transported from the hotel to the airport. A sense of panic gripped the election monitors, who expressed a desire to leave Sarajevo as soon as possible; it was, according to Kreso, a 'very dramatic' situation.[81]

The EC monitors expressed a desire to leave the hotel – and Sarajevo – as quickly as possible, and buses were arranged to take them to Sarajevo Airport. They were advised to return to their rooms until the buses arrived, which they duly did.

Aware of the continuing tension and in an attempt to bring the key political players together to discuss ways ahead, the European Community Monitoring Mission (ECMM) representative, Colm Doyle, left his base at the Hotel Bosna in Ilidža to drive through the barricades with his colleague, Der Cogan, to the Holiday Inn in an effort to engage the SDS leadership – who were, according to Doyle, 'operating their own crisis committee, which was setting demands'.[82] On reaching the hotel he found 'a chaotic scene', the hotel atrium 'packed with officials, election observers, police and media'.[83] Doyle set about negotiating the safe passage of the EC monitors, but with Karadžić still in Belgrade he decided to bypass the SDS leadership in the Holiday Inn and approach the barricades to talk to the Serb militia manning them. The situation was very tense and while

Doyle succeeded in engaging with the armed men they brusquely told him that the barricades could only be lifted 'on the personal order of Radovan Karadžić'.[84] However, after lengthy negotiations, the EC monitors were taken by the JNA to Sarajevo Airport – through six SDS barricades – and were subsequently flown to Belgrade.[85]

Despite the ongoing tensions in Sarajevo, the international press corps largely departed Sarajevo in the wake of the referendum, the result of which was clear – 63.4 per cent of the population had voted, of which 99.7 per cent had done so in favour of independence. Nevertheless, Sarajevo remained extremely tense throughout the second and third of March, by which time, the SDS had turned the Holiday Inn into 'a stronghold for Bosnian Serb leaders and a billet for the growing contingent of Karadžić's bodyguards'.[86] Indeed, the Holiday Inn was now, informally, the headquarters of the *križni stab* (crisis committee) of the SDS. On that day, Rajko Dukić and Velibor Ostojić – in Karadžić's absence – gave an SDS press conference there, stating that the barricades were a reaction by the 'Serbian people in Bosnia and Herzegovina' to the shooting in Baščaršija and the 'illegal referendum', the result of which the SDS would not accept.[87]

Yet, despite the tensions and the threats from the SDS, those calling for peace and further dialogue – those who marched on the barricades – won a small, though hollow, victory that evening. Negotiations between Izetbegović and Karadžić, brokered by the JNA, led to the barricades coming down and 'joint patrols' being established. Thereafter, citizens of Sarajevo began to mobilize. In the early days of March, a loose organization simply entitled *Valter* (Walter) was created. It was named after the partisan resistance fighter, Vladimir Perić 'Valter', who was lionized in the 1972 film *Valter brani Sarajevo* (Walter Defends Sarajevo)[88] and comprised a collection of citizens who were protesting against all of the governing political parties, their dangerous brinkmanship and the erection of the barricades in Sarajevo. Among their leaders was Neven Andjelić, who was a popular journalist and broadcaster known to younger generations, in particular, as host – and then editor-in-chief – of the *Omladinski program* (Youth Programme) on Radio Sarajevo. He announced the beginning of the *Valter* protests – without permission – on his show on 3 March 1992, though the initial protest was planned only to be a one-day event.[89] *Valter* was in essence a citizens' movement and one that had a civic, non-nationalist orientation with no clear leadership structure, but with a distinct brand – the *Mi smo Valter* (We are Walter) logo which was created by Alija Hafizović, a well-known Bosnian artistic designer. Moreover, the involvement of opposition political parties was discouraged by the protest's organizers. The *Valter* movement was active throughout March 1992 and they had their successes, although their endeavours, which contributed to the dismantling of the barricades, were not enough to halt the inexorable slide to war.

The dismantling of the barricades provided only a temporary respite. Indeed, in the month before the outbreak of armed hostilities in Sarajevo, the SDS and SDA/HDZ-BiH intensified their preparations for war.[90] On 3 March 1992, the SDA leader Alija Izetbegović declared the Republic of Bosnia and Herzegovina to be an independent state, a declaration immediately ratified by parliament. That evening, said the Bosnian journalist and writer Miljenko Jergović, Sarajevo was 'in panic'.[91] Just across the street in the Holiday Inn, Karadžić, giving an interview to AP, told journalists that Bosnia's independence was 'a unilateral decision that Serbs will oppose'.[92] Sarajevo, around

which the Bosnian Serbs had initiated the process of placing heavy weapons on the hills surrounding the city, remained extremely tense. Meanwhile in Sarajevo, the *Valter* peace demonstrations continued, with large crowds gathering in the city centre on 5 March and for many days thereafter.[93]

The arrival of new 'guests' in the Holiday Inn in mid-March 1992 contributed, albeit temporarily, to an easing of tensions. It had been decided by the UN that the headquarters for the implementation of the 'Sarajevo Agreement', essentially a ceasefire that temporarily froze the conflict in Croatia, would be based, not in Croatia – or Serbia – but in the Bosnian capital. Not only would this prove logistically problematic, the new base for UNPROFOR operations was itself becoming increasingly unstable, and the organization's staff would soon find themselves drawn into the vortex of war in Bosnia and Herzegovina. On 13 March 1992, the UNPROFOR team, including the Canadian general, Lewis MacKenzie, and the Indian general, Satish Nambiar – the elder brother of Vijay Nambiar, who would later become UN Under-Secretary General and the UN Secretary General Ban Ki Moon's Chief of Staff – as well as a small contingent of Swedish peacekeepers arrived in Sarajevo and were initially based in the Holiday Inn.[94] Upon their arrival, the ECMM's representative, Colm Doyle, noticed that the hotel was 'full of heavily armed Serbs, who were Dr Karadžić's henchmen and bodyguards'.[95] MacKenzie, too, immediately noticed the tension in the building. 'The hotel's reception area', he said, 'was packed with hundreds of [armed] people … the bulges under their arms were a little obvious, and some of them were carrying automatic weapons in plain sight, although wearing civilian attire.'[96]

The UNPROFOR team would soon begin to 'demilitarize' the hotel and improve security, and the newly arrived UNPROFOR team met with Cedric Thornberry, UNPROFOR's political adviser and the EC's main negotiator in Sarajevo, Jose Cutileiro, who briefed them on the situation in the city. The latter had become convinced that the UN would have no role if the latest peace proposal worked and that they should expect a quiet time in the city. 'We were delighted to hear that', stated MacKenzie; 'In fact we quite wondered why we were there, because we really didn't want to put our headquarters in Sarajevo.'[97] Yet their arrival appeared to calm the tensions, the Sarajevo daily *Oslobođenje* observing the change in atmosphere in the hotel after UNPROFOR's arrival:

> Instead of armed civilians, under whose coats the most modern battle weapons protrude, an airport checkpoint for guests and passers-by has been set up at the main entrance to the hotel. All the world's languages are being spoken, and the two large letters 'UN', with the well-known insignia of this world organisation dominate the hotel's parking lot. The 'Holiday Inn' is the temporary location of the General Staff of UNPROFOR, with General Satish Nambiar at the head. The hotel that had recently become the headquarters of the paramilitary units of one national party [the SDS] was transformed overnight into a multi-national shelter.[98]

Such an easing of tensions was encouraging, though Nambiar's response, when asked by an *Oslobođenje* journalist whether his family would be joining him in the hotel and in Sarajevo, was less so. His response – that they would not – did little to assuage

the growing fears of Sarajevo's citizens that war was approaching.[99] Unbeknown to them the UNPROFOR team in the Holiday Inn were engaged in organizing a 'pool' to place bets on when the war would begin.[100] The hotel now hosted a rather strange mix of 'guests'; ECMM and UNPROFOR staff, foreign journalists, TV crews, the leadership of the SDS – including Karadžić and his personal bodyguards – all of whom rubbed shoulders on a daily basis. By the end of March 1992, however, the majority of UNPROFOR personnel were preparing to leave the Holiday Inn and move to the *Dom penzionera* – a newly constructed care home for the elderly painted in lurid primary colours and known to the UNPROFOR troops as the 'Hotel Rainbow', located near the *Oslobođenje* building in the Nedžarići area.

By the time UNPROFOR were preparing to depart, Karadžić, was more or less a permanent resident in the hotel, having decided that he and his family were potentially endangered in their apartment in *Ulica Sutjeska* (Sutjeska Street) in central Sarajevo. He had moved himself, his wife Ljiljana and their two children, Sonja and Aleksandar (Saša) into the hotel, where they occupied rooms 526–530 – essentially a suite of rooms on the fifth floor – known as the 'Olympic Apartment' due to the first occupant of room 530 being the IOC President, Juan Antonio Samaranch, in January 1984 in advance of the 1984 Winter Olympics.[101] Karadžić and other leading SDS figures regularly gave daily briefings and interviews to media from all over Europe. Indeed, growing legions of foreign journalists and delegations visited the hotel in the weeks following the independence referendum, largely seeking an audience with Karadžić, eager to determine the SDS leader's intentions as the potential recognition of Bosnia and Herzegovina was being debated by the international community.

That Karadžić was both nervous and agitated in the increasingly febrile context was not lost on those who interviewed him in the days leading up to the outbreak of war. Writing in *The Spectator*, Robin Lodge stated that the Holiday Inn, 'run by Serbs and doubling up as public relations office for Radovan Karadžić's SDS' was permeated with tension in the days leading to the outbreak of war in Sarajevo. Walking around the hotel were young, armed SDS activists; 'Sour-faced, puppy-fat youths hang around the gloomy corridors, fondling the safety catches of their automatic rifles, daring you to ask them to step aside.'[102] Maggie O' Kane of *The Guardian* described meeting him as akin to 'an audience with a Mafia don; Young men with Kalashnikov's knocked on the door ... announcing that Dr Karadžić was ready to receive. In the Olympic suite, the boys in the anteroom frisked the visitors before entering.' Karadžić was, she said, 'a genial host; a nice guy with a sting in his tail, who was paranoid about his own security'.[103]

Radovan Karadžić, though based in the Holiday Inn, spent much of March involved in the so-called 'Carrington-Cutileiro Plan' negotiations.[104] The plan, also known as the *Lisabonski sporazum* (the Lisbon Agreement) envisaged a 'cantonized' Bosnia comprising of autonomous units that reflected the ethnic balance in each canton – though there was some ambiguity over which ethnic group was dominant in each canton. It went through a number of revisions and was rejected, in the first instance, by the Bosnian Serbs. By the time of the fourth revision, however – which envisaged a division of Bosnia into three ethnic units – Serb, Croat and Muslim – agreement appeared closer.[105] The plan was signed by Karadžić, Boban and Izetbegović,

respectively, on 18 March 1992. Ten days later, on 28 March 1992, Izetbegović withdrew his signature, insisting that he would not accept a territorial division of Bosnia. The 'Lisbon Agreement' was thus annulled. The failure to reach agreement brought conflict even closer, and this was compounded by the SDS declaration of a 'Serbian municipality' in the Novi Grad area of Sarajevo.[106] In the days following, military vehicles were seen taking positions on Mojmilo hill.[107] Yet, many of Sarajevo's liberal intelligentsia simply did not believe that war was possible. Gordana Knežević, the then editor of the political section of *Oslobođenje* recalled:

> We believed that what would protect us from war was the multi-ethnic structure of the city. Our reasoning was that whoever might fire a shell at the city could kill a Serb, Muslim or a Croat. It was impossible to shoot at one of these nations in the city; wherever you aim your weapon you aim at all three peoples, so we thought being mixed was actually an advantage. What we did not know then, not understanding the nature of this war, is that this is exactly what made our situation so precarious. Those who attacked the city were, in reality, fighting against communal life.[108]

Beyond the capital, however, the war had already begun. Clashes in Bosanski Brod and the attack on Bijeljina – in eastern Bosnia – led by the *Srpska dobrovoljačka garda* (Serbian Volunteer Guard), better known as *Arkanovi tigrovi* (Arkan's Tigers – after their leader, Željko Ražnjatović 'Arkan') or merely *Arkanovci* – were dark portents of things to come.[109] There were very few journalists there to witness events in Bijeljina. Two correspondents from *Oslobođenje* were in the city but Halid Rifatbegović was, as a Muslim and a journalist for a newspaper that was regarded by Bosnian Serb extremists as 'anti-Serb', in significant danger. The paper's experienced war correspondent, Vlado Mrkić, was also to arrive in Bijeljina.[110] Both were apprehended and placed in custody, though both were later released and managed to leave the city alive.[111] Only one foreign photojournalist, a young American called Ron Haviv, was in the town to capture the horrific events. Haviv had already made a name for himself in 1989, having published a series of visceral images – in *Time* magazine – on post-election violence in Panama, where Manuel Noriega had lost the election and quickly annulled it. He had already covered the wars in Slovenia and Croatia and had already ingratiated himself to Arkan in November 1991 in Erdut, Croatia, where the Tigers' training camp had been established. Haviv's photograph of Arkan holding aloft a baby tiger while his men sat astride a tank was one that was approved by Arkan. Having been tipped off that 'something was going to happen' in Bijeljina, Haviv was given Arkan's blessing to join a group of his men.

> Arkan told me that he was in the town to 'liberate' it from what he called 'Islamic fundamentalists'. He sent me off with a group of soldiers; I think the reason I was sent with them was that one of them was an Australian Serb who spoke English. We went through the town and I witnessed, among other things, the *Arkanovci* executing unarmed civilians and taking prisoners. Eventually, however, Arkan confronted me, realising that I might have pictures of these executions. But I managed to hide some of the film.[112]

Haviv completed his work in Bijeljina and headed back to Belgrade, though he returned to Bosnia and Herzegovina a few days later to cover the 6 April 1992 events in Sarajevo. His photographs taken in Bijeljina, when published in *Time* magazine, caused international outrage and the subsequent wrath of Arkan himself. Thus, by the time he had reached Sarajevo, therefore, Haviv knew that his life was in genuine danger should he ever cross paths with the *Arkanovci* again. While Haviv was preparing his trip to Sarajevo, information about the killings started to trickle out from Bijeljina, and on 4 April 1992, the Bosnian government announced a general mobilization call.[113] Karadžić, in riposte, stated that this gave Bosnia's Serbs a clear indication of Izetbegović's true intentions and 'that this would lead to war'.[114] The SDS then announced the creation of an exclusively Serb Interior Ministry (*Ministarstvo unutrašnjih poslova* – MUP), the justification for this being that they considered the Bosnian MUP an instrument of the SDA and – in part – the HDZ-BiH.[115] Once again, barricades appeared across Sarajevo, while fighting broke out in Kupres in central Bosnia – where the Bosnian Serbs soon took control.[116]

The events of 5 and 6 April 1992

The atmosphere in Sarajevo was tense following the mobilization call. Karadžić would later claim that the evening of 4 April 1992 was one of fear, anxiety and tension; the streets, he said, 'were deserted … everything was blocked and we could not leave the hotel; so we waited to see what would happen'.[117] The citizens of Sarajevo, too, could see that war was becoming, at best, increasingly inevitable and, at worst, unavoidable. The following day, 5 April 1992, SDS gunmen attacked the police academy in Vraca, while the – Muslim – Green Berets took control of a number of key buildings in the city centre. Meanwhile, a peace demonstration began in the Sarajevo suburb of Dobrinja, with numbers steadily growing as the demonstrators reached the centre of the city. As they crossed the Vrbanja Bridge towards Grbavica – which had been blocked off by SDS barricades – chanting *Grbavica je Sarajevo!* (Grbavica is Sarajevo!) shots were fired, killing Suada Dilberović, a young medical student from Dubrovnik, and Olga Sučić from Sarajevo.[118] As parts of the crowd charged towards the house – the *žuta kuća* (yellow house) where they believed snipers to be located, JNA jets flew menacingly low across the city.

Despite the increasingly desperate pleas for the respective leaders to work towards finding a way out of the crisis, any form of constructive dialogue proved impossible. Even ostensibly straightforward matters, such as deciding upon a location for the leaders to meet, proved problematic. The former suggested the *Konak* in the Old Town as a meeting place, a suggestion immediately rejected by Karadžić, largely on the basis of symbolism.[119] In response, Izetbegović refused to meet at the Holiday Inn and thus Karadžić and his entourage remained in the hotel throughout the evening of 5 April 1992. They became increasingly convinced that they were encircled and endangered by the Bosnian government forces and the Muslim *Zelene beretke* (Green Berets), who had raided and looted Karadžić's apartment in Sutjeska Street earlier in

the day, only adding to the existing paranoia.[120] By early evening, those who had led the *Valter* demonstrations the previous month now broke into the parliament building and occupied by force of numbers. Declaring themselves 'The People's Assembly', they hastily elected a *Komitet nacionalnog spasa* (Committee of National Salvation), which pledged to organize and schedule a new round of elections. Speaker after speaker conveyed the same message: it was imperative to avoid intensification of the crisis and Sarajevo's citizens should remain united. The city was paralysed, with traffic and public transport at a standstill.[121] TV Sarajevo (TVSA) relayed the events continuously to a bewildered and frightened population, shocked by the gravity and speed of the events which were unfolding.

The following morning, 6 April – the 47th anniversary of Sarajevo's liberation from German and Ustaša occupation in 1945 – the EC recognized Bosnia and Herzegovina as an independent state, while the US followed suit the following day.[122] Having repeatedly declared that they would not recognize the legitimacy of an independent Bosnia and Herzegovina, this provided the pretext the SDS needed. That morning, a local journalist, Edina Bećirević, who was working for World Television News (WTN) managed to enter the Holiday Inn with her cameraman – who had good connections with the SDS – to get a statement from Karadžić. The atmosphere in the hotel was, she said, 'very, very dark'. 'He gave me a short statement, and I don't recall exactly what that was; what I do remember, however, is that I felt quite threatened; it was clear that tensions were extremely high and I couldn't wait to get out of the building.'[123]

In the meantime, the demonstrators who had been ensconced in the parliament building throughout the night were bolstered the following morning by greater numbers; some, having seen the events of the previous day and despite the obvious

Figure 1.1 Peace demonstrators outside the Bosnian Parliament, 6 April 1992 (Ron Haviv/VII).

dangers, came from beyond Sarajevo to lend their support. According to Neven Andjelić, who would later address the demonstrators at the parliament, his route there was peppered with barricades:

> Driving from my flat to the parliament building, I was forced to pass through a number of hastily-constructed roadblocks, though by now I was familiar with the sites of these barricades. The Serb paramilitaries who manned theirs were heavily-armed and masked, but most of those I passed through had been erected by supporters of the SDA and ordinary Sarajevans following the mobilisation call on 4 April 1992. Unlike the Serb/SDS barricades, these were rather ramshackle affairs manned by men carrying old firearms and wearing green berets with 'Patriotic League' badges. The greatest danger one faced was from one of their firearms going off accidentally or from Serb snipers who were firing into the city from the surrounding hills (though rumours were circulating that snipers were located in tower blocks in tall buildings surrounding the parliament building).[124]

By 12.00 pm the majority of the demonstrators – which Karadžić described as 'Izetbegović's armed peace activists' – had reached the parliament building across the street from the Holiday Inn.[125] The *Mi smo za mir* (We are for peace) demonstration drew large crowds, most of which were gathered around the parliament building – according to the estimates of the Sarajevo daily *Oslobođenje*, 100,000 people had assembled there.[126] They carried banners bearing messages such as *Mi želimo mir* (We want peace) and *Mi smo Titovi, Tito je nas* (We are Tito's, Tito is ours) while chanting *Dolje vlada!* (Down with the government). According to Neven Andjelić:

> The square was packed with people, the crowd spilling over into the side streets. The demonstrators represented a cross-section of Sarajevan, or Bosnian, society; every type was there – impoverished workers (once known as proletarians), miners from central Bosnia carrying pictures of their idol, Tito; vociferous doctors from Sarajevo's hospitals, sober and serious. There were even quite a few hip young professionals who usually keep well away from political gatherings. School teachers were meeting their students in front of the building, and couples had even brought their children.[127]

However, those among the SDS leadership that were in the Holiday Inn perceived this gathering as something more sinister than merely a peace rally organized and led by the citizens of Sarajevo. Karadžić and his armed entourage had 'a front row seat' and could watch the events unfold from across the street in the Holiday Inn – his suite had a direct view of the large public space outside parliament.[128] According to Karadžić's own account, he became increasingly convinced that the events were far from spontaneous and organized by his political opponents.[129] As the demonstrations intensified, Momčilo Krajišnik, who was at home watching the events unfold on television, advised Karadžić that 'they could easily arrest him' and that 'this peace movement was very dangerous'.[130]

The paranoia of the SDS crisis staff who remained in the hotel only grew as, at around 2.00 pm, part of the crowd surged towards the Holiday Inn to directly confront them.[131] Civilian UNPROFOR staff, who were watching events unfold on television in their rooms in the hotel quickly realized that they, too, were about to be unwillingly thrust into the eye of the storm. The crowd, who were advancing rapidly towards the hotel, may have expected some resistance from the SDS guards in the Holiday Inn, but they did not expect that they would fire indiscriminately into their midst. According to Kemal Kurspahić, the editor of *Oslobođenje*, the demonstrations were peaceful and an 'extraordinary and unprecedented demonstration of unity' until 'Serb snipers from Karadžić's headquarters [the Holiday Inn] began shooting at unarmed demonstrators'.[132]

Prior to the shots being fired, the American photographer Ron Haviv – who had driven down to Sarajevo from Belgrade in the early hours of 6 April 1992 – had arrived in the Holiday Inn. 'Everything seemed quite normal,' he said, 'though I didn't have a clear sense – not knowing the city very well – of exactly what was going on.' He teamed up with a young British photographer, Michael Persson – who then worked for AFP – and they took up positions on the road between the Holiday Inn and the parliament building. Both were photographing the crowds outside the parliament building when the some in the crowd began advancing towards the hotel. Shots rang out. 'We were,' said Haviv, 'right in the middle of the road – a great place or a terrible place, depending on your perspective. The crowds were scattering in different directions and we were lying on the ground trying to capture the events throughout what I remember as quite sustained fire.'[133] Witnesses claim that SDS gunmen located in the upper floors moved from window to window – accounts vary with regard to which floor the snipers were located – firing directly into the crowd, killing six and wounding many more.[134] Those who were exposed in the large, open space between the Bosnian parliament building and the Holiday Inn ran for cover, cowered behind bins, cars or anything else that would provide them a semblance of protection. These dramatic events were being relayed live on TVSA throughout, with commentary on them being provided by the journalist, Mladen Paunović – who, upon hearing the shots uttered the now famous line *Da li se čujemo?* – 'Do you hear that?' He had, according to Gordana Knežević – later the deputy editor of *Oslobođenje* – been hitherto 'relatively sympathetic to the SDS, believing that their stated objective of preserving Serb culture was entirely legitimate'. However, she noted, 'his position was transformed, literally live on air, when he witnessed what that party was now doing.'[135]

At the cessation of the firing, a small crowd swarmed around the outside of the hotel, smashing the ground floor windows. Armoured police cars fired into the fourth and fifth floors of the Holiday Inn before, a Bosnian MUP 'Special Unit' led by Dragan Vikić – known also as *Vikićevi specijalci* (Vikić's Specials) – who were ostensibly there to provide security during the rally at the adjacent Assembly building – entered the hotel.[136] According to a UN report, UNPROFOR staff witnessed windows being smashed and smoke bombs and tear gas canisters being thrown into the lobby of the hotel.[137] One of the British journalists in the hotel lobby at the time was *The Independent* correspondent Marcus Tanner, who was made aware of the imminent attack by Cedric Thornberry, the Director of UNPROFOR's Civil Affairs, who was swiftly leaving the

Figure 1.2 Demonstrators take cover from shooting from the Holiday Inn, 6 April 1992 (Ron Haviv/VII).

hotel after a bullet had shattered the window in his room. When the Bosnian special unit entered the hotel's large atrium, 'I crawled to safety in a corner of the reception area under the stairs, waiting for the battle between Serbs and Muslims for control over this strategically important building in the city center to finish.'[138]

The *Times* correspondent Tim Judah leaped over the reception into an adjacent cloakroom, where he and a few others waited nervously. 'We were afraid', he said, 'that they [MUP] would burst in to the room, shoot, and ask questions later ... the tension was palpable; but soon after we heard someone shouting for the journalists to leave the hotel, which we duly did.'[139] As the journalists and some members of the hotel staff fled, a number were apprehended and taken to local police stations where they were questioned about the alleged shootings. What Judah described as the 'sacking of the Holiday Inn' now began.[140] The MUP units then began a floor-by-floor, room-by-room search of the hotel to identify and apprehend the gunmen. The hotel's guests, workers and the journalists located inside the building, terrified by the unfolding events, emerged from behind the reception counter, the stairwells, the ground floor hairdressing salon and the atrium's concrete pillars where they had been sheltering.[141]

During the storming of the hotel eight alleged SDS snipers – the number was later confirmed by *Oslobođenje* as three – who had attempted to evade their pursuers by climbing to the roof of the building, were overwhelmed by sheer numbers, apprehended and beaten before being taken to the lobby and briefly questioned by members of the – Bosnian – MUP before the latter secured the area.[142] Frightened and claiming to have no knowledge of the shootings, they were, according to the UNPROFOR General Lewis MacKenzie, 'in a mess by the time they reached the lobby of the hotel'.[143] They were

then dragged from the hotel to face a baying crowd and an uncertain fate.[144] Having managed to edge nearer the Holiday Inn, Ron Haviv recalled how a Bosnian MUP member exited the hotel to inform the crowds still outside its immediate perimeter that the snipers had been captured. 'The crowd cheered and the mood was jubilant. In retrospect, of course, no-one in the crowd would have known what these events had set in motion.'[145] Fortunately for the alleged gunmen, however, they represented valuable bargaining chips for the Bosnian government, and were later exchanged for Bosnian police cadets who had been held prisoner at the Vraca police academy, which had been overrun by SDS militia the previous day.[146] By the time the SDS snipers had been arrested, however, the party's leadership, including Radovan Karadžić, had fled. Jonathan Landay of UPI was in the lobby of the hotel as Karadžić, his family and his security guards made a brisk exit, recalling that his group left carrying what he described as 'large green duffle bags'.[147]

Karadžić may have escaped, but he left a number of SDS members and some of his armed guard to an uncertain fate. Whatever the mode of transport, Karadžić soon turned up in nearby Serb-held Ilidža, where he briefly settled in the Hotel Serbia in the hotel complex near *Vrelo Bosne* (the Spring of Bosnia).[148] Karadžić, however, claimed that he had already left the hotel before the shots were fired, having been taken to the Sarajevo TV station to meet with Izetbegović and Kljuić before being instructed by his security detail not to return to the Holiday Inn and instead was taken to Lukavica.[149] Robert Donia noted that telephone intercepts – used during Karadžić's trial at the ICTY – demonstrate that, at the time of the shootings he was seeking a safe route out of Sarajevo.[150] In an interview for Radio Belgrade following his escape from the Holiday Inn, Karadžić denied that SDS snipers had been responsible for the shootings and claimed that the whole incident had been staged; he placed the blame for the shootings and the subsequent storming of the hotel squarely on 'Muslim militia' who, he claimed, had fired from the Unis towers adjacent to the Holiday Inn.[151] This view was later supported by General Milutin Kukanjac, the JNA's commander in Sarajevo, who later claimed that 'Everything was staged … Izetbegović was behind it all.'[152] In any event, when Karadžić did leave the city, he would stay at the Hotel Serbia in Ilidža – where he was warmly greeted by local SDS officials – for only a few days before establishing a permanent base in Pale, the small mountain town in which wealthy Sarajevans had *vikendicas* (weekend houses) and where the SDS leadership would be 'compelled to live together in unhealthily close proximity'.[153]

Tim Judah of *The Times* and Marcus Tanner of *The Independent* had managed to escape from the hotel, running across the car park while 'absurdly waving our passports in the air as some kind of protection' and towards the nearest apartment block, where a family allowed them to stay in their home until the worst of the shooting was over.[154] A couple of hours later they returned to the Holiday Inn to collect their belongings. Judah discovered that his camera, computer and suitcase had been stolen; Tanner's room had been left untouched. Judah then managed to gather what remained of his possessions, bundling them into a bedsheet – his suitcases had been used to extract an assortment of cameras and laptop computers from neighbouring rooms – and carried it down to the reception.[155] As the two British journalists approached the front entrance of the hotel, they were stopped by a gunman, and quickly realized that they might be

mistaken for looters. Instead, the gunmen demanded the key to Judah's car – a black Fiat Uno parked in the basement garage – but, he said, 'they had no interest in it – it was a right hand drive, and was clearly not the car of choice for a Sarajevo gunman – so thankfully the car was safe'.[156] They then joined a group of other journalists who were then taken in convoy to the *Hotel Beograd* (Hotel Belgrade).[157]

In the hours following the events at the Holiday Inn, Sarajevo descended into a menacing uncertainty; MUP fighters in the hotel exchanged fire with Serb militia located in nearby Grbavica and Skenderija, the TV station in Alipašino polje was shelled, and further skirmishes broke out in other parts of the city. Roadblocks were again erected, and by nightfall an air of grim uncertainty and terrifying anticipation of darker events hung heavily over the city. TV Sarajevo continued to broadcast footage of the day's events, occasionally pausing to display a message on the screen to citizens of Sarajevo, which read: *Narodi BiH, ujedinite se protiv rata – nemojte pucati!* (People of Bosnia and Herzegovina, unite against war – don't shoot!). The following morning, Ron Haviv walked around the centre of Sarajevo. The city, he said, 'seemed pretty empty; it seemed like the city was not going to be defended'. And, for Haviv personally, there was the small matter of possible retribution for his Bijeljina photos. 'Rumours were circulating that the Serbs, including Arkan's Tigers, were coming to take the city, and this became a matter of some concern for me because of the publication of the images I had taken in Bijeljina'.[158] Indeed, Haviv's photos had been published on 6 April 1992 in *Time* magazine and he knew that if he fell into the hands of the Tigers he would almost certainly be severely punished, even executed. After witnessing the first few days of the siege, he decided that it was time to leave Sarajevo. He left by car for Zagreb, Croatia, though he would return to Sarajevo – and other parts of Bosnia and Herzegovina – on many subsequent occasions.[159]

On 7 April 1992, the leadership of the SDS gathered in Banja Luka to proclaim that the 'Serbian Republic of Bosnia and Herzegovina' was now an 'independent state'.[160] Nikola Koljević and Biljana Plavšić resigned from their posts in the collective Bosnian presidency to assume new positions in the self-proclaimed republic. One last attempt, however, was made to avert war. On that evening, Momčilo Krajišnik travelled into the centre of Sarajevo, at significant personal risk, to meet with Alija Izetbegović at the deserted Bosnian parliament, where just hours earlier the area had been teeming with anti-war demonstrators. Krajišnik implored Izetbegović to make a proposal about the division of Sarajevo;[161] the latter responded that he would rather Krajišnik forward a proposal first.[162] In a context within which the SDS sought to create ethnically 'pure' territories, Sarajevo became an 'unsolvable knot';[163] the resulting impasse dictated that their meeting ended with no progress being made on an agreement vis-à-vis Sarajevo and thus the blockade and siege of Sarajevo by the Bosnian Serbs would commence, and would be executed ruthlessly. As the uncertainty increased, a sense of panic took hold among the citizens of Sarajevo. Long queues for bread, milk and other basic provisions became commonplace, while looting became more frequent – though not widespread.[164] Many clung to the belief that war was simply not possible in Sarajevo, others were preparing to stay and 'tough it out' believing that it might not last long. As Kemal Kurspahić later wrote,

> The war did not come to Sarajevo completely without warning. But loving that marvellous city the way we did, serene in the belief that its diversity of cultures, traditions and religions was a special blessing, a gift, and entirely secure in the respect that each one of us was raised to give his neighbour, we refused to consider the possibility that something as devastating as a fratricidal war would ever happen to us.[165]

Equally, however, many were preparing to leave. Thousands of Sarajevans began to evacuate the city using whatever means they could; many travelled by plane – the airport remained open for the next month though controlled by the JNA – others by car, bus or train.[166] Schools were declared closed until further notice and convoys of – largely, though not exclusively – women and children began to leave Sarajevo on buses, headed for Split in Croatia and an uncertain future. These convoys would continue until early May 1992, when the encirclement of the city was complete and the siege tightened – thereafter transportation out of the city became far more difficult.[167] As they departed, the numbers of foreign journalists arriving in the city steadily increased.

2

The early months of the siege

In the immediate period following the 6 April 1992 events, sporadic sniping and shelling by the Bosnian Serb gunners from their 'strategic positions' on high ground increased, with the old Ottoman part of Sarajevo, Baščaršija, taking the brunt of the shelling.[1] Food was in increasingly short supply; shops had been looted, banks were closed and citizens queued for what could still be purchased from shops and markets.[2] There was significant confusion about who controlled which areas of the city, who was shooting and from which locations. What would later become frontlines were, at this stage, fluid and contested.[3] The city, built along a relatively narrow valley and surrounded by steep hills and mountains – the majority of which were held by the Bosnian Serbs and the JNA – was rendered dangerously exposed and in these early weeks, before the defence of the city became more organized, was at its most vulnerable.[4] Indeed, as Peter Andreas noted, 'If Sarajevo were to fall or be bisected, the most likely time would have been when the siege was first imposed, before the city had mobilized militarily and a substantial international presence established.'[5] Yet, Sarajevans, according to the BBC correspondent Misha Glenny, remained 'astonishingly resilient' and 'they sat in cafés, chatting and drinking beer, with mortars exploding around them'.[6]

The foreign correspondents who had stayed in the city after the Holiday Inn shootings were attempting to report on what was an opaque, complex and uncertain situation. During early exchanges, the city's relatively lightly-armed defenders held out, but the situation, broadly, remained very uncertain. These defenders were a disparate group; some were well-organized groups – such as *Zelene beretke* (Green Berets) and the *Patriotska Liga* (Patriotic League) – while others were formed spontaneously.[7] In the absence of a professional army, volunteer units – some of which comprised members of Sarajevo's criminal fraternity and led by underworld figures such as Ramiz 'Ćelo' Delalić, Jusuf 'Juka' Prazina, Mušan 'Caco' Topalović and Ismet 'Ćelo' Bajramović. They played a vital role in the early defence of the city, though, as Donia noted, they did so 'without abandoning their traditional activities of smuggling, theft, protection and extortion'.[8]

Sarajevo thus became a complex web of areas, each *mahala* controlled by a different local unit, each with its own commanders and checkpoints. The existence of spontaneously formed 'defence committees' also added another layer of complexity.[9] Traversing the city became exceptionally difficult and time

Figure 2.1 Ismet 'Ćelo' Bajramović in Sarajevo, July 1992 (Paul Lowe/VII).

consuming, even for those with good knowledge of its geography.[10] The foreign journalists who had to attempt to understand these complexities were scattered throughout the city and had little means of communicating or sharing intelligence. Moreover, they were often vulnerable to having their cars or equipment stolen. A core group, therefore, began to gather at the Hotel Beograd (Hotel Belgrade) on Kulovića Street, just off Maršal Tito boulevard, and the Hotel Europe in Baščaršija, both of which remained functioning – until the former was gutted with incendiary shells and the latter was badly damaged by mortar shells. According to Steve Crawshaw, writing in *The Independent*, the Hotel Beograd was 'seedy but bearable', and was no safe haven:

> The doors stayed locked all day in an effort to keep the gunmen at bay. Here too, however, there was no escape from trigger-happy gangs. There was a shoot-out in the porch one evening and, at two in the morning, a militia gang burst in upon the receptionist and, demanding to see the owner of a car on the street which boasted Belgrade (i.e. enemy) plates. A Finnish journalist had to be dragged from his bed before the militia were satisfied.[11]

Reporting from within Sarajevo at a time where the parameters of the siege had not yet been established, and the situation vis-à-vis the city's defence being so unclear, was hazardous. As Jean Hatzfeld of the French daily *Libération*, who was based in the Hotel Beograd, recalled,

The first weeks and months were very dangerous because the frontlines were not clearly defined; neither the nascent defenders of Sarajevo nor the citizens had adapted to the new and frightening circumstances. When the shooting started, they did not know how to protect themselves, how to move or how to get supplies – and that was true also of the journalists.[12]

The *Times* photographer Chris Morris observed that there was a deceptive, though uneasy, peace in Sarajevo at that point: 'The cafés were open, lots of soldiers were sitting around drinking … life seemed to be going on as normal but you could also see that there were a lot of arms on display.'[13]

Most foreign journalists opted to attempt to operate independently or in small groups while staying in small hotels or private accommodation. Three American journalists, Jonathan Landay (UPI), Michael Montgomery of *The Daily Telegraph* and Chuck Sudetic of *The New York Times* elected to stay, with the help of Senada Kreso – the Bosnian government liaison with foreign journalists – who allowed them to use her own apartment in Ciglane for a few days before they found a small apartment in the Čengić Vila area. Kreso recalled how Sudetic would loudly dictate his copy down the phone to his editors in New York and that 'this drew unwanted attention'. There was, she said, 'a JNA soldier on guard in our building – as was common at the beginning of the war – but that man left soon after to join the VRS, and my apartment, one among twenty in my building, was targeted and hit four times – which seemed too much of a coincidence'. (add footnote)

When Landay, Montgomery and Sudetić eventually left Kreso's apartment for their own lodgings, they soon discovered that functioning independently meant dealing with more mundane practicalities. The troika discussed the distribution of 'domestic chores' and how a decision would be reached about areas of responsibility, resulting in Montgomery being responsible for cleaning the apartment, Sudetić for cooking meals and Landay for 'shopping'. It was, said Landay, 'the proverbial short straw; there was almost no food to be found in the city; there had been food-runs in the shops, looting and, as a consequence, they were practically empty. Some people were waiting in lines for water because their own supply had been cut off.'[14]

Landay, writing in *The Times*, noted that by the end of April 1992, 'The scenes in Sarajevo are distressing. Most shops have been looted. Banks are closed. Buses and trams have ceased running.'[15] However, with their food stocks running low, Landay decided to go to the *Klas* bakery and flour mill – known locally as *Velepekara* and distinctive because of its large silos – in Čengić Vila in an attempt to acquire some flour to bake bread. It was here that he first encountered the dangers that would become so evident throughout the siege:[16]

> I was standing by a large building near the large silo but observed that there was a big space between it and the silo, so I knew I had to cross that before I could reach where there might be flour. As I was running toward it, I felt my hair twitch (I had long hair in those days) and I realised that a bullet had gone straight through my hair, within an inch of my scalp. It was only after I felt this sensation that I heard the crack of the sniper's bullet hit the wall. I turned and ran as quickly as I could away from the silo and toward the cover of the building. I went home empty-handed.[17]

Figure 2.2 Citizens of Sarajevo waiting in line to fill plastic jerry cans of water, Summer 1993 (Paul Lowe/VII).

Despite the occasional flirtation with snipers, Landay, Montgomery and Sudetić were able to get their stories out of the city with, at that time, relative ease. As print journalists, they did not need satellite phones, merely telephone lines which, at this point, were still functioning in the city. Thus, they could dictate their stories to their respective bureaus with little difficulty. But doing so easily would become untenable after 2 May 1992, when Sarajevo's main Post Office was destroyed by JNA sappers – and members of the elite 'Niš Commandoes Unit' from Serbia[18] – rendering almost all of the city's telephone lines out of service.[19] Thus, operating independently in Sarajevo became more difficult as the communications infrastructure in the city largely ceased to function and by this time, according to Donia, 'most of the elements of the Sarajevo siege were in place'.[20] Indeed, by the end of June 1992, almost all telecommunications in the city had been cut off, meaning that foreign correspondents could no longer rely on the local communications infrastructure to file their stories.

The Hotel Bosna, Ilidža

Those journalists not already accommodated in the city – those arriving, predominantly from Belgrade, in the wake of the 6 April 1992 events – opted to stay on the western outskirts of Sarajevo, in the Hotel Bosna, in Ilidža – one of three hotels set in picturesque parkland close to *Vrelo Bosne* (Spring of Bosnia).[21] The hotel complex had been a popular destination for tourists but had, for several months, been the base of the European Community Monitoring Mission (ECMM), led by an Irish colonel,

Colm Doyle.[22] By mid-April 1992, however, the hotel had become an important communications hub for a number of news agencies and TV crews. In a report for *The Times*, Tim Judah noted that the Hotel Bosna 'was hardly the best place from which to observe the siege of the Bosnian capital' but that after the sacking of the Holiday Inn and the bombing of the Hotel Beograd – the latter badly damaged after heavy fighting in Sarajevo on 2 May 1992 – it was the only place with functioning phones.[23] Thus, the Hotel Bosna was used by journalists, in the main, because it functioned – it had food, electricity and international dialling – not because it was convenient.[24]

One of the first to arrive was a small team from the European Broadcasting Union (EBU), who established a communications infrastructure that would prove vital for transmitting images and footage out of besieged Sarajevo. The EBU, consisting of all European public service broadcasters, would create, in Sarajevo, technical services in the field and provide and coordinate news exchange for media organizations that were not in the city. Thus, the EBU's arrival would not only make it easier for foreign journalists, particularly TV crews, to get their reports out of Sarajevo, via a satellite uplink, but also helped to solve a very serious problem faced by TV Sarajevo (*Televizija Sarajevo* – TVSA) and YUTEL, who were also based in the city's TV building. Bosnia and Herzegovina had no satellite uplink – the SFRJ only had two: one in Ivanjica in Serbia, which was built in 1974 and one in Zagreb, which was created in the late 1980s. The pictures broadcast live on 5 and 6 April 1992 were not seen in many parts of Bosnia and Herzegovina. This was no accident. In August 1991, the SDS had assembled a team of engineers who recalibrated the receivers in the parts of Bosnia and Herzegovina in which they held political control. Hitherto, TVSA was broadcast throughout Bosnia and Herzegovina, facilitated by a network of eleven main transmitters and 186 relay stations. From August 1991, however, the SDS – working in concert with the JNA – began to seize these transmitters and block the transmissions from Sarajevo and reconfigured them so that viewers in SDS-controlled areas would only receive a signal, and thus TV news, from Belgrade. By the end of March 1992, five of the eleven transmitters had been seized and repositioned.

The first transmitter to be seized was that located in Kozara, which was used to transmit TVSA to much of north-central and north-western parts of the republic – including towns such as Banja Luka, Prijedor and Sanski Most, which were, as Mark Thompson noted, ethnically cleansed 'with the utmost brutality the following spring and summer'.[25] According to Dragan Miovčić, an engineer from TVSA, 'They [the SDS] installed a receiver, a satellite receiver that could broadcast the program of Belgrade Television on the second program of the Kozara transmitter.'[26] This meant that large parts of what would become *Republika Srpska* were receiving their TV from Belgrade, not Sarajevo. By mid-April 1992, only three relay transmitters were broadcasting TVSA to limited parts of Bosnia and Herzegovina – developments described in *Oslobođenje* as an 'information blockade' – while the re-orienting of the transmitters ensured that over half of its territory was covered by Radio Television Serbia (*Radio-televizija Srbje* – RTS).[27] Others would follow. On 28 October 1991, the Plješevjca transmitter was seized and re-adjusted to receive RTS; this was followed in February 1992 by similar operations in Doboj (north-central Bosnia) and Majevica (north-eastern Bosnia) and, in March 1992, Trovhr (south-eastern Bosnia) and Vlasić

(central Bosnia).[28] This essentially determined that the populations in the parts of the republic that were politically controlled by the SDS had no access to TVSA.[29] The loss of the transmitters not only determined that TVSA had lost its ability to broadcast across Bosnia and Herzegovina, it had also lost its connection to the world. As Mark Thompson noted, 'In television, as in everything else, Bosnia was thoroughly enmeshed in Yugoslavia. TVSA's usual access through international exchange networks – such as Eurovision – lay through Zagreb and Belgrade. Only satellite links remained.'[30]

TVSA had, therefore, to attempt to find alternative means to broadcast from the city – and one possibility was to appeal to the EBU for assistance.[31] However, while Yugoslav Radio Television (*Jugoslovenska radiotelevizija* – JRT), based in Belgrade, was a member of EBU, TVSA – the first TV channel based in Bosnia when it began broadcasting in 1961 and Radio Television Bosnia and Herzegovina (*Radiotelevizija Bosne i Herzegovine* – RTBiH), of which TVSA was part of – was not.[32] Satellite uplinks were located in Belgrade and Zagreb, through which TVSA would transmit their pictures. This was, however, no longer a reliable mechanism for TVSA to broadcast images emanating from Sarajevo. A letter sent – by telex – to the EBU on 6 April 1992 from the 'Managing Director' of TVSA, Aleksandar Todorović, appealed to the former to help them establish a satellite uplink that would allow for news and images to be transmitted from Sarajevo to Europe – and beyond. The letter stated that:

> The journalists and technicians of this organization have managed so far and are taking enormous risks to inform their audience and the world about everything that has happened during the last dramatic hours ... In a confused situation where the legal status in Bosnia is unclear, our friends from TVSA need moral support from all their EBU colleagues, as well as to see that their reports received and distributed to a large European audience. Having in mind such a delicate situation in Bosnia & Herzegovina, the links connecting Sarajevo via Belgrade or Zagreb with the Eurovision network may be interrupted. Therefore, I suggest that you consider sending a mobile earth station to Sarajevo to ensure the continuing flow of information from this critical area.[33]

The EBU thus took the decision to install a separate satellite uplink in Sarajevo and despatched a small 'Special Operations Team', led by Myriam Schmaus – but including Charlie Vanderhoop and Alan Monday, both satellite dish operators; Marc Stanislas, a cameraman/editor; and Salem Ben Achour, a technician – on 8 April 1992. They drove their equipment, including editing machines and a satellite dish, down to Sarajevo from Zagreb, arriving the following day. However, the very presence of the EBU team in Sarajevo was not without controversy. JRT were opposed to the EBU establishing a satellite uplink in Sarajevo – though the EBU argument was that they were not 'reporting', were entirely neutral and were merely 'providing transmission services'.[34] But they were, by accident or design, providing a vital service to TVSA, who could not transmit programmes beyond very limited geographical parameters.

The day after the arrival of the EBU team, the BBC crew, which included Martin Bell, drove from Belgrade down to Sarajevo – during which they captured footage of Bosnian Muslims fleeing Zvornik. Prior to the events of 6 April 1992, BBC staff had stayed at the Holiday Inn when reporting from Bosnia, but when returning to Sarajevo from Belgrade – on 10 April 1992 – they set up in the Hotel Bosna. Sarajevo had been heavily shelled the evening before they arrived,[35] but it would be the intensification of clashes around the hotel complex in Serb-held Ilidža that rendered their residency there increasingly treacherous; and though the logic was to use the Hotel Bosna as a safe base from which to travel into the city centre, they found themselves in the midst of an approaching maelstrom.[36] In the meantime, Bell and his crew captured some memorable images – in particular during the 'Battle for Sarajevo', throughout which the embattled defenders of the city repelled the onslaught from the JNA in April and May 1992.

The Hotel Bosna, therefore, became the only place where journalists could access something approaching an infrastructure that allowed TV crews, in particular, to function effectively. In the first two weeks, however, it was relatively quiet in Ilidža and in the Hotel Bosna. One issue, according to the EBU's Myrian Schmaus, was Radovan Karadžić's repeated attempts to create a base for the SDS in the hotel. Karadžić had fled to Ilidža with his entourage after the Holiday Inn shootings on 6 April 1992 and was keen to have a foothold in the hotel where foreign journalists were based. 'We at the EBU', said Schmaus, 'resisted this vigorously'; 'We did not want Karadžić attempting to influence our work or that of the other broadcast media.'[37] In any event, the SDS soon lost interest and would become increasingly hostile, not to the foreign press corps per se, but their local staff. Indeed, just before hostilities broke out in the immediate vicinity of the Hotel Bosna on 22 April 1992, two EBU staff and a local stringer/translator working for them were arrested while travelling back to Ilidža from Sarajevo. The two staff were quickly released but the translator was not. Upon hearing the news, Myriam Schmaus contacted the police station in Ilidža and informed them that if her translator were not released, she would take her sleeping bag and camp outside their premises – and be filmed doing so – until such time as he was. Her threat elicited an immediate response. 'It was dusk and I was just preparing to leave the Hotel Bosna and head toward the police station', she recalled, 'when a car drove into the hotel car park at great speed and threw our translator out while still in motion.'[38] He was unhurt but shaken by his experience. During his interrogation in the Ilidža police station he had been accused of 'political activities' but this was, said Schmaus 'impossible', adding that 'any local staff employed by the EBU had to stay with the crew 24-hours a day – there was no scope for anything else'.[39]

After heavy shelling of Sarajevo's city centre on the night of the 22 April 1992, Bosnian fighters attempted to break the nascent siege and reach Sarajevo Airport and thus fighting around the hotel complex would begin on that day and continue throughout the next three weeks.[40] The small BBC team, which included Martin Bell, was among a group of journalists in the hotel. On occasion, they would broadcast – live – from the balcony of the Hotel Bosna. On the morning of 22 April 1992, with fighting intensifying all around – Bosnian government forces had launched a fierce attack on Ilidža from the surrounding areas of Sokolović Kolonija, Butmir and Hrasnica and had

surrounded the hotel, pinning down the retreating Serb militia – Martin Bell went on air to do a live two-way feed to the BBC breakfast news programme. As he did his piece to camera a small flash could be seen – a bullet had passed directly behind him and had become embedded in the wall.

> We were on the balcony of the hotel and while we were there a huge battle erupted around us. Sometimes things happen, and I felt the air above my head – something was happening to it. A bullet had whistled by, sucked the air out of it and hit the wall behind me. At that point, I turned to the cameraman and said 'let's get the hell out of here'. So, we just closed down and went inside. That was the last time we did a two-way live feed in a public space in Bosnia for the whole of the war.[41]

Bell kept the bullet as a 'good luck charm'. In the ensuing firefight, BBC equipment, such as their Sony BVW-75 editing machine, was badly damaged.[42] The residents of the hotel, 'a bizarre combination of EC monitors, Western journalists and Serb militiamen' were roused from their beds to the sound of gunfire before 'panic broke out' among them when one of the EC monitors received a phone call warning that the Hotel Bosna – because of the presence of the aforementioned Serb militias – was about to be attacked by Bosnian government forces. Writing in *The Guardian,* Yigal Chazan described the scene as 'People rushed downstairs, only to be told that the hotel did not have a basement. Most journalists hurriedly returned to the first floor, where they huddled in corridors … The journalists were in a sober mood, mentally exhausted by the relentless pounding.'[43]

While the ECMM managed to calm the situation in Ilidža, the situation in Sarajevo would steadily worsen. Indeed, when the Ilidža-based journalists could get out of the hotel complex, there was much to report in other parts of the city. Heavy fighting had broken out between the Bosnian Serbs and the JNA on one side and the lightly-armed groups defending Sarajevo raged in the early days of May 1992.[44] Sarajevo was bombarded by shells and mortars, while some fire also emanated from within the JNA barracks in the city in which there were still soldiers. On the first day of May, the nascent Army of Bosnia and Herzegovina (*Armija Republike Bosne i Herzegovine –* ARBiH) surrounded JNA barracks, a move which was, according to Robert Donia was 'the first step in holding these troops hostage'.[45] The next day, the JNA responded and the de facto siege of Sarajevo began. On 2 May 1992 the remnants of the JNA, now an army in essentially a foreign country[46] and becoming transformed into the Army of Republika Srpska (*Vojska Republika Srpske* – VRS), intensified their onslaught upon the city.[47]

Battles raged in Sarajevo, with the JNA pushing towards the centre of the city and meeting fierce resistance at the Skenderija and Vrbanja bridges. In addition, there were intense exchanges in areas such as Ilidža, Sokolović Kolonija, Butmir, Dobrinja and other areas surrounding the city's airport. Both sides blamed each other for the intensification. The whole spectacle was shown live on television, with the Sarajevo TV anchorman Senad Hadžifejzović, playing a mediatory role between those witnessing events from within Sarajevo and the JNA who were firing upon the city.[48] The intensity of fighting was, however, about to be eclipsed by subsequent events later in the evening of

2 May 1992 during the 'Battle for Sarajevo'.[49] The JNA and the Bosnian Serbs attempted to penetrate the centre of Sarajevo and reached as far as the Skenderija crossroads, where they were pinned back by Bosnian armed defenders.[50] Though lightly armed, they stymied the JNA advance in what was one of the fiercest battles of the war.[51] Recording the efforts of the city's defenders was a BBC crew, including Martin Bell, in his characteristic white suit.[52] The images captured by Bell's cameraman Brian Hulls, and soundman Colin Jones, remain some of the most defining of the battle.[53]

While the fighting raged in Sarajevo, the Bosnian President, Alija Izetbegović, was returning from the latest round of peace talks in Lisbon, Portugal. Upon arrival he and his travelling companions, Zlatko Lagumdžija, Izetbegović's daughter, Sabina, and the president's bodyguard – were supposed to be given safe passage into Sarajevo by a UNPROFOR guard, but were instead met by the airport's manager, Mile Jovičić, who escorted Izetbegović to his office.[54] Izetbegović was then informed that he and his companions would be taken to the JNA barracks in Lukavica. Complex negotiations ensued, in which Kukanjac and the JNA sought safe passage out of their barracks in the Bistrik area of Sarajevo – and to Lukavica – in exchange for Izetbegović and his party being transferred to the Presidency building. But things went awry from the outset. The JNA convoy was ambushed by elements of the nascent Army of Bosnia and Herzegovina (*Armija Republike Bosne i Hercegovine* – ARBiH). The number of JNA soldiers killed remains furiously debated, with some figures suggesting the number was as high as forty-two. Ultimately, the exchange was completed, but it came at a high price – seven JNA soldiers were killed.[55]

After the JNA advance of 2 May 1992 and the subsequent Dobrovoljačka incident, the JNA and Serb nationalist forces consolidated their control of Sarajevo's western approaches; they now sought to cut off the city much closer to the centre, just west of the Holiday Inn and the Bosnian parliament.[56] Despite having temporarily crossed the Miljacka River at both the Skenderija and Vrbanja bridges, the attack had failed to divide Sarajevo at Skenderija – the stated objective of the SDS – but the area of Grbavica – directly facing the Holiday Inn across the Miljacka River and an area that had traditionally housed many JNA officers and their families – fell under complete Serb control.[57] Nevertheless, Marrack Goulding, the UN Special Envoy who visited Sarajevo on 4 May 1992, would later note that by then 'Sarajevo was already in deep distress. It was besieged by the Serbs and shelled daily. Food was in short supply. The airport was usually closed and no public transport was functioning. Economic activity was at a standstill.'[58] The following day, the ECMM team based in the Hotel Bosna decided to begin their evacuation from Sarajevo citing a 'sharp deterioration of conditions' in the city.[59]

Less than a week later, at an SDS Assembly session on 12 May 1992, Radovan Karadžić asserted that 'We hold all our areas, all the municipalities and the settlements around Sarajevo, and we hold our enemies – now I must and can say – we hold our enemies in complete encirclement, so that they cannot receive military assistance, either in manpower or in weapons'.[60] At the same time, the battle continued to rage around the Ilidža hotel complex. The journalists in the Hotel Bosna would soon be forced to evacuate their otherwise pleasant semi-rural lodgings, though they were initially unable to do so because of heavy fighting. The BBC Radio journalist Misha Glenny

described the atmosphere among the journalists in the hotel as one of 'controlled chaos'. A mortar then landed in the BBC TV's editing suite, and although there was damage no one was injured. The journalists in the hotel were pinned down while the fighting raged around them.[61] The Visnews – now Reuters Television – cameraman Rob Celliers was injured by shrapnel from a shattered drainpipe as he attempted to film the first wave of counterattacks by the Serbs who held the hotel complex and would eventually 'liberate' Ilidža.

The evacuation from the Hotel Bosna

On the evening of 14 May 1992, journalists gathered for a meeting and, following a vote, the majority opted to commence with preparations for an evacuation from the Hotel Bosna to Split in Croatia the following morning. Among them was Jean Hatzfeld from *Libération*, who had left the Hotel Beograd and moved to the Hotel Bosna in Ilildža a couple of days before. He was among a small group that was keen to return to the centre of Sarajevo, though this was not the majority view among the press corps.[62] According to WTN's Edina Bećirević, 'most of the foreign journalists just wanted this to end, they felt trapped there' and plans were put in place to leave – though she did not, even though she could have done so.[63] Joel Brand, then working for *Newsweek* was sharing a room at the Hotel Bosna with two Catalan journalists – Erick Hauck and Jordi Pujol Puente; he decided to leave while they, fatefully, decided to stay. He recalled the events that led to his departure:

> I remember that the three of us were in our room debating whether we should stay or leave. I was inclined to leave but also wanted to stay. It was taken out of my hands because *Newsweek* told me that I had to leave; essentially, I was ordered to leave. In some respects, it was a relief; a relief that the decision had been taken for me. Jordi and Erick, of course, stayed ...[64]

The following morning, with the battle raging around them, the BBC crew, the EBU team – led by Anna Erickson, who had replaced Myriam Schmaus early in May 1992 – and many other foreign journalists began their evacuation, by convoy, to Split. All of the equipment was left behind – including the BBC's editing equipment and the EBU satellite – and was subsequently taken by the Bosnian Serbs to be used to bolster their nascent TV service in Pale – *Kanal-S*, known commonly as 'TV Pale'.[65] The retreat was, said Martin Bell, 'The BBC's Dunkirk' and, furthermore, 'an inglorious episode'.[66] Thereafter the crew and other members of the 'Sarajevo Survivors' Club' headed south via – Croat-held – Kiseljak through the harsh, arid and mountainous landscape of Herzegovina towards the Croatian border and, eventually, to the port city of Split on the Dalmatian coast.

The small group that remained and were awaiting evacuation back into the city included the local journalists, Edina Bećirević, Zoran Stevanović and Hana Prguda, who sat in the hotel waiting to be evacuated. Bećirević recalls that there were some

Figure 2.3 Foreign journalists en route to Split following the evacuation from Ilidža (courtesy of Joel Brand).

tense moments. 'We could see from the window of the hotel one red-haired woman who belonged to Arkan's Tigers.'[67] The hotel staff told us that her boyfriend had just been killed and she was 'looking for Muslims to kill'. Bećirević asked a member of the hotel's staff to call Tomislav 'Tomo' Kovač, who was the chief of police in Ilidža, to ask that he get them out. 'He wasn't very happy about it, saying that he could face consequences if he helped us, but he reluctantly agreed.'[68] They were taken in a police car to Ilidža and were then driven by a small group of Associated Press (AP) journalists, who had opted not to join the convoy to Split, through back roads to the 'Hotel Rainbow', located near the *Oslobođenje* building in Nedžarići, where the UNPROFOR troops were themselves preparing to leave. The heavy shelling in the days after their return forced UNPROFOR, protected by a lightly-armed Swedish infantry, to withdraw from Sarajevo. The Hotel Rainbow and the PTT building, both home to UNPROFOR soldiers, were both heavily bombarded on the 14 May 1992 – though the former more so.[69] The Hotel Rainbow was hit on several occasions; one civilian member of staff was seriously injured and one Kenyan UNPROFOR soldier was wounded. Seven UN vehicles in the building's car park were destroyed.[70] Following the attack, UNPROFOR withdrew the majority of their personnel from the city to Belgrade – their base was heavily shelled as they organized their departure – leaving only a small group of around 120 personnel and, moreover, doubts about the viability of continued UNPROFOR operations.[71]

As the BBC, EBU and others crews were departing, the shelling in Sarajevo intensified. For those who had been attempting to report from within the city, their ability to function had been severely diminished. Heavy fighting raged in parts of the city. Few foreign journalists witnessed the 'Battle for Pofalići' in mid-May 1992,

though it was one of the pivotal actions of the early months of the siege, during which local military forces again halted a Serb advance that would have cut the city in two.[72] Moreover, few were there to witness the massacre of sixteen citizens waiting to buy bread in Vaso Miskin Street in the centre of Sarajevo on 27 May 1992 as a consequence of three mortar shells being fired from VRS positions, though a TVSA cameraman, Benjamin Filipović – who was also a well-known film director – did capture the awful images of the dead and injured. There were, recalled Edina Bećirević, almost no journalists in the city after the evacuation from the Hotel Bosna: 'It was the worst of times', she said, 'a really horrible period with heavy shelling and sniping.'[73] And, as UNPROFOR began their evacuation from Sarajevo, a small number remained to cover the increasingly heavy bombardments throughout May and June 1992. A few journalists stayed on – such as Jean Hatzfeld of *Libération*, the AP reporter Tony Smith, the AP photographers Santiago Lyon and David Brauchli, the photographer Peter Northall – from the Black Star photo agency – and Joel Brand's erstwhile roommates, the reporter Erick Hauck and the young photojournalist, Jordi Pujol Puente – both of whom were working for the Catalan-language newspaper *Avui*. They did so, according to David Brauchli, 'because we thought the story was more important than the risks we might take being there – we wanted to let the world know that Sarajevo was on the map, that the city was suffering tragically'.[74]

The decision of the AP team to stay in Sarajevo was never really in doubt because all were in agreement that it was not the right time to leave the city, particularly as the shelling had increased and most of the press corps were departing. However, according to Brauchli, the AP team 'did not have the equipment we needed to operate in a city that was under siege'. They therefore 'scrounged' equipment from those who were departing the Hotel Bosna, including some flak jackets, an Inmarsat satellite phone – which AP bosses insisted they have but, at fifty-five pounds, were heavy to move around – and other essential items.[75] The trade-off, said Tony Smith, was that 'we could borrow the BBC satphone but were obliged to file a daily report to the BBC in London'.[76] With the equipment secured, the AP team found an apartment in Koševsko Brdo, through a local journalist/fixer, Peđa Kojović, which, according to Brauchli, 'was on the hill and quite exposed – and from there set out to cover events within the city'. After all, with almost no foreign press remaining in the city, AP had something of an exclusive which was, said Brauchli 'what you do the job for'.[77] On 17 May 1992, Bruachli, Pujol and Lyon had agreed to split up to cover different parts of the city. The routine of the AP team was agreed before they set out. According to Tony Smith, 'we didn't have reliable communications when we were outside the apartment, so we had an agreement that we would try to avoid working alone and preferably always in pairs – and we would do so for a maximum of ninety minutes'.[78] On that day, however, Brauchli and Pujol had not returned after the agreed ninety minutes. While Lyon had gone alone to the centre of the city, Brauchli and Pujol went to the area around the Hotel Bristol, near the pedestrian bridge that leads into Grbavica. However, they were straying, perhaps unbeknown to them, to a very dangerous area. Following the battle in Pofalići, the area around the Hotel Bristol had become exceptionally dangerous. A 'sniper war' between Bosnian government units located in the upper floors of the hotel and Bosnian Serb snipers operating from high-rise apartment buildings in

Grbavica and their barracks in a student hostel in Vraca was intensifying.[79] Shell and mortar fire, often aimed at the Hotel Bristol, also increased in intensity. It was there that a mortar round landed right upon Brauchli and Pujol:

> We didn't know exactly *where* was dangerous; it was still a fairly fluid situation. When we were hit, we had no warning. You can't hear a mortar before it has hit you. By the time I heard the tremendous bang, I was thrown into the air and then slammed to the ground. I had to then assess the situation, so I crawled to where I thought was safe and looked around me and I saw Jordi in the middle of the street. I couldn't walk because I had been hit in the legs, so I crawled over to him. I could see he had two wounds in his chest and it didn't look good.[80]

While Brauchli had been wearing a flak jacket, Pujol had not and was killed almost immediately. Two cars drove past, stopped and picked up Brauchli and Pujol and those in the car eventually arranged for both to be taken to Koševo Hospital. Bruachli underwent an operation to remove a testicle without anaesthetic – he was given an epidural instead.[81] To restrain him, nurses tied his hands to the side of the bed while the operation took place.[82] Jordi Pujol died upon reaching the hospital. He was the first foreign journalist to be killed in Sarajevo. And subsequent events demonstrated, if any further evidence was needed, how dangerous Sarajevo was. On 18 May 1992, the day after Pujol's death, Frederic Maurice, the head of the International Committee of the Red Cross (ICRC) was wounded in Sarajevo. He succumbed to his injuries the following day, hastening that organization's departure from the city.[83]

Tony Smith received the tragic news of Pujol's death from Hana Prguda, a local fixer who has gone to the hospital to look for Brauchli and Pujol. His main objective then became to get the body of Pujol and the injured Brauchli out of Sarajevo.[84] This was not without obstacles:

> We then had to get David – and Jordi's body – out of the city. This was a terrible and frustrating task, as the goalposts were in constant motion. The UN, which had seriously downsized its presence, couldn't or wouldn't help us. We didn't have space in our two cars and mine had a wrecked front-end after I had hit a tank trap. Eric, however, managed to buy an old VW Golf with fuel for 1.000 US dollars, so we had the transport we needed. But we had to wait for David to recover sufficiently to be able to be transported. He had been operated on in Sarajevo hospital without anaesthetic and was obviously in great pain and could not be moved so quickly.[85]

After a difficult journey to Split, Pujol's body was taken back to Spain – Pujol's father came to Split from Barcelona to collect his son's body)[86] Brauchli was later medevaced to Switzerland where he spent a month recovering.[87] Upon his return to Sarajevo, Tony Smith assessed that the apartment they had rented was becoming too dangerous to operate from and too far from their 'office' which was situated on the third floor of the semi-derelict *Jugobanka* building near the Presidency.[88] The proximity of the apartment, he said, 'was problematic – it was quite exposed and vulnerable to stray shells that were targeted at the hospital; and, moreover, we had to take the satellite

phone to the roof of the apartment to get a signal, again potentially exposing us to danger'.[89] The AP team were, therefore, forced to look for an alternative base from which to operate. They were subsequently introduced, through local contacts, to Bakir Izetbegović, the son of Alija Izetbegović, who in turn introduced them to Sulejman Druškić, the well-connected owner of the Hotel Belvedere – who had once played professional football for Udinese in Italy – in Višnjik, near Koševo Hospital.[90] Tony Smith and Alison Smale – AP's bureau chief in Vienna – then brokered a deal that would allow for the rental of the entire building and some additional services. It would prove, according to Tony Smith, a good deal for AP:

> The Belvedere, which before the siege had, apparently, a colourful 'adults-only' past as a pizzeria downstairs with four en-suite rooms upstairs, was perfect for us. Luckily, though very close to Koševo Hospital, it was located in a dip, so seemed – unlike the apartment we had been in – not to be in immediate danger of shelling. It became AP's headquarters for the duration of the siege. Because we had a whole office set up there and it was self contained and not really a target for snipers or shelling, it also became a home for months on end for those like me who came from outside for longer stretches and for our Sarajevo colleagues, for whom it became a second home as it was more comfortable and safer than their own apartments.[91]

From their base at the Belvedere, the AP team would go out into the city every day. As a wire service, their schedule was relentless. 'We had to file every day at every waking hour', said Tony Smith, 'and what we needed was inside intelligence about the military and political situation; patrolling the city was a must, as was talking to the locals, and sitting round the table with colleagues at the Belvedere during a visit from local military types – that was where the news came from.'[92] The Belvedere would prove an excellent base that provided relative safety and would ensure that the AP team operated more or less independently, away from the majority of the foreign press corps that would ensconce themselves in the Holiday Inn upon that hotel's reopening in late June 1992. According to Samir Krilić, who began work for AP in December 1992:

> The Belvedere would prove a great location for us. We became completely independent and self-contained. Crucially, it was safe, close to the hospital and Sulejman Druškić ensured that we did not have any problems with anyone who might, for example, want to steal our equipment. That had happened to me when I had worked as a fixer for ABC, but such things were never a serious concern for the AP crew at the Belvedere. We also had our own generators and a reasonably consistent supply of diesel, which we needed quite a bit of. And, of course, we had food – I mean, nothing special but we might have pasta with tinned mackerel instead of just plain pasta, and certainly more than the majority of the citizens of Sarajevo were surviving on.[93]

While the AP team were seeking to establish a permanent base in Sarajevo, most journalists were scattered throughout the city, staying in small hotels – such as the Hotel Beograd – or private apartments. There were also a number of other crews

that continued to come in and out of the city, often from Belgrade via Pale. Among them was Aernout van Lynden and his crew from Sky News, which was one of the few 24-hour news in existence at the time – their programmes could be received by anyone who owned an Astra home satellite. Van Lynden was an experienced television journalist, one of the key figures in establishing Sky News in 1989 and, for a short time, its news anchor. As a foreign correspondent he had covered the Iran–Iraq War, the Soviet invasion of Afghanistan, the Lebanese civil war and the Romanian Revolution. The Sky News crew did not operate from Ilidža, but from Pale, from where they would travel into Sarajevo. The absence of other major media outlets gave them a competitive edge, though it was by accident rather than design. Indeed, van Lynden acknowledged that he and his crew 'knew nothing about' the media's departure from the Hotel Bosna until they reached the city and discovered that they were preparing to leave.[94] Sky's previous correspondent, Dan Damon, had also departed though he was due, in any event, to be replaced by van Lynden. The new Sky News team drove down to Sarajevo by car – a Volkswagen Golf – from Pale, down through Lukavica and across the airport runway – the airport was still under the control of the JNA at this point.[95] Upon arrival in the city, van Lynden was struck by the eerie emptiness of the streets:

> As soon as we entered into the territory that was held by Bosnian government forces, we saw, quite literally, almost no-one on the streets and almost no traffic on the roads. The few people that we saw were running across intersections or across roads and if we did see any cars, they tended to be driving at extremely high speed. At that time, the Marshal Tito barracks had not yet been evacuated so we had to take a rather complicated route through the back streets to the centre of Sarajevo.[96]

With nowhere to stay, the Sky News producer, Zoran Kusovac, looked around for some potential places to base themselves and had previously identified the Hotel Beograd as a possibility. However, while visiting the Presidency building, they met a contact who arranged for them to be accommodated at the *Klub delegata* (Delegates Club), which had previously served as the base for the UNPROFOR general, Philippe Morillon and Major-General Lewis MacKenzie. From there, however, it was impossible to see the attacks on the city, so the decision was reached that the Sky News team would find somewhere appropriately elevated, from where they could film. According to van Lynden, 'we were looking for an elevated spot, from where we could see the effects of the shelling of the city'.[97] On the suggestion of the Sky News cameraman George Davis, they agreed to find a high-rise building from which to film and tried to enter the Unis towers, though the armed guards there would not agree to allow them to enter.[98] Thereafter, the crew went to report on casualties being treated at the *Vojna bolnica* (military hospital) and while there met with the hospital's director, Abdulah Nakaš, who explained, among other things, that the building had been heavily shelled. Van Lynden asked to be taken to the top floor of the twelve-floor building, which was no longer being used. 'I could see that all of the windows had been blown-out, but at the back of the top floor there were still beds. It was a little exposed, but I asked if we could stay for the night.' Though somewhat surprised by the request, Dr Nakaš allowed them to do so. The location was, for van Lynden's team, perfect. 'There were small

two balconies and we could see, and thus film, most of Sarajevo.'[99] Initially, they had cameras but no satellite phone, dish or uplink which remained in Pale. The EBU was no longer in Sarajevo – though they would return in June – so there was no possibility of transmitting within the city. Not without risk, therefore, they would take the film out of the city and edit and transmit in the Bosnian Serb wartime capital.[100] The arrangement was thus: Van Lynden and his small crew – George Davis – cameraman – and Anthony Fyfe – soundman – would stay in Sarajevo to report and when they had completed this they would drive with their tapes to Ilidža, where they would be met by their producer, Zoran Kusovac, who would take the tapes back to Pale where they could be edited and transmitted. This meant that Kusovac had to drive from Pale down to Lukavica and then across the airport runway every day in his 'soft-skin' – i.e. an unarmoured car – Volkswagen Golf. It could, according to Kusovac, be a terrifying experience:

> I crossed the airport over twenty times, of which I was shot at seventeen times and hit seven times. Once I entered the threshold of the runway, I had to get onto the runway and drive two-thirds of the way down the runway and then towards the apron and to the terminal building. Dobrinja was in Bosnia government hands and shooting would start from there when the car was spotted and then I would be shot at from the Serb side, who would see me coming from 'Bosnian territory'. There were also an astonishing number of checkpoints to have to deal with, so just dealing with the logistics of getting our footage collected, edited and transmitted was a serious task.[101]

This arrangement continued throughout May and June 1992, with van Lynden taking the film to Kusovac on a daily basis, who would, in turn, collect the film and bring food for the Sky News team in Sarajevo because they had little access to food in the city.[102] At a later stage, they would move the satellite phone and two engineers into the city, so that they could broadcast from within siege lines, and when van Lynden reported from Sarajevo, he would continue to base himself and the Sky News in the military hospital. 'Being there had its advantages; we got on very well with the staff and it meant that we had access to the hospital and could report on the wounded being brought there and, of course, to report on the dreadful experiences of the people of Sarajevo.'[103] But while having their equipment in the city – and being able to broadcast from there – it also created logistical problems. 'If you have a satellite dish *in situ*', said van Lynden, 'you need dish engineers, a producer and a picture editor, and that means more equipment and more people to feed in a besieged city where food was becoming increasingly scarce.'[104] Regardless of these difficulties, however, the Sky News crew, from the top floor of the military hospital – they would later have to move down to the sixth floor after the top floor had been badly damaged by the impact of a tank grenade – were able to film the bombardments of the city though late May and early June 1992, as the Bosnian parliament building and the Unis towers were attacked, and they captured some of the most visceral images of the bombardment of Sarajevo.[105] The intensity of the shelling that the Sky News team filmed was such that Zoran Pajić – then a Professor of International Relations at the University of Sarajevo – in an interview for *The Guardian*, stated: 'We are not witnessing a battle. We are witnessing a one-sided attack on a city. There is no weaponry and there is no army to return the attack.'[106]

While the Sky News crew may have been the only foreign TV crew filming from within Sarajevo during that period of particularly heavy shelling, they were by no means the only foreign journalists in the city. Among those who had stayed in Sarajevo after the departure from the Hotel Bosna was John Fisher Burns of *The New York Times*. An experienced foreign correspondent, he was something of an anomaly in the US, being one of few leading foreign correspondents not from the United States. He had worked at the Canadian *Globe and Mail* before moving on to *The New York Times* in 1975. In the 1980s he had been the paper's bureau chief in both Moscow and Beijing – he was, in the latter, arrested and accused of espionage, and although charges were dropped, he was subsequently expelled from China. In the midst of a meteoric rise, however, he was, in 1990, diagnosed with cancer while in the UK. Having exhausted the available treatment in the UK, he was, he said, 'resigned to placing a deck chair in the garden and enjoying whatever time was left to me, with my children and reading a good book'.[107] He was, however, persuaded by friends to return to the US to receive treatment, whereupon he underwent intensive chemotherapy at the Sloan-Kettering Memorial Hospital in New York. Following this treatment, he 'could barely walk from one side of the room to the other', sensed that the treatment had been unsuccessful, and held no expectation that he would be returning to work. However, his editor at *The New York Times* offered Burns a posting in the Balkans, one he felt he had to take – the paper had, he said 'looked after me and my family, so I felt an obligation'.[108] He left New York to travel to London and upon arrival felt so unwell that he could go no further, though he pressed on to Belgrade. Two days later he went to Vukovar, where he witnessed the aftermath of the fall of the town – somewhat surprisingly, he started to feel rejuvenated. 'It may seem odd to say so', said Burns, 'but the former Yugoslavia, and particularly Sarajevo, was my recovery ward.'[109]

After covering the latter stages of the war in Croatia, Burns moved between Belgrade and, later, to Sarajevo where he covered the early days of the siege. He, too, had relocated to Ilidža in early May 1992, but had decided – against the wishes of his employers – not to join the convoy to Split but to remain in Ilidža with Andrew Reid, a young photojournalist from New Zealand. Having spent several days in the 'deserted' Hotel Bosna, the pair decided to attempt to re-enter the centre of Sarajevo. Burns knew this was defying the request to leave the city from his superiors in New York, but, he said,

> It was a Friday and I knew most of my editors at the *New York Times* would have been away for the weekend, so if I could get in and out quick, they would not have known what was going on – and if I *could* get in, get the story and get it on the front page of the paper, there would be no arguing over whether I had done the right thing.[110]

But the journey back into the city was, according to Burns, fraught with danger:[111]

> We decided to fill our vehicle with as much food as we could muster before attempting to re-enter Sarajevo. We made a dash for the city centre and it was the

most horrendous passage. On the first night my car, a hire car, was literally split in two by mortar fire, so the 'return option' was well and truly gone. I spent the next few weeks in the city, covering the story and attempting to get my stories out, often using the most rudimentary methods.[112]

Continuing to reject requests from his superiors to leave Sarajevo, Burns found accommodation first with a family who lived in the Old Town and then in the Presidency building, from where he would file his stories back to New York. He also slept in the office of Jovan Divjak – the then Deputy Commander of the Bosnian TO – before moving to the reopened Holiday Inn in July 1992. He quickly established himself as a key figure among the press corps and would go on to write numerous memorable despatches from Sarajevo. Foremost among them was the story of Vedran Smajlović, the 'Cellist of Sarajevo'. It was, however, the photographer Andrew Reid who introduced him to Smajlović. According to Reid:

> I was standing near the site of the breadline massacre when a bearded fellow wearing 'tails' strolled up to me and began explaining to me that he was a cellist with the Sarajevo Philharmonic Orchestra and that he would be playing Albinoni's *Adagio in G Minor* every day for a month, in the open and at the sight of the massacre, as a tribute to the victims. His name was Vedran Smajlović. I proceeded to sit in the cellar of the Ragusa restaurant, one of the few that was still open in Sarajevo, drinking red wine with Vedran long into the night. We both periodically went outside where he would again play – my own private concert. I later bumped into John Burns and told him the story, because I knew Vedran's story would resonate with readers of his newspaper.[113]

And, indeed, it did. Burns wrote a piece in *The New York Times* for which he was awarded, in 1993, the Pulitzer Prize – he would subsequently win another Pulitzer for his coverage of the rise of the Taliban in Afghanistan in 1997. He credited the Nomad transmitter with facilitating his reporting from the city and thus winning his first Pulitzer.[114]

During May and early June 1992, it was the Sky News TV crew that capitalized on the absence of other foreign TV crews. Their decision, to report from Sarajevo driving daily, or almost daily, from Pale and base themselves in Sarajevo's military hospital meant that they garnered exclusive pictures of the bombardment of the city – which was particularly intense after the departure of the last JNA troops from the Marshal Tito barracks in early June 1992. Such exclusives jarred with those who had chosen to leave Sarajevo in mid-May 1992. 'TV news is a competitive business', noted the BBC's Martin Bell, so 'someone had to find a way back in and end the Sky News monopoly'.[115] Thus, in mid-June 1992, Bell's crew took the risk of crossing the no-man's land of Sarajevo's airport runway in a 'battered old BBC Vauxhall Carlton' – a journey that had been made daily by Zoran Kusovac for the Sky News team.[116] Bell was accompanied by his new cameraman, Nigel Bateson and his translator and fixer, Vladmir Marjanović – the latter being sent back to Pale because he was 'unwelcome' in Bosnian government-held Sarajevo.[117]

The Early Months of the Siege 51

Figure 2.4 Cameraman Nigel Bateson films from the BBC's Vauxhall Carlton, Dobrinja, July 1992 (Paul Lowe/VII).

Crossing the airport runway from Bosnian Serb-held to Bosnian government-held territory was the most dangerous part of the journey, as they could easily be caught in the crossfire. As a precaution, such as it was, they kept the windows of their car rolled down because, as Bell explained, 'a bullet hitting you may produce a cleaner wound, it might pass straight through you; a car window being hit will shatter and puncture you with shards of glass producing, potentially, a much more dangerous wound'.[118] The BBC team travelled relatively light – with no editing equipment; only Bateson's camera equipment, the soundman's equipment and a satellite phone.[119] They were permitted by UNPROFOR to place their satellite dish in an annex of the PTT building, from where they could their send reports.

A number of other journalists had attempted to re-enter Sarajevo in early June 1992, though conditions on the ground were hardly conducive to doing so easily; it was a febrile and dangerous environment for journalists to attempt to work in.[120] UNPROFOR had, however, just reached an agreement – on 31 May 1992 – that allowed them to take control of Sarajevo Airport, following the UN Security Council Resolution 757 which declared that 'All parties and others concerned create immediately the necessary conditions for unimpeded delivery of humanitarian assistance' to Sarajevo and other destinations in Bosnia – the resolution simultaneously imposed economic sanctions on the Federal Republic of Yugoslavia. General Lewis MacKenzie was despatched from Belgrade to Sarajevo with a small group of Canadian and French UNPROFOR troops to begin the process of administering the airport – which would not formally be handed over to UNPROFOR until 29 June 1992, the day after the surprise visit to Sarajevo by the French President, François Mitterrand.

On 11 June 1992, the BBC Radio correspondent Allan Little, Phil Davison of *The Independent* and John Holland from CBS, had driven down from Belgrade to Sarajevo, taking an astonishing five days to reach the Bosnian capital. It was not Little's first visit to the city. He had travelled to Sarajevo in 1979 as a nineteen-year-old student attending the University of Edinburgh, fascinated by Yugoslavia which, he said, 'seemed like a different kind of country'.[121] By June 1992, the placid capital of Bosnia and Herzegovina that he experienced some thirteen years before had been transformed. Upon his arrival in Lukavica, on the fringes of the city, they were met by what he described as 'a mix of rather unruly, freelance paramilitary formations and some professional JNA soldiers, and you could see the tension between the two groups'.[122] They were told to return to Pale for the night and come back the following morning to a specific address and from there they would be given instructions as to how to enter Sarajevo. Early the next morning, they went to the address in Lukavica and were offered coffee and a glass of Johnnie Walker 'Black Label' whisky, which Little and Davison accepted but Holland did not. They were told that they had to drive fast across the airport runway towards the terminal building and if they reached there they would probably get to the city. The danger of doing so, however, was evident, and Holland decided the risk was too great. Little and Davison decided the risk was one worth taking. According to Little:

> We knew it would be a white-knuckle ride, so we waited and waited until we plucked up the courage to do it. Just then, however, a small convoy of UN *panhards* [small armoured vehicles] appeared and we decided to tuck in behind them and make a dash for the terminal building. Once there, we saw another convoy of Canadian UN vehicles and we followed them into the city. But the drama wasn't over. We got stuck on the flyover west of the city when one of the vehicles in front of us was hit. There we were, stuck in one of the most exposed parts of the city in our soft-skin car rented from Hertz car rentals in Budapest with gunfire and mortar fire all around us.[123]

They reached the PTT building and set about finding accommodation within the city. Through Jon Jones, a photographer on assignment for *The Independent* who was already in the city, they made arrangements to stay at the nearby Delegates Club in Ciglane, a one-time meeting place for Bosnia's communist elite. Martin Bell and his crew, who arrived just after Little, set up their operations in a private flat in Koševsko Brdo. The Delegates Club could not provide the service it had done when it had been used by senior UNPROFOR staff prior their departure in May 1992, but had, according to Little, one great benefit – the phone lines were still operational.[124] 'We discovered that they worked so, as a radio reporter, I could file from there – though the phone lines were not always reliable; when they were not functioning, I used the office space that had been rented by Associated Press (AP) where I could use their satellite phone.'[125] However, rumours were abundant among the journalists already in the city that the Holiday Inn had reopened, but, according to Allan Little, this was viewed with some scepticism. Its location, he said,

> Made it so exposed, so risky. I didn't like the idea of operating from the Holiday Inn for the simple reason that it seemed too exposed and that, therefore, you couldn't really walk out of the building – you had to drive in and out in, if you were lucky, your armoured car – although in June 1992 none of us had those.[126]

As more foreign journalists began to return to the city from early June, a number were killed or wounded.[127] On 10 June 1992, a car carrying Alfonso Rojo from the Spanish daily *El Mundo* and George Gobet from AFP came under heavy fire and both were injured.[128] Less than a week later, on 16 June 1992, Ivo Štandeker, a correspondent for the Slovenian weekly *Mladina* died from injuries sustained during the shelling of Dobrinja, while his colleague Jana Schneider, who worked for the SIPA agency, was wounded in the same attack.[129] As they were being transferred to Koševo Hospital, the ambulance they were travelling in was stopped by Bosnian Serb paramilitaries. After a lengthy delay and the intervention of UNPROFOR troops, the pair were transferred to a hospital in Pale, where Štandeker passed away from his injuries.[130] On 30 June 1992, the *Liberation* journalist Jean Hatzfeld and the photographer Kevin Weaver, who was then working as a freelancer for *The Guardian*, came under fire near Sarajevo Airport, on the road described by the *RTL* and *Le Monde* correspondent Remy Ourdan as 'the most dangerous for journalists'.[131] Hatzfeld was seriously injured in the attack and, with his shin bone shattered by bullets, he subsequently had his leg amputated as a result of his injuries.[132]

Weaver, a young photojournalist based in London, who had previously covered the revolutions in Czechoslovakia and Romania and the first multi-party elections in Bulgaria, arrived in Sarajevo in early June 1992, having driven through Europe down to Zadar and then Split in Croatia. For the majority of his journey from Split to Sarajevo he was accompanied by a Spanish radio journalist, Xavier Espanoza but having reached the outskirts of Sarajevo, the latter decided that he did not wish to take his car into the city. So, they decided to hitch-hike into the city which, he acknowledged, 'was, in hindsight, a pretty stupid thing to do'.[133] Weaver and Esponoza were picked up by another journalist with whom he drove into the city. 'It was quite a disturbing scene – we didn't really know where we were going, and besides a few landmarks in the city, didn't really know how to navigate our way through it; when we reached the centre of the city it was completely deserted.'[134] Weaver eventually found a place to sleep at the Delegate's Club but had to leave after two days – as senior UNPROFOR officials returned. He subsequently found a room at the Hotel Beograd on Kulovića street, where a small group of journalists had gathered, among them a journalist from the French daily *Libération*, Jean Hatzfeld – who had been in the city since mid-April 1992.[135] The hotel had already been damaged by shell fire and was home to tens of refugees; thus, the journalists who stayed there had to populate the damaged upper floors. The hotel was relatively obscured by adjacent high-rise buildings but from the balcony the journalists there had a clear view of the Bosnian Serb positions on Mount Trebević. From his base in the hotel, Weaver attempted to get out and familiarize himself with the city and the dynamics of the siege; it was not easy. 'I didn't know the city well', said Weaver, 'and was learning on the job; I didn't even know the sound of mortar fire, such was my level of ignorance at that time, and, of course, I had no insurance and no flak jacket.'[136]

On 30 June 1992, the day after the UN reopened Sarajevo Airport, Weaver and Jean Hatzfeld, decided to go the airport to report on the UNPROFOR operations there. They needed permission from the UN to go there, so they went to the PTT building but did not succeed in acquiring that permission. They decided to go nevertheless and headed towards the airport. It was a huge risk. Just after the final Bosnian government checkpoint just beyond Nedžarići their car was peppered with gunfire. As Weaver recalled:

We must have been doing about 80 miles an hour when I heard the first burst of gunfire. Jean screamed, we started slowing down and he said that he could not make the car go any faster. His leg, which had been on the accelerator, was clearly damaged – it had been shattered by two bullets – so we pulled-up. Under intense fire, I curled up and could see the blood coming from Jean's leg. I waited until the firing stopped – which seemed to take forever – and I ran around the front of the car and tried to pull Jean out. I could see his leg was very badly injured. I carried him into a ditch and laid him down and started shouting – I didn't know much of the local language except *Ne pucaj! Engleski novinar!* (Don't shoot! English journalist!) but the bullets stopped and then a guy appeared, looking very frightened and carrying a Kalashnikov. I thought he was going to shoot but he didn't. He and a few other soldiers eventually arranged for our transit to Koševo Hospital.[137]

It wasn't until a few minutes later that Weaver realized that he himself had been shot. 'I knew I had been hit', he said, 'but my focus was on Jean and getting him to safety and my adrenaline was going through the roof.' Weaver had his wound looked at by a female Bosnian soldier who told him that the bullet – in the upper thigh/lower buttock – had entered and exited his body, so after making sure Hatzfeld was safely at the hospital the returned to the Hotel Beograd. 'I woke up the next morning and was paralyzed', he said. 'I didn't know it at the time, but the bullet had actually been lodged in my leg.' Remarkably, he then *walked* to the Hotel Belvedere where he met the photojournalist Jon Jones, who took him to the hospital where a nurse explained to him that, contrary to what he had been told, the bullet had entered his body and travelled up his thigh, wedging itself just two inches from the base of his spine. The bullet was therefore removed without anaesthetic – Weaver was given only whisky to dull the pain – before a few days of rest before he was 'medevaced' out of Sarajevo.[138] The experience had been a traumatic one for both Hatzfeld and Weaver, though both would return to Bosnia and Herzegovina, and Sarajevo, to report on the war.

The early months of the siege were, in many respects, the most dangerous for foreign journalists working in Sarajevo. The risks were such that many of the journalists were relatively limited in their ability to travel within the city. Martin Bell, for example, acknowledged that 'for weeks at a time, during the years of working from Sarajevo, we would venture no further than the airport in one direction and the Presidency in the other' and that 'our measure of Bosnia was approximately the length of a single street in its capital'.[139] Few dared to tread much beyond this well-beaten path – the airport, the TV building, the Holiday Inn – when it reopened – and the Presidency. Sarajevo, in the early months of the siege, was difficult to cover and journalists were limited in what they could report. However, the operations of journalists quickly became better organized and a reporting infrastructure began to emerge, one that would significantly change the daily routines of journalists. But the dangers of reporting from the city were such that regardless of an emerging infrastructure, journalists remained very exposed. As the injuries to them increased, so too did the need to increase their level of protection.

3

The emergence of a reporting infrastructure

The infrastructure of the siege that would evolve and crystallize throughout the summer and autumn of 1992 was gradually emerging by the beginning of July 1992, by which time the Bosnian government had declared, somewhat belatedly, that a state of war existed.[1] With the reopening of Sarajevo Airport at the end of June 1992, journalists could now access the city more easily – no longer was it necessary to drive from Belgrade, Zagreb or Split, they could, once they were in possession of a UN press pass, fly into Sarajevo Airport.[2] However, these flights could sometimes be suspended if there was fighting near the airport and thus the routes, by car, into the city either via Kiseljak though Ilidža and into the city, or from Pale through Lukavica, would have to be used. Once through the hazardous peripheral roads and beyond the numerous checkpoints – some of which were relatively makeshift, others more robust and protected by tank traps – so-called 'Czech hedgehogs' – they could navigate towards the key buildings in the city that had become important nodes in this infrastructure.[3] With the establishment of both the European Broadcasting Union (EBU) transmission point in the TV station building and the UNPROFOR headquarters at the PTT Engineering building – both in Alipašino polje – the reopening of the Holiday Inn hotel made it – with a few notable exceptions – the home for many foreign correspondents and TV crews. The Presidency building, the morgue and both of the city's main hospitals – *Vojna bolnica* (military hospital) in Marindvor and the Koševo Hospital in Koševsko brdo – also became part of what became part of well-established 'rat runs' through the city.[4] Marcus Tanner of *The Independent* had left Sarajevo in April 1992 and was not able to return to the city until late July 1992; upon his return, the city and the emerging infrastructure had transformed the way that journalists functioned:

> The airport opened for UN flights and, from then on, journalists could fly in to the airport on a UN plane and then get into the city on an UN APC. The whole situation rapidly stabilised. You flew in, checked in at the Holiday Inn, went to the UN building for press briefings every morning, occasional briefings at the Presidency building and, if need be, to the EBU transmission point at the TV station. As a consequence, our reporting changed. There was no longer much to say militarily, so it all became a business of finding new angles about 'life under siege' – hospital shortages, kids killed while out playing, the myriad ways that people developed to survive, and so on.[5]

When the French President, François Mitterrand, paid a highly symbolic visit to Sarajevo on 28 June 1992, during which he met with the General Lewis MacKenzie and Alija Izetbegović, he made it clear that the opening of the city's airport was of paramount importance.[6] His visit to Sarajevo was covered by a growing number of foreign journalists. Zrinka Bralo, who had recently begun working for the EBU at the TV station recalled that after his meetings Mitterrand came to the TV station with MacKenzie to make a direct call, using the EBU uplink, to the *France 1* TV channel. It was an operation that demonstrated that the EBU infrastructure was working effectively. After his departure, local staff from WTN and Visnews various continued, through the night, to send their reports to agencies that did not have correspondents in Sarajevo.[7]

Within a number of days, the airport was indeed reopened. The airport was secured by Canadian UNPROFOR troops on 1 July 1992 and they proceeded to open the 'air bridge' that allowed aid to be flown into Sarajevo. This, while ostensibly feeding the citizens of besieged Sarajevo, created, according to Peter Andreas, a situation that led to a prolongation of the siege. The opening of the airport and the functioning of the airlift meant that, 'Western powers immediately stopped insisting on a cease-fire and the withdrawal of heavy weapons around the city. The airlift made the siege locally manageable and therefore internationally palatable.'[8] From the beginning of July 1992, many of the foreign correspondents who arrived in the city did so via UN aid flights, normally from Zagreb (Croatia), Ancona (Italy) or Split (Croatia), which became known as 'Maybe Airlines'. The UN press accreditation that was required to travel on these flights was provided in advance and was not, in itself, terribly difficult to

Figure 3.1 François Mitterrand and General Lewis MacKenzie at the PTT building during the French President's visit to Sarajevo on 28 June 1992 (courtesy of Kevin Weaver).

The Emergence of a Reporting Infrastructure 57

Figure 3.2 A Hercules C-130 on the tarmac at Sarajevo Airport (courtesy of Kevin Weaver).

acquire, as Cees van der Laan, a correspondent for the Dutch newspaper *De Telegraaf* recalled: 'I bought a ticket from Amsterdam to Zagreb and then went straight to the UNPROFOR office. I received the press accreditation the same day and got a place on a UN flight from Zagreb to Sarajevo the next day – it was as easy as that!'[9]

Upon arrival, normally on a Hercules C-130 – known to the British RAF crews, who were among those that flew them, as 'Fat Alberts' – that had performed the so-called 'Khe Sanh landing', the UN provided some sage advice for journalists arriving there for the first time.[10] In a UN document, circulated to journalists and written by Fred Eckhard – a UNPROFOR spokesman – they were cautioned about travel, accommodation and food. In terms of travel, the document stated that:

> UNPROFOR has strict regulation prohibiting transport of non-UN personnel in UN vehicles. Therefore, journalists must make whatever arrangements they can with colleagues in the media who have their own transportation. Please be advised that at a Serbian checkpoint between the airport and the city passage is frequently denied to journalists who do not have accreditation issued by the SDS. Please ask your colleagues in the media about their experiences in how best to obtain this accreditation.[11]

The UN also cautioned foreign journalists that there was a distinct shortage of food in the city and that accommodation was scarce and that 'Given the large number of journalists currently in Sarajevo, UNPROFOR is not in a position to provide, even on a temporary basis, food and lodging to visiting journalists. Similarly, those unable to

leave the airport for the city cannot expect assistance with food or accommodation at the airport.'[12] The document ended by stating that journalists were advised to return on the earliest outgoing flight if they were unable to solve these practical problems upon their arrival.[13] Upon his own arrival in Sarajevo, Cees van der Laan received something of a shock. 'You could feel the tension the second you departed the plane', he said. 'Psychologically, it is a bit shock and you have to adapt quickly. The first thing that grips you is fear, not a normal fear – fear of flying, for example – but an existential fear.'[14] Thereafter, the 'airport road' had to be taken to reach Sarajevo.

The death of David Kaplan

After UNPROFOR had taken control of Sarajevo Airport, most journalists flew into the city and then drove from there to the PTT building, the TV Station or the Holiday Inn. ITN's Michael Nicholson noted that 'was only about two miles but as every reporter or cameramen who has travelled them will agree' those miles were 'the longest and most dangerous miles anywhere in the world'.[15] Indeed, the relatively short journey from the airport to the hotel was known to journalists as 'one of the best laxatives known to mankind'.[16] This involved a nerve-shredding dash through the airport road and then into the city and down *Vojvode Putnika* – now *Zmaja od Bosne* (Dragon of Bosnia street – Sniper Alley) – which was the main artery into the city.[17] As Joel Brand, writing in a piece for *Rolling Stone* noted, 'Strictly speaking, it is called Branko Bujić alley. But to journalists it is known as the airport road. Really, it is the road to hell.'[18] Indeed, the entire route from the airport to the Holiday Inn was exceptionally hazardous, and numerous journalists were either killed,[19] – such as the American Broadcasting Company (ABC) senior news producer David Kaplan who, while accompanying the Yugoslav Prime Minister, Milan Panić, was fatally wounded by a sniper's bullet on 13 August 1992, minutes after arriving in Sarajevo – or seriously injured, such as the CNN camerawoman Margaret Moth, who was seriously injured (shot through the jaw) near the *Oslobođenje* building in the Nedžarići section of 'Sniper Alley' on 23 July 1992.[20] Moth, who had been in Sarajevo since early June 1992, had been sitting in the back of a 'soft-skin' van clearly marked 'TV' when it was attacked.[21] She and her colleague Mark Dulmage – who was CNN Bureau Chief in Rome – were sitting in the back of the vehicle and took the brunt, with Moth being shot through the jaw and Dulmage suffering arm and facial wounds.[22] Another CNN correspondent, Stefan Kotsonis, was in the front of the van and was unhurt. It was the latter who helped take her, with the help of Bosnian militia, to Koševo Hospital, where doctors there did what they could to save her. Moth's injuries were extremely serious and though she survived, she required extensive facial reconstruction surgery. Speaking before her death in March 2010, she said:

> We had gone along that road many, many times before and we did get shot at other times but not right at this point [next to the *Oslobođenje* building]. Someone shot three rounds into the van; I didn't hear them because I guess I got hit by the first

one ... I don't remember the actual shot but it must have knocked me onto Mark. He was sitting next to me and I just remember, maybe a second, [that aside] I don't remember anything.[23]

Thus, CNN personnel were more than aware of the dangers of travelling around Sarajevo in non-armoured vehicles. Very few journalists had access to armoured cars at this point, unless they were taken from the airport to the PTT building in a UNPROFOR APC. When the ABC team arrived in Sarajevo, Sam Donaldson and Milan Panić were put into the APC, which had limited space, while David Kaplan – who had left his flak jacket on the plane – got into a blue Volkswagen Transporter van that belonged to TVSA with ABC's David Sherwood. In his memoir, Milan Panić recalled that while on the flight to Sarajevo he had been informed that he should wear a flak jacket because they had received information that he may be subject to an assassination attempt. He refused to do so and, according to Panić, Kaplan told him, 'If you're not wearing one, I'm not wearing one either.'[24] Thus, when they emerged from the plane onto the tarmac, Kaplan was not wearing a flak jacket. However, according to Sam Donaldson, 'The driver [of the van] took off his own flak jacket and offered it to David Kaplan. David refused.'[25] Doing so would cost him his life. The CNN cameraman David Rust also arrived in the city with Christiane Amanpour on 23 July to replace the CNN crew that had been working with Margaret Moth when she had been shot. For the CNN crew, this was a particularly relevant story – the new prime minister of the newly promulgated 'Federal Republic of Yugoslavia' was a Serbian-American, Milan Panić, who owned a successful pharmaceutical company, ICN Pharmaceuticals. This was, according to Christian Amanpour, 'an important story for us because Panić was an American, so it was a very effective way for audiences in the US to connect the dots; there was real interest in the story.'[26] Amanpour's cameraman, David Rust, recalled the events that led to Kaplan's death:

> When we arrived at the airport, we saw a crew from ABC arrive with their reporter, Sam Donaldson and producer David Kaplan, who were both travelling into the centre of Sarajevo with the Yugoslav Prime Minister, Milan Panić. Christiane greeted them both just before they departed. Donaldson and Panić drove in an armoured UN vehicle followed a few minutes by Kaplan, who had hitched a ride with another TV crew in an unarmoured van. Just after leaving the airport, the van was hit by sniper fire. The bullet entered rear of the van right between the letters 'TV' that were written prominently on the back of the vehicle and continued to travel through the van, entering Kaplan from his back and exiting from his chest. The wound was massive and he died within minutes.[27]

The vehicle that Kaplan was travelling in would never reach Sniper's Alley, where Moth had been shot. The fact that the van in which Kaplan was driving had 'TV' clearly marked in large letters on it made no difference. The TVSA vans were, according to Eddie Maalouf, an EBU satellite engineer who had arrived in Sarajevo at the same time as the ABC crew, usually 'bore no identification markers' but were 'well known around Sarajevo and were often targeted'.[28] Just after the departure from the airport a single

shot was fired at the vehicle carrying Kaplan. Details surrounding precisely who fired the shot remain sketchy; Sam Donaldson, however, stated that he believed the shot had been fired from Bosnian government/ARBiH positions.[29] Kaplan was rushed to a UN triage centre – staffed by French doctors – which was located in the PTT building, but died from heart failure due to heavy blood loss. Milan Panić later acknowledged that when he learnt of Kaplan's death he 'could not help but feel personally responsible'.[30]

In the minutes leading up to and immediately after Kaplans's death, the atmosphere in the environs of the airport was febrile, with the sound of sniper fire peppering the air. The EBU crew, which included Pierre Peyrot, Eddie Maalouf and two satellite engineers, were aware that the area they had to navigate between the airport and the TV station was treacherous, they opted to leave ahead of the UN-led convoy – of which the van carrying Kaplan was part. They, too, drove in a non-armoured TVSA van, though they felt confident that they could make the journey without difficulty; after all, the EBU had, said Pierre Peyrot, 'had already been set up in the TV station and we had our own fixers and drivers' and the route was well known to them.[31] As they pulled away from the airport towards the city, the van approached a truck that had been parked partially blocking the route to Ilidža – which they did not intend to take – but protruding out into the main road. There was, said Maalouf, 'something odd about the truck's position – and that caught my attention.' As the van passed the truck a Bosnian Serb 'militiaman' appeared from behind the truck and fired a single shot at the van. According to Maalouf:

> Instinctively and without hesitation our driver released the gas and slammed on the brakes, bringing the van to a complete halt. This single action turned out to be the most excellent and wise decision he could have made. It most likely stopped the young Serb from firing additional bullets. The driver then shifted into reverse and backed-up to the militiaman's position. By the time he [the driver] had shut the engine down, the militiaman and his colleagues had surrounded us and had started to wave their guns and shout obscenities at the driver. They were unhappy that we had driven through their makeshift checkpoint, a sign of disrespect on our part. They could have easily fired their guns into the van killing all of us.[32]

The EBU crew and their driver were then instructed to follow a red Yugo car that took them to Ilidža police station. En route, they were stopped by two APCs. A tense stand-off ensued while the soldiers who emerged from the APC demanded their identification papers. Some of the soldiers were, according to Maalouf, 'Serb irregulars' who were dressed in the 'Chetnik style'; among the group was one individual, who seem to have some authority, who was particularly 'agitated, careless and undisciplined'.[33] After attempting to ease the tension, Maalouf attempted to make conversation and distribute his supply of cigarettes as a way of engaging the soldiers. The situation soon calmed and the EBU crew had their documents returned and were permitted to leave. The Yugo car then provided an escort back to the main airport road. The EBU's driver was warned never to pass a checkpoint without stopping.[34] It was a lesson Maalouf subsequently heeded. 'Over the course of the next three years, he said, 'we listened and always stopped at checkpoints.'[35] On their eventual arrival at the TV station, the

EBU crew learned, from Anna Erickson – who had replaced Myriam Schmaus – of the death of David Kaplan. His death, said, Maalouf, 'caused most, if not all, international press organizations to purchase and deploy armoured vehicles in the city'.[36]

Pazi snajper!

Citizens of Sarajevo were exposed to sniper fire on a daily basis and could 'at any moment have been hit by a bullet from an unseen killer, in a situation that had become a way of life'.[37] Signs warning citizens *Pazi snajper!* (Beware Sniper!) began to appear at every intersection and many street crossings, the most dangerous of which were the streets in immediate proximity to the Holiday Inn – in particular *Trščanska ulica* (Trieste Street), where the greatest number of Sarajevans were hit by sniper fire – and the intersection near the Ali Pasha mosque near Skenderija – usually referred to as *kod Higijenskog*.[38]

Sniper fire also represented a significant risk for journalists operating within the city, particularly if they were on foot. And it was the cold, calculated nature of sniper fire, rather than the more random nature of mortars, tank shells or artillery shells that made the snipers so feared. Peter Maass of the *Washington Post* recalled that he:

> Hated the snipers more than anything else. First you heard the crack of their shots, then the whistle of the bullet, then the echo of the crack and then silence. Everything happened in a millisecond. Crack, whistle, echo, silence. The sound was uniquely chilling, in a way that made it feel more menacing than a mortar

Figure 3.3 Citizens of Sarajevo prepare to cross an intersection, July 1992 (Paul Lowe/VII).

blast or the rat-tat-tat of a machine gun. A sniper shoots one bullet at a time, a bullet that stands out as distinctly as a single, piercing note from an opera diva overpowering her chorus. You hear that lone shot and you know, instinctively, that the bullet is aimed at somebody, perhaps you, and this is quite different from mortars fired, as many were around Sarajevo, without any particular target in mind. It is the sound of a professional assassin.[39]

Being in a form of automated transport was no less dangerous. On their daily journeys from the Holiday Inn to the PTT building, the TV station or the airport, journalists would have to tackle 'Sniper Alley', which began in Nedžarići and stretched all the way to the Holiday Inn in the Marindvor district. It was a relatively wide street with three lanes of traffic on each side with a middle section for the tram system and was extremely exposed and vulnerable to sniper and small arms fire from the high-rise buildings, and from mortar fire from the surrounding mountains. As Marcus Tanner observed, 'while the narrow streets of the old part of the city afforded some protection from sniper fire, the most dangerous areas were wide and laid out in a rectangular grid pattern, which made it easy for the VRS stationed up in the hills to see what was going on, and to target people', adding that 'on the wide communist-era boulevards to the west of the city, you were a sitting duck for those targeting the city from the hills above'.[40] The entire route was extremely hazardous but there were particularly dangerous intersections and exposed areas near the TV station, the *Elektroprivreda* building – near Grbavica – and in Marindvor, where the Holiday Inn was located. This drive was, according to AP's Tony Smith 'the most-fear-inducing because, particularly in the early days of the siege, you were acutely aware that you could be hit at any minute – it was down hard on the accelerator, push back into the driver's seat and try to hide behind the car's B-pillar'.[41] On occasion, journalists driving from the airport to the PTT building would receive a UNPROFOR escort, but on their arrival they would be, in the main, on their own. Hugh Pain, the experienced Reuters correspondent described vividly his first foray on to this dangerous thoroughfare in December of 1992:[42]

> To this day, whenever I think of Sniper Alley, there is always in my mind's eye the body of a young woman, hands still clutching her shopping bags, hair whitened by the morning frost, and the long trail of her blood across the road. A gun shooting in your direction sounds sharper than one pointing away. A crack rather than a bang. So, even without seeing the bullets landing, I knew that a machine-gun that had opened up nearby was telling me something, if only to go away. Wild animals in the face of death seem to achieve a kind of calm. Well, it wasn't like that. In sheer gut-wrenching panic, with no protection at all in what the military calls a soft-skinned vehicle – like its occupant – and knowing that the unseen gun could rake my car whenever it chose, I slammed into gear and careered on into the town.[43]

So, once on Sniper Alley, it was a case of driving extremely fast and hoping for the best. John Sweeney, then working for *The Observer*, described the dangers of driving along this road and what could potentially go awry:

Askold Krushelnycky (from *The European* newspaper) and I were driving towards Holiday Inn in a very old BMW – a 'soft-skin' of course. On the way there I realised he didn't know the way. We had missed the turn off and we were driving straight along Sniper Alley. I told him to turn as soon as he could, and he moved to take next left, lest we be exposed for too long. But in full view of the Serb snipers the car stalled. As he tried desperately to start the engine, I sat there for what seemed like a long time waiting for the bullets to hit the car. Needless to say, we felt very, very relieved to reach the Holiday Inn.[44]

Safe arrival at the Holiday Inn was best ensured by driving extremely rapidly toward it and then entering the basement car park of the hotel at breakneck speed or, if on foot, at the rear of the hotel – its northern side.[45] The area around the hotel – so-called *Snajperska raskršća* (Sniper's Crossroads) – was one of the most dangerous intersections in Sarajevo and had to be tackled at speed. CNN's David Rust recalled his first approach to the Holiday Inn in August 1992:

> As we approached the hotel, there was an open area where the van was, once again, exposed to sniper fire. Our local staff advised us to cover up and get as low down in the vehicle as possible. When we were ready, the driver gunned the engine and we raced across the open area (approximately 200 yards) and headed for the hotel's underground parking.[46]

Similarly, in a column for *The New York Times*, John F. Burns noted that 'drivers must gun their vehicles, tires squealing to get down the ramp into the garage before the snipers can fire'. If returning to the hotel car park after nightfall, drivers had to ensure that their headlights were turned off, lest they give snipers a clear indication of one's location.[47] Dina Neretljak experienced the drive from the Holiday Inn to the PTT building on the first day of her work, as a translator, with AFP. She was surprised to see that the car was not only a soft-skin but that the windows were open:

> We were driving towards the PTT building extremely fast. The car offered no protection because it was a so-called 'soft-skin' and the windows were wide open. When I tentatively enquired about this, I was told by one of the French journalists, who was an 'old hand' who had reported from Beirut, that you always leave the windows rolled down because should you be hit it could be the glass that kills you and that you should never lock the door in case you needed to escape from the vehicle. In the main, these were rented cars anyway, so the people driving them didn't care what happened to the car.[48]

Therefore, accidents were, according to Joel Brand, 'the norm in such circumstances, particularly as the winter set in and the driver had to deal with the snow and ice'.[49] Colin Smith of *The Observer* noted that 'more journalists were injured by accidents caused by driving too fast or erratically than being shot by snipers; we were driving very quickly and accidents were somewhat inevitable'.[50] This was, of course, evidenced by the condition of the cars in the basement garage. There, according to John F. Burns,

Figure 3.4 'Welcome to Hell' graffiti on Sniper Alley, July 1992 (Paul Lowe/VII).

'cars that have endured a few weeks of the siege look like wrecks from a stock-car race, riddled with bullet holes, their windshields and side windows shattered'.[51]

Driving down Sniper Alley was certainly hazardous; walking was even more so. On his first trip to Sarajevo in December 1992, the BBC's John Simpson decided that he would walk from the TV station to the Holiday Inn. After all, he said, 'I had taken long walks after dark in Tehran, Baghdad and other weird places ... Why not Sarajevo as well?' Though colleagues at the TV station tried to convince him otherwise, he reasoned that it was 1.00 am; surely 'the snipers would be safely in their beds'.[52] At the first crossing he came to, he heard a bullet hit the building behind him. 'I immediately threw myself on the ground and stayed there for a good five minutes', he said, 'but then decided to get up and move around a bit – well, I heard another bullet smack into the wall behind me.'[53] Simpson then waited another ten minutes before attempting to move again, and when he did the sniper again fired a bullet, though this time a metre or so above his head. 'I realised he was probably just playing with me, so I just waved into the darkness and walked on; there were no more shots.'[54]

The Holiday Inn

Despite the aforementioned reservations about the Holiday Inn's exposed location, it soon became the main centre for foreign correspondents in Sarajevo and would thus attain the dubious reputation of a 'war hotel', as so many had been labelled in previous conflicts such as the Continental Palace in Saigon (Ho Chi Minh City), the Commodore in Beirut, the Ledra Palace in Nicosia and the Hotel Europa in Belfast, the

last having the even more dubious honour of being 'Europe's most bombed hotel'. The reopening of the Holiday Inn did mean, however, that journalists who had hitherto been scattered across different parts of the city were now located in the same building – they could cooperate, share intelligence, knowledge and draw upon their collective experience of a city that many of them barely knew. Thus, the Holiday Inn became both 'accommodation and a social base'.[55] Moreover, according to Robert Donia, the continued functioning of the hotel throughout the subsequent three and a half years of the siege allowed for an 'army of privileged observers [to] get in and out of the city, stay in relative comfort in the Holiday Inn … ride in armoured vehicles along the city's most dangerous routes, and send dispatches to the outside world using the latest communications technology'.[56]

The Holiday Inn had closed after the dramatic events of 6 April 1992, the interior of the building badly damaged by the events of that day. In the immediate aftermath of those events, however, it wasn't evident that the Holiday Inn could realistically function as a working hotel. From an external perspective, the Holiday Inn's location dictated that it was situated in an area that was in the middle of an emerging frontline – though this was not wholly evident at this point – while the interior of the building, in particular the atrium and the ground floor windows, had been badly damaged by the storming of the building by MUP and the subsequent room-by-room searches – many of these rooms had been ransacked. In addition, looting continued on 7 and 8 April 1992 and, with the hotel essentially unstaffed and unprotected, everything from food and alcoholic beverages to computers and cutlery was taken by looters. Thus, following the events of 6 April 1992, it would take a significant clean-up operation before the building could revert to its normal function.[57] The Holiday Inn's exterior had, however, escaped the worst of the intense bombardments of early May 1992, which saw some of Sarajevo's most notable buildings – the Vijećnica (which housed the National Library), the Oriental Institute, the Hotel Europa, the Olympic Museum and the Zetra Sports Hall, and the Unis towers – destroyed by artillery fire.[58] The Bosnian parliament was also hit on several occasions during this period, an attack that was filmed by the Sky News team from the upper floors of Sarajevo's military hospital.

During late April and early May 1992 the hotel's staff stayed away, though in the early weeks of the siege many people, remarkably, continued with their routines as best they could, often risking their lives to attend their jobs – though the work had all but stopped – and clinging to the hope that the war would be short-lived.[59] Tentatively, the remaining staff of the Holiday Inn, too, began to return with a view to reopening, though their numbers were depleted. Some of the previous members of staff – particularly those deemed to have been close to the SDS – including the hotel's manager, Danilo Dursun, departed Sarajevo in the wake of the MUP storming of the hotel on 6 April 1992; some to Serbia or Montenegro, others merely to Serb-held parts of Sarajevo.[60] When a small number of staff returned to clean and repair, they found the place pretty much as it was after the events of 6 April. After this process had been completed, the hotel could now be prepared for reopening. It was the hotel's former accounts manager, Željko Juričić, who persuaded those staff that remained in Sarajevo to return to the hotel to begin a clean-up operation with a view to opening its doors to the only prospective guests in the city – journalists.

The Holiday Inn would eventually reopen in June 1992, albeit under new management, a significantly reduced staff and an extremely difficult operational environment. The staff had remained 'employees' while the hotel had been closed during April, May and June and many had returned to work rather than be isolated in their homes.[61] Their first job was to repair the damage, as best they could before making the hotel habitable for the steady trickle of journalists that would come back to Sarajevo throughout June 1992 – a number which increased significantly after the reopening of Sarajevo Airport. However, running a hotel under such circumstances represented a considerable challenge. Milan Knežević, one of the deputy managers, said that the hotel had 'lost seventy five percent of its windows and only 100 of 330 rooms were now usable. Before the war started we had almost 500 staff. Now we make do with seventy.'[62]

The Holiday Inn was dangerously exposed to mortar and sniper fire, located as it was in a key strategic area that was coveted by the Serbs, who made no secret of their wish to divide Sarajevo in two parts, severing the link between the Ottoman and Austro-Hungarian parts of the city and the western suburbs.[63] The (SDS) leadership of the RS exerted pressure on the Bosnian government to accept the division of the city – during peace negotiations in Geneva in September 1992, Biljana Plavšić, Vice-President of the RS, stated that the Bosnian Serbs intended to take the entire city 'west of the Holiday Inn'.[64] While there is little evidence that the Bosnian Serbs aimed to conquer Sarajevo in its entirety, Karadžić openly declared that one of the Bosnian Serb's six core war aims was to divide Sarajevo into Serb and Muslim parts which would become the parallel 'capitals' of two new ethnically pure states.[65] A dividing line, similar to the so-called 'Green Lines' in Beirut (Lebanon) and Nicosia (Cyprus), was, seemingly, an acceptable solution for the Bosnian Serbs, as if Beirut and Nicosia were shining examples of how to settle such matters.[66] The SDS leadership proposed that Muslims and Croats be given the *čaršija*, the surrounding *mahalas* and part of the Austro-Hungarian section of the town, meaning that the 'Muslim/Croat part' of Sarajevo would include the Ottoman and Austro-Hungarian parts of the city that represented an 'ethnically impure' area – as it contained a mixture of different religious buildings – including the Serbian Orthodox Church.[67] The Serb section of a divided Sarajevo would, it was proposed, include those western parts of the city built mainly in the 1960s and 1970s - extending from the Holiday Inn all the way to Ilidža – and would represent an ethnically pure – Serb – zone, absent of so-called 'ethnic markers' of the eastern part of the city.

Thus, the location could not have been worse; being not only within siege lines but directly facing the frontline and within what became known as 'Sniper's Corner', the most dangerous part of *Aleja snajpera* (Sniper's Alley). It was surrounded by high ground controlled by the VRS and just across the Miljacka River from Grbavica and from the Bosnia Serb-held *Metalka* building – located on the end of Franje Račkog Street – the *Invest Bank* building and other high-rise structures in Grbavica – mainly those located on Lenjinova Street – where snipers had a direct line of sight towards the Holiday Inn.[68] Sniper fire would also emanate from the Jewish cemetery in Kovačići-Debelo Brdo area – on the lower slopes of Mount Trebević. The dangers of entering and exiting the hotel were such that many opted, according to Kevin Myers, who was in Sarajevo writing for *The Guardian*, for 'just a few darts here and there, no more than

Figure 3.5 Opasna zona (dangerous zone), the Holiday Inn, Winter 1994 (Paul Lowe/VII).

a mile or so from the [Holiday Inn] hotel, always at top speed, horn sounding, and always without exception attracting sniper or even machine gun fire'.[69] Jeremy Bowen also acknowledged the problems with leaving the Holiday Inn, particularly after dark when most journalists would bed down in the hotel. 'The city outside the hotel', he said, 'was always dangerous … at the beginning of the war, no journalist left the hotel at night unless they had a very good reason to do so'.[70]

The Holiday Inn may have had its drawbacks – it was exposed – but it was in the middle of the city, half way between the old town and Sarajevo Airport and reasonably close to the TV station and the PTT Engineering building. While the southern side of the hotel was very exposed, and there were obvious hazards, journalists could, from the hotel, sprint across the road towards the frontline at Grbavica. Thus, in the days following the opening of the airport, more journalists arrived on UN flights from Zagreb and those arriving then found that the Holiday Inn had reopened. Within

weeks the hotel would become something of a 'home from home' for the many foreign correspondents covering events in Sarajevo, and while its charms were generally lost on all but those seeking a satellite phone or some other access to communications equipment, the Holiday Inn became a 'strangely comfortable, almost familial retreat' for the journalists that were compelled to live and work there.[71] Allan Little's BBC Radio colleague Malcolm Brabant, who arrived in Sarajevo in early July, didn't consider the Delegates Club to be sufficiently protected from incoming fire either. 'I took a look out of the window', he said, 'and had a clear view of Trebević where the Serb guns were stationed. If I could see them, they could see me. I didn't like it ... one mortar and the roof would have a skylight.' The decision was taken, therefore, to move to the Holiday Inn. 'It was little more than a hundred metres from the nearest Serb sniper on the opposite bank of the Miljacka River', said Brabant, 'but it was solidly built and there were familiar faces in the lobby.'[72]

Likewise, Martin Bell left the BBC flat – through his crew remained there – and took a room at the Holiday Inn. It was to be quite a new experience in hostelry for the veteran correspondent. 'War hotels', he said, tend to 'defy their surroundings and provide a measure of calm and luxury in a turbulent world. The Holiday Inn offered neither ... it was, and remained, the ultimate war hotel, like living at ground zero. From there you didn't go out to the war, the war came in to you.'[73] While life there was not, strictly speaking, a comfortable one, it was the only viable option – the city's other major hotels – the Bristol, the Europa and the Central – had all been badly damaged in the early months of the siege. The Holiday Inn, while providing for many of the journalists' needs, was by no means a safe haven. Many parts of the building were exposed to sniper fire, the lobby windows were no more than dangling shards of glass or open spaces covered with tarpaulin, and virtually every window on the building had been damaged by gunfire; dust and debris covered the discarded pieces of unusable furniture. Marcus Tanner, writing in *The Independent* noted that the newly opened Holiday Inn was 'pummelled and blasted with shells'.[74]

For many journalists, even the experienced among them, living in the midst of the fighting was different and challenging – quite unlike covering other war zones, where the hotels they resided and worked in were some distance from the frontline. According to Remy Ourdan, there was a vast difference between covering events in Sarajevo, and residing in the Holiday Inn, and other conflicts. 'You were living on the frontline, and constantly at risk of coming under sniper fire. In other war zones, you cover the stories but you move around – staying at the Holiday Inn, you were *within* siege lines, very close [to] the frontline.'[75] Indeed, the southern side of the Holiday Inn was shelled, shortly after reopening, adding to the existing damage on that side of the building.[76] Upon his arrival, Kevin Myers, writing for *The Guardian* stated that 'Large parts of the hotel are in ruins, and heaps of broken glass lie on corridor floors ... the lobby consists of dangling shards of sheet glass in front of a rest area. Everybody expects a shell to send the plate glass shredding through the lobby at any time.'[77] Joel Brand, upon his return to the hotel – he had previously stayed there during the referendum weekend of 29 February–1 March 1992 – immediately noticed the abundance of glass and what it meant in a war context. An entire wall of the lobby, he noted, 'was sheet glass, which was not only a hazard in itself, but offered absolutely no protection from shrapnel or sniper fire'.[78]

Even during daylight hours, operating in the exposed area around the Holiday Inn was perilous. Indeed, in early July 1992, an ITN crew that included the cameraman Sebastian Rich – the author of a memorably entitled book *People I Have Shot* – and the veteran reporter Michael Nicholson were returning from the Sarajevo TV building to the hotel after completing a live satellite feed for 'News at Ten'. But their efforts came to the attention of a sniper who, said Nicholson, 'obviously enjoyed this deadly sport'.[79] The crew attempted to sprint across the car park toward the hotel but were fired upon at every attempt. 'We waited there for an hour', said Nicholson, 'becoming ever anxious at the prospect of being left out on our own unprotected and at the mercy of all sides.'[80] A passing UNPROFOR armoured vehicle stopped, however, pointed its heavy machine gun towards the sniper's nest allowing cover for the ITN crew to make the dash across the open space to the entrance of the Holiday Inn. Not content with the footage he had managed to cobble together under the sniper fire, Rich continued to attempt to garner footage of the snipers at work in Grbavica but did so from *within* the building. He bedded down in one of the south-facing first-floor rooms, which had been rendered uninhabitable by shell fire in the first months of the siege and was filming when his camera was suddenly blown off his shoulder in a shower of plastic and metal. Rich then stumbled down to the lobby of the hotel where three colleagues dowsed his injuries with vodka, which was, said Nicholson, 'the only disinfectant we had with us'.[81] After a rather uncomfortable night, Rich was evacuated on a UN flight out of Sarajevo to Germany, and to hospital in Berlin the following day. Still reeling from his injuries, he assessed his condition. The ITN crew were temporarily pulled out and while Rich received medical treatment, Nicholson was ordered by his superiors in London to return to Belgrade.

Guests were generally advised not to dally in the exposed areas around the hotel, dubbed by both locals and foreign correspondents as an *opasna zona* (danger zone), within which one was in sight of VRS positions and thus at serious risk of being targeted. On 15 July 1992, for example, snipers intermittently targeted 'guests' attempting to enter or exit the hotel; Joseph Ageto, a member of the French humanitarian organization *Équilibre* and two local journalists – Slobodan Tasić and Miodrag Rajak – were wounded doing so.[82] 'You never, but never, left by the front door', said the Scottish freelancer Paul Harris, though without cars or armoured vehicles freelancers had to make a 'heart-stopping dash across a 100-yard space' from the back door towards cover – the first shelter being in the shadow of the Unis towers.[83]

Kevin Sullivan, who worked for United Press International (UPI) had decided to move to the Holiday Inn in October 1992. The UPI team had previously stayed at a small motel called *Monik*, near the Hotel Bristol which belonged to the one-time Bosnian Minister of Interior, Alija Delimustafić – who owned the Cenex trading company – and which was badly damaged in the early months of the siege and where Princess Anne (Britain) stayed during the 1984 Winter Olympics. They used the Cenex offices – which had a satellite phone – in Čengić Vila to send their despatches, but when the office was destroyed in early October 1992, the UPI team had to find alternative accommodation.[84] 'We had to move to the Holiday Inn,' said Sullivan, 'because it had become impossible to use the satellite phone without our own generator; we had to warm up the car battery and use it to power the phone.'[85]

Upon entering the Holiday Inn he made the potentially fatal mistake of attempting to enter the hotel through the front doors, possibly in full view of snipers, and was met by a disgruntled member of staff who, recalled Sullivan, 'gallantly moved to a more exposed position, unlocked the door and ushered me in with the characteristically baroque formula of muttered oaths and indignation over the ineptness of strangers'.[86] On another day, an attempt to enter the hotel through the front door could have proved costly.

Nearby buildings were testament to the dangers; the Bosnian parliament building and the Unis towers had been heavily shelled throughout May and June 1992.[87] To see the 'action' venturing beyond the Holiday Inn was, on occasion, not necessary. From the relative safety of their rooms, journalists could observe at close proximity the horrors of the siege. As Jeremy Bowen noted, there was frequently sniper fire all around the building, with the exposed area around the car park being particularly dangerous. On one occasion, he witnessed someone being shot just outside the hotel.[88] He was, said Bowen, 'hit on the thigh and collapsed to the ground. I couldn't just leave him there, so I went downstairs to the cark park, got in the car and drove out there to help him. But when I got there he had gone, and I have no idea how he managed to extricate himself.'[89] Likewise, Vaughan Smith of Frontline News vividly recalled witnessing the work of the snipers within minutes of arriving in the hotel:

> I got to the Holiday Inn, very tired after a long journey. I went straight to my room, on the fourth floor on the safest [northern] side of the building and threw my bags on the bed. It was summer and the room was stuffy, so I went to open the window and saw a woman with a child in hand scurrying across exposed ground. As I opened the window I heard the crack of a sniper's bullet and saw the woman fall to the ground. Very quickly, people came to her aid and I believe she survived. That was my introduction to the Holiday Inn.[90]

Such occurrences were far from rare. According to Peter Maass from *The Washington Post*, 'Even when you were in the hotel, there was a chance that you could see incidents from your room, if you had one of those facing the more exposed areas around the hotel.'[91] The Holiday Inn, said Maass,

> became a grandstand from which you could watch the snipers at work. A journalist could convince himself on a slow afternoon that he was doing his job by peering through a window at people running for their lives … I could stand at my own window, out of the line of fire, and watch more drama unfold in five minutes than some might see in a lifetime. It was all there, within a 200-yard radius of my room at the Holiday Inn.[92]

On rare occasions sniper fire would penetrate the windows of the building while journalists were at work. In August 1992 the BBC Radio correspondent Malcolm Brabant was in the Reuters office on the fifth floor (west side) of the building when 'a bullet came through the window and whizzed past me (about an inch above my head), virtually parting my hair'.[93]

Of course, not all of the foreign correspondents reporting from Sarajevo gravitated towards the Holiday Inn, even those that were well established. Gigi Riva opted not to stay in the hotel – though he knew it well, having been based there during the Bosnian independence referendum – preferring instead to stay with the deputy editor of *Oslobođenje*, Zlatko Dizdarević, with whom he had developed a friendship. Doing so, said Riva, 'gave me the opportunity to be closer to the inhabitants of the city and, of course, I had the advantage of picking up the latest news from Zlatko'.[94] For those that did not have such access, the Holiday Inn became a vital 'hub' in Sarajevo.

The Holiday Inn as a communications hub

The Holiday Inn functioned well below its pre-war capacity and could provide only the most basic of services, but, as Peter Andreas notes, it could provide these and 'a central location that could make the daily routine of a foreign journalist much more comfortable than one might imagine possible in the middle of a war zone'.[95] They were, of course, *on* the frontline but, on the plus side, they had access to basic resources and the ability to send despatches globally using state-of-the-art communication technology – though most dictated their despatches orally over the phone – that could be powered by generators.[96] By July 1992, the Holiday Inn was emerging as a key communications hub for foreign journalists and their local staff. According to Zoran Kusovac, then of Sky News, 'You could find, if you needed one, a fixer, a translator, a driver; it worked both ways. Bosnians would come to the hotel to offer their services, and thus the foreign press had easy access to them.'[97] Likewise, as Remy Ourdan noted, 'We were dependent on the Holiday Inn, in that there were satellite phones that belonged to AFP, the BBC and Reuters.'[98] Vaughan Smith of Frontline News would visit the Holiday Inn, even if not staying there, to make people aware that his crew was around. 'The big agencies had crews, but not every journalist did, so we would be hired to film for them. Most of this was done over the phone from our office in London, but it was important to be in the Holiday Inn to network and generate business.'[99] So the very fact that the hotel could provide even the most basic functions and additional services that they often needed made it an invaluable location for foreign journalists. By July 1992, the Holiday Inn had become invaluable to them. As CNN's Christiane Amanpour noted, 'we considered at the time that [there] was safety in numbers and safety in knowledge and we thus ended up working in ways that could be considered as unusual in journalism – we all looked out for each other'.[100]

The BBC's Jeremy Bowen, who took over from Martin Bell in July 1992, having arrived in Sarajevo on a Hercules C-130 flown by Saudi pilots, who, according to Bowen, 'were very competent but a bit nervous on the ground, so they wanted to turn it around pretty fast'.[101] Under the circumstances, therefore, Bell's handover to Bowen was rather short. 'Martin just walked straight up the ramp of the aeroplane' said Bowen 'and merely told me that I would enjoy it – if I survived.'[102] The BBC continued to pay rent on the flat – though Bell had stayed there only intermittently – so Bowen was initially located there. He was enthusiastic about his posting to Sarajevo, but was less enthused by the apartment, which he described

Figure 3.6 Jonathan Landay, Martin Dawes, John Burns and Chris Helgren in the Holiday Inn, Summer 1993 (Paul Lowe/VII).

as 'pretty grim, stuffy, uncomfortable' with 'a poor water supply', adding that 'it was not suitable for an asthma sufferer like myself'.[103] After a night tossing and turning on a dusty couch, Bowen decided that his 'huge respect for Martin did not extend to sharing his sleeping arrangements'.[104] And while the accommodation was not to his liking, Bowen felt detached and isolated there. 'Every other press agency or organization, with the exception of Associated Press (AP) who were based in the privately owned Belvedere Hotel near the Koševo Hospital was based in the Holiday Inn, so I checked in there, and the crew soon joined me.'[105] Though the BBC had no infrastructure there, engineers came to Sarajevo in the subsequent weeks to establish a working space for both the TV crew and the radio correspondents and a storeroom.[106]

By the time Bowen had arrived at the Holiday Inn in July 1992, a number of journalists had already established a semi-permanent base there, despite the fact that only 100 of its rooms were inhabitable.[107] The hotel, he said, was 'gloomy, often without electricity or water; it did not have a bar and there was also a constant soundtrack of gunfire and explosions to accompany the depressing atmosphere'.[108] Bowen had previously covered conflicts in El Salvador and Croatia – among others – but soon learned that Sarajevo was uniquely dangerous. That danger, he said, was not just present on the streets or in exposed areas but *inside* the hotel: 'Bullets fired into the front of the building [the Holiday Inn] occasionally penetrated through to the six-storey atrium in the middle of it, smashing the glass panels around it which showered down into the lobby – it was, to put it mildly, lively.'[109]

Those journalists and agencies that had arrived soon after the hotel's reopening staked a claim to the best – safest – rooms on the north side of the building, with those arriving later forced to take their chances in the more exposed parts of the building, at least until preferable alternatives materialized. After all, noted Miroslav Prstojević in the *Sarajevo Survival Guide*, 'The Holiday Inn ... was one of the few hotels in which the most prized rooms were those without a view. A view of the mountains meant a view of the snipers' nest. During the siege the rule was: if you see him, he sees you.'[110] Location of choice was a room – or if one worked for one of the larger agencies, a suite – on the northern side of the hotel, facing the so-called *Karingtonka* (Carrington) apartment block, which was not exposed to sniper fire emanating from Grbavica and was by far the safest side of the building. The western side – facing the Maršal Tito barracks – was relatively safe, although snipers could still angle their shots into those rooms. Guests in these rooms could often hear bullets whizzing past their windows. There were, according to Remy Ourdan – then of *Radio Télévision Luxembourg* (RTL) – who had moved into the Holiday Inn in August 1992, 'small parts of one's room which were exposed and were thus to be avoided' and it was necessary to 'manoeuvre around the room to avoid the dangers'.[111] But while less desirable than the north-facing rooms the western-facing rooms had benefits; those who used satellite dishes required that their equipment be facing west, where the best signal to could be received.[112]

Only the first five floors tended to be inhabited by the press, though rooms above the fifth floor were used during busy periods. Rooms on the upper floors facing the northern side were rented out, and they were cheaper – these were often taken by freelancers who could not afford the more desirable rooms.[113] Nobody was permitted to use the rooms on the southern – front – side of the building, which was exposed to sniper fire and occasional shelling, though these rooms, being empty and well ventilated, were occasionally used to store electricity generators – journalists were occasionally required to tread carefully into these exposed rooms to check on them, particularly if they were not functioning properly – but had to be careful not to illuminate themselves with torchlight if doing so in the darkness, lest they become a target for snipers.[114] Southern-facing rooms were also, albeit infrequently, used by cameramen to capture images of night-time tracer fire, with the cameraman slipping in and out only to change tapes.

The established, and thus wealthier, agencies such as Reuters – who were originally based on the west side of the hotel but later occupied the 'Olympic Suite' on the fifth floor – the Cable News Network (CNN), the British Broadcasting Corporation (BBC), the American Broadcasting Company (ABC) and numerous major newspapers, simply could not do their jobs as effectively anywhere else in Sarajevo. The Holiday Inn would thus host some of international journalism's biggest names, with TV networks, press agencies and journalists from the United States and Europe staying in the hotel, often for long periods. While initially less experienced than Burns, an American journalist in his mid-forties, Kurt Schork, would make his name in Sarajevo. Kurt Schork came late to journalism, and his trajectory toward a career as a war correspondent was quite unlike many of his contemporaries, but his commitment to the job and the quality of his reporting meant that he became highly regarded among his peers. Having been a Rhodes Scholar at Oxford

Figure 3.7 Kurt Schork in the Sarajevo TV station, Winter 1994 (Paul Lowe/VII).

University – where he had been a contemporary of Bill Clinton – he worked as an aide to the Democratic governor Michael Dukakis, before carrying out similar roles with both the Democratic representative Michael Harrington and the Democratic senator, Bill Bradley. Increasingly disillusioned with politics, he left to work instead for the New York Metropolitan Transit Authority, essentially running the city's subway. His relationship with Deborah Wong, herself a journalist who would later work for ABC, convinced Schork that he should pursue a career in journalism.[115] He began as a freelancer in Asia, covering, for example, the war in Sri Lanka, before joining Reuters. But it was in Sarajevo that he made his name as a serious journalist. Schork not only worked hard, he was willing to take significant risks and had a clear sense of moral purpose, helping civilians when he could.

Sarajevo also became a magnet for younger journalists eager to make a name for themselves, some as stringers, who were paid only for whatever stories they published, 'super-stringers' who were paid an additional retainer and freelancers who did not have a string but were hoping to pick one up. According to Vaughan Smith, 'Journalism was becoming increasingly democratised and many young journalists could get to Bosnia by bus or by car. Moreover, technology made it possible to get travel independently with your gear … so it was accessible in a way that previous conflicts were not.'[116] This accessibility determined that many aspiring journalists, many of them freelancers, made their way to Sarajevo in the hope of getting their break. Once in Sarajevo, few could afford to stay in the Holiday Inn and many of them opted instead to stay in private apartments. Kevin Weaver, for example, stayed in a number of apartments in Bistrik, staying with the parents of a contact he knew in London:

I rented a room in a house with an elderly couple. They were lovely people but the circumstances they were living in were pretty miserable. And, generally, this became my experience of living and working in Sarajevo. It wasn't at all like living in the Holiday Inn. Journalists there had electricity, meals, alcohol and would stay up late talking. I was in an apartment with no electricity, heat and nothing much to eat, so once it was dark there was nothing to do but go to bed in numerous layers of clothing.[117]

Whether staying at the Holiday Inn or not, many freelancers hung around to network, make themselves available and – sometimes – 'camp-out' in the upper floors of the hotel in some of the damaged rooms, hoping not to be noticed by staff. Some paid, but without the clout of a large agency behind them, were given unfavourable rooms in the hotel. Paul Harris, a freelancer who had various strings – mainly for *The Scotsman* and *Scotland on Sunday* – found himself 'staying in rooms that had been completely boarded-up'.[118] For many staying in the hotel, at least those that did not have the better rooms, staying at the hotel differed little from camping – plastic sheeting, provided by the United Nations High Commissioner for Refugees (UNHCR) replaced the glass in the atrium and in most of the rooms stopping shards of glass from injuring anyone but rendering them difficult to heat. The electricity supply was inconsistent, and there was rarely running water.

Less experienced young photojournalists eager to forge their careers also gravitated towards Sarajevo – and to the Holiday Inn. With little knowledge of operating in wars, Sarajevo became a training ground for young journalists and photojournalists keen to establish themselves. The American photographer Robert King, having just graduated from the Pratt Institute in Brooklyn, New York and in recent receipt of a graduate grant, had headed for the Zagros Mountains in northern Iraq to work on a story about Kurdish peoples there. While there he met two photojournalists who recommended he try his luck in Sarajevo. 'I didn't have an agent or even a press card', said King, 'but they called in a favour and got me a small job with an agency called JB Pictures and they provided my first accreditation that allowed me to get on a UN flight to Sarajevo.'[119] He was, by his own admission, 'pretty green' when he first arrived in the city and had little idea of the dynamics of the story or how to operate in a war zone. 'I had absolutely no clue about the disintegration of Yugoslavia or war in Bosnia, so I had no idea who the political players were or who was shooting – when I got there I just explored the Holiday Inn and the micro-world that existed there.'[120] A 2008 documentary film about King called *Killer Image: Shooting Robert King* shows him turning up at the hotel, which he could not afford to stay in, attempting to network with the journalists and photographers in the hotel and 'cheat the waiters' when possible.[121] King soon left the 'Hollywood of the Holiday Inn, Sarajevo' to find cheaper accommodation, sometimes renting small rooms, staying with friends or squatting, though he would return to the hotel on occasion to work with other journalists.

Among the established and the young, aspiring journalists, photographers and local translators and stringers there were those who were curious about the war and had thus found their way to the Holiday Inn. They had no formal press accreditation and many of the more established journalists viewed them simply as 'war tourists'. According

to the BBC's Jeremey Bowen, 'Some strange people washed up at the Holiday Inn ... fantasists and desperadoes, soldiers and reporters, often lubricated by the leveller of drink.'[122] Similarly, Paul Harris, writing in *The Scotsman,* noted that the 'war tourists' were a mix of 'do-gooders' and 'thrill-seekers with battered copies of the warmonger's handbook *Soldier of Fortune*[123] stuffed into their flak-jacket pockets'.[124] Though they lacked the credibility that a press card would bestow, they added, if nothing else, an even more bizarre flavour to the strange atmosphere in the hotel, which had become, according to the writer and critic Christopher Hitchens, 'the clearing-house for every kind of defector, rumour-monger, movie director and gun-runner'.[125] Writing in *Rolling Stone* magazine, Joel Brand noted that the core 'Holiday Inn crowd' were rather distinct:

> Foreign correspondents in general are strange types, but the ones who are willing to spend weeks or months on end in a place like Sarajevo are still another breed. Obtaining what amounts to full membership of the press corps here is a drawn-out process. It requires spending enough time under fire to be able to ignore pretty much everything except for when the [Holiday Inn] hotel takes a direct hit – and even then, it needs to be hit with something heavy. People who can't take being shelled ... tend to have brief stays.[126]

Those foreign journalists that had stayed regularly in the hotel during the siege became, however, increasingly frowned upon by many Sarajevans. As they became more disappointed with Western reluctance to intervene and break the siege, they began to view representatives of the West – including the journalists in the Holiday Inn – with near contempt.[127] They became increasingly cynical about their presence and the conditions in which they lived and worked.[128] The Bosnian weekly *Dani* noted that 'The citizens of Sarajevo, mainly hungry and frost-bitten, sometimes hated the hotel',[129] while the Belgrade independent weekly *Vreme* wrote that, 'Humanitarian workers, diplomats, international bureaucrats, military officers, wheeler-dealers and one or two dumbfounded intellectual-humanists ... They [the journalists] drive around town in armoured white Land Rover's with air-conditioning. Even then they are in radio contact with somebody back at the Holiday Inn ... The citizens of Sarajevo look on them with a mixture of scorn and disappointment.'[130] An even more cynical perception was that these media professionals were akin to vultures feeding their own career ambitions on the misery of Sarajevo. Increasingly, the Holiday Inn – and its guests – became strangely detached from the city, somehow not *of* it. Some of the press corps, particularly those that did not stay in the hotel for long periods, concurred with this assessment. *The Times* correspondent Anthony Loyd noted that 'Too many simply walked into the basement of the Holiday Inn each day, drove out in an armoured car to a UN headquarters, grabbed a few details, filled them with the words of "real people" acquired for them by local fixers, and then returned to their sanctuary to file their heartfelt vitriol with scarcely a hair out of place.'[131]

Although the Holiday Inn remained a relative safe haven and did not suffer the fate of some of its adjacent buildings, the hotel was occasionally targeted. On 13 November 1994, for example, the hotel was hit by two shells that caused a fire within the building.[132] Samir Korić, who worked alongside Kurt Schork for Reuters said, 'We

didn't feel completely safe in the Holiday Inn but we spent most of our time reporting outside, so I felt *safer* in the hotel but there's no way we could have felt completely safe.'[133] Yet a perception grew that those within the Holiday Inn were protected, and those within it enjoyed something of a charmed life. Rumours were abundant that the Holiday Inn was protected by a shady deal which maintained this status quo. Thus, the fact that the hotel was not attacked as often as it could have been fuelled significant speculation about why this was the case and whether the hotel's preservation was agreed upon by the warring parties.[134] As *The Washington Post* correspondent Peter Maass observed:

> It was surprising that the Serbs hadn't shelled the hotel to the ground, but there was a reason for their oversight. War causes inconveniences for both sides, but some can be overcome with mutually beneficial consequences. It goes like this: the Serbs have a building that they want to preserve, perhaps an old church, and the Bosnians have a building that they want to preserve, perhaps the Holiday Inn. The two sides cut a deal on shortwave radio in which the Serbs agree not to wreck the Holiday Inn, and the Bosnians agree not to wreck the church. It can be simpler than that, too: the Bosnians simply pay the Serbs not to shell the Holiday Inn … That, and the presence of the foreign press, helps explain the hotel's survival.[135]

Anthony Loyd also speculated that there could perhaps have existed 'a tacit understanding within the Serb command that the hotel was the focal point of the media in Sarajevo and should be left untouched' or, moreover, that a deal had been struck 'to ensure its security'.[136] Of course, the Bosnian government had an interest in keeping the international press ensconced in the Holiday Inn. By keeping them in relative comfort in the hotel, they could file their stories and *Sitreps* (situation reports). Certainly, the hotel was not targeted as frequently or aggressively as might have been the case, though the Serb gunners on Trebević could have destroyed – with incendiary shells – the Holiday Inn, as they had destroyed the neighbouring Unis towers and the Bosnian parliament building. When Kevin Sullivan of UPI travelled through VRS lines to Ilidža through to Lukavica and then down into to Grbavica he 'ended up at a spot about 300 metres from the Holiday Inn. You could see very clearly where our rooms were.'[137] Yet, while it may have been uncomfortable to become aware of just how exposed one was in the Holiday Inn, most journalists were equally aware that their presence in the hotel may have rendered a major assault on it unlikely. Džemal Bećirević of UPI concurs with this, stating 'the Serbs knew that there were many foreigners in the Holiday Inn, and they knew there would be international condemnation and potentially bad consequences, so they more or less let it be'.[138] Sabina Ćosić of Reuters added:

> There was no safety *per se* but we felt safe during the shelling of the general area. We would be in our offices filing or photographers were taking pictures of shells landing in the neighbourhood (that you could see with your own eye) and yet, we weren't hit. Occasionally a sniper would hit our satellite dish and yes there were occasional shells that would hit the building forcing everybody to run for cover, but by and large I had a feeling, from the moment I set foot in the Holiday Inn, that I was protected by the presence of foreign journalists.[139]

The Holiday Inn was not immune to the dangers of sniping and shelling throughout the siege and whether there was a deal to protect it remains a matter of conjecture. More likely, it was the presence of the journalists, and to a lesser extent UNPROFOR staff, that assured it was a *relatively* safe place to reside in the context of besieged Sarajevo.

The Sarajevo TV station

Like the Holiday Inn, the Sarajevo TV station building was also a vital part of the infrastructure used by the foreign press corps; it was from here that the vast majority of reports by foreign journalists were filed.[140] Completed, like the Holiday Inn, in advance of the 1984 Winter Olympics,[141] this large grey concrete structure – originally conceived and designed by the Sarajevo-born architect Milan Kušan and Branko Bulić and known colloquially as *sivi dom* (grey house) – was among the least aesthetically pleasing, though one of the solidly constructed buildings in the city.[142] This ensured that, though it was regularly targeted, it could withstand the kind of destruction wrought by the destruction of the *Oslobođenje* building with incendiary shells in June 1992. Indeed, according to Peter Andreas, 'The Radio and Television building was one of the city's least attractive but most durable structures, successfully weathering Bosnian Serb fire throughout the siege.'[143] Based in the Alipašino Polje district, almost at the halfway point between the airport and the Holiday Inn, it housed RTV Sarajevo (*Radio-Televizija Sarajevo* – RTVSA) – the first TV channel based in Bosnia when it began broadcasting in 1961 – Radio Television Bosnia and Herzegovina (*Radio-Televizija Bosne i Herzegovine* – RTBiH) and YUTEL; the latter ceased broadcasting in May 1992.[144] The building played a crucial role in broadcasting the 1984 Winter Olympics, and many of the large US broadcasters present in Sarajevo during that time used the building.[145]

During the siege, it became an even more vital node in the communications network of the city and was, from late 1992 onwards, the transmission point used by international media organizations. In the early days of the siege, however, the building was a frequent target. It was hit repeatedly because SDS officials 'denounced the alleged bias of the RTV Sarajevo and demanded that it be split into three nationally-controlled parts'.[146] Indeed, on 19 April 1992, Sarajevo TV received a telephone call from the Serb leadership in Pale that unless they ceased broadcasting within ten minutes their building would be shelled. Despite assurances to Colm Doyle of the ECMM from Radovan Karadžić that no such attack would take place, Sarajevo TV was indeed attacked. There were two casualties. According to Colm Doyle, the Bosnian Serbs were determined to stop the TV station from continuing transmission:

> The Bosnian Serbs were obsessive, even paranoid, about Sarajevo TV. As long as the 'Muslims' controlled the national television station, Karadžić and his people had little chance of asserting a greater influence over the population. In this battle over control of television, relay installations were a target … seven of the nine television transmitters scattered throughout the republic had been seized by the Bosnian Serbs in February and March 1992, who then reoriented transmitter

signals toward Belgrade and relayed programmes from there (and exclusively from there, until the TV facility at Pale began to function). Thus, the majority of Serbs in Bosnia had only been able to receive TV from Belgrade while the TV station in Sarajevo could only reach populations in limited parts of Bosnia.[147]

Throughout April and May 1992, the TV station was the home primarily for TVSA, but the EBU, having evacuated their base – and left their equipment – at the Hotel Ilidža in May 1992, attempted to re-enter Sarajevo in mid-June 1992 and establish a base at the TV building. On 19 June, Myriam Schmaus, who headed the EBU's 'Special Operations Team' – which included satellite engineers Kevin Diebert and Charlie Vanderhoop – succeeded in bringing new equipment to the Sarajevo TV station. But the challenges faced in so doing far exceeded those faced when the EBU were based in the Hotel Bosna. The EBU team established an office facing north, which was not exposed to sniper fire – so their internal arrangements were acceptable. However, as Schmaus noted, 'The area around the building was very exposed and dangerous. There was little opportunity to go outside and we were exposed to dangers, permanently, at the front of the building and its immediate environs – quite different from our Ilidža operation.'[148] Nevertheless, the EBU team succeeded in establishing a base in the TV station and safely positioning their satellite dish.

Zrinka Bralo, a young journalist working at Radio Sarajevo, was told by her colleague Merdijana Šuvalija, who was already working for Sky News, that there were a number of foreign journalists in town looking for interpreters. So, the following day, she made the treacherous journey to the TV station where she found Boro Kontić, the

Figure 3.8 UNPROFOR Warrior APC outside the TV station in Sarajevo (courtesy of Kevin Weaver).

founder and one-time editor of the *Omladinska program* (Youth programme) where she used to work. He sent her, due to her knowledge of English, to the 'international department' of TVSA to help interpret for foreign journalists. 'My mother wasn't too happy about it', she said, 'because a job at the TV station meant that I had to make the dangerous journey to the TV station daily – and we knew that doing so was indeed dangerous, as my neighbour, Saša Lazarević, who had also worked with foreign journalists, had been killed on 20 June 1992.'[149] In any event, Bralo was subsequently assigned by them to work with the EBU. Her job involved, she recalled, 'running around fixing whatever they needed translating with the local engineers'. She was 'literally waiting for them on the street' when they arrived in Sarajevo.[150] One of her first tasks was to help the EBU team identify a safe place to locate their satellite dish, lest it be the target of shelling and they settled on hiding it among bins to obscure it from those who might be inclined to target it. 'Under the circumstances, it was all very slick', said Bralo, 'The EBU team came in and set up very quickly and efficiently, running cables up and down the building and setting up the transmission point.'[151]

There were, however, political pressures to contend with. Schmaus recalled that the Bosnian government wanted the EBU to establish the infrastructure then let them use it and that she had vigorously resisted 'so that I could ensure the neutrality of the EBU operation in Sarajevo'.[152] In July 1992, Myriam Schmaus handed over to Anna Erickson – as she had in May 1992 – before the arrival of Pierre Peyrot. Under his stewardship, the EBU consolidated their presence and continued to coordinate the satellite feeds. Most of the networks and agencies had offices there until the signing of the Dayton Agreement in November 1995. The EBU 'Transmission Point' was based on the fourth floor of the TV station building – though it would be moved to different locations within the building between 1992 and 1995[153] – and was, according to Eddie Maalouf, an EBU satellite engineer, 'dark, damp and devoid of furniture' with the adjoining rooms, corridors and public areas without windows or with broken or missing panes of glass.[154] The EBU workspace was divided into two sections within one large room, the larger section of which was set up as the main transmission point. 'Picnic tables' were used to place the editing machines and other TV equipment.[155] The EBU team were permanently based in the TV station and their work was, according to Pierre Peyrot, 'non-stop':

> We lived in the building and this meant that we both worked and slept there. It was dangerous to travel, so there was no point getting in our battered Audi to go from the TV station to the Holiday Inn. The nature of the work meant that you were dealing with broadcasters from all over the world, though the majority were European. So, with different time zones – say, the US or Japan – to take into account, we had to be working almost constantly. We had a small staff and we were the only ones there, so the work was pretty relentless for the EBU team.[156]

The EBU team would generally consist of four people with clearly defined roles – a producer, two engineers and a film editor. The engineers were particularly vital because they were responsible for maintaining the EBU's infrastructure, including cameras, satellite dishes, satellite phones and editing equipment.[157] Zrinka Bralo essentially helped to coordinate the team:

I had to help engineers create the conditions in which 24-hour news was possible and to describe and sell news to editors in various European centres. If there was sufficient interest in the news from Sarajevo, footage would be transmitted at a designated time – several times per day – when all of those centres received a satellite signal. At the beginning, I was completely unfamiliar with how this all functioned and I had to learn fast. Often, I would do so while running around the TV station with the EBU engineers looking for the safest place for the satellite antenna and laying hundreds of meters of audio/video to an improvised studio on the second floor.[158]

Different TV crews, radio journalists and print journalists would all use the facilities of the EBU, which included editing, satellite feeds of the film footage or dictation using satellite phone; whoever was working on the EBU editing desk would also edit footage on request.[159] In time, TV crews also established permanent offices in the TV building with the BBC sharing an office with ABC News, whilst CNN, ABC, ZDF (Germany), Channel 1 (France), ARD (Germany), Associated Press TV (APTV) and WTN among others, were also based there.[160] The EBU operation – essentially a means of transmission from A to B – was vital to all of these, and other, agencies because it was still, at this point, not possible to transmit pictures by satellite phone – which could, in the early 1990s, be used only for text and radio.[161] Moreover, it gave crews an important base for building their own mini infrastructure. CNN's David Rust noted that their workspace at the TV station was absolutely vital to them; the place where they would edit their material and keep their videotape library. Originally, the CNN team transmitted their video from a satellite dish located in the PTT building – as the BBC had done during the early months of the siege. Eventually, however, they installed their own satellite dish at the TV station, after which, they would only visit the PTT building for UN briefings.[162] Thus, the EBU transmission point became a hub for foreign correspondents, as Eddie Maalouf noted:

> In addition to providing electronic services to the outside world, the transmission point served as a central meeting point for all broadcast crews and their local translators/fixers. Journalists spent their time talking on telephones, reading the latest newspapers or magazines flown-in by the UN or discussing possible story options ... a variable but strangely soothing hum of vowels and constants generated by a multitude of languages filled the space and often permeated into the outside hallway.[163]

The EBU transmission point could also receive TV from outside Bosnia and Herzegovina and thus journalists, their crews and local staff would often gather there to watch sporting events that were not accessible elsewhere.[164] All of this would have been far more difficult, noted Pierre Peyrot without the local electricians who came to be known as 'blue coats': 'If we had a problem, they came in like the cavalry ... to installing showers for us or, during the dead of winter, making sure that the gas flowed and we had heat ... they were amazing.'[165] But, of course, the lack of electricity and gas for long periods rendered their work difficult, if not impossible. As Zrinka Bralo recalled:

By the onset of winter 1992, it was very cold. There was no electricity in the TV station and everything was running on the generator. Even when there was electricity, you couldn't even plug in any heaters because they would just blow the fuse because it was drawing too much power. Only essential equipment for transmission and editing was permitted. It was so cold that only those who *had* to stay in the TV station would stay.[166]

To remain functioning, the TV building was also reliant on generators that required a constant supply of black market fuel, the price of which could fluctuate significantly.[167] This meant that the challenge to keep the operation running was unrelenting. As a consequence, the EBU team were almost constantly working within the environs of the TV station building. 'On the whole', said Steve Ward, 'we stayed in our small rooms in the TV building. We had generators, power and small electrical heaters and unless we were in Sarajevo for long periods, we would generally eat, sleep and work in the building'.[168]

The TV station building, robust as it was, was targeted throughout the siege – though its thick concrete walls saved it from the kind of destruction that was wrought on the *Oslobođenje* building, which had been destroyed in August 1992 by incendiary shells – though the newspaper continued to be printed in the basement of that building. Nevertheless, it was thought to be one of the most secure buildings in the city.[169] The worst of the attacks on the TV station came on the morning of 28 June 1995 when a large explosion, caused by a modified, or improvised, 'air bomb' fired from Ilidža killed one – a security guard called Ibrahim Šalaka and injured – some of them seriously – twenty-eight locals and internationals working in the building.[170] The timing of the attack meant that the building was particularly busy, as journalists from both RTV-BiH and numerous foreign press agencies assembled to commence their work to plan their activities for the day ahead. Eldar Emrić, a local cameraman – though originally from the town of Maglaj in central Bosnia – who worked for APTV had come to the TV station that morning with what he described as a 'feeling that the building might be targeted'.[171] His concerns were underpinned by his knowledge of what had happened in the environs of the TV station in the days before the attack. Emrić had witnessed, and filmed the effects of, similar improvised bombs causing devastation in an apartment building in Alipašino polje, the GRAS trolley-bus depot and in the *Žica* factory – part of the *Energoinvest* company – close to the TV station. While covering these incidents, he had speculated that the real target may actually have been the TV building and that the VRS were 'testing and recalibrating the accuracy of the weapon'.[172] At approximately 9.30 am, he was in the APTV office drinking coffee and discussing with colleagues their plans for the day when he heard 'a really strange sound' and then a loud bang, as the rocket hit the flat roof of the building. He instinctively reached for his camera but, within a second or two, saw a flash of fire followed instantly by a huge explosion. It was, he said, 'in its destructive power, unlike many of the other explosions – through shell or mortar fire – that I had witnessed in my years of covering the siege'.[173] Subsequent reports in *Oslobođenje* suggested that there were two detonations inside the building but it is likely that the sequence of events is as Emrić described – the impact of the rocket on the roof and detonation *inside* the building.[174]

The destruction within the building was significant; the numerous offices used by foreign media agencies, which were separated by partition walls constructed of wood, brick and glass, were badly damaged; indeed, some of these internal walls were completely destroyed. The EBU's editing room and feed point, so crucial to many of the foreign correspondents, was also badly damaged by the impact of the blast, though, incredibly, most of their equipment still functioned. According to Steve Ward, who worked as a film editor for the EBU, 'those editing machines were encased in steel frames and were tough, bulky pieces of kit; they had a lot of superficial damage but we just took them down to the basement and repaired what we could and they, unbelievably, continued to work'.[175] The impact was far more significant elsewhere in the building, however. The small offices and editing rooms of APTV, ARD, WTN, Reuters TV and RTV-BiH were all severely damaged. Eldina Jašarević, who worked for the German media agency ARD, was thrown to the ground by the blast as the bomb detonated:

> Once I had recovered from the initial shock, I stood up and realised that I was OK, that I hadn't been injured. I was in a small office and when I opened the door I couldn't believe it – the corridor outside had been completely destroyed. That part of the building had been partitioned by temporary wooden walls, and these collapsed with the impact of the blast. All of my colleagues from ARD were fine, but we were lucky because we were not in the editing room, which was badly damaged.[176]

In the midst of chaos, those who escaped injury helped to carry those that were injured to various cars and vans to transport them to hospital – APTV's Sabina Arslanagić was among those that helped her colleagues and others to evacuate the building. Eldar Emrić, who was in the APTV offices at the time, had also been thrown into the air by the explosion but had begun to help those among his team that were most seriously injured. His APTV colleagues, Asja Rasavac – a producer – and Mirsad Helac – APTV's driver – were injured in the blast, as were Hana Prguda, Rijalda Musaefendić, Fadila Serdarević and Feridoun Hemani of WTN. The CNN cameraman, David Alpiton was also seriously injured.[177] Emrić originally believed that he had been unharmed, but became increasingly aware that the blood on his shirt might be his and not those of the injured around him. As it transpired, he had been hit in the chest with shrapnel – essentially, hot metal that penetrated his skin leaving almost no marks – and was helped by his colleagues, Hakija Hadžalić and a German APTV cameraman called Volkmar Kienoel, into the back of an armoured Land Rover which was then driven by Kienoel – who had only recently arrived in Sarajevo and did not know the city well – to the military hospital near the Holiday Inn. There, Emrić – whose condition continued to deteriorate – was operated on by Abdulah Nakaš, the esteemed surgeon who was specialized in dealing with trauma injuries, before he began a long and painful road to recovery. Thereafter, he was medevaced out of Sarajevo – first to the UN 'Triage Centre' in the PTT building then by a French UNPROFOR APC via the 'Blue Road' to Mount Igman, from where he was airlifted to Split and subsequently by plane to London. There he underwent further medical treatment and recuperation at the Royal Brompton Hospital.[178]

Though the attack in the TV station on 28 June 1995 was by no means the first, it was by far the most serious and the most deadly. The Bosnian daily *Oslobodenje* described the scene of destruction as akin to what one might expect after a 'catastrophic earthquake.'[179] It further underlined the significant dangers journalists faced working in Sarajevo, even within a building that was considered one of the more secure in the city. Though an obvious target, the robust construction of the building determined that it could withstand the sporadic shelling and mortar attacks that it had endured since April 1992. It remained, throughout the siege, a hugely important part of the reporting infrastructure, without which television images of the siege of Sarajevo and the privations of citizens would not have been as widely disseminated to international audiences. And the attack did not lead to the departure of foreign media organizations from the TV building – within days, those agencies that had been worst affected simply moved their operations to the basement of the building and continued to work.

The PTT building and the UN briefings

UNPROFOR had used one floor of the Postal, Telegraph and Telephone (*Pošta, telegraf i teleefon* – PTT) building between March and May 1992, though the majority of UNPROFOR personnel were based at the 'Hotel Rainbow' (*Dom penzionera*) before their temporary withdrawal in May 1992. That building had been gutted in June 1992, so after their return, they established a base in the PTT building in the Alipašino polje district. The building was part of the wider PTT infrastructure in Sarajevo, which included the main post office – the interior of which had been completely destroyed in May 1992 – and the Sarajevo Centar PTT building in Dolac Malta. The building used by UNPROFOR had been where PTT Engineering was based and was, in some ways, an unusual choice for UNPROFOR. They were initially located – when they began to occupy the building in July 1992 – on the seventh floor of a building that possessed a large glass façade, making it somewhat hazardous for its occupants. Indeed, despite being the UNPROFOR headquarters it was not immune from sniping and shelling.[180] According to one Canadian UNPROFOR soldier, the building 'had a glass stairway that went up to our floor, which you avoided like the plague if you could because you always heard the bullets going through the glass … constantly we would be listening to the glass falling and you could hear the snap of bullets going right through the stairway'.[181] Part of the building also faced south, towards Bosnian Serb lines, so UNPROFOR staff preferred to work and sleep in the offices that faced north.[182]

One of the daily rituals of the foreign press corps in Sarajevo was the UN – UNPROFOR and UNHCR – press briefings held there which, on occasion during particularly heavy fighting, would take place in the basement of the building. These briefings, dubbed as the 'Nine O' Clock Follies' – a play on the 'Five O' Clock follies' delivered by the US Army in the Rex Hotel in Saigon during the Vietnam War – could often be rather fractious affairs, with the gathered journalists often being deeply critical of the role of the UN and their 'administering' of the siege. According to Peter Maass of the *Washington Post*:

The briefings began with the 'weather report', which was UNPROFOR's tally of the previous day's bombardments around Sarajevo. The UN was laughably incompetent at stopping bombings but amazingly adept at keeping count of them, so every morning we got a scorecard of the numbers of mortars, tank shells and artillery shells fired by each side. This was followed by a breakdown of the number of food convoys, and the numbers were impressive, perhaps fifteen convoys a day, ten tons of food on each, and so on. It was the same sort of bullish impression that might have gotten at the Five O' Clock Follies in Saigon ... The impression, of course, would be the reverse of reality.[183]

Others were more sympathetic to the difficulties experienced by UNPROFOR and the UNHCR. According to the BBC's Jeremy Bowen, 'The UN agencies took a bit of a beating at these briefings; I tried not to do this because I knew that the UN's mandate, not the personnel on the ground, were the problem.'[184] It was, said, CNN's Christiane Amanpour:

Difficult for the UN staff on the ground; and their limited mandate tied their hands. But we had generally, very good relations with the UN staff – we had a daily briefing, they always answered our questions, we would get special briefings from time-to-time, and let's face it, when any of us working in Sarajevo got into trouble the first port of call would be UNPROFOR. They had the infrastructure to help our colleagues.[185]

Nevertheless, there would be moments of tension and many points of disagreement between the UN personnel and the gathered journalists. One such occasion was during the visit of the UN Secretary General, Bhoutros Bhoutros-Ghali, in December 1992. Following a meeting with Alija Izetbegović and other Bosnian government representatives at the Presidency building he gave a press conference at the PTT building where he was pressed on his recent statement in which he suggested that there were 'many places in the world more dangerous than Sarajevo', though, according to John Simpson, 'he had a hard time telling us exactly where those places were.'[186] CNN's Christiane Amanpour was shocked, moreover, because of Bhoutros-Ghali's insistence that UN staff should refrain from specific terms to describe the situation in Sarajevo. 'I remember him telling UN personnel not to use the word siege', said Amanpour, 'which seemed astonishing under the evident circumstances.'[187] Indeed, in August 1993, the UNPROFOR spokesman Barry Frewer would openly reject the journalists' use of the word. 'You call it a siege', he said, 'We say they [the VRS] are deployed in a tactically advantageous positon.'[188]

The PTT building was also the termination point for the UNPROFOR shuttle service (by APC) to and from the airport. Those that wished to use this service had to register and be provided with relevant paperwork. Though UNPROFOR committed to providing a free service for those who were registered, the accompanying document cautioned that those who travelled with them in the APC that UNPROFOR would 'not be held responsible for any loss, injury or death in connection with the provided transport'.[189] Initially this service, and flights in and out of Sarajevo, was used mainly by foreign correspondents, UNPROFOR staff and aid workers – provided they had the

Figure 3.9 UN press briefing at the PTT building, Winter 1993 (Paul Lowe/VII).

appropriate UN press accreditation. For local staff, however, it was a different story. That they could not leave, at least for some respite, became a matter of concern for the foreign journalists and agencies that employed them. This, primarily but not exclusively, was the driver for the foundation of the 'Sarajevo International Journalists Association' (SIJA), an ad hoc group with no permanent membership and no constitution, which acted as a 'union' representing the interests of foreign journalists and the staff in their employ. According to Allan Little:

> We became increasingly troubled by the difference in treatment between the foreign correspondents and our local colleagues, to whom we had grown pretty close. We could, with our so-called 'Blue Card', fly in and out of Sarajevo through the air bridge, while they could not. We wanted the local staff to be treated the same as us, so we made representations to the UNHCR and UNPROFOR essentially making a case that there should be no difference between us and the local staff – we should all have the same accreditation.[190]

Thus, it was the SIJA that brokered a deal with UNPROFOR that allowed local staff to be given the right to leave the city for short periods of rest and recuperation. Hitherto, foreign journalists had, given their ability to get in and out of the city, become the only means of communication with the outside world for most citizens of Sarajevo.[191]

However, after an agreement had been reached, local journalists, stringers, translators, cameramen and fixers could, once in possession of a UN 'Blue Card', fly out of the city and be transported to the airport from the PTT building by a UNPROFOR APC. However, Senad Pečanin, the editor-in-chief of the magazine *Ratni Dani* argued that even with permission it was never straightforward.

Figure 3.10 UN 'Blue Card' (Courtesy of Amra Abadžić).

I heard about the permission, which was given to local journalists to use the UN planes maybe a week after the decision was proclaimed in Geneva. I heard about it quite accidently. I think that at that period the UNHCR kept the decision a secret from local journalists. I got the transcript of that decision and I brought it to the UNPROFOR headquarters [at the PTT building]. They verified the nature of the decision. They were very uncivil though, and they did not want to help us get to the airport.[192]

Blue Cards also meant that holders could purchase goods unavailable elsewhere in Sarajevo – and at non-inflated prices – at the UN's 'PX Stores' which were located in both the PTT building and the airport – where items like biscuits, cigarettes, alcoholic beverages and a limited amount of food could be bought.[193] Access to the goods available, in the PTT, the airport or across the frontlines in Kiseljak or Pale, meant that journalists often came under pressure to smuggle goods into the city to friends in the city. Kevin Weaver recalled how 'the perception among many Sarajevans is that journalists had so much power, that we could simply fix these things':

> That might have been the case for someone working for CNN, the BBC or some other large media organisation, but as a freelancer I had no power, other than [that] I possessed a UN Blue Card and could get in and out of the city. I was constantly being asked to source these cards for friends who were desperate to get out of Sarajevo and be reunited with their families. It was so difficult because you wanted to help but did not have the power to do so. As a consequence, I became

wracked with guilt knowing that I had the freedom to leave the city and that my friends in Sarajevo could not. The contrast between how much freedom I had and how little they had always sat uncomfortably with me.[194]

Possession of a UN Blue Card became highly coveted. The local staff that could exit and re-enter the city joined the foreign journalists in the role of courier, bringing mail in from friends and relatives from outside and then carrying it back out again when they left. Gigi Riva of *Il Giorno* recalled that when he walked through the city he met many people who asked him to take mail to their relatives and friends. 'I took parcels or letters every time I went in and out of Sarajevo', he said, 'not least because there were many Bosnian refuges in Italy – people entrusted me with this task and I took it upon myself to ensure they reached their destination.'[195] At times, this meant smuggling post into the city, as there was a ban on bringing mail in on UN flights. According to Andreas, foreign journalists and locals with Blue Cards 'routinely smuggled letters for Sarajevo residents and their friends and family members abroad, with many of the in-bound letters filled with cash'.[196] The front pockets of flak jackets with the ceramic plates removed therefore provided a useful hiding place for the 'contraband' (mail). As the reporting infrastructure consolidated so too did the journalists' role as ad hoc couriers, though the UN would eventually impose limits on the number of letters and the amount of cash that individuals could carry.[197]

4

Operating in a city under siege

With a basic infrastructure established, journalists – whether based in Sarajevo or on brief assignments – could now function relatively effectively within the city. Throughout the summer of 1992 this infrastructure had developed and consolidated. Routes into the city and methods of travel were well established, and a basic daily routine emerged. Furthermore, while the physical conditions may have improved, the human capital was vital, too. The effective functioning of foreign correspondents would have been rendered near impossible without the assistance of local stringers, translators and fixers. Their role in ensuring the continued functioning of the 'system' that had evolved in Sarajevo was vital. As it became clear that the siege was going to continue, the city drew a wide variety of journalists, both those who were well established and experienced and those who were seeking to make their name. In Sarajevo, the norms of journalism – and the competitive character of it – were somewhat rejected and replaced with cooperation on a scale hitherto unknown, with the creation of the Sarajevo Agency Pool (SAP) being the most tangible manifestation of this. An additional, and equally significant, element was the increasing 'armourization' of the press corps which increased rapidly after the death of David Kaplan in August 1992. This shift towards armoured cars, flak jackets and helmets was deemed necessary, although it was not welcomed by all.

Types of journalists: staff, stringers and freelancers

The term 'journalist' covered a myriad of different ways in which a media practitioner could be working, and for a myriad of different dissemination outlets and therefore a wide range of audiences. One differentiation was between the different outlets for their work; print journalists and photographers worked for newspapers and magazines, while broadcast journalists and crews were divided largely into radio and television, although in the BBC there was some overlap between them, and then there were a number of documentary film crews who made long-form films about the siege.

A major distinction within the print environment was between the news agencies such as Reuters, Associated Press (AP), *Agence France Press* (AFP) and the European Press Agency (EPA), who supplied their stories and photographs on a subscription basis to a wide range of clients, and journalists who worked directly for particular publications. The wire service journalists' output was dictated predominantly by the

Figure 4.1 The BBC's Kate Adie doing a piece to camera in Sarajevo, Summer 1995 (Paul Lowe/VII).

breaking news of the day, whilst those who worked directly for one or more outlets had more freedom to pursue stores beyond the immediate news agenda. Another distinction can also be drawn between staff employees, usually for the major news organizations, and freelancers, who would sell their stories and images to clients for an agreed fee. In between there were stringers, usually younger journalists and photographers who were making their names covering stories about which the more senior staff were wary. Martin Dawes of BBC Radio recalled that in Bosnia:

> What started to happen was that it became a place within the BBC that the senior correspondents didn't do … it was left to more junior ones, people who were making their name a bit more. Sarajevo became a place that they maintained full time, and then the deployment of British troops was announced, so they maintained a crew in Central Bosnia full time so that there was always attention for the story.[1]

The etymology of stringer is debated, but in essence it describes a journalist who works on a regular basis for a particular client but who is not employed as staff. A superstringer is a term applied usually to a stringer who has managed to secure a more regular arrangement that can include a contract for a regular payment or retainer for a specified period or number of stories, making their situation less precarious than a simple stringer. Usually this tied the stringer to working for that client exclusively in the particular territory of the publication. Many of the journalists who made their reputation in the former Yugoslavia had been drawn to Eastern Europe in the wake of the fall of the Berlin Wall and the subsequent revolutions across the region, making

their bases in cities like Budapest, Warsaw, Belgrade and Bucharest. Charlotte Eagar was typical of this generation and explains the attraction. She worked as a stringer for the *Daily Mail* and the *Standard* at the time, and recounts how she went to the Ukraine where she spent about three or four months 'mucking around' on what she called her 'teach yourself how to be a foreign correspondent course' which entailed 'going around the edges of the Soviet Union as it was collapsing because it was very cheap and there were lots of stories to do'.[2]

These young aspiring correspondents were therefore well placed at the start of the conflict to cover Yugoslavia, as they already had regular clients and some experience of operating in more difficult conditions, even if they were generally unprepared for the violence of all-out conflict. The more entrepreneurial stringers realized that they could work for multiple clients at the same time, supplying the same stories with a change of headline or title for publications in Britain, Canada and America for example. Charlotte Eagar explained how the same story could be repurposed for several outlets with a subtle change of emphasis. Ironically, working as a stringer could be even more profitable than as a staff reporter, as working for multiple clients meant that the same story could be sold multiple times. Eagar remembers how Chris Stephen, for example, set something of a precedent as he 'would write for *The Sydney Morning Herald*, *The Scotsman*, *The Guardian* and *The Mail* and he would turn the same piece around for five different people. But I didn't want to do that, what I was aiming for was a staff job.'[3] Eagar later secured a contract as a super stringer for *The Observer*, from which point on she remained loyal to that one client exclusively. As she recounts the contract was relatively lucrative, combining a monthly fee plus a payment for each story she filed, 'I was on a retainer of I think £600 a month to start with and then it doubled and then I got lineage on top per piece that I wrote, but I wasn't allowed to write for their competitors.'[4] Photographers were similarly divided between wire services, either staff or stringers, staff photographers for major publications, or as was the case for the majority, freelancers who worked through their own independent agency. In any event, many of the younger stringers lived in Sarajevo – or Bosnia and Herzegovina – on a semi-permanent basis but, despite their obvious commitment to the story, they could be usurped by the visit of a more established staff reporter from London or New York, known as 'big footing' which involved a 'more experienced, generally older and better-paid person who knew less, but who would turn up from London'.[5]

Apart from the wire service staff and stringers, many of the photographers who covered the siege were affiliated with one of the independent photo agencies such as the three French-owned giants of Sipa, Sygma, Gamma, or the cooperatives like Magnum and Network Photographers. These agencies mostly supplied images and stories to the magazine world, predominantly either the weekly news publications like *Time*, *Newsweek*, *Stern* or *Paris Match*, or to the Sunday supplements of major newspapers like the *Sunday Times*, *The Independent on Sunday*, or *The New York Times*. The agencies would syndicate their photographers' work to clients, negotiating fees and usage rights on behalf of their members, allowing the photographers to concentrate on making their images in the field. The marker of success in these markets for the more news orientated photographers would be a cover, or a double page spread, also known as a double truck, whilst those who worked with a more documentary approach would

hope to have their work published as an extended photo essay over several pages. Almost all of these photographers were freelance, although some like Chris Morris or Ron Haviv might have contracts with magazines such as *Time* and *Newsweek*, respectively, that would ensure a reliable income in return for an element of exclusivity. The more established shooters could hope for a guarantee from a particular magazine, which entailed a fixed sum of money in return for exclusive rights to their images in a particular territory. Most, however, worked 'on spec', hoping that their agency could sell their photographs and stories on their behalf.

Local stringers, fixers and translators

It was local staff who were perhaps the most vital part of the infrastructure utilized by foreign correspondents. Their contribution was significant. They were hired ostensibly to translate and for their knowledge of the local context, but they often possessed myriad skills, such as enterprise, reliability, quick-wittedness and an ability to negotiate in sensitive situations such as dealing with military or paramilitary forces manning roadblocks or barricades.[6] As the BBC's Martin Bell noted, 'knowledge is safety – or relative safety', and local staff provided a rich source of information and contacts that could assure relative safety while operating within the city.[7] The foreign correspondents that were more or less permanently based in Sarajevo had equally permanent local staff, while those briefly visiting the city, often worked closely with local stringers, translators and fixers on a more ad hoc basis. Their services would be procured, most often, at the Holiday Inn. Indeed, the Dutch journalist Cees van der Laan recalled that on his first visit to Sarajevo in July 1992 he had 'a driver, a fixer and a translator within an hour of arriving at the hotel'.[8] It was something of a 'buyer's market' for journalists in Sarajevo and many young Sarajevans, the majority of whom had no previous experience working in journalism – but could speak foreign languages – found employment as translators and stringers.[9] Many simply fell into the job, after chance meetings with individual journalists or TV crews, sometimes on the streets of the city. The income was good and thus these jobs were highly coveted because they paid relatively well and always in cash – either deutschmarks or dollars. Most of the wire agencies recruited local stringers such as Danilo Krstanović who worked for *Oslobođenje* as a sports photographer before the war, and who joined Reuters in 1992. Krstanović was by no means alone – a number of Sarajevo-based photographers – such as Milomir 'Strašni' Kovačević, Damir Šagolj, Dejan Vekić, Nermin Muhić, Šahin Šišić, Kemal Hadžić and Nihad Pušija – worked closely with the foreign press corps.[10] Krstanović recalled that this background equipped him well to work in a conflict situation, feeling that he was 'well prepared to shoot the war. Good reflexes, good instincts.'[11] He also felt that his fellow Sarajevans were equal to any of the foreign photographers who came to the city, as they had:

> A view from the inside ... If I were to go to Poland, I don't think I'd be better than a local Polish guy ... the quality of ideas is better on our side. We have a better

understanding of what happens here, what life is like here. They come in for two weeks, a month, and can hardly wait for their shift to end. They cannot love this city the way I do, and I try to bring that to my photos.[12]

Amra Abadžić also started working for Reuters in the summer of 1992. Originally employed as a translator, she quickly became a crucial part of the Reuters operation, which was based, until 1994, in the Holiday Inn. For locals who would work for the press corps their first experience of life in the siege-era Holiday Inn was also a disconcerting experience. Abadžić remembers vividly the atmosphere in the Holiday Inn on her first day. It was, she said, quite surreal: 'The hotel was absolutely full of journalists and photographers. They had plenty of war experience and were, it appeared to me, tough characters that had been to many wars. It was quite frightening to see them in Sarajevo, my home.'[13] Similarly, Džemal Bećirević's own trajectory to working for United Press International (UPI) and, later, *The Washington Post*, first came into contact with foreign journalists in May 1992, when he ran into the BBC's Martin Bell during the intense fighting. In June he met Blaine Harden from *The Washington Post* and Jonathan Landay from UPI in the centre of Sarajevo and subsequently worked as a stringer and translator for them.[14]

Dina Neretljak began working for Agence France-Presse (AFP) in August 1992, as an interpreter – though she would later become a fixer and local stringer for them. Her appointment was 'quite by chance – and rather surprising, given that I had finished English literature at university, did not actually speak French and had absolutely no experience in journalism'.[15] She had, along with Dina Hamdžić – who would go on to work for BBC Radio – and others who would work for international media agencies, studied under Bill Tribe, an Englishman who taught English language and literature at the University of Sarajevo. Neretljak had left Serb-held Grbavica in mid-May 1992, during a truce, crossing the *zeleni most* (green bridge) that spans the Miljacka River near the Hotel Bristol. 'Grbavica had become', she said, 'a nightmare by then.' 'It had been very difficult since March, during the first appearance of the barricades, but by May it had become too dangerous.'[16] She left with her family to stay with relatives in the Breka district of Sarajevo, believing that she would return home in a few days and carrying only essentials and one book – Aldous Huxley's *Point Counter Point* – a book in which one of the main protagonists is Walter Bidlake, a young journalist. She hoped to find work and was informed by her friend, Dina Hamdžić – her one-time neighbour in Grbavica – who was working as a translator for the BBC, that AFP, one of the agencies based in the Holiday Inn, were looking for someone who spoke English to work with them as a translator. The following day, she was interviewed by AFP and was given a three-day trial, with a view to becoming more permanent. 'It was well paid and I really wanted the job', she recalled, 'because it meant I would have something to contribute to my family and I could afford to buy cigarettes, which was an absolute necessity because at that time I smoked'.[17]

The job was, according to Neretljak, 'quite dynamic' and involved gathering news from the previous evening on the Bosnian radio – and then conveying that to her team – then moving on to the PTT building for the UN briefings before beginning work on the day's story.[18] Working for AFP – a wire service – was demanding as they

had to report on events as they emerged and they could not afford to miss anything. This could include reporting on military developments in the city or on the frontline, human stories about citizens of Sarajevo or covering massacres of civilians. It was the latter that was most difficult for Neretljak:

> The main difficulty for me was dealing with issues of real sensitivity. Of course, when there had been a massacre or whether we were covering a funeral, I was obliged to ask questions – after all, if questions were not asked and answered we had nothing. You had to know how best to deal with this situation and, on occasion, I felt like a buffer between citizens and the foreign journalists. Sometimes this was really difficult. If a photographer had a huge camera with a tele-photo lens pushing into the faces of mourners at a funeral, it could be distressing for the relatives of a victim – so I often also had to act as a 'go-between', mediating between locals and the journalists.[19]

Dina Hamdžić also recalled dealing with such sensitivities. 'We were not hired for the purpose of being a buffer', she said, 'we were employed only to translate, to fix interviews and to use our knowledge of the city to help the journalists function properly, but we inevitably provided advice and guidance on cultural norms and what was acceptable'.[20]

Slobodanka 'Boba' Lizdek was rather late in joining the small group of largely young Sarajevans working with these media, though as a polyglot her linguistic skills – she spoke English, French, Spanish, Italian and Russian – made her a perfect candidate. She had returned to Sarajevo in October 1991, having completed her master's studies in Madrid. She was due to embark upon her PhD studies in the US in September

Figure 4.2 Photographers at a funeral in Sarajevo (Rikard Larma/AP).

1992 – which she never, ultimately, enrolled in – and had not envisaged, even when it became clear that the situation in Sarajevo was worsening by the day, that the war would last for long. 'I stayed in Sarajevo', she said, 'because I imagined it would all pass and that it wouldn't last more than a few weeks; two months, at that time, was unimaginable – besides, I planned to go to the US as soon as I could.'[21] During the early months of the siege she instead worked with a small group of friends to produce an amateur fanzine called *Libero* – four editions of which were printed between April and September 1992. Having refused an offer to work for UNPROFOR in May 1992, by the summer and autumn of 1992, she realized that her early optimism that the war would be short was misplaced. Moreover, the situation was becoming more difficult for her family, with whom she lived with in Čengić Vila. Her parents had been relatively well off but their savings disappeared with the collapse of *Jugobanka*; now they were in the midst of a particularly harsh winter with little money, food or wood to burn. She recalled:

> By December 1992, I decided that I needed to earn money and I had something to offer the foreign press corps because I could speak different languages. I went to the Holiday Inn, under some quite heavy shelling on that particular day, to enquire as to whether there might be any jobs and the first person I met there was a Spanish journalist called Julio Fuentes who worked for *El Mundo*. We spoke Spanish for a few minutes and by the end of our conversation he had offered me a job, translating and fixing for 100 dollars per day, and sometimes more if there were particularly difficult or dangerous assignments. That's how I started.[22]

Lizdek would go on to work for a number of French, Italian, Spanish and Mexican media agencies and individual journalists, but primarily with the French newspapers *Libération* and *Le Monde*.[23] 'The job was very diverse; I was mostly translating but sometimes I was essentially a field producer, finding stories and keeping up with events as they happened.'[24] Lizdek's summation of her role is not untypical. Many of the local staff were absolutely invaluable to the foreign journalists and TV crews. Their intimate knowledge of the city and its social, economic and political dynamics were absolutely essential in facilitating the work of the foreign press corps.

Similarly, Samir 'Krila' Krilić began working for AP in December of 1992, though he had some previous experience working for the media, having worked for the local Sarajevo TV station *Dobre vibracije* (Good Vibrations) before the war. However, he had joined a unit of the Bosnian special forces – led by Dragan Vikić – in April 1992 but was wounded three months later. During his recovery, he was approached by Ron Bagnulo of ABC to do some work as a fixer and translator.[25] Krilić was ideal for the role – he was smart, streetwise and, as a native of Sarajevo, knew the city well. He also spoke excellent English, which he had honed at American school in East Pakistan – now Bangladesh – where his father, a civil engineer and project manager for *Energoinvest*, one of many Yugoslav companies that won contracts from non-aligned countries. Krilić worked for just over a month for ABC and was then introduced to Tony Smith from AP who offered him a job. He would become a key member of the AP team based in the Hotel Belvedere.

The Sarajevo Agency Pool

TV crews were in particular danger while attempting to document events in the city. As the BBC's John Simpson noted, 'Television is nothing without pictures, and to get the pictures the crews were obliged to stand out in the open, often being very exposed in so doing.'[26] In a context where there were a growing number of TV crews operating in Sarajevo, the danger was increased by everyone attempting to cover the same incidents. Though he can hardly be regarded as risk-averse, the BBC's Martin Bell nevertheless became acutely aware of the dangers to which he and his fellow journalists – particularly TV crews – were exposed and sought to limit their exposure where possible. He disliked what he referred to as 'hotel roof dish monkeys' – journalists who would rarely leave the hotels in which they were staying – of which, he added, there were few in Bosnia – but he recognized that the journalists, more precisely, the news agencies they worked for, were increasing their risk by competing with each other to garner the most sensational stories and the most powerful images and mitigate against this competition becoming fatal – thus, the Sarajevo Agency Pool (SAP) was created.[27] The principle was, said Bell's BBC colleague Allan Little, 'if you can't reduce the risk then reduce the number of people exposed to it, so for stock events it made sense to have fewer people there and share the footage'.[28] According to David Rust, a CNN cameraman, before the SAP emerged journalists were being unnecessarily exposed by their desire to obtain the best footage. In the early days of the siege, he said, 'all TV outlets would rush from a shelling site to the hospital and then drive around the city

Figure 4.3 Sean Maguire, Kurt Schork and Corrine Dufka with the SAP armoured car (Courtesy of Sean Maguire).

collecting reactions. It was difficult to cover all of the bases with multiple crews at each location, crews were being put in danger.'[29]

In order to mitigate these dangers, Bell led the establishment of the SAP, a collective which sought to minimize the risk to journalists and cameramen. It was, said, Bell, 'an unprecedented experiment, a voluntary pooling between the TV networks and news agencies' that would mean 'that there would be no exclusives, but the coverage would be available to everyone'.[30] CNN's David Rust described how this worked in practice:

> If, say, a market was attacked and many civilians were killed or injured, the local Bosnian crew would immediately go to the marketplace. Since most of the TV workspaces were in relatively close proximity, we would coordinate who went where. One crew went to the hospital, another to the airport or PTT for [UN] reaction and maybe another to the Presidency for comment. At the end of it all, we could come back to the TV station and make dubs of all the work.[31]

Rust added that 'Because of the SAP, our stories contained more material [and] the crews were less exposed to danger' and that 'keeping journalists as safe as possible was more important than exclusives or competition'.[32] Christiane Amanpour added that, 'We all worked together, though we didn't necessarily share our feature stories. However, instead of all of us rushing to an incident in the city – and risk being targeted – we decided it was best to delegate tasks, take it in turns and share the footage.'[33] In this regard, the local staff played a particularly key role. The Sarajevo-based cameramen, Muharem 'Hare' Osmanagić – who had previously worked for YUTEL – and Semsudin 'Čenga' Čengić, were particularly notable for their bravery and their willingness to take risks to garner footage that would then be shared by members of the SAP. According to Martin Bell, 'Their contribution and courage were never sufficiently acknowledged, but their coverage was transmitted all over the world and had a lasting impact.'[34] Yet, while the SAP undoubtedly saved lives, he acknowledged that the SAP wasn't, ultimately, popular. 'It penalized the brave. It rewarded the indolent who did not leave the hotel or their bunkers at the TV station.'[35] Journalists, he said, 'are not by their nature team players'.[36] Nevertheless, the arrangement lasted until the summer of 1995 when Reuters TV opted to leave the SAP over the issue of archive rights, a move which heralded the end of what had been a novel experiment that lasted much longer than might have been expected.

Armoured cars, helmets and flak jackets

At the beginning of the siege, those foreign journalists who were reporting from Sarajevo drove soft-skin vehicles and what were essentially lightweight bulletproof vests, not proper flak jackets. Some simply did not have access to such equipment. As the EBU's Zrinka Bralo recalled, 'At the beginning, many of the young and rather inexperienced journalists were almost a danger to themselves and they simply did not understand the dangers that lurked around every corner.'[37] Even those who worked for news agencies were not sufficiently protected. Christian Amanpour recalled that:

> We didn't know we needed greater security at the beginning, and so we all drove around in soft-skin cars. But in the Bosnian war, journalists were actually deliberately targeted, which was a new situation for us and nobody was prepared for it. In previous wars, journalists had generally been injured or killed when they were caught in the crossfire – here, however, we were targets, so after the death of David Kaplan we at CNN, and those in other international news agencies, started re-orienting ourselves towards greater safety and security'.[38]

Though a number of journalists had been seriously wounded, this process did not begin in earnest until after the death of David Kaplan in August 1992. Indeed, as the risks of reporting from Sarajevo became evident, the bigger news agencies would purchase armoured cars for their employees – the BBC and CNN were the first, but others soon followed – rather than have them traverse the city in 'soft skins'. Such cars, of course, afforded little or no protection. The dangers of driving down 'Sniper's Alley' in a normal car were apparent to all who made the journey. 'We took real chances taking the route from the airport to the Holiday Inn in a soft skin', said Zoran Kusovac of Sky News, 'my car was like a sieve, having been hit many times'.[39] The basement car park of the Holiday Inn was full of cars in various states of disrepair, many riddled with bullet holes and missing windows, almost all with 'Press' or 'TV' painted on the doors or bonnets. As Paul Meller, writing in *The Guardian,* pointed out, 'the concept of *armoured journalism* was born, with flak jackets and armoured cars becoming the norm for correspondents'.[40] The American photographer Ron Haviv recalled the shift towards armoured vehicles:

> As the numbers of wounded increased, it really kicked it up a notch ... the BBC was one of the first to bring in the armoured vehicles and then that kind of followed to the point where even like photo agencies like Sigma had a small armoured vehicle. This was particularly the case in Sarajevo itself when dealing with the dangers within the city. It did look odd to be kitted up photographing a mother holding a child trying to cross the street. For many of us, myself included, there were times it felt uncomfortable but I knew it was necessary. If you were driving down Sniper Alley you *had* to protect yourself as much as possible.[41]

As Haviv noted, the BBC were among the first to bring armoured vehicles to Sarajevo. Their soft-skin car was, by July 1992, reaching the end of its life. As the BBC's Jeremy Bowen recalled, 'the first car I used in Sarajevo was the old Vauxhall Carlton that had been used by Martin Bell and his crew; it looked like a Mad Max vehicle and had so many bullet hoes in it felt like it was being held together by gaffer tape'.[42] After Martin Bell and his crew were hit several times crossing the runway at Sarajevo Airport whilst returning from a trip to Jahorina – held by the VRS – he called his editors in London and demanded better protection. Despite his misgivings about the efficiency of the BBC system, which he described as hiding 'behind a blizzard of paperwork and a maze of interdepartmental meetings,'[43] within two weeks an ex-British Army armoured Land Rover that had seen service in Northern Ireland with the Royal Ulster Constabulary was secured for the TV crews. Painted white to conceal its military origins, it was quickly

nicknamed 'Miss Piggy', the four-and-a-half-ton vehicle was difficult to manoeuvre but Bell felt reassured by her solidity, recalling that 'from within her armoured recesses the war seemed different and somehow survivable'.[44] However, the new arrival caused some consternation amongst the BBC Radio team, as Allan Little recalled:

> It caused a bit of unease among us rotating radio correspondents because it looked identical to our unarmoured vehicle – right down to the logo on the side. For a few weeks we drove around thinking that by now word has got around that this is an armoured vehicle and people might take the odd pot shot at it for fun – except ours isn't armoured at all.[45]

Miss Piggy was soon followed by another Land Rover, this one dubbed 'Winnie the Pooh'. It was driven into Sarajevo by the redoubtable Allan Hayman, the corporations fleet manager who, as an ex-British Army Regimental Sergeant Major in the Royal Electrical Mechanical Engineers, had the necessary experience to organize the complexity of keeping the growing fleet of vehicles maintained. 'You have to supply the logistics of a small mechanized army' is how he described the task to the American reporter Blaine Harden. Hayman's expertise went as far as even building an armoured cab for a soft-skin Land Rover in the basement garage of the Holiday Inn from steel plates he carried out from the UK in the back of 'Winnie the Pooh'. To the relief of the radio correspondents, they too soon received a Land Rover with an armoured cab, painted a bright yellow to distinguish it from the TV vehicles it was initially dubbed the 'Yellow Peril' before becoming more affectionately known as 'Piglet'.

Figure 4.4 One of the BBC's armoured fleet in Sarajevo (courtesy of Sean Maguire).

By August 1992, many of the news agencies began acquiring armoured cars, following the BBC's lead. CNN also brought in their first armoured car, though it was petrol – which was more problematic in that fuel could not so easily be sourced and was, in the event of being hit, potentially more dangerous. The Sky News team in Sarajevo had also been attempting to persuade their superiors to provide an armoured car for them, and they had a piece of fortune in that one of their cameramen, George Davis, used to race Land Rovers back in the UK and had very good contacts with the company. They subsequently bought a diesel Land Rover with an external add-on kit; fuel was not a problem, as it could, according to Zoran Kusovac, 'always be sourced from UNPROFOR in exchange for food, alcohol or cigarettes'.[46] He recalled, however, that the Land Rover that arrived was not quite what they had expected:

> These kit vehicles pre-dated the siege of Sarajevo and were designed as an add-on kit for Land Rovers that were intended to be used by British diplomatic missions and deployed in countries that were considered potentially unstable. So, they would be 'normal' Land Rovers and would then be 'kitted-up' by technicians in the event of armed conflict breaking out. To do this, however, you needed the full kit. But because demand was so high, we did not receive the completed version: we had an armoured 'pick-up' truck and the rear of the vehicle was to be sent out and installed later *in situ*. This means we were a little constrained for a while because not all of our crew would be protected and some of us still had to travel in soft-skin cars.[47]

The BBC, some of whose armoured fleet was also only 'cabbed', were happy to share their knowledge with their colleagues, as there was a realization that the situation in Sarajevo was unique. As one of their field producers, Anthony Massey, explained 'We are the leading news organization when it comes to safety, we are freely sharing our experience with any agency that wants to know. We have a theory that in Bosnia nobody loves the journalists, so we better love each other.' Massey went on to detail how the need for enhanced security and protection for correspondents and crews had been recognized at the highest levels:

> We have never had to do this before, not in Northern Ireland, not in Lebanon, not in Africa, not anywhere. But everybody in our senior management feels Yugoslavia is too important not to cover. It is in the middle of Europe ... Basically a city the size of Bristol is being tortured just down the road from London, and we have a responsibility to be here. If you do it, you've got to do it properly.[48]

This attitude was increasingly shared by many of the other organizations sending their staff to the city. According to Tony Winning, then Reuters' European News Editor, the agency knew how dangerous it had become in Sarajevo and that 'we had an obligation to our staff there, some of whom were relatively inexperienced, to ensure that they had the best level of protection that we could provide in a situation where they could easily get caught in the crossfire'.[49] Thus a greater number of armoured cars were imported into Sarajevo. Visnews purchased an armoured Audi saloon that had been bought in

Germany and was, according to Sean Maguire, 'once owned by a German industrialist who feared attack by the Baader Meinhof gang'.[50] However, it was not a four-wheel drive and was extremely heavy. They could, said Maguire, 'move quite fast if driving in a straight line, but they really struggled if you needed to turn quickly'. Thereafter, Reuters purchased their first Land Rover that was re-fitted with armoured plates. Some of the armoured cars were only 'cab armoured' in the front of the vehicle – where the driver was positioned – and some were fully fitted and equipped armoured cars – though these were, of course, far more expensive.[51] Armoured cars, though they offered no real protection from heavy weapons, would protect the driver and passengers from sniper fire or machine gun fire – on the downside, they were 'top heavy' and could be difficult to control. They did, however, save lives. Sean Maguire recalled one such instance:

> We were driving back from the TV station down Sniper Alley in a SAP armoured car. We were hit by a sniper bullet and the noise was indescribable. The bullet had hit the door just above my head. If we had been in a soft skin car the bullet would have undoubtedly hit the passenger. It was testament to the solidity and power of these vehicles that they could absorb the impact. It saved our lives on that evening.[52]

Other journalists also convinced their bosses that the protection afforded by a 'hard car' was a necessity. Chris Morris persuaded *Time* magazine that it would be a wise investment and set about sourcing a suitable vehicle, knowing that the demand for Land Rovers was high. He opted for an alternative:

> I had done research and I found out the companies that the US government use to armour 'Suburbans' and I realised the pickup truck was perfect. You could buy a truck for 14,000 dollars unarmoured, but I just had to get it armoured. So, I found the company that worked for the US State Department and they gave us this amazing deal, a complete truck, the whole thing for 50,000 dollars. It was an amazing truck, 6.5 litre turbo-diesel, they put two extended 300-litre fuel tanks. With the cost of fuel there basically I could fill up with probably 5,000 dollars-worth of fuel because fuel was so expensive on the black market. Then to get it here, to show you the urgency of it, they didn't put it on a boat, they flew it from Dallas to Frankfurt on Lufthansa Air Express for 14,000 dollars, same as the truck, and I drove it into Sarajevo.[53]

Morris' truck was equipped with run-flat tyres and, though it was by far the strangest looking armoured vehicle in Sarajevo, it served him and the *Time* team well; indeed, despite being damaged by gunfire and shrapnel multiple times it survived for the duration of the war. Thus, armoured cars undoubtedly saved lives and while, for some, acquiring them was deemed a necessary evil, many journalists recognized that it was also a 'barrier' between them and the ordinary citizens, who had no such protection. Some of the armoured cars, too, brought difficulties – they were a mixed blessing; forever falling off mountains or rolling into ditches.[54] They also brought additional logistical problems. According to Pierre Bairin, who was video editor with CNN, 'The

armoured cars were constantly requiring attention; they would frequently break down and would constantly require spare parts. So, the logistical challenges just keeping them on the road were significant.'[55]

The wearing – or otherwise – of flak jackets was also an issue that divided the press corps. In the early months of the siege, only a few foreign journalists had anything like the kind of 'body armour' that they would later acquire, such as the tabard vest with Kevlar ballistic plates. By the late summer of 1992, it became commonplace to see journalists wearing flak jackets – with the journalist's blood type prominently displayed on them, should they require a blood transfusion – and helmets. When Peter Maass of *The Washington Post* arrived in Sarajevo in July 1992, he had a light bulletproof vest that he had borrowed from the 'Budapest police department'. The UN soldiers that he encountered at the airport asked him if it was 'filled with straw'.[56] He soon realized that he needed something more robust:

> As the war dragged on and became a deadly serious affair for journalists, the flak jackets got heavier. Within a few months of my maiden visit to Sarajevo, I had spent 1,500 dollars of the *Washington Post's* money on something called Body Armour, Level II, at a survivalist shop in a seedy part of London. The thing weighed twenty-five pounds, had an internal cushion of Kevlar, bullet stopping ceramic plates in the front and back, a Kevlar collar to protect your neck and a flap that you pulled down from the waist to cover your groin. Its colour was a menacing shade of dark blue. It was the real thing, and the UN soldiers took me more seriously.[57]

Whatever the perceived protection such 'armour' gave you, added Maass, it could also heighten the sense of vulnerability because 'regardless of the physical protection it offers, the mental security it provides is negligible'.[58] David Brauchli from AP, wore a flak jacket but often without the additional Kevlar chest plates which, he said, were 'very heavy when you were carrying all of your camera equipment and, in a situation where you had to run around a lot, they could be as much of a hazard as a benefit'.[59]

For most, however, wearing a flak jacket was regarded as necessary. According to Joel Brand, there was no dilemma among the majority and that 'if you wore them, it wasn't something that you put on as you started your journey, the way one might casually buckle-up a seatbelt after you had begun driving. Even stepping outside the door without a flak jacket and helmet felt very risky.'[60] Likewise, the BBC's Jeremy Bowen noted that while he felt 'Very uncool, in every sense of the word, sweating in my flak jacket while other people wandered around in their short sleeves', it was simply prudent to wear one. After all, he said, 'All of us had seen people dying or dead, who hadn't had one, with tiny shrapnel wounds in the chest. A piece of shrapnel the size of a pea can kill you if it goes into your heart.'[61]

Some media organizations insisted upon their staff wearing body armour. According to CNN's Christian Amanpour, 'not much was put in place with regard to greater safety measures after Margaret Moth was shot; it was really only after the death of David Kaplan that we started receiving flak jackets and, at times, armoured vehicles'.[62] David Rust recalls that after Kaplan's death:

CNN decided to invest heavily in protective gear. According to CNN management in Atlanta, we were required to wear bullet-resistant vests and helmets while on assignment. As a rule, we wore the gear every day, though some team members felt the sheer weight of the vests made them difficult to work in. Of course, the vest and the helmet would not have made a difference to Margaret [Moth] since she was shot in the jaw, but I felt that I owed to it my own family to take as few risks as possible.[63]

Some understood the drawbacks, in terms of creating a barrier between themselves and ordinary citizens but, equally, understood the need for wearing them. According to Marcus Tanner, flak jackets 'created an extra barrier to communicating with a community from whom we were already separated by dint of the fact that we had regular food, and they didn't, and we could come in and out of the city, and they could not'.[64] Allan Little acknowledged that flak jackets 'separated us from the experience of local people – but, then again, we were outside, exposed and moving around the city much more than most people, so there was a logic to wearing them'. Even then, he added, 'there was no guarantee that a flak jacket would save you, and people were killed even while wearing them – but they did, if nothing else, improve your chances should you come under fire'.[65]

Likewise, Bob Simon of CBS stated that while he believed it to be reckless not to wear a flak jacket 'most days' in Sarajevo, but that 'it made you feel miserable ... when you are wearing a flak jacket and doing a story on Sarajevo and you are mixing with civilians who are not ... it's a terrible, terrible feeling'.[66]

For the local stringers and fixers who would accompany foreign journalists, the wearing of flak jackets was somewhat taboo. Though it was the policy of his employers to wear flak jackets and helmets (AP), Samir Krilić would wear his 'only when we knew it could be very dangerous' because 'out of respect for my fellow citizens, I couldn't wear one – when you show up, as a local, with head-to-toe in helmet and body armour, it changes they way people see you; you are no longer sharing their experience'.[67] Some flatly refused to wear them, including Boba Lizdek, who chose not to do so; 'Not because I was irresponsible but because I was in my own city and among my own people. How could I talk to them when I had protection, purely because of my work, and they did not?'[68] For Amra Abadžić, however, the wearing of a flak jacket proved crucial – the first time she wore one, it saved her life. When Abadžić first started working for Reuters in the summer of 1992 she was not initially equipped with one, but soon after they sent out enough to supply the whole team. She recalled how she was initially resistant to wearing one, as 'at the time I weighed forty-six kilos, I was very thin and the jacket was about twenty kilos, almost half my bodyweight, so it was difficult to walk in it for me'. However, when the Reuters team went – with a BBC TV crew that included Jeremy Bowen – in August 1992, to cover the funeral of two children, Vedrana Glavaš and Roki Sulejmanović, who had been killed by sniper fire near the *Oslobođenje* building during their evacuation from the Ljubica Ivezić orphanage in Sarajevo, Kurt Schork told her that she had to take it with her. According to Abadžić:

> The funeral was in the Lion's cemetery, we were quite visible. We could hear some shooting starting and Kurt insisted that I should put the flak jacket on. Literally a

few minutes after that they started shooting with anti-aircraft cannon. There was mayhem in the cemetery, I felt like someone punched me in the back around my kidneys, and I thought to be honest with you that was it, all the people I'd interviewed before that said that when you are hit you don't feel the pain when the wound is still warm. I was wearing white trousers, so I was looking down for blood, and then I realised that the flak jacket had been hit and it had broken the lower part of it but it didn't penetrate through, I just had a really bad bruise for quite a few days.[69]

However, despite all reasonable precautions, and the wearing of a flak jacket, the risks remained. Martin Bell was wounded by shrapnel from a mortar which landed near the *Energoinvest* building, where he was preparing to give a piece to camera. Bell, who made no secret of being superstitious, had narrowly escaped being hit while reporting – live – from a balcony in the Hotel Bosna in Ilidža in May 1992 and had developed thereafter a relatively complex ritual of always wearing his trademark white suit and green socks – walking in and out of the hotel through the same – broken – window, walking to his room in a clockwise – never anti-clockwise – direction and carrying on his person a number of good luck charms, including the bullet extracted from the wall of the Hotel Bosna. He also committed to listening every day to both sides of a cassette of 'The Love Songs of Willy Nelson'.[70] The American singer-songwriter is, according to Bell, the 'troubadour of war correspondents'.[71] However, on 25 August 1992, despite wearing a flak jacket, he was shot and wounded near the Maršal Tito barracks.[72] Bell recalled the moments leading up to the incident:

> The crew and I stopped at a place we knew very well and I thought it was, well, relatively safe. We filmed for a while and then stopped; we had done this kind of piece before so we decided to go back into the car. But then we heard shooting and I thought we should get the camera out again. At that point, I didn't have any footage, which we needed. And it was while I was outside that I was hit. I made a mistake, broke one of my own rules and got hit. It's a trade-off and, on that occasion, I got my calculations wrong.[73]

Bell had been wearing a helmet – though he had not fastened it properly – and a flak jacket, though it did not protect him from being hit 'underneath the flap'.[74] In any event, Bell was taken to the Triage Centre in the PTT building and then medevaced to the UK. The bullet that had almost killed him on the balcony of the Hotel Bosna had been stolen along with a small amount of money and his passport. 'I thus had', said Bell, 'the unusual experience of being wounded by the Serbs and robbed by the French on the same day.'[75]

Some journalists were, despite the relative protections they provided, critical of the shift toward the use of armoured cars, flak jackets and helmets. While the majority that possessed them understood them to be necessary – while simultaneously recognizing their drawbacks – others saw their use as nothing short of grotesque. Remy Ourdan of *RTL* and *Le Monde* could 'never wear a flak jacket or helmet among the citizens of Sarajevo' and would never drive an armoured car, even though he had access to one. 'Both *RTL* and *Le Monde* bought armoured cars', he said, 'and as their permanent

correspondent in Bosnia & Herzegovina I had the keys for those cars – but I never used them because I did not consider it appropriate to use an armoured car while living among citizens who did not have access to such protection'.[76]

The most strident of the critics of the increasing use of armoured cars and flak jackets was the French radio reporter Paul Marchand. He had reported from, and lived in, Beirut before coming to Sarajevo, and had a number of 'strings', working for French, Canadian, Swiss and Belgian radio stations, and though he did not have the clout of a big media organization behind him, he became one of the best-known figures among the journalists in Sarajevo – largely, though not exclusively, for his eccentricity.[77] Almost always immaculately dressed, often donning a straw hat and constantly puffing on large Cuban cigars, he would spend his evenings in the Holiday Inn playing poker and talking politics. He could, on occasion, be brusque and uncompromising. A self-declared 'artisan', he refused to wear a flak jacket because he could 'not find one that matched his clothes'.[78] Marchand not only drove a 'soft-skin', a white Ford Sierra, but one with 'Don't shoot, you will waste your bullets, I'm immortal' written in large letters in English and, in Latin, *Morituri te salūtant!* (For those about to die, we salute you!) emblazoned on the bonnet and rear his car. He would, according to John Burns, 'mock the flak jackets and helmets of his fellow reporters', while driving around Sarajevo in a battered car 'with doors that must be held shut and a broken exhaust system that advertises his arrival from a mile away'.[79] And this was merely one example of Marchand's idiosyncratic and eccentric behaviour – other antics included regular abseiling sessions from the highest points inside the atrium of the Holiday Inn and down the adjacent Unis towers. On one occasion he even persuaded Hugues Renier, the French guest conductor of the Sarajevo Philharmonic Orchestra – who played a concert in the hotel in 1993 following a recital in the destroyed Sarajevo City Hall – to conduct while suspended by climbing ropes from the atrium roof of the Holiday Inn.[80]

Marchand genuinely took risks and was often scathing of what he regarded as journalists becoming detached from the reality of the conflict by traversing Sarajevo in armoured cars while wearing flak jackets and helmets. Interviewed by the filmmaker Marcel Ophuls in 1993, Marchand, railing against their use, stated that such cars were merely 'status symbols'. 'I'll never get in an armored car' he said, 'I'm an artisan; I stay one. There are people who even wear a vest and flak protection [and drive] an armored car … it'll be a chain reaction – tomorrow a bodyguard, in a year, army protection. That's journalism?'[81] Marchand learned to adapt to the 'rules of the game' in and around the hotel and in Sarajevo. He took, no doubt, significant risks, but maintained that his approach was authentic and thus justified. But he, too, was badly injured in October 1993, when the Alfa Romeo car he was travelling in with Philippe Lobjois, a French reporter working for the French-language Belgian newspaper *Le Soir*, and Boba Lizdek was hit in Lukavica, in the area between VRS and UN checkpoints.[82] After the shooting, in which Marchand's right arm was badly lacerated, Lizdek succeeded in reaching the UN checkpoint where Marchand was taken to the Triage Centre in the PTT building before he was medevaced to Ancona in Italy before being returned to France. After numerous operations, he spent the subsequent years writing novels – he had to learn to write with his left hand after losing the ability to do so with his right – but struggled to cope with the reality of being unable to continue doing the work he loved. He committed suicide in Paris in 2009.[83]

The car that Marchand, Lizdek and Lobjois had been travelling in was a 'soft-skin' and their misfortune served to illustrate the fact that traversing the city in such a vehicle was very dangerous. Of course, many journalists working in Sarajevo had no access to armoured cars as they either worked for agencies that would not invest in them, or were working as freelancers and could not afford them. One way to circumnavigate this problem was to rent one for short periods. One enterprising photojournalist who realized there was a 'gap in the market' was Gary Knight, who came to Sarajevo for the first time in 1993.

He had spent much of the previous five years in Cambodia and Burma and the first time he visited Sarajevo – having travelled from Split over the Mount Igman road – he was struck by the harshness of the landscape and of the Bosnian winter. 'I just remember how cold, grey and bleak it was ... and I remember it being like some dystopian nightmare.'[84] That first trip included a long trek into the besieged town of Goražde, as well as familiarizing himself with Sarajevo. He would frequently return to Bosnia and Herzegovina and, thereafter, to Sarajevo, though transport was always an issue:

> The transport logistics were, unless you worked for a big news agency, a nightmare. There were no cars to rent in Sarajevo and I couldn't have afforded to rent one even if there had been. I occasionally hitched rides with people who did have cars, though most of these were not armoured cars. The photographers I knew who had cars were ones that were rentals from, say, Vienna, which were reported as stolen as soon as they crossed the border. These cars would be trashed and end up sitting in the basement garage of the Holiday Inn. So, my principal memory of my early months in Sarajevo was that I walked everywhere, unless I could hitch a ride with someone else.[85]

Figure 4.5 Gary Knight at work in Sarajevo, Summer 1993 (Paul Lowe/VII).

Prior to his second stint in Sarajevo, Knight met, by chance, an Australian cameraman called Robbie Wright, who wasn't on assignment but had brought an armoured car which he planned to rent out to TV companies for a fee of 1,000 US dollars per week. Though he had 'absolutely no money' to buy one, he committed to exploring the idea further at the end of his latest assignment. Indeed, upon his return to the UK, he met with his friend Greg English, a former Sigma and AP photographer. They agreed, even though they had almost no money to invest in the idea, to work together to raise the funds they needed – approximately 100,000 US dollars. While visiting his mother in Solihull Knight decided to go to Coventry and to the headquarters of a company called Courthaulds – on the recommendation of the BBC's fleet manager, Alan Heyman – that built armoured cars for the British Army. He made an appointment to see one of the company's sales managers in their warehouse:

> I walked in and told the sales manager that I wanted to buy one of their armoured cars and take it to Bosnia. He had no idea who I was but he was very charming. Anyway, he talked to me about the armoured car – some technical details and so forth – and then explained that in order to buy it we needed to have an arms trader licence, that he couldn't sell an armoured car to an individual. The next problem was that not only did we not have a company, we had no money. He looked at me in horror, but I explained that our plan was to take the vehicle to Bosnia, rent it out to American agencies such as ABC News, CBS News and NBC News for a rate of 1,000 U.S. dollars a week. I told him that when I had the money I would come directly here and give it to him. After a moment of silence, he picked up the phone.[86]

The sales manager called Alan Hayman at the BBC and explained that a young man was in his office and that he was asking to walk out of Courthaulds with an armoured car without a deposit; could he be trusted? Hayman responded that he could. But trust wasn't quite enough. It was explained to Knight that he would not walk out of the warehouse with a promissory note and an armoured car – he would have to set up a company and would have to provide a guarantor. Setting up the company – in the Channel Islands – that would give them the arms' traders licence was relatively easy and was completed within days. The new company, called 'Knight & English', could now legally purchase the armoured car. The guarantee, however, was provided by Knight's then girlfriend, now wife, Fiona Turner who worked for ABC – the two had met in Tuzla during Knight's first trip to Bosnia – and who had money in the bank because she had recently sold her house and had not yet bought another. So, with all of this in place, Knight drove out of Courthaulds with a British Army Kevlar Land Rover, which he and Greg English then drove from the UK down to Split. Their gamble soon paid off, as Knight explained:

> We had literally no money left when we pulled into the Hotel Split. We needed a stroke of luck and we got it. The hotel was full of journalists and TV crews, and we managed to reach a deal with a CBS crew on the spot – they rented our brand new armoured Land Rover 30,000 U.S. dollars for thirty days. They gave us a cash advance so that we could get home.[87]

Upon returning to the UK, business improved further. An NBC crew had crashed their armoured car and wished to rent a new one; when the CBS 'contract' finished, the armoured vehicle was rented immediately to NBC for three months. Thus, within four months of walking out of Courthaulds, 'Knight & English' had paid the company back. 'I only wanted to do something that would pay off my overdraft – I had no desire to become an armoured car dealer, I had no resources to do it all again; the problem was that Greg and I were the only journalists who could legally acquire them.'[88] So, by accident rather than design, business began to flourish and 'Knight & English' would go on to purchase a further armoured Land Rover for NBC – with NBC providing a six-month contract as way of guarantee of payment to Courthaulds. Once this transaction was completed, the demand continued to increase and Knight was buying Land Rovers and Range Rovers – both armoured and soft-skin – from all over the UK. 'Pretty much everyone I knew with a driver's licence was persuaded to help me take these cars down to Croatia ... because we had, at one point, amassed thirteen or fourteen cars, which, by the time the contracts had ended, we had to take back to the UK, re-spray them and resell them.'[89]

Knight was not the only foreign journalist to make an additional income through the rental of armoured cars. Joel Brand and Alexandra Stiglmayer decided to buy a bulletproof car, take it to Sarajevo and rent it out to visiting foreign correspondents. Stiglmayer bought a used armoured Volkswagen Golf from Italy. After some issues with registration, Brand drove it down to Sarajevo where he rented it out to whoever needed the protection. 'I already had a Washington Post/Newsweek armoured car, so the Volkswagen was only for renting out, and it was out on rent almost constantly. We rented it out to Annie Liebowitz, for example, when she was in Sarajevo.'[90] The money generated was more than enough to sustain Brand when in the city. 'We could charge up to 500 US dollars a day, so it was a reasonably profitable enterprise.'[91]

Water, electricity and heating

Flak jackets and armoured cars had, by late 1992, become the norm and the preserve, largely, of those who could afford them. But it was the basic necessities that were often in short supply. The Holiday Inn was the only hotel in Sarajevo that could provide everyday supplies such as water, a – reasonably – consistent supply of electricity and, when required, heat. Water was hardly plentiful at the Holiday Inn, but cisterns of water were delivered by truck on a – more or less – weekly basis, allowing for a supply of water, albeit limited and, of course, cold. There were no such luxuries for ordinary Sarajevans for whom collecting water often meant embarking upon a treacherous journey – mainly on foot or by bike – carrying large and heavy jerry cans from the nearest available source of water to their homes.[92] That access to water was severely curtailed by the Bosnian Serbs was no surprise; that access to it was 'impeded from within' is more so.[93] According to Andreas, television images of Sarajevans carrying water for their families under sniper fire was 'highly visible evidence for a global audience that the civilian population was a victim of Serb aggression'.[94]

Whether subject to the political or economic dynamics of the siege, water was a valuable commodity. When there was no water supply in the city, and thus in the hotel, staff found ways of providing a limited supply for the guests, capturing the last of the remaining supply from the basement, where the little water that remained would drip slowly from the taps. Here it would be bottled and distributed to the hotel's guests, normally in empty wine bottles – the hotel had long exhausted their stocks of mineral water, so this bottled water would often be used, when absolutely necessary, as drinking water. But these rations had to be used sparingly, and for the most basic of functions. As UPI's Kevin Sullivan recalled, 'Water was infrequent, which meant there was a permanent miasma emanating from loos that were never properly flushed; water had to be kept for the essentials – basic washing and flushing toilets with the minimum amount of water possible.'[95] The guests, too, would seek to collect and preserve their own water supply when it was viable to do so. 'There were rarely', according to Jeremy Bowen, 'protracted periods without *any* water, but it could be pretty irregular.' He maintained a supply in his own room by 'keeping the bath full of water so that I could immerse myself in it in an attempt to keep clean – and when it got too dirty I would use it to flush the toilet'.[96] But the water could be replenished periodically. According to Bowen's colleague Allan Little, 'A water tanker would arrive at the hotel every couple of weeks or so and fill the cistern, but you had to make sure you were in so that you could fill your bath tub to the brim to last you till the next delivery.' But it was, he said, 'a catastrophe if you hadn't put the plug in properly and the water you'd carefully stored drained away slowly in the night'.[97] Bath plugs, therefore, became an essential item of kit to be packed in advance of departure to Sarajevo; a simple item that proved invaluable.

Bathing was, however, generally endured in cold water. This, according to Joel Brand, meant simply that one 'had a tough choice between a heart-stopping plunge into a bath full of cold water or adding another day's layer of adrenaline-laced sweat to our already unwashed bodies'.[98] Myriad ways to circumvent the need to bathe in cold water were found. Some of the hotel's guests brought their own electric elements, which after a few hours would heat the water sufficiently to bathe more comfortably. But in the winter, when demand for electricity was high, these electric elements drained a lot of power, and their use became increasingly unpopular with the hotel management. The heating elements would, if discovered, be confiscated.[99] For the few 'in the know', there was, however, an alternative. There existed a 'secret' supply of hot water to which, according to Džemal Bećirević of UPI, very few of the guests had access. 'I knew some staff at the Holiday Inn', he said, 'and they told me there was a room in the basement which had extremely hot water – I think because of the proximity to the kitchens – so I used it on occasion, and, occasionally, told some of my colleagues about it.'[100] According to Kevin Sullivan, Bećirević's colleague at UPI, who used the shower – though rarely – 'Usually by the time we got there, the water had been reduced to a scalding trickle but it was still possible to soak a towel, allow it to cool a little and conduct tactical ablutions.'[101]

The real problem, particularly during the harsh winter of 1992–93 was not water, but heat. Cold penetrated the building and it was not a problem that could be easily solved. The snow and ice, known colloquially as *bijela smrt* (white death), had a significant

impact on the lives of Sarajevans. Christiane Amanpour recalled that first terrible winter: 'People were cutting down trees, cutting down branches, chopping up furniture, burning books and picking up grass and dandelions – and doing so in very exposed and dangerous areas – to cook up some kind of soup.'[102] As a consequence, many trees in the centre of Sarajevo were felled to be used as firewood and some burnt their treasured book collections just to generate some heat. The *Oslobođenje* journalist Hamza Bakšić described powerfully the pain of burning his books. 'In order to be curious', he said, 'a man has to be alive. To stay alive, I have to be warm enough, and to stay warm I have to burn books. Books are also some sort of memories. Shopping for books has always been a highly personal act for me. Burning them is a painful version of the same thing.'[103]

After an unseasonably mild early winter, temperatures had dipped significantly by late December 1992 and this made reporting from Sarajevo more challenging. Of course, the Holiday Inn provided a level of comfort marginally better than in most of Sarajevo but the difference in temperature between the inside of the hotel and the outside was negligible.[104] Amra Abadžić acknowledged that 'in comparison to the rest of Sarajevo, there was relative luxury in the hotel' but 'when winter arrived keeping warm became a major problem, even within the concrete walls of the Holiday Inn'.[105] She described how:

> We slept in temperatures of minus 20 degrees in that first winter, and the rooms had no heating. There was nothing we could do, short of taking panelling from the walls and making a campfire in the middle of the room. Of course, you had things that you would cover yourself with a sleeping bags or blankets, but you literally couldn't breathe and then you removed them from your face to find that it is too cold without them. You couldn't sleep, and that was the *real* privation in the Holiday Inn during that winter.[106]

Sleeping in such cold required keeping one's clothes on. Paul Harris, a freelancer working for *The Scotsman* said that there were 'two reasons for doing so: to keep sufficiently warm and to be prepared to exit the room quickly should it be targeted and you had to be evacuated'.[107] Most journalists ensured that they purchased the most robust sleeping bags and down jackets to protect from the cold *within* their rooms. Many rarely changed their clothes. The BBC's John Simpson, who had arrived in Sarajevo as the first snows of winter fell, recalled:

> For days on end I would simply wear the same things ... it was so cold that I only took off my boots and quilted jacket before creeping into my state-of-the-art sleeping bag, covering myself with three blankets, putting on my gloves and tying a scarf around my neck like an old woman going to market. And even then, it was so cold that sleep took a long time in coming. Guns rumbled and chattered not far from the hotel, but I didn't bother to creep put of my refuge to look through the window.[108]

Working in the cold was also challenging. Joel Brand wrote in his room – which had no windows, only plastic sheeting – under candlelight 'to be able to see the keyboard and to be able to keep my hands warm so that I could type'.[109] When there was electricity

in the hotel, the journalists could use small electric heaters, and Stéphane Manier of France 2 recalled bringing several of these to the Holiday Inn for his colleagues. They were, however, not very energy efficient and thus strained the limited electricity supply. The hotel management, he said, 'soon realised that it was more viable to provide us with a small amount of heat through the central heating system rather than have these small electric heaters draining the electricity, which is what they eventually did'.[110]

As temperatures dropped, the lack of fuel, or sufficient amount of it – small rations could be purchased at the PX Store in the PTT building – and the poor quality of the fuel available on the black market became a serious issue. Fuel would often be watered down and would have to be filtered before use.[111] To do this, jerry cans would be left outside so that the water would freeze and thereafter separated from the fuel.[112] With fuel to run the generators, heat could be generated, but preserving heat *within* the building was quite another matter. The Holiday Inn's expansive atrium was difficult to heat even when all the windows and doors were intact, but now that the majority of those windows and doors were shattered and the glass replaced by plastic UNHCR plastic sheeting, any heat generated soon dissipated.

Of course, lack of electricity for heat was less than ideal, but it was 'manageable'. Electricity in Sarajevo was scarce, with many citizens of Sarajevo going without it for long periods – and many reliant on candles or car batteries to power small lightbulbs for light; most domestic appliances had not been in use since the beginning of the siege.[113] For journalists, however, electricity was not a luxury, it was a necessity. While some could adapt to the lack of water, heat or decent food, they could not do without the electricity supply needed to run or equipment or recharge batteries. The Reuters correspondent Kurt Schork, electricity was *the* most important of the scarce resources. 'Without it', he said, 'my computers don't work, my telex won't work and I cannot send my stories. I can do without water and I can do without food, but I need electricity.'[114] Providing that there was a consistent supply of electricity in a city that was often without it was a constant challenge. The hotel did possess generators, though running them required fuel, most of which had to be procured on the black market at varying cost. Sabina Ćosić, who worked for Reuters recalled that 'I often bought gasoline from black marketers who would come straight to the hotel garage and I would give them ten thousand deutschmarks for, say, anything between ten to forty marks a litre.'[115] Some of the French contingent also fixed deals with the Ukrainian and French UNPROFOR troops based in the Maršal Tito barracks to buy fuel to run the hotel's generators – some of the French UNPROFOR troops were later based *in* the hotel. In the early days, Paul Marchand was pivotal to this trade – the 'interlocutor' between the journalists and the UNPROFOR troops. He was the fixer of many of these deals, agreements that would be crucial in assuring the ongoing functioning of the generators.[116] If fuel was available, the generators would run, though they had to be regularly serviced under circumstances where spare parts could not be easily acquired.

The privations suffered during the winter of 1992/93 represented something of a nadir. By the summer of 1993 conditions improved, albeit only slightly. The area around the hotel remained as dangerous as ever, but by April 1993, during the Vance-Owen Peace Plan (VOPP)[117] negotiations – the plan was eventually rejected by the Bosnian Serb Assembly during a long session in the Hotel Bistrica in Jahorina on

6 May 1993 – the lobby bar was again serving alcoholic drinks until the early hours, and by the end of July the flow of consumables was increasing, due in part to the opening of the tunnel beneath Sarajevo Airport which, though largely used to bring arms and other military and medical supplies, would also be used to bring in food.

Siege food

Food was also a serious problem for many journalists functioning within the city. For those based in the Holiday Inn, or for the AP team based at the Hotel Belvedere, food was less of an issue. For freelancers, it was far more problematic, as they did not have access to the sustenance that was available at the Holiday Inn or, frequently, to transport where they could go to Pale or Kiseljak to stock up on supplies. Many stayed in private apartments, with local families, and thus shared the same privations as citizens who had to source food locally. They would compound their meagre stocks with what they could smuggle into the city from Pale or Kiseljak or from the UN 'PX Store'.[118] The situation at the Holiday Inn was, of course, much better. Samir Korić, who worked as a fixer for Reuters recalled that 'We always had food and we almost always had water. If we compare the journalists' life inside the hotel compared to that of ordinary Sarajevans, this was a 6-star hotel!'[119] Indeed, dining at the Holiday Inn was a key part of the correspondent's working day – an opportunity to prepare and, after the working day, to unwind. According to Christiane Amanpour, 'there was one sitting for breakfast and one for dinner' and everyone gathered there.

'These were different times, really before the era when reporters were expected to go live every hour on the hour. So, we left the hotel in the morning, worked all day, transmitted our stories from the TV station and then returned to the Holiday Inn.'[120]

The real heroes in this daily endeavour were the hotel's staff. According to UPI's Kevin Sullivan, 'The staff were friendly and helpful, there was a lot of camaraderie and most journalists were sensitive to the fact that the hotel staff *had* to be there and didn't have the option of leaving.'[121] While serving dinner waiting staff always wore their green (and later brown) jackets, white shirts and back bow-ties.[122] They would, noted Allan Little, 'always endeavour to ensure the comfort of the guests while they were having dinner, even suggesting politely that at times when shelling was intense that the guest should sit nearer the centre of the room and away from the external wall, lest they be injured'.[123] Sabina Ćosić noted that 'The waiters were beautifully trained so they made a great show of serving everything properly, approaching you from the right side and so forth. They were absolutely professional, even though they were serving junk; the whole thing had a surreal aura to it.'[124] John Sweeney, furthermore, noted that 'the juxtaposition between being served beautifully while the vibrations from the bombs outside made the cutlery and crockery rattle on the tables was striking – the waiters continued as if it was quite normal, demonstrating real grace under pressure'.[125] The waiting staff always endeavoured to keep the guests happy, despite the occasional setback. In the late summer of 1992, the BBC's Kate Adie was having dinner in the restaurant when 'a thunderous explosion' that 'brought down the plaster and shook the

foundations' hit the hotel; seconds later one of the hotel's chefs appeared to announce that dinner would be served as usual, albeit a bit late as a consequence of the kitchen being damaged.[126]

Even within the hotel comfort was rather limited in the early months of the siege, but as the harsh winter of 1992/93 set in, conditions became more difficult. Regardless, the staff retained their professionalism and dignity. The veteran BBC correspondent John Simpson noted that 'in the dreadful winter of 1992 the waiters wore dinner jackets and white shirts with bow ties even though there was there was no water, no soap and no way of drying anything'.[127] He also noted, however, the charmed life for the guests in the Holiday Inn. 'It's very easy, he said, 'to start to live in the journalistic *milieu* and forget what the reality of life is – the reality of life [in Sarajevo] is not that there's light and a certain amount of limited, boring food. The reality of life is that people are chopping down trees to keep warm.'[128] And food, however limited or boring, was always available in the Holiday Inn – though the quality and quantity varied significantly – and at a time when the vast majority of the residents of the city survived on meagre rations of UN humanitarian aid.[129]

Since the beginning of the siege the black market had flourished.[130] The hotel's management were not immune to the economic dynamics of the siege and had to become highly proficient in dealing on the black market to make the hotel function at even the most basic levels. A consistent supply of food was, after all, crucial to the hotel's ongoing viability – UN humanitarian aid in itself would not be sufficient – and to facilitate this the hotel's management developed their own 'micro-economic strategy', trading on the black market to ensure the supply of food, water and fuel for the electrical generators.[131] They became rather effective in doing so, ensuring that the hotel could continue to be a viable operation. As Janine di Giovanni noted, the fact that the Holiday Inn managed to function at all under the circumstances was 'testament to the astonishing black-market contacts of the management'.[132]

Of course, food plays a significant role in all wars – and in a siege the difficulties in acquiring food are even more acute. Soldiers have to break from battle to replenish, a refugee mother still has to feed her children, often under impossible circumstances, and even correspondents have to 'fuel up'.[133] The largely successful endeavours of the hotel's management, their access to hard cash and good connections ensured that there was sufficient food to feed the guests at the Holiday Inn. It was a constant challenge, though placed in a wider context this was a challenge faced in a far more serious way by citizens of Sarajevo, who experienced significant difficulties in attaining the necessary nutrients to sustain physical existence.[134] Providing food, however, was more challenging – particularly when there was a lack of consistent electricity to power the refrigerators. Food had to be bought daily and this required significant endeavour and a sufficient amount of hard cash. The basics could be provided, with the hotel's basement bakery ensuring a daily – and vital – supply of bread for the guests.[135] But basic provisions such as flour, eggs and butter required to make the bread were highly prized and thus their cost was significantly – though artificially – inflated. The cost of even the most basic goods on the black market which *within* siege lines – even UN aid – was controlled by Sarajevo's criminal gangs, increased dramatically as the siege tightened, subjecting citizens of Sarajevo to a 'siege within a siege'; one external

– imposed by the VRS; and one internal – imposed by predatory criminals – often defenders of the city who were celebrated – and corrupt politicians.[136]

The Belgrade weekly *NIN* noted that in the autumn of 1992, 'There are places in Sarajevo where it is possible to eat well … the Holiday Inn offers first-class meals even during the wartime days of general hunger in Sarajevo. There, if you have money, you can drink cognac and eat pastries, and also have a choice of cutlets.'[137] Likewise, the *Oslobođenje* journalist Zlatko Dizdarević knowing the privations suffered by ordinary Sarajevans, was surprised by what he saw being served at the Holiday Inn when he visited the hotel in July 1992: 'In the restaurant the tables are laid with immaculate white tablecloths. The silver cutlery and the water and wine glasses are sparkling. Everything is perfect. The waiters look as if they have no inkling of what goes on outside. The menu offers steaks, French fries, beef stew, crêpes with chocolate sauce.'[138] But during the first winter of the siege, providing meals for the guests became increasingly problematic, even if sufficient food could be procured. If the generators were working and there was electricity, food could be cooked as normal; if not, kitchen staff would simply fire the barbeques and cook on an open fire.[139] Under such circumstances, the food available was never going to be of a very high quality. It was, recalled Kevin Sullivan of the UPI, 'pretty dodgy – meat, pasta and *ajvar*[140] with everything'.[141] 'War Soup', consisting of stock, rice or noodles and small pieces of meat was on the menu frequently, much to the displeasure of the guests. Rice was part of the staple offering, though it could be made palatable with some added salt and, when available, a splash of Tabasco.[142] Nevertheless, the quality of the food in the hotel far outstripped that on offer in the rest of the city, as di Giovanni noted, 'What we were eating at the Holiday Inn' was akin to 'Julia Child's *canard a l'orange* compared to what was available in the city outside' where 'the civilian population of Sarajevo was subsisting on rice, macaroni, cooking oil, a small packet of sugar, and some tinned meat or fish'.[143] Thus, though many of the guests at the Holiday Inn may not have dwelt too much on it, there was evidence that the 'highest quality humanitarian aid items were showing up on the tables at the Holiday Inn' and not in the homes of ordinary Sarajevans.[144] According to Vaughan Smith, the enterprising cameraman who had established – with Rory Peck, Peter Jouvenal and Nicholas della Casa – the Frontline Television News Agency,[145] 'the calorific intake of the journalists at the Holiday Inn far outstripped that of most ordinary Sarajevans' and, he further noted, 'while journalists have to eat, it should not be at the expense of someone else's calorific intake, particularly in a siege situation where everything *should* be divided equally'.[146]

A short, albeit fascinating, film entitled *Hotel na liniji fronta* (Hotel on the Front Line), produced in 1993 by SAGA Films Sarajevo, provides a glimpse into life in the hotel during the summer of that year. The external footage clearly shows the damage to the southern side of the hotel – facing Grbavica – which had absorbed at least six large hits from shells as well as significant damage to the façade from small arms fire. Almost every window on this side of the building had been shattered. Footage taken from within the hotel shows a strange mix of apparent normality and chaos; the shattered glass of the windows and doors near reception, the almost complete destruction of the *Nacionalni* restaurant, the *Hertz* car rental office, the *Putnik* travel agency, the bunt-out corridors on the seventh and eighth floors of the building

and the basement car park, full of cars in various states of disrepair. Conversely, the footage also reveals a busy working hotel, full of guests – journalists – with a working laundry service, an efficient and functioning kitchen and dining room – the tables resplendent with white table cloths, salt and pepper shakers, folded napkins, ashtrays and jugs of water – where journalists were offered an alcoholic *aperitif* before dining on food, such as fresh bread, cheese and *pršut* (dry-cured ham) that ordinary citizens of Sarajevo could only dream of.[147] In any event, Žalica's film conveys the stark contrast between the normality and the chaotic context within which this 'normality' is preserved. It is, however, merely a snapshot, and perhaps captures a short period where everything appears to function well. Had the same crew visited the hotel in the winter of 1992–93, they would have found the guests staying in a far more challenging environment.

The lack of 'luxury' food items provided by the hotel could be circumvented by the guests bringing their own supplies, and some became increasingly creative in doing so. Food could be bought at a fraction of the price of that available within siege lines in Pale, Ilidža or, in particular, Kiseljak. Journalists made frequent trips to the small town, where they could buy gasoline and food supplies.[148] These could be found and purchased at the Hotel Kontinental – which was, according to the BBC's Kate Adie, a 'hub of veracious black-marketeering',[149] and this could then be brought back into Sarajevo – though they were likely to be depleted by having to provide small 'incentives' for those manning the various checkpoints between the source of food and the Holiday Inn. The BBC also had a small office in Kiseljak with a satellite phone where, according to Peter Maass of *The Washington Post*, 'You could get a cup of English tea and call your girlfriend for 25 U.S. dollars a minute.'[150] Zoran Stevanović, who worked for Reuters, could scarcely believe how calm it was in Kiseljak, and how much food could be purchased there:

> I had actually never been to Kiseljak my whole life and that it would be my first time to go to the town which was around 30 kilometers from Sarajevo. At that time, in the eyes of foreign journalists, Kiseljak was Casablanca. An oasis of peace. As much food, electricity and water as you need … After passing all checkpoints, after a few bends Kiseljak comes into view. People are strolling leisurely in the streets, walking in the middle, not next to walls. There is an abundance of everything and everything is open … A little later I sat down in a restaurant and ordered almost everything they had on the menu. They had it all.[151]

Whether travelling by car or by *Maybe Airlines*, foreign journalists would also smuggle food along with their equipment. According to di Giovanni, the food being brought to the Holiday Inn by foreign journalists was quite diverse – the British brought chocolate, the Italians brought pasta and, when possible, parmesan cheese, though the Americans, she said, 'as a rule, did not share … American newspaper reporters tended to operate like lone wolves: each man for himself'.[152] It was, however, the French contingent that was most successful in garnering desirable consumables, such as champagne, French mustard and *foie gras*. Even Sarajevo's stray dogs, according to the France 2 cameraman, Jean-Jacques Le Garrec, knew that 'the best food was with the French'.[153] Utilizing the so-called *Systeme-D* – a term used to describe 'making do' during the Second World

War – they succeeded in making life in the Holiday Inn bearable. In an article for *The Spectator* magazine, Janine di Giovanni described how it functioned:

> The French journalists are the experts, having narrowed down the best way to survive in the worst of conditions. They call it *Systeme D* ... It meant that while the rest of us began to scratch and look decidedly seedy, the French seemed to grow more chic and elegant. They risked the harrowing airport rat-run to pick up packages containing necessary items such as crates of wine, tins of pâté, and slabs of good salami from Paris.[154]

Stéphane Manier from France 2 TV remains unsure whether *Systeme D* was anything more than the French being well organized and having ensured that enough 'luxury' food was packed in advance. For the France 2 crew the normal shift in Sarajevo was normally one month, so enough additional luxuries had to be brought to the city for that period. This was, said Manier, 'more problematic when we had to reach Sarajevo by car because we needed to carry a lot of gear'. It was, however, easier when it was possible to enter Sarajevo by plane. 'We would then buy food in Paris and put it in large military-style cases – sometimes we would take sweets and even, on one occasion, a whole ham – enough to last one month, which was shorter than many who stayed at the Holiday Inn, but was our usual shift in the city.'[155] But the crew would also take trips out of Sarajevo to buy food, something which was impossible for ordinary citizens of Sarajevo. That food was something precious to the people of the city was brought home in the starkest terms to Manier in the winter of 1992/93, when interviewing a Bosnian soldier – a Serb from Sarajevo serving in the ARBiH – in the centre of the city. That morning, before the interview, Manier and his crew had been to Kiseljak to purchase food and hadn't had time to drop it off at the Holiday Inn, and the food had remained in the back of their armoured car. After concluding the interview, Manier offered the soldier a lift home. The soldier accepted and entered the vehicle, and according to Manier:

> When he opened the back door of the vehicle and saw all the food we had in the back he almost collapsed. He asked me if he could buy some eggs (which were then *very* expensive in Sarajevo) for his pregnant wife. Of course, we offered the eggs to him – we could never accept anything for them. As we were handing them over, one of the eggs fell on the floor and smashed. He got on the floor and ate the raw egg. That was really terrible, and a reminder of the privations that ordinary Sarajevans were suffering. We could get to Kiseljak or Pale and buy food ... they could not.[156]

Indeed, while those fortunate enough to be staying in the Holiday Inn could consume decent food – or have the ability to bring it into Sarajevo – electricity and some heat, for the ordinary citizens of Sarajevo it was an entirely different matter. Although many had settled into a routine of survival, the winter had made life far tougher. The UN was ensuring that humanitarian rations were being delivered into the city but collecting water and firewood and keeping warm in homes that often had no windows – and were thus very exposed to the elements – remained the primary objective and the

daily preoccupation of many.[157] People slept with their clothes on in an attempt to keep warm. The Bosnian government, unable to break the siege of the city 'above ground', began work – in May 1992 – on the construction of an underground tunnel under Sarajevo's airport, which would connect government-held territory in Butmir and Dobrinja – Bosnian Serb forces held the territory on either side of the runway, in Lukavica and Ilidža – and allow them to get weapons and other key supplies into Sarajevo, circumventing, to some extent, the UN arms embargo.[158] The tunnel, known as *Tunel spasa* (Tunnel of Life) which took nearly a year to construct and was 800 metres in length, created a link between the besieged city and the outside world, had been built underneath Sarajevo's Butmir airport. Thus, by the summer of 1993 the supply of food was more consistent. Of course, there were more pressing concerns – arms and other military material took precedence, but slowly food was also brought into the city. According to Remy Ourdan:

> In 1992 and early 1993 there wasn't much food and what existed was of varying quality. Before the opening of the tunnel we had only black-market goods and humanitarian aid. One can only presume that this humanitarian aid was being sold on the black market and bought by the hotel, with our money, in order to feed us.[159]

The Guardian correspondent Maggie O'Kane noted that, by the summer of 1993 already, 'bottles of *cuvee* specially bottled in the Franciscan cellars' were on offer in the hotel.[160] Likewise, Jeremy Bowen noted that French UNPROFOR troops would appear at the rear of the hotel to unload cases of Bordeaux – which were issued as part of their rations – to journalists for the equivalent of approximately fifty US dollars per bottle.[161] The guests could consume wine largely because the hotel management were able to buy stocks from existing wine cellars in Sarajevo that otherwise had no outlet for selling their remaining stock. So, alcohol, which helped to 'oil the wheels', was available at the right price to journalists who were awash with cash from their employers and, claims Bowen, 'no-one, least of all those working for the big media networks, was in a mood to skimp on such luxuries'.[162] Beer was always available, though of varying quality. Indeed, the Sarajevo Brewery in Bistrik continued to produce their famed *Sarajevsko pivo* (Sarajevo beer), which was brewed using rice during the siege.[163] Those that smoked could purchase locally produced cigarettes – primarily *Drina* or locally-made *Marlboro* from the *Fabrika duhana Sarajevo* (Sarajevo Tobacco Factory), and often in plain packaging – from the newsagent kiosk inside the hotel which, during wartime, served largely as a tobacco vendor; cigarettes were highly valued during the siege, becoming a parallel currency of sorts.[164]

A handful of venues managed to operate at a later stage of the siege, mostly located in basements that offered a degree of protection from the dangers of the street and an atmosphere of – relative – security. The café and bar in the Academy of Drama, known as *Obala*, was the heart of a thriving arts scene, serving ersatz coffee and weak beer from the Sarajevo Brewery. One establishment that offered a more upmarket option was *Jež* (Hedgehog) restaurant. Opened in 1994, it supplied both the foreign press corps and the more prominent members of the city's underworld with a surprisingly rich menu, albeit at extraordinarily inflated prices.

5

Reporting daily life

As the siege relentlessly continued, a daily routine of reporting became increasingly established. Many of the TV and radio reporters and crews and the photographers working for the wire services were often based in Sarajevo for one or two months at a time. This core group rotated frequently in and out of the city, building up a network of contacts and the experience of the layout of the city that helped to keep them safe and gave them access to politicians and, to a lesser extent, the ARBiH. Yet, the daily rhythm of reporting was quite unlike that to which they had become so accustomed. According to Christiane Amanpour:

> The experience of reporting from Sarajevo was very different from reporting today, where you have all of the demands of 24-hour live news. We worked constantly from early morning to sundown and spent most of the time gathering and telling stories – and, in the case of Sarajevo, many of these were human stories. We would go to hospitals, schools, talk to women, children and tell their stories of survival. This is why, I believe, the reporting from within the besieged city of Sarajevo was so powerful and effective.[1]

While 24-hour news was emerging – CNN was a rare exception at the time – even for those who worked for those channels that operated around the clock, the rhythm of the day became quite well established and, for some, rather pedestrian. The BBC Radio journalist Martin Dawes recalled how he was, 'Away for six months a year for the whole of 1993. That was basically doing Central Bosnia or Sarajevo, normally three weeks, sometimes four weeks at a time.'[2] For these reporters, daily life often followed a relatively predictable routine. Indeed, one of the notable features of the siege was that outside the periods of very heaving shelling and fighting, the city could be eerily still, with little to report. The AP photographer Enric Marti recalled that 'the front lines were very stable, there was not too much shooting ... for the ones that were actually living there like I did there were periods, they were long periods actually where there was not much happening.'[3] At such times, Sarajevo would fall off the news agenda of the editors back in the journalists' respective countries. Even during periods of heavy fighting the story of Sarajevo was often a hard sell and entirely dependent on what might be happening domestically. As Gigi Riva noted, he found it harder to convince his editors to publish pieces on Sarajevo – and Bosnia and Herzegovina more generally. 'The Bosnian war',

he said, 'was considered a second-tier conflict in Italy and, above all it just didn't sell newspapers.'[4] So, during these periods, the working lives of many journalists followed a predictable formula. Dawes explains the morning ritual for the BBC Radio team:

> If it was routine, fairly routine, you would get up, talk to your translator and ask what was on radio Bosnia if they'd been listening, that was the first thing. You might then have some connection with Reuters who were in the Holiday Inn, so you'd pop up to them. Then there was always the UN briefing. So, you tended to go to that, and later on there was a quieter briefing in the evening with UN too.[5]

The morning UN press briefing, or so-called 'Nine O'clock Follies', provided not just a source of information and stories during the briefing itself but also an opportunity to talk to other reporters, and to glean information from the various UN sources 'off the record' after the briefing had finished. It also allowed reporters access to UN staff and other NGOs to set up stories and trips, and to facilitate visits to frontlines accompanied by UNPROFOR troops. Thereafter, journalists went to find stories, though they also had obligations to their editors. BBC Radio journalists, for example, had a number of key points during the day based on the broadcast times of the various news shows that included the *Today Programme*, *World at One* and the *Five o' Clock News*. In addition, they worked for the BBC World Service, which had a dominant position at that pre-internet time as a major source of global news. In any gathering of journalists, the ritual setting up of their Sony short-wave radios, antennas erect, just before the top of the hour could be observed. In the evenings at the Holiday Inn, the moment was often accompanied by the soft glow of Maglite torches turned on their ends in candle mode, creating a pattern of fairy lights across the dining room as the distinctive music began that marked the start of the news bulletin.

The timetables of both radio and, to a greater extent TV, reporters were increasingly dominated by the 'tyranny of the 2-way', as live links between the studio and the reporter in the field became increasingly popular, facilitated by the improvements in satellite technology that allowed real-time uplinks. As Nicholas Fraser observed in *The Times*, with these satellite uplinks 'a journalist can send pictures instantaneously from anywhere in the world, creating "real-time" news'. He cautioned, however, that such immediacy meant that journalists had no time to think and to interpret or bring critical analysis to events.[6] Moreover, the capacity for the individual correspondent to investigate more deeply was limited by the need for them to be available for multiple news bulletins during the day, frequently severely affecting the ability of journalists to actually go out into the field to gather information and report. At moments this became counterproductive, especially for those working for US networks, when the main evening news in America would be in the middle of the night in Sarajevo. Martin Dawes of BBC Radio recalls how during the NATO airstrikes in 1994[7] he was in demand almost constantly for the whole day, trapped in the Holiday Inn:

> You were the 'Joe on the mic', basically. So, if anybody wanted you, they took you. And certainly, I was in that spot doing the radio when NATO struck ... the big frustration was that for the biggest story of my life I hadn't seen anything. I was stuck

in my bedroom from three o'clock in the morning until about nine o clock at night, and I think I told BBC Radio Manchester in the end that I was going off air because I had missed so much. You were basically tied [to] the tyranny of the two-way.[8]

Dawes also recalled how his ability to report was curtailed by NATO itself during the attacks as he tried to record a live segment during the actual airstrikes. It was, he recalled, 'A lesson in military technology ... I never got a single word out because every time NATO planes came over all the electronic signals were suppressed by other planes. So, all I could do was just watch the needle go wild.'[9]

Given the relatively static nature of the frontlines around the city during the siege and the difficulties in attaining the appropriate permissions from the ARBiH to visit the frontlines, covering the actual fighting as and when it happened was frequently a frustrating experience for journalists used to the fluidity of other conflicts. Sean Maguire of Reuters explained, however, why at times proximity to the action was necessary to actually find out what was happening in the confusion of the fighting. Sarajevo was, he said, 'an echo chamber' in which 'nobody can tell you where the booms and bangs are coming from and going to, the rattle of machine-gun fire evaporates in un-locatable confusion and unless you happen to be in the street where a grenade lands it might as well be an event in another war. The shelling can be both fiercely local and exasperatingly distant.'[10] Trips to the trenches around the city had to be arranged in advance, and written permission sought from the Bosnian government, and then once access was approved, there was often not a great deal of action to report on. Amra Abadžić explained that the rationale behind the process was frustratingly bureaucratic, but it was a necessary one if you wanted to access the front:

Figure 5.1 Chris Helgren with satellite phone in the Holiday Inn, Summer 1993 (Paul Lowe/VII).

You had to go to the first corps headquarters to meet Aida Čerkez, who was responsible for relations with journalists. You needed authorization from them for places where you needed to be escorted or taken because you couldn't find your way there, so most of the time it was permission to access Dobrinja. Parts of town were almost completely cut off, with just one street as a lifeline, and you wouldn't know without someone from the ARBiH telling you what the safe route in and out was.[11]

Even when there were skirmishes or outbreaks of more heavy fighting, the nature of the conflict meant that proximity did not necessarily allow for successful reporting. When the VRS attacked the suburb of Otes near the airport in December 1992, Reuters decided to try to cover the story, as it had become the most serious outbreak of fighting to date. Richard Mole, a British Army colonel heading the UN team of military observers in Sarajevo, informed them that the area had been the target of 1,500 rounds of artillery and tank fire on successive days.

> We wanted to go to Otes to see what was happening, but the situation by the time we decided to go was already horrible; we couldn't find a way to get there, not knowing the area well. The VRS were already on both sides, there was only one narrow road leading to it, even the army could not go back and forth, and only one person was going there every day, risking his life in an old Golf. He was taking the bread supply for the soldiers there, so we just followed him.[12]

Sean Maguire was also part of the Reuters team, which included the American photojournalist Corrine Dufka, on the day and recalled how dangerous the battle was. He described feeling as if he was a 'trench rat that had invited itself to the Battle of the Somme' and recalled that 'One soldier I met told me that there was an eighty per cent chance of getting killed in Otes.'[13] Amra Abadžić expressed how the trip to try to ascertain the situation on the ground almost cost the team their lives:

> To be honest it was a mistake, the shelling was horrendous and you couldn't see anything. By the time we got there, Otes was already falling. It was not made of higgledy-piggledy houses, it was [a] modern part of town, almost like a grid system or a big chess board, so you were surrounded by tanks from every side, stationed on each intersection of these long streets, they were just shelling everything that moved. We couldn't cross the street, we couldn't see anything, it was full of smoke.[14]

Realizing quickly that filming anything in such a desperate and exposed situation was impossible, the team sought shelter from the relentless shelling, but quickly discovered that there was a fatal flaw in the design of the suburb that made it even more dangerous:

> Otes was built on a marsh so the houses had no basements for people to hide. People were huddled together in the ground floor of the buildings trying to protect

themselves. The soldiers were buying time for the civilians to escape as the tanks were moving in, they sacrificed themselves basically, lots of people did manage to run across that narrow exit and get to safely, we got out four minutes before the tanks came in and Otes fell. Corinne got shrapnel in her leg, apart from being scared it was a pointless exercise because apart from keeping your head down you couldn't do anything.[15]

Otes was, in the winter of 1992, *the* most important story in Sarajevo, but such events were not always a daily occurrence. On those days when there was no obvious news story, photographers from the wire services would drive around the city, visiting the places where, at the very least, daily life photographs could usually be found to fulfil the demands of the newswire. As Chris Helgren of Reuters recalls, on quiet occasions he would patrol the city checking out a series of locations that regularly offered opportunities for images:

We had this big heavy armoured car and usually nobody wanted to drive it so I took it, and I would just go cruising around, up and down Sniper Alley … from the frontline near the airport all the way to the other end of the city. So, you'd look around there and go and drive around the neighbourhoods. See if there's anything interesting: that could be people gathering wood, or water, or food or just kids being goofy. And at some point, if it was in the middle between quiet and not quiet when you might have a bit of sniper fire, you might just sit and wait, almost wait for something to happen at a bad intersection.[16]

People queuing at standpipes for water was a popular recurrent image, as was the variety of improvised carriages used for transporting wood, water canisters and food. Such situations provided the opportunity to 'feed the beast' and provide daily illustrations of life during the siege for wire agencies such as AP and Reuters. Photographers would also be alert for any unexpected dramatic incident, as they were all connected to their radio networks using handheld Motorola 'walkie-talkies', later upgraded with a repeater 'base station' to increase coverage and strength of signal. This allowed their reporters to quickly respond to events across the city, as the local stringers who worked for them also carried radios so could quickly inform the office about the situation on the ground. The radios were also essential for safety; if a journalist came under attack and was wounded, then help could be summoned in an emergency.

Another uncomfortable undertaking that challenged ethical boundaries, but was nevertheless tragically routine, was visiting the morgue to ascertain the number of casualties on any given day. At the start of the siege in April 1992, all but one member of the staff at the morgue were Serbs, who all fled Sarajevo, taking much of the store of coffins and funeral supplies with them. Alija Hodžić was a local bus driver, and a leader in the neighbourhood who volunteered for the unpaid job as director of the morgue because nobody else would do it. He meticulously recorded by hand each victim into the book of the dead, known as the *Evidencija ulaz umrlih* (Record of the Entrance of Deceased). Amra Abadžić recalled that she:

Figure 5.2 The feet of a young female casualty in the Sarajevo morgue, Summer 1993 (Paul Lowe/VII).

Went to the morgue almost every day, sometimes even twice a day, because Reuters wouldn't trust the reports in the local media because they though they might inflate the numbers of dead. We would ask Alija to show us the ledger in which he recorded the casualties, we would open it up and look, it had the name if there was one, or quite often just male, female, child, when the body was brought in, and cause of death. The book was in his little room at the entrance, then you would open the door and behind were the bodies. In the beginning it was mayhem, there was no heating, no electricity and a terrible smell, they just kept on piling up the bodies, there were over two hundred of them there with no cooling system, just piled up, they had no contingency plan for burying that many people. Later on, it became better organized and when it was quiet it was manageable, but during heavy shelling or the massacres again it would pile up really badly. Alija had a certain calm to him, he just kept on in a very dignified way. He kept working all the way through, even when they brought in his own son. He had just finished his shift, when they called him and they brought in his son and his nephew, several members of his own family.[17]

The morgue also confronted photographers with a difficult task. The corpses of victims made for powerful images, but also raised ethical concerns about violating the privacy of the dead. Determining the limitations of the acceptable in that context was a matter that occupied the minds of many of those whose work required them to do so.

The daily demands

For the wire service teams, speed was of the essence, as they had to get their material out onto the newsfeed as quickly as possible – and often competing with their rivals to break a story first. For photographers, this meant that they had to decide when they had a good enough shot from any given situation to allow them to leave to file. This was in stark contrast to those working for the weekly news magazines or on their own assignments, who had the luxury of time to wait to see what else might occur. For the Reuters, AP and AFP photographers, tied to the daily demands of the wire service, their schedule was relentless. Once they had sufficient material, they had to race back to their respective bases to develop their film and transmit it back to their offices in Europe and America. This was a complex, time-consuming and involved activity, albeit easier than a generation earlier, whereby a physical print had to be made in a portable darkroom to then be transmitted on a wire machine. Chris Helgren described the complex process of developing the film:

> You had [to] get the temperature of the water up and then mix the chemicals, you put them in, you have two pots where you take your film and you put it into a black bag in the dark, put the films inside a canister in the dark, seal it in the dark, and then you take it out and then you can pour in your chemicals, if it's the right temperature, that's the developer. You wait, depending on the temperature, for three-and-a-quarter minutes or something like that, and then dump it out and then it immediately you fill it with fixer which is another one to ten minutes. The longer you do leave it the better the negatives are going to last. Then you dry them. You could have a dryer or just a hair dryer or just hang them up in the bathroom.[18]

On occasion, photographers had to resort to rather unusual methods to get their film processed, as Helgren recounts 'at one point, I remember in Vitez [Central Bosnia] I melted some snow because I didn't have any water'.[19] An even more extreme solution was used by Danilo Krstanović, who explained that whilst working at *Oslobođenje*:

> Everyone would send their film to me and I'd use my magic to develop it, with no chemicals, no water. I have to say – and this may seem a little offensive – but we sometimes used our own piss to fix the photographs. We would use a few drops of fixer, and a little water, but for the rest we would use piss [urine]. We rinsed them with rainwater.[20]

Krstanović had to be very careful with his supply of chemicals and was able to process fifty films from the amount that would normally be used for ten rolls, although this meant that the processing time was up to one hour. Once the film was dry, it could be examined frame by frame with the aid of a loupe, often simply held up to a lightbulb or the window to illuminate the negative. The strip of negatives could then be cut, usually into a set of three, from which the middle frame would be placed into the scanner. At the start of the conflict, Reuters and AP were using the 'Leafax 35' negative scanner, introduced in 1988.[21] The size of a small suitcase, the Leafax could scan an image in just a few minutes and, once scanned,

caption details could be added via the keyboard and minor adjustments could be made to the image using a 5-inch screen. The Leafax could then be connected to the satellite phone to transmit the photograph, a process that took around fifteen minutes for a black and white image, and up to forty-five for a colour one as each of the colour separations of yellow, magenta and cyan which are needed to make a full colour image had to be sent separately. If the signal dropped or was cut off altogether, the process had to be restarted for that separation, a common problem given the unreliability of satellite communication at the time. By the end of the siege, photographers had switched to the newly introduced Nikon Coolscan paired with a laptop computer, often the Apple Powerbook running the revolutionary Photoshop software, that allowed for a much higher resolution image to be produced. This also greatly reduced the amount of time that was needed to transmit the image as it negated the need to send each separation individually. This gave the wire service photographers a new competitive edge, as it meant that they could transmit a much higher volume of images and their photographs were now of a high enough quality to be printed in news magazines like *Time* or *Stern*, allowing them to challenge the photographers from the independent agencies such as Gamma, Sipa and Sygma.

The photographers working for weekly magazines, however, had to physically get their film back to their editors in Paris, London or New York, as the limitations of transmitting via a satellite phone did not provide the quality and quantity of images needed for magazine publication with double page colour spreads. Most of the photographers shooting colour were using slide film which creates a positive image rather than a negative, and needed specialist developing in a professional laboratory. To get their film out, they either had to return with it themselves at the end of their assignment or story, or give it to someone, usually a fellow journalist on their way home, to physically carry it out of Sarajevo for them. Although this may seem absurd today, asking a friendly looking stranger at an airport to take a bag of film home with them and then be met by a courier at the airport on their arrival was then common practice. According to Ron Haviv, 'You were, essentially, handing a package to somebody, with incredibly important work for which you risked your life, to someone that you may or may not know ... you can't even hand somebody an envelope to get it onto an airplane directly, so you were constantly on the lookout for who's leaving, who can take your film.'[22]

Radio journalists also had a set of routines they had to undertake in order to send their audio files to their desks. They would use handheld sound recorders with an external microphone to record their interviews and voiceovers, and atmospheric 'wild sound' that could be used as a background to their reports.[23] Each segment of the story had to be cut in the field before they could all be sent as a 'package' for the editors at the home base to work with to create edits of the story for each of the news outlets. Dawes recounted how he had a small editing suite set up in his hotel room, and would prepare his script for a 50-second news bulletin:

> You had a mic and satellite system with a codec with a mic thing. You had a recorder which went to basically a Marantz cassette, which you'd dub things off. Your bedroom was next to the satellite link and the mic, which was the lifeline ... For your packages, you tended to rely more on dubbing off cassette, doing the links and then somebody in London putting them together. It was quite complicated to do.[24]

Print journalists would return to their hotel rooms or apartments to write, usually on a portable computer. Eagar used a small Tandy – known colloquially as 'Trash 80s' – with a memory of just 10,000 words, but whose great advantage was that it ran on normal AA batteries so could still be used even when there was no electricity. Once the story was written, it had to be sent via satellite phone, occasionally by directly reading the copy to the sub editor if the connection was particularly bad, but usually by means of an acoustic coupler, a device that connected to the handset to allow the transmission of the file, with Eagar recalling the agonizing wait for the sound which meant the two computers were finally talking to each other.[25] She described how the daily news reporter had a very short feedback loop between finding and writing the story and its publication:

> When you write for a daily newspaper, it's very real ... you're completely happy once a day. You do your story. It's actually very companionable; you go out every day with a gang of people. It's quite fun and you file your story ... It's covering the story of the day and then you get it out there and then you go and get drunk basically if you're a war correspondent, it enlightens us to what we do. And that's how your life works, getting the story of the day.[26]

Some print journalists did, however, have relatively advanced equipment that allowed them to file their stories. In November 1992, John Burns departed Sarajevo briefly to collect an armoured car and a portable 'Nomad' data transmitter that allowed him to work independently – though electricity was still a difficulty – and send his stories without requiring access to telephones – most of which were no longer working in the city – or satellite phones – which were large and cumbersome and of which, at that time, there were few in Sarajevo:

> I could charge the data transmitter and my computer through the cigarette lighter facility and thus I could write and transmit simultaneously, which was a tremendous leap forward for me in terms of my ability to function more or less independently. But doing this in the armoured car came with risks; I could write and transmit, but I could not do this from the basement of the Holiday Inn. I had to be outside the hotel and facing west in a very exposed area. You could never be sure that one of the gunners or snipers wouldn't detect the blue glow emanating from the van, so it was never an entirely edifying experience.[27]

Wire service reporters – and to a lesser extent daily print correspondents' – routines were dominated by the round of press conferences, ceasefire announcements and the inevitable subsequent breakdown, and shelling and sniper attacks. Jonathan Landay, who worked for both UPI, a wire service and *The Washington Post* described what that entailed:

> At the Washington Post, I was on to the print side and they didn't want breaking news. They were, you know, what we called a 'mailer' – they mailed copies out to their subscribers, and there was, of course, no website back then. What they wanted

was analysis. So, I was able to do analysis for them and they wanted their copy by 1pm Washington-time so I could either get up really early or, in the evening write up the piece for the Post and then during the day I would work for UPI.[28]

Correspondents writing for a weekly publication, however, had a very different rhythm to their working week, given that they were much less driven by the mainstream news agenda – except, of course, when a story broke on the day before their newspaper or periodical was published. They therefore tended to seek out longer, more feature-based stories, concentrating more on daily life and human interest stories, looking for a unique angle or aspect that could bring a different perspective to the story, allowing for arguably a more thoughtful and reflective approach to the situation.[29] Working for a weekly newspaper or magazine therefore had a very different rhythm from daily news, as Eagar explained:

> The Sunday paper is very different. Somebody once described it as a bit like having a weekly disease, it's very, very high stress because, you are always having to live with the need to find something completely different; that is the reason you are there. You were there for your ability to find something different and look at it in an imaginative and unusual way. And, in general, as you had more time, the story was also better written than a daily newspaper piece. 600 words, or possibly even less, is normal for daily piece but I never wrote under 900 and quite often up to 2500 words for a weekly.[30]

This combination of the necessity to find a unique angle that would illuminate the larger news situation and the extra depth that a longer article allowed, meant that the journalists had to be creative in finding a story that would stand up to the demands of the weekly publications. Eagar recounted how the typical week would unfold for a reporter working for a Sunday newspaper:

> On Monday you feel fine and then on Tuesday you start to feel a little bit worried and then on Wednesday you were feeling really very, very peculiar indeed. By Thursday you have to have made the decision about where your story is going to be. So, you are in the full fever of the whole thing Thursday, Friday and Saturday and then on Saturday afternoon once you file the fever has broken, and then on Sunday you are wandering around feeling a bit convalescent on wobbly legs and then on Monday the whole process starts all over again.[31]

Like many of her contemporaries – amongst the stringers – Eagar had just graduated from university. Many were inexperienced, bright but nevertheless learning their trade 'on the job'. Eager, however, found the routines of life as a journalist in Sarajevo strangely familiar:

> The routine of being a journalist in Sarajevo was like being at university. I'd come straight from the university so I was still very much in that intellectual space and writing for *The Observer* was very like doing one essay a week really, which is pretty

much what I was trained to do and had been doing for four years. In Sarajevo, we would get up in the morning and we'd go to a lecture (which was the U.N. press conference at the PTT building) ... I come back, take lots of notes and then I go out and find a story, instead of going to the library I'd go in front of human beings and talk to them for several days, and then I'd sit down and write my essay at the last minute.[32]

Sarajevo provided a rich source of human-interest stories, and as a cosmopolitan, educated city many journalists found an immediate connection with ordinary citizens of Sarajevo. As Eagar explains, the plight of its citizens to survive was one with which readers could find an important point of empathy:

Sarajevo was a particularly good story for *The Observer* and the stories that I wrote resonated with our readership. They were much more interested in Sarajevo than they were in the rest of Bosnia. A lot of the other newspapers were very keen on their correspondents writing about the British troops in central Bosnia, but *The Observer* was much less interested in that. They really wanted to know what it was like for a family of middle class intellectuals to survive under a medieval siege.[33]

Indeed, many foreign journalists found a strong connection with the people of the city. What often began as a story frequently deepened into a closer relationship, with journalists spending time with families in their homes, sharing their lives. Eagar recounted how she met her 'adopted family' by chance at the beginning of her first trip to Sarajevo. She was in the city centre when a massive bombardment trapped her near the Presidency building – she quickly sought shelter in a nearby Austro-Hungarian apartment block, typical of the urban architecture of the western part of the city centre. She had been attempting to find an old lady to give her a parcel that she had been given by a fellow journalist to deliver. Eagar knocked on the door of one of the apartments to ask for help. The door was opened by a young man, who invited her into his family apartment, where he began to tell her about his life and about his parents. Eagar wrote about her encounter with the family for her first ever piece from the city for the *Evening Standard;* the response was immediate, her editor called and said 'this is what we don't read. We only read about death in Sarajevo. We don't read about everyday life.'[34] Eagar realized that the story of how they survived was 'completely fascinating and actually rather amazing ... an impressive demonstration of human endurance'.[35]

During her repeated trips to the city, Eagar would return regularly to see the family and wrote regular stories about them for *The Observer*, such that the readership could connect with them as humans and not just as nameless subjects. Like many other journalists, Eagar would help her family with food, often crossing over to the Serbian side to buy provisions. In the case of her family, sugar was one of the most vital foodstuffs, as it was a vital ingredient in their production of *rakija*.

Barbara Demick of *The Philadelphia Inquirer* took a similar approach to following one group of people over a long-term period with her extended series of stories of everyday life on one street in the centre of the city. She describes how when she first came to Sarajevo she wanted to find an entry point into the story that would resonate

Figure 5.3 Charlotte Eagar in the Holiday Inn, Summer 1993 (Paul Lowe/VII).

with her audience and cut through the politics of the conflict to connect directly with the human experience of ordinary people:

> When I arrived in January 1994, an 'empathy fatigue', as they called it in the humanitarian aid business, had settled ... Readers around the world were numbed to the suffering of a people whose names they couldn't pronounce in a place they had never been. To bring home the reality of the war, my editors at the *Philadelphia Inquirer* suggested I pick a street in Sarajevo and profile the people living there, describing their lives ... I knew the street I wanted to write about the first time I walked up it. Even battered by war, it was a beautiful street, rising uphill at a perfect perpendicular angle from the main thoroughfare, three white minarets piercing the sky above red rooftops. I spent the better part of two years on Logavina Street, knocking on doors, drinking coffee from people who could barely afford it, hearing their tragedies.[36]

The series proved so successful that she eventually turned it into a book entitled *Logavina Street, Life and Death in A Sarajevo Neighborhood*, published in 1996.[37] She felt that perhaps her relative inexperience as a reporter actually helped her to see the relevance of the story, 'I think my naivety and freshness as a foreign correspondent is conveyed in the book and the things that I saw – maybe they wouldn't surprise me much now, because I've seen a lot but then I'd never seen anything like it.'[38] Demick followed the lives of the street's residents for two years, weaving the intricacies of their daily lives together with the bigger picture of the politics of the siege to produce a compelling portrait of how ordinary people cope with extraordinary circumstances.

Many of the photographers who came to the city also worked on longer term stories, returning multiple times to build a body of documentary work. Although like Eagar, Roger Hutchings worked for *The Observer* newspaper, which sent him to the city on assignment twice, he also undertook several other trips without the restrictions of working for a specific client. This freed him from the need to file photographs according to the timetable of the news, as he comments: 'I didn't want to be hemmed in by the idea of working for someone, once you are liberated from that you can set off in all sorts of different directions.'[39] He regarded the freedom this gave him as an antidote to the potentially more restrictive agenda set by working on assignment, and the dangers of simplification of the story that that can entail, arguing that 'you know what the market wants so you pursue those clichés, it's the media's fault that things look like stereotypes'.[40] His motivation was not to cover the conflict per se, but instead to document everyday life under the siege. As he explained:

> I wouldn't consider myself to be a conflict photographer in any way really ... what I was very interested in was in people and society and how they manage against the odds when something unpredictable happens. So, I decided to concentrate on this idea of survival, the necessity of survival ... the thing that fascinated me was the human capacity to survive in such difficult circumstances and the kind of ingenuity and adaptability and pragmatism that people displayed.[41]

Hutching's visual approach reflected this interest in the minutiae of everyday life, eschewing the dramatic moments of violence for a more considered, subtle approach. This proved to be a successful strategy for his work; his photo essays on the life of the city were widely published including three extended stories in *The Observer* magazine. Like Eagar, he sought to subvert the expectations that the siege was only about violence and suffering and sought to illuminate how the everyday struggle for survival was also an important human story. One of his most enduring images from the siege typifies his approach; it depicts a group of women in an outdoor courtyard putting rollers into each other's hair. This quiet image of female solidarity explores how even in the height of the siege, keeping up a sense of femininity was a powerful way in which the women of Sarajevo resisted the psychological deprivations of the situation. In seeking out these subtler moments he documented how the everyday struggle for survival was also an important human story. He wanted, he recalled:

> To make pictures that would people would look *at* and not look away from. Obviously, it's good to have evidence, to have proof of things but it's also important to have pictures of people we'll look at and which can have more subliminal messages without them feeling ... that they're too vicious, too brutal, too violent ... so that they want to turn the page and look away from it immediately. I think those kinds of pictures actually endure quite well rather than some kinds of pictures which actually are in the news moment and perhaps extremely powerful then but don't travel through time. What I was always trying to find were moments or circumstances which were kind of universal and enduring that people could relate to ... you know they could be your brother, sister, mother, son, your family.[42]

Reporting art and culture during the siege

One of the most compelling and extraordinary aspects of the story was the variety of ways in which the creative community of the city responded to the violence of the siege. The citizens of Sarajevo defended their homes and families not only with rifles and grenades but also with art, culture and music. Indeed, according to Predrag Matvejević, 'The life of Sarajevo and of other cities in Bosnia and of Herzegovina has changed into one of survival. Culture has helped its citizens survive.'[43] The Bosnian war, and in particular the siege of Sarajevo, was viewed by many as an attack on civic values, with repeated and sustained attacks on the fabric of society and culture, including the firebombing of the National Library with its priceless Ottoman manuscripts. In response, artists continued to paint and sculpt, musicians and actors to perform, filmmakers to make movies and writers to write. As Remy Ourdan noted, 'In Sarajevo, reporting civilian life was very important both because of the scale of the killings of ordinary civilians, and because of the importance of the political, intellectual, cultural resistance, in parallel with the military resistance.'[44]

Throughout the siege, as their resistance to the aggression and in defence of the values that they considered make us human, impromptu exhibitions, concerts and theatre performances would be organized, with venues and times of performances circulated by word of mouth to avoid being targeted by VRS shells. The event that was covered significantly by foreign media was the 'Miss Besieged Sarajevo' contest, which took place in the Bosnian Cultural Centre in December 1993 – an event that was to be made globally famous by the Irish rock band U2's song, *Miss Sarajevo* and which was also the basis of a film of the same name directed by Bill Carter. The winner was Inela

Figure 5.4 The 'Don't Let Them Kill Us' banner held aloft by 'Miss Sarajevo' contestants, December 1993 (Paul Lowe/VII).

Nogić, a seventeen-year-old Sarajevan, though the result was less important than the image of the participants holding aloft a banner at the end of the event emblazoned with the words *Don't Let Them Kill Us*.

Theatre performances were, however, even more important to citizens. The archives of the international theatre festival in Sarajevo (MESS) record premiers of fifty-seven separate theatre shows, with the total number of performances running into the thousands. Around 170 exhibitions of art were mounted, and forty-eight major concerts were held along with countless smaller performances of musicians ranging from the Sarajevo String Quartet to the post punk band 'Sikter'. The theatre director Haris Pašović explained the motivation both to make art and for audiences to respond to it even in a time of crisis:

> The meaning of art in a time of suffering, a time of war, is much more intense. People are more focused ... You have to imagine that for more than two years there was no electricity in town, so most people haven't watched TV, they didn't listen to the radio, they didn't listen to music. We were completely cut off ... You find yourself in your apartment, waiting to be killed, because your neighbor has been killed. And, of course, for one week, for two weeks, it's a kind of temporary crisis, and you can bear it somehow ... But after one month, two months, it's completely insulating. What to do? ... You find some kind of courage, and new pride. And then you see what is given to you–excluding the war. And what was given to people was, in our case, theater, film, music, literature, architecture and visual arts.[45]

Pašović himself was the director of MESS, and organized numerous theatre performances and was instrumental in the first film festival held in the city. Held in 1993 and entitled *Poslije kraja svijeta* (Beyond the End of the World), the festival was a major event. He described how:

> We had more than 20,000 people in 10 days. It was a major film festival. We had three theaters, 10 screenings per day. And the main hall was at the corner of ... Sniper Alley. They were shooting all the time. And people were coming to the screening with good perfumes–the clothes were just wonderful. They would run across the street to avoid the snipers. Then, they would come to the theatre.[46]

His response when questioned about the rationality of holding such a public event at the height of the siege was typically Sarajevan in its humour, 'Many people, many journalists, asked me during the film festival, "Why the film festival during the war?" But I say, "Why the war during the film festival?" – that is the question. It's normal to have a film festival in a big European city.'[47] The festival continued, becoming the Sarajevo Film Festival, under the guidance of Mirsad 'Miro' Purivatra, who described how at the 1995 staging of the event 'the hunger for films was enormous. The people had gone four years with almost no connection to world cinema. They just wanted to be part of the world again.' The guests included the directors Alfonso Cuaron and Leos Carax, who rode in armoured cars over the mountains into the city, the film canisters were smuggled in through the tunnel under the airport, and the price of admission to the cinema was the donation of a cigarette in place of hard currency.

Before working on the festival, Purivatra had already earlier established the *Obala Theater* (Obala Theatre) as a thriving focal point for the city's artistic production. The original theatre was destroyed by shelling early in the war, leaving the ruins to become a public short-cut to avoid the snipers. Purivatra had the inspired idea to turn it into an exhibition venue. Writing in *The Independent* in 1994, the Scottish academic, composer and conductor Nigel Osborne described the atmosphere of the space:

> The results were extraordinary. Often objects and images were created from the materials of destruction, like Mustafa Skopljak's stalagmites of shattered glass and dolls' faces buried in sand, or Ante Jurić's installations of debris, mud and water. Here, it is as if the legacy of Joseph Beuys has become a dark prophecy, but the processes of the work are modernism in reverse. This has nothing to do with fragmentation, deconstruction or the atomic blast that scatters meaning and reference. It is integrative and reconstructive: an almost sacred act of nurturing and healing.[48]

One of the artists who welcomed journalists – and other visitors – was Edin Numankadić, who told Osborne that 'In the war we have become disciples of Duchamp, living our lives like art. We have learnt to exist at the very edge of things: of our resources, inventiveness and mortality.'[49] Numankadić was a well-established artist before the war and had been given a studio at the top of a newly built apartment building in Novo Sarajevo by the city authorities in recognition of his talent. Even though this studio was located on the opposite side of the city from his home, he would make an almost daily pilgrimage there to paint, sculpt, read and reflect on the experiences of the war. Interviewed in 2018, he recalled that:

> I own my atelier for 38 years. I spent the whole war in it. I walked eight kilometers in one direction to go there, because I live in the city center. I saw plenty of things. Going to the studio during the war, in fact, was some kind of nostalgia for those good times. You could not concentrate and paint, but you did something to make yourself feel better.[50]

Osborne was one of a large number of artists, musicians and writers who were drawn to the city to offer their support. Aspiring authors hung out with the journalists at the Holiday Inn and the hotel served as a base for Western artists and intellectuals as well as the press.[51] As Peter Andreas noted, Sarajevo attracted 'a wide assortment of artists, intellectuals and celebrities, such as Susan Sontag, Bianca Jagger, Bernard-Henri Lévy – who was making a film entitled *Bosna!* – Vanessa Redgrave and Joan Baez', giving the city 'a hip, intellectually fashionable profile arguably unmatched in any war zone since the Spanish Civil War'.[52] They pitched-up at the Holiday Inn because they did not have an appropriate support network in Sarajevo – upon arrival, however, they could embed themselves in the hotel and utilize the knowledge and get logistical assistance from the journalists based there – such as gaining access to travel in armoured cars.[53]

The American singer-songwriter Joan Baez visited Sarajevo in April 1993, making the Holiday Inn her base throughout her stay. She was in the city to attempt to bring attention to the US public the plight of the besieged city. While there she would

perform at the *Kino Imperijal* (Imperial Cinema) in a concert in which she sang, among other songs, Kemal Monteno's ode to Sarajevo, 'Sarajevo ljubavi moja' (Sarajevo, my love). After the concert she returned to the Holiday Inn and socialized with the journalists. She was, recalled Džemal Bećirević, 'very relaxed and easy going'. 'After the concert', he said, 'we heard that John Burns received the Pulitzer Prize (and it was also his birthday). I asked her to come and she just put her dressing gown on and came long to Burns' room. She sang "Happy Birthday" to him, joined us for drinks – it was very pleasant and relaxed'.[54] She later stood on a chair and sang a rendition of the Chilean songwriter Violeta Parra's *Gracias a la Vida*.[55]

But perhaps the most famous 'celebrity' to visit Sarajevo was the New York-based writer and theatre critic Susan Sontag, who had been persuaded to visit Sarajevo by her son, the American journalist David Rieff – who had been covering the Bosnian war and the siege of Sarajevo for, among others, *The Nation*. Rieff had befriended Miro Purivatra, who recalls how he was instrumental in unknowingly bringing Sontag to the city, recalling that he told Rieff in conversation that 'one of the persons who could be perfect to come here to understand what's going on would definitely be Susan Sontag – for sure, I did not know that he was her son – David said he would do what he could'. A few weeks later Rieff subsequently knocked on Miro's door, with a surprise visitor, 'we hugged each other and he told me, "Okay, you asked me something and I brought your guest here". Just behind the door, it was her. Susan Sontag. I was frozen.'[56] Convinced of the need to do something for the citizens of the besieged city, Sontag arrived in Sarajevo in April 1993 – staying at the Holiday Inn. On her first visit, she met many of the city's writers, directors and artists and left persuaded that she should return. Sontag eventually came to Sarajevo a total of eleven times during the siege, gaining the respect of the city's inhabitants, including Una Sekerez, who had issued her with a UN press pass on her first trip, and who remembered that:

> We were very cynical about the whole circus element of these war safaris. There were other people like that, like: What are they doing here? I just assumed she was in for a quick look at how these people on the reservation lived—and she would go. Then she stayed. That was very, very unusual.[57]

Likewise, the American journalist Janine di Giovanni was similarly impressed with Sontag's commitment, recalling how 'Lots of celebrities came, and the reporters were cynical. I remember hearing she was coming and not being that impressed. But she didn't complain. She sat with everyone else, she ate the crap food, she lived in the bombed-out rooms we lived in.'[58] Others, however, remained cynical. Tony Smith of AP, for example, felt that it was driven by self-promotion and the attempt to bring 'a little bit of East Village, New York, to Sarajevo under siege' was not something that sat well with him.[59]

On her initial visit, Sontag had met Haris Pašović and discussed with him the concept of mounting a theatre production. She initially suggested Samuel Beckett's *Happy Days*; his response was 'but Susan, here in Sarajevo, we are waiting', and the decision became obvious: to direct a version of *Waiting for Godot*. She realized that this play was 'the ultimate fringe production' which seemed 'written for, and about, Sarajevo'.[60] One of the actors chosen for the production, Izudin Bajrović, immediately saw the connection between the themes of the play and the situation in the siege:

> We really were waiting for someone to come and to free us from this evil. We thought that would be a humane act. A decent act. To free us from this suffering. But nobody came to help us. We waited in vain. We waited for someone to say: this doesn't make sense, for these innocent people to be killed like this. We were waiting. We actually lived *Waiting for Godot*.[61]

The performances took place in the Pozorište mladih (Youth Theatre) where there was no electricity, so it was staged by candlelight. Even attending a theatre play was a potentially dangerous event in Sarajevo, as any gathering of people was likely to be targeted by the besieging forces. Gordana Knežević explains how at *Oslobođenje*:

> We did not publish the time and date of the performance, as copies of the newspaper were finding their way to the hills surrounding Sarajevo, where most of the Serb guns and artillery were positioned. Such information would have meant the addition of a theater, cinema, or exhibition to the list of targets. We learned that the hard way. Once, in the first month of the war, we published information about a 5 p.m. opening of an exhibition of political cartoons, providing the address. Less than five minutes after it opened, the shelling began. I was not hit, but the detonation threw me to the floor. I was unable to move or to help the wounded who were just meters away.[62]

Another of the actors, Admir Glamocak, felt that 'it was a miracle what we achieved, we performed for cigarettes or beer because no one had any money. In this way, we tried to feed our own spirit and the spirit of Sarajevo.'[63] In July, Sontag returned accompanied by the photographer Annie Liebowitz, who covered the stage production for *Vanity Fair* magazine.[64] Though staying in relative comfort – in comparison to her actors – in the Holiday Inn, Sontag was known to conceal rolls of bread in her bag to give to them.[65] Given Sontag's international status, and the uniqueness of the story, the performance gained significant international coverage in the media, with the story appearing on the front page of *The Washington Post* with the headline 'Waiting for Clinton', 'Waiting for Intervention'. Izudin Bajrović recalled that 'we were hoping that this project would open the eyes of the world. And they will see what is happening to us and they will react. And we were hoping that Susan Sontag was powerful enough to move things.'[66]

Sontag and Baez were by no means the only high-profile figures to endorse Sarajevo's plight, but others were in Sarajevo to document, and offer a rather more serious critique, of the role of the media in covering the siege of Sarajevo, and the journalists residing in the Holiday Inn.[67] Foremost among these was the renowned French filmmaker Marcel Ophuls, best known for *Le Chagrin et la Pitié* (The Sorrow and the Pity), the epic 1969 film documenting the Nazi invasion of France and the imposition of the Vichy regime, and *Hotel Terminus*, a documentary about the 'Butcher of Lyon', Klaus Barbie. The documentary, released in 1994 and entitled *Veillées d'armes: Histoire du Journalisme en temps du guerre* (The Troubles We've Seen: A History of Journalism in Wartime), is characteristically eccentric though it is, equally, a very prescient analysis and evaluation of the role, motivation and dilemmas faced

Figure 5.5 Susan Sontag with the Sarajevo cast of *Waiting for Godot*, August 1993 (Paul Lowe/VII).

by those attempting to document and convey the complexities of war in a way that is consumable to their – often fickle – domestic audiences. It was a project that Ophuls had been planning for some time, though his original idea had been to make a film about foreign correspondents and the reporting of the First Gulf War, where most of the journalists were reporting from their hotels in Riyadh. The film was never made, said Ophuls, largely because the BBC, who he had offered it to, opted not to fund it. However, the war in Bosnia and Herzegovina provided another opportunity to make such a film – funded by Little Bear – though the context of the war and the siege of Sarajevo was 'very different indeed – and Bosnia was much colder than Saudi Arabia'.[68]

He arrived in Sarajevo in January 1993 to begin filming and did so 'in a completely disorganised manner', travelling without making any prior arrangements for travel

or accommodation within the besieged city.[69] Having travelled from Paris down to Zagreb, he and his crew organized a flight on an UNPROFOR plane flown by German pilots. Upon arrival, they had little knowledge of how to function in the city but were fortunate enough to find a space on an UNPROFOR APC that took them to the Holiday Inn. One of the first journalists Ophuls met there was the BBC's John Simpson who was in Sarajevo covering events over the Christmas and New Year period with his crew – Nigel Bateson and Eddie Stevens. Simpson knew Ophuls' work well, admired it and was keen to be part of his latest project. 'We were at the Sarajevo TV station when I saw this character all wrapped up in a scarf and coat. He introduced himself and I knew immediately that this was the man who had directed *Le Chagrin et la Pitié*. Anyway, he explained that he had come to Sarajevo without the means to travel around and asked whether he could perhaps share the BBC's resources. I couldn't have said no; he wasn't young, had come to Sarajevo at his own expense and couldn't get around without transport … so we agreed that he could accompany us.'[70] Thus, Simpson and his BBC crew gave Ophuls and his crew the opportunity to travel around Sarajevo and its environs, including Pale, in an armoured car – a resource they would not otherwise have had access to. The film, said Ophuls, 'would not have been possible without the BBC crew – we would not have gained any traction. After all, we had come to Sarajevo with nothing other than some clothing and our equipment.'[71]

Divided into two parts – or 'journeys' – though filmed over five separate trips to Sarajevo – Ophuls' stated objective was to understand not just the motivations of the journalists covering the Bosnian war, but the contradictions of reporting war in the context of an increasingly fast-moving and transient media environment. The 'first journey', filmed in December 1992 and January 1993, focuses largely on Anglo-American journalists, with the BBC's John Simpson – and his crew which included the South African cameraman, Nigel Bateson and the BBC's translator Vera Kordić – and *The New York Times*' John Burns taking centre stage.[72] The latter part again focuses on the work of John Burns, but shifts towards a focus on the France 2 crew, led by Stéphane Manier and the cameraman Jean-Jacques Le Garrec, and their endeavours to capture the experience of Sarajevans – of all ethnic backgrounds – living through the daily deprivations of the siege, though, as Stéphane Manier notes, 'when Marcel was there it was reasonably quiet, so it was a snapshot, and not really a representative one in the wider context of the siege'.[73] Many of the interviews with the journalists take place in the Holiday Inn – where Ophuls and his own crew stayed during their visits to Sarajevo – and they provide a fascinating insight into life in the hotel – though, ultimately, only a snapshot of the days in which Ophuls stayed in Sarajevo.

The 'second journey' continues in a similar vein, though the tone is markedly darker and more cynical, critiquing the role of the media in war zones. The focus remains firmly on French journalists, with a few exceptions. The film includes many interviews with French print and television journalists, including Remy Ourdan, Martine Laroche-Joubert, Stéphane Manier, Paul Marchand and the French filmmaker Romain Goupil, in either Sarajevo or Paris. Additional scenes were shot in Belgrade – where Ophuls conducts a slightly bizarre interview with Slobodan Milošević – and Pale, where Ophuls conducts an interview with both Radovan Karadžić and Nikola Koljević in which they berate the *New York Times* correspondent John Burns for

'writing against Serbs'. During the interview, Ophuls jokes with Karadžić and Koljević that their – Serb – snipers 'must know his room number' at the Holiday Inn, to which Koljević responds, 'I think you are not too well informed who is really counting on snipers – it's much more of a Muslim speciality', while Karadžić – in the background – mumbles that 'our snipers are too distant from Sarajevo'.[74]

The extensive interviews and scenes from Sarajevo are intercut with short images from, for example, the 1940 film *De Mayerling à Sarajevo* (From Mayerling to Sarajevo) directed by his father, the celebrated filmmaker Max Ophuls, as well as excerpts from Laurence Olivier's 1944 film rendition of *Henry V*. Collectively, it makes for a rather unusual film. Though perhaps one of Ophuls' lesser-known works, is an insightful analysis of the nature of war reporting, and the moral dilemmas faced by those journalists whose role it is to do so – though some critics claimed that the film was 'somewhat ragged' in contrast to his previous work.[75] Ultimately, while the film was admired by many critics, it was not a commercial success. The film, said Ophuls, 'was released, and broadcast on various European TV channels, in 1994, by which time people had grown jaded by the war in Bosnia and the siege of Sarajevo' – the timing was poor.[76]

A more intimate – indeed, deeply personal – view into the lives of ordinary Sarajevans was provided by Bill Tribe. He was, unlike Ophuls, no transient visitor. He knew Sarajevo well, having taught English language and literature at the University of Sarajevo for twenty-six years. He also knew a number of the SDS leadership – in particular Nikola Koljević – from his time there. Tribe had been living in the city when war broke out and had worked for several months as a translator for the Bosnian Press Agency. He had returned to the United Kingdom in August 1992, to be with his daughter, who was expecting her second child – her husband, Samir, remained in Sarajevo – but decided to visit the city again in December 1992. The film, shown on Channel Four in the UK – entitled originally *Urbicide: A Sarajevo Story*, though an updated version entitled *A Sarajevo Diary: From Bad to Worse* was released later – is remarkable.[77] He continued to visit the city throughout the siege and became deeply critical of the role of UNPROFOR in what he described as their 'contribution to the destruction of Sarajevo'.[78]

Though they may have been far less acquainted with Sarajevo than Bill Tribe, many of the journalists and 'fellow travellers' who came to Sarajevo developed a profound sense of identification with the lived experiences of the city's inhabitants and found points of connection with them that went beyond the usual relationships between the press and the subjects of their reporting. Whether documenting the daily lives and struggles of Sarajevans to survive, or their efforts to maintain the civic values that many held dear, they helped to ensure that the concept of the 'Spirit of Sarajevo' endured. The foreign press corps recognized this spirit, and the ways in which culture and art were therefore one of the central ways in which Sarajevo created its reputation as a 'European Jerusalem'. Indeed, its artists sought actively to promote this concept to the journalists who came to the city. As Larisa Kurtović argued:

> During the war, the cultural producers who remained in Sarajevo, nearly without exception, supported the cause of Bosnian independence. From their perspective, such a position stemmed not out of some exclusionary notion of national

Figure 5.6 Bill Tribe looking through the window of a UN plane during one of his many visits to the besieged city (courtesey of Kevin Weaver).

self-determination nor a wish for the destruction of Yugoslavia, which was already in the process of disappearing, but out of the (perhaps naïve) desire to protect the multi-ethnic character of social life in Bosnia and Herzegovina proper. Artists' wartime engagement was hence aimed at showing to the outside world that what was being attacked in Sarajevo was not just a political vision of an independent Bosnia and Herzegovina, but a model of inter-ethnic togetherness.[79]

Collectively, for the artists and performers, the audiences who participated in the cultural life of the city, and the journalists who covered them, these moments of connection with each other were vital to their mental survival, as it gave them a sense of a communal identity that cut across ethnic lines and a sense of the shared preservation of a set of civic values, what it meant to be part of an urban culture. Participating in cultural life was therefore an act of active resistance to the forces that were seeking to destroy the city both physically but also psychologically. As Pašović argued, art formed powerful bonds between people: it was, he said, 'Maybe, your last exhibition, your last concert. And that gave a specific intensity. You played productions, performances, knowing that maybe it was going to be the last production, the last performance. And the audience knew the same. And that basic feeling returned us to the basic simplicity of life. We lost our egomania. We lost our self-importance.'[80]

6

The troubles we've seen

The war in Bosnia and Herzegovina and, in particular, the siege of Sarajevo, generated numerous ethical challenges for those who reported from the city, ranging from those ethical dilemmas that journalists had to face in the 'immediate moment' of reporting in the aftermath of violence, to broader, more philosophical debates and dilemmas about the very role of journalism in a context where they witnessed daily abuse of human rights – but did not always see, and thus report, similar abuses taking place elsewhere. As John Lloyd, writing in *Prospect* magazine noted, the siege of Sarajevo was, 'one of the more important of our contemporary ethical crucibles'. It was a time when, in Martin Bell's words, journalism became a 'moral profession', and when journalism won a decisive battle against its great rival, politics.[1] Bell received, however, significant criticism for his position, not least from Mick Hume, the editor of *Living Marxism*, who launched a withering critique of Bell's journalism.[2] Yet, despite the graphic nature of the visceral images emanating from Sarajevo, the equally powerful despatches in print media and the mounting numbers of civilian deaths, the story of the siege did not receive the same sustained media attention for the duration of the siege that it had during the summer of 1992 – the narrative of the Olympic city of Sarajevo being under siege while the Olympic Games were taking place in Barcelona gave the story a particular resonance that was time limited. That the story of besieged Sarajevo did not continue to make the front pages as regularly, or that Western political elites resisted such calls until the late summer of 1995 when NATO eventually took decisive action against the VRS, was a reality that they had to adapt to.[3]

The 'something must be done club'

At a relatively early stage in the siege, the lack of a more robust Western intervention and a perceived failure to impose a settlement that would end the suffering of the citizens of Sarajevo animated many foreign correspondents. As Robert Donia noted, 'Though the outside world watched Sarajevo intently, no single nation or group of nations was prepared to take the necessary steps to end the killing … those with the means to break the siege, the major European countries and the United States, lacked the will to employ them, preferring to focus on the humanitarian needs of the conflict's victims.'[4] The West's reticence in committing military power for purposes other than

the mere containment of the Bosnian conflict had become a matter of significant concern for journalists, and many began to believe that their endeavours in bringing to the wider public the grim realities of the siege had, ultimately, made little impact on policy. Even in the early months of the siege, foreign journalists were making a case for international military intervention. According to Miljenko Jergović, who was then writing despatches from Sarajevo for the Montenegrin independent weekly *Monitor*, noted that foreign journalists and TV crews were 'coming [to Sarajevo] as if it were the Olympics again' and that it was 'obvious that these people have much more faith in military intervention than Sarajevans themselves'.[5]

The war in Bosnia and Herzegovina, and in particular the siege of Sarajevo, challenged the assumption that many journalists held – that is, that if governments and decision-makers were informed about ethnic cleansing, forced population transfer, murder, the besieging of cities, the establishment of camps, sniping and shelling of non-combatants – they would take action, driven by their moral impulses, to rectify the situation. As the *Newsday* correspondent Roy Gutman stated:

> I've always felt that the best journalism was not advocacy journalism but simply the straightforward reporting of extraordinary information that reflects unacceptable practices or behavior. The reporting of it in the straightest possible way should alert people and exposing it should stop it. That is the great let-down for all of us who have been covering Bosnia. This hasn't proven [to be] true.[6]

There existed something of a misalignment between the narratives of the dynamics and trajectory of the conflict that were conveyed by journalists and those posited by the major Western governments, particularly the French and British. The majority of the Sarajevo-based press corps concurred that the conflict was mainly the result of an aggressive Serbian state, led by Slobodan Milošević, who used the forces of the rump of the JNA, Serbian paramilitary groups, his SDS clients and the VRS to attack and capture a series of towns and villages across Western Bosnia, the Drina Valley and Eastern Herzegovina in 1992 and, to a lesser extent, 1993.[7] A substantial number of journalists argued, therefore, that the conflict was not per se a civil war between Bosnians, but a war of aggression *upon* Bosnia and Herzegovina by Serbia and, later, by Croatia. Moreover, they argued that the UN-imposed arms embargo favoured the aggressors, particularly the VRS, who had inherited significant stocks of weapons from the JNA – which had been one of Europe's largest armed forces and the Bosnian Serb leadership, at least until 1994. According to Allan Little, 'It was obvious to me, and to everyone who knew anything about the war, and was interested in the truth about it, that it had been choreographed in Belgrade from the start. The West, or at least most people in the West, took three and a half years to realize this obvious fact.'[8] However, Western governments largely argued that the fighting was the result of a civil war based on 'ancient ethnic hatreds' and that military intervention brought with it too many risks. According to Allan Little, this represented a complete misrepresentation of Bosnia and Herzegovina as a land in which its peoples had 'spent centuries fighting each other, and all that rubbish', a narrative that served merely to justify the avoidance of military intervention.[9]

Thus, when intervention failed to materialize and the siege continued, what emerged was something of a crisis of confidence in the Sarajevo-based foreign press corps and with regard to the role they had played in reporting the conflict. Many had argued for intervention, and that had failed to materialize. The ongoing siege of Sarajevo and the close connection that many foreign media professionals felt with ordinary citizens did mean that some sought to hold their own governments to account on the issue of Bosnia and Herzegovina. Probably the best example of this was on 3 May 1994, during a CNN special entitled 'Global Forum with President Clinton'. As part of the broadcast, Christiane Amanpour, on a live feed from Sarajevo, challenged Clinton, who was in a studio in the CNN headquarters in Atlanta, on US policy. When Clinton said that Bosnia was 'a humanitarian catastrophe', Amanpour then asked 'Surely, Sir, you would agree that it is so much more than that? It's a fundamental question of international law and order.' She went on to question US policy vis-à-vis Bosnia and Herzegovina and ask 'Why has it taken so long for the US to formulate a policy on Bosnia? And do you not think that the constant flip-flops of your administration on the issue of Bosnia sets a very dangerous precedent?' Clinton, clearly annoyed, responded that 'There have been no constant flip-flops, Madame', before he went on to defend his government's position.[10]

To critics of those journalists who tried to hold their governments to account, exchanges such as this were dismissed as merely 'campaigning journalism', a form of advocacy with the objective of influencing policy.[11] Such journalists were, according to the then British Foreign Secretary Douglas Hurd in a now rather famous speech at the Travellers' Club in London in September 1994, members of the 'something must be done club'.[12] In Hurd's view, some within the British media operating in Sarajevo – he singled out the BBC, *The Times*, *The Independent* and *The Guardian* as the main culprits, but did not mention the names of individual journalists – had become crusaders for military intervention. He further argued that in so doing they had been 'selective' in their reporting and had thus quite explicitly aligned with the Bosnian government.[13]

Hurd was by no means alone in criticizing the reporting from Sarajevo. There existed a broader perception that a 'journalism by consensus' among the Sarajevo-based press corps had led to biased reporting which, by extension, became the basis for explicitly campaigning for armed intervention against the VRS.[14] Moreover, it was alleged that the 'Holiday Inn crowd' had fallen under the influence of the Bosnian government – who always maintained a presence in the building. Some questioned whether the camaraderie that had developed among the Sarajevo-based press corps had led to the development of a 'pack mentality' that undermined their ability to remain objective and led to a one-dimensional caricature of the war and of the siege of Sarajevo. There *was* a camaraderie among journalists in Sarajevo – perhaps best illustrated by the creation of the SAP. Indeed, according to Emma Daly of *The Independent*, there existed 'a genuine sense of community' within the journalistic milieu and that they were something akin to 'a dysfunctional family'.[15] Did this mean, however, that this led to the development of a consensus between foreign journalists about the dynamics of the war in Bosnia and Herzegovina and, by extension, the siege of Sarajevo? Certainly, in the case of Sarajevo, the majority felt, not unreasonably on a human level, a strong sense of solidarity with ordinary citizens and the injustices

that they were suffering on a daily basis. But they also identified the Bosnian Serb political leadership, the VRS – and the Milošević government in Serbia – as the primary aggressors.

The most critical, perhaps almost vitriolic, assessment of the role of the foreign press corps was provided by the American journalist Peter Brock, who argued that the reporting from Sarajevo had been 'blatantly one-sided' and that the Holiday Inn had 'a profoundly institutional effect on its guests/inmates, who daily churned out the victim idolatries of exploited tragedy obtained from government propagandists or overheard in its dining room and hallways. It was, in fact, the Bosnian government's de facto public relations annex that provided endless grist of misery and ready access to media-ready misery.'[16] This, said the BBC's John Simpson, could have been due to the relative inexperience of the Sarajevo-based press corps, which he noted was 'profoundly partisan' and 'openly one-sided', and thus played into the hands of the Bosnian government, for whom international public opinion was their 'chief weapon'.[17] Any suggestion that this may have been a factor was generally unwelcome.[18] Indeed, according to Simpson, 'If you share the sufferings of a city under siege you instinctively side with the people in it; that's natural enough. But what many of the journalists based there did, and it has to be remembered that many of them were young and inexperienced, was to line up with the Bosnian government rather than with the people.'[19]

Simpson was, however, by no means alone in his critique of the foreign journalists in Sarajevo. Phil Davison of *The Independent*, who had first entered the city with the BBC correspondent Alan Little in June 1992, stated that some foreign journalists had allowed their emotions to get the better of them and that if journalists are drawn into this they would only aggravate the situation. 'This is why', he added, 'there are so many calls for the bombardment of Belgrade ... I consider these to be unjustified emotional reactions.'[20] Likewise, Ljiljana Smajlović, once a journalist with *Oslobođenje* but writing in the Belgrade weekly *Vreme*, wrote a series of highly critical articles in which she bemoaned the foreign press corps' lack of objectivity and the 'media consensus' that had emerged during the war in Bosnia and Herzegovina. While under the pretext that they wanted to help suffering citizens, she said, the foreign journalists had explicitly identified 'with one party to the conflict' and were manipulating stories 'for the purposes of the evening news'.[21] 'They took sides in the conflict', she said, 'and started calling on their governments to take to weapons'.[22] She further lamented the biased reporting of the Western – and particularly British – media, stating, 'The reputable world press has shown double standards in its editorial policy concerning the Balkans: the Anglo-Saxon criteria in journalism is, it seems, strictly applied only when reporting from the Anglo-Saxon soil.'[23] In subsequent articles she questioned the legitimacy of John Burns' and Roy Gutman's Pulitzer prizes, claiming that both had openly expressed sympathy for the Bosnian government and the Bosnian Muslims and had demonized the Bosnian Serbs as those primarily responsible for the war.[24]

Many foreign journalists, however, committed themselves to the story of the siege of Sarajevo – and the war in Bosnia and Herzegovina more broadly – in a way that went beyond the boundaries of conventional reporting. The Sarajevo press corps included major established figures in journalism, such as the BBC's Martin Bell, but it also comprised a new, younger wave of journalists who became deeply enmeshed

in the story. For them, the war in Bosnia and Herzegovina was 'their war', in the way that Vietnam and Lebanon had been the defining stories for previous generations. Gary Knight, for example, called it 'the most significant story of the early part of our lives'.[25] For many journalists, it was thus a defining moment in their careers. It was Bell, however, one of the most senior and established figures within the foreign press corps in Sarajevo that posited that journalists, while they have a duty to report as objectively and as honestly as possible, must consider the evidence. If that determines that one party is clearly the aggressor and the other the victim, then a neutral position is unacceptable. This he termed the 'journalism of attachment', in which identifying one side as morally wrong and therefore accountable for their crimes does not necessarily impinge on the professionalism of the journalist. He further argued that taking such an approach did not mean being partisan, biased or the abandonment of accurate reporting 'set around with all kinds of qualifications, like meticulous attention to the details, seeking out supposed bad guys, explaining what's happening, why they're doing what they're doing'.[26] Bell defended the reporting of his fellow journalists, stating that in the context of Sarajevo 'dispassionate and distant journalism … was simply not an option'.[27] Likewise, John Burns of *The New York Times* stated:

> To have stuck then to the neutral view might have served the notional ends of impartiality, but not of fairness, or of truth. And much of the reporting of the time in English and American publications, it's safe to say, was not, in that narrow sense of the term, impartial … There are still those, particularly among Serb nationalists, but not alone among them, who condemn reporters of the time for having enlisted in the cause of the Bosnian Muslims, as though we had made a choice of our champions, and our villains, without troubling ourselves with the facts. But the overriding reality was that on any fair weighing of the facts as we knew them, there was a truth we owed to our readers, and most of us reported it that way.[28]

Likewise, Zoran Kusovac of Sky News stated that, 'I do not believe in neutral journalism; I believe in honest journalism and in journalism that is fair and non-biased, but not neutral.' He added that, 'We, the journalists were part of this story and we were involved; it's not something we took lightly and we discussed in real depth daily developments.'[29] Indeed, journalists debated the dynamics of the siege, and of the wider conflict in Bosnia and Herzegovina, endlessly, debating the semantics of whether the policy of the Serbian attacks on civilians could be considered to be genocidal and defined the term 'ethnic cleansing' to describe the policy which sought to eradicate Bosnia and Herzegovina's statehood and to remove the Bosnian Muslim population of those areas claimed as part of a 'Greater Serbian' state-building project.[30] There was, said Christiane Amanpour, little in the way of ambiguity about the nature of the siege of Sarajevo:

> We [journalists] witnessed the heroic resistance of a population under siege and shelling and sniping for nearly four years. We learned the pain of watching men, women and children brutally slaughtered. These were the non-combatants, casually targeted in the crosshairs of the sniper's rifle, blown apart by mortar shells when they went to collect water, bread, fuel or even heading to school … The

Bosnian Serb Army behaved disgracefully; of that there can be no doubt. They violated international norms and humanitarian law by targeting civilians and journalists and they placed an entire city under siege. I didn't believe there was much ambiguity there and I was always clear about how I reported the story. I don't use the phrase 'journalism of attachment' but, rather, 'truthful, not neutral'. We had an obligation to tell the truth but not to be falsely neutral – and that means drawing no false moral equivalent. And, in any event, being neutral would not have been possible in a context within which the deck was so heavily stacked against one side and, moreover, against civilians. Objectivity, of course, means getting all sides of the story, but it does not mean that you treat all sides equally.[31]

Much of the reporting of the siege focused on the everyday lives and privations of citizens, as covering military aspects of the siege was, for foreign correspondents, difficult. As Jeremy Bowen noted, 'There was not a great deal of reporting from the trenches at the front line ... it was almost impossible to get permission from the Bosnian Army to visit soldiers' but that the whole of Sarajevo 'was a front line'.[32] Remy Ourdan did try to cover both military and civilian aspects of the siege. 'If you don't cover the fighters', he said, 'how will you understand what people are fighting for? And if you don't cover frontlines, how will you understand who is winning or losing a battle? In Sarajevo, I reported from the Bosnian government front lines and those of the VRS, but I was covering both the fighters and the civilians.' However, according to Robert Donia, foreign journalists 'frequently relegated ARBiH military operations [in and around Sarajevo] to an informational black hole':[33]

> ARBiH operations were typically shrouded in secrecy and conducted in obscurity. Journalists often portrayed ARBiH troops as well-intentioned and hapless engaged in a futile struggle against overwhelming odds. Bosnian government supporters encouraged this representation during the war to highlight the plight of the city's civilians, but armed defence of the city was more effective than outsiders often portrayed it.[34]

Foreign journalists did not cover extensively, for the aforementioned reasons, developments on the front lines, though most knew of the ARBiH's plans to construct a tunnel underneath Sarajevo Airport. The Bosnian government, unable to break the siege of the city above ground, began – in May 1992 – the construction of an underground tunnel under Sarajevo's airport, which would connect government-held territory in Butmir and Dobrinja – the VRS held the territory on either side of the runway, in Lukavica and Ilidža – and facilitate the smuggling of weapons and other key supplies into Sarajevo. The tunnel, known as *Tunel spasa* (Tunnel of Life), took nearly a year to construct and was 800 metres in length, created a link between the besieged city and Bosnian government-held territory beyond siege lines. This particular story created a dilemma for foreign journalists:

> The building of the tunnel was kind of [a] military secret (though the VRS military intelligence almost certainly knew about it and were regularly firing shells at the

entrance), but the lack of media attention maybe didn't push them to destroy it. The tunnel was, for sure, one of the main reasons why the city of Sarajevo had survived. Most of us correspondents felt we couldn't be responsible for the closure of the tunnel, a development that may have led to the fall of the city. So, personally, I didn't write about it. And other correspondents didn't write a single word about it until one journalist, who came for a few days attracted by the exclusive story, did so.[35]

Journalists instead continued to report daily on the sufferings of the ordinary citizens of Sarajevo. Witnessing this led many journalists to become increasingly frustrated with the lack of substantive action on behalf of Western governments and led to repeated calls for intervention on the side of the Bosnian government against Serbian military targets, in particular those besieging the capital city, Sarajevo, and the eastern Bosnian 'safe havens' of Goražde, Žepa and Srebrenica.[36] That the foreign press corps did not simply accept the narrative spun by the Bosnian government is illustrated by Remy Ourdan's reporting from Sarajevo. Ourdan, who had been in Sarajevo almost continuously since the summer of 1992, had come to know the city and its internal political dynamics well. In September 1994, he published as story in *Le Monde* entitled *La fin du rêve bosniaque* (The End of the Bosnian Dream).[37] The main thrust of his argument was that Alija Izetbegović's SDA had no intention of maintaining Sarajevo's multi-ethnic character. The report was to cause him significant difficulties:

> That was one of the most difficult stories to write, politically speaking, about nationalistic and authoritarian Bosniak, or SDA, rule in Sarajevo, and I was declared *persona non grata* – by the SDA newspaper *Ljiljan* – and was asked to leave the city, by some officials, or I would be killed. I refused and stayed, and after weeks of threats, it was clear that I was not going to be killed. However, that story totally changed my relationship with the Bosnian government. On the other hand, it changed my relationship with the citizens of Sarajevo, many of whom were critical of the SDA's political power.[38]

The representation of suffering

For journalists covering conflicts, there exists a constant tension between witnessing the suffering of others and drive for 'getting the story' for their newspapers or agencies that ultimately generates professional recognition. Foreign correspondents are, by their nature, drawn to the violent and the tragic; war is, after all, about killing and high drama.[39] The more dramatic, brutal and emotive the situation that they are reporting on, the more likely it is to be the lead story in radio or TV news bulletins or reports or on the front page of the newspapers. The BBC's Jeremy Bowen noted that, 'For a journalist who wants to get on the main television news bulletin most nights of the week, that very often meant finding stories that were so compelling that they could not be ignored – about dead people, how they died, and what that did to the people left behind.'[40] Yet, while reporting such stories might indeed assure visibility, the search for compelling stories of

suffering can be both uncomfortable and traumatic for journalists. This is especially the case with photographers, who have to maintain a close, often uncomfortable, proximity to their subject(s). Nevertheless, the 'chase' for the story that will be the first on television news or an image that will reach the front page of newspapers or periodicals is inexorable. The AP photographer Enric Marti who, in November 1994, would capture one of the most powerful images of the siege – the death of a young boy called Nermin Divović, who was killed by a sniper's bullet – recalled, when he was informed of the Markale marketplace massacre in February 1994, his initial response was, in the first instance, one of frustration that he was not in the city at the time:

> My first reaction? The first reaction was that I fucking missed it. Okay, yes, it is like the first reaction when I took the pictures of Nermin Divović. You see, the first, my first reaction is like what a hell of a picture I have. Then comes the rest of it. But when you're working like that, it's ... You become some sort of an alter ego that is competitive and hungry for taking pictures. And this is what we photographers do. It's like an addiction. Especially with news and in conflict situations ... I know that many of us like to talk on how the conscience of us changing the world is part of doing your job. Which is also true, but I think that the first feeling that one has in this business is competition and getting that shot, and then of course we're humans but that kind of feeling protects you from feeling a lot of things, then they call it post-traumatic stress or whatever, for me it is all part who we are.[41]

A Reuters photographer, Peter Andrews, recalled his shock at witnessing the aftermath of the second Markale massacre of August 28, 1995 – an event which would be the trigger that initiated the NATO bombing of VRS positions around Sarajevo. 'Usually, in a situation like, this my first reaction is to help people but, in this case, I was overwhelmed. Bodies and body parts were lying everywhere and the wounded were screaming for help.'[42] In such circumstances, the camera and the act of photography could serve as both a 'barrier' and psychological aid that provided a distance from the terrible scenes. As Danilo Krstanović of *Oslobodenje* explained:

> Taking photos of the rest of it – the destruction, the killing – it's not so hard once you have the camera to your eye. The photo I am unfortunately best known for is of a man's body cut nearly in two after the infamous market bombing of August 1995. I had been sitting in a café, about two hundred yards way. I heard an explosion and everything started to shake. At first, I was afraid to leave the café, so I just peeked out, brought my camera up to my eye, and walked straight ahead. That was the first time in my life that I set the camera to fully automatic operation, focus, f-stop, everything. I didn't know what I was taking photos of until I developed the film. Afterwards I was in a state of shock. It's possible that if I had put the camera down I'd have gone mad.[43]

During more serious shelling, photographers would largely remain indoors and under cover until it had ended, and then head straight for the hospital to photograph the aftermath of wounded victims being brought into the emergency room. Enric

Marti recalls that although this became a normal practice, at times it still felt deeply uncomfortable to be witnessing the victims as they arrived at the emergency room:

> We were going around with armoured cars and cracking jokes and smoking while we were waiting for something to happen. We were sometimes waiting literally at the hospital, for something to happen, a bunch of photographers. The hospital was very near the AP office [The Belvedere], so when there was a lot of shelling and so on, we always had somebody there. We would take shifts to be there and there were other photographers too of course and then wounded people will come and you would take pictures of them. And it was me or whoever with a bunch of other people taking pictures, or TV, and that would be fine, but one time I was alone in the hospital, nobody else. There was a shelling and it was a lot of kids wounded and it was pretty bad. I was alone and, actually, I was paralysed. I couldn't take pictures, I felt like a vulture. I felt bad about it. I took some but it was not the same as being there with other photographers where it is not actually only you ... it made me feel a bit guilty.[44]

Chris Helgren explained, however, that there was an unspoken sense of when it was acceptable to be present at the hospital. You could, he said,

> tell by acknowledgement from the doctors or the families if it was okay to take pictures; in most cases, they understood, they felt that it was okay for the journalist to be there ... Put it this way, they wanted to get the story out there. You would still feel a bit like a vulture, but at least you would feel a bit better because you would speak to people afterwards and they were happy that I was there or we were there.[45]

Attacks on the city inevitably also brought with them the tragedy of funerals, which again offered an opportunity for powerful images to be generated. But these, too, demanded a sensitivity to the situation, especially from the photographers who had to be in the proximity of the burial site. Helgren felt that in a similar way to the hospital, the presence of the media was accepted, but that it had to be moderated and with an acute sense of respect. Understanding the boundaries and interpreting the mood was key. You could, he said, 'generally tell if you were welcome or not. And in most cases I was always welcome, but I would tend to stand back with the long lens and give them space. I know that some people, who go nameless, like to get in there, close, with a wide lens. And I didn't. I wasn't comfortable with that.'[46]

Another ethical dilemma for reporters was the level of graphic violence that they could, or should, express in their work. How could this be done sensitively but in a way that conveyed the shocking nature of events? Martin Dawes of BBC Radio recalled his reporting from the scene of the first Markale marketplace massacre on 5 February 1994, an attack by the VRS that took the lives of sixty-eight citizens – the most lethal single incident throughout the siege. Having been informed of the attack while at a UN press briefing in the PTT building, he rushed to the site, recorded on the spot and expressed, honestly and without pulling punches, the brutal reality of what he witnessed: 'I recorded a piece directly into my microphone, which people complained

about in the UK because it was too graphic. I received complaints about it. I had said that there was a pool of particularly pink glutinous blood that comes from brains. Well, while it may have been true, that was considered too much.'[47] Consequently, Dawes' report received some negative responses from the listeners, who called in to the BBC to express their discomfort at his language.[48]

Vulture, voyeur, saviour

As the siege ground on, foreign journalists increasingly became the targets of criticism from the population of the city for cynically trading on, or profiting from, their suffering. This was particularly notable during the latter part of 1994, when French UN anti-sniper teams were deployed around the Marindvor area – close to the buildings of the Faculty of Philosophy and the *Zemaljski Muzej* – the National Museum of Bosnia and Herzegovina. UN armoured vehicles were parked at key intersections to provide cover for civilians, who would then run across the open ground between them. This created a scene of people lined up ready to sprint for their lives, which made a compelling image for photographers and TV crews. However, this also laid them open to accusations of profiting from the suffering of the civilians, waiting for someone to be hit by a sniper's bullet. Writing in *The Independent*, Emma Daly described the atmosphere on Sniper's Alley in June 1995, 'It's obscene to see people with their faces all screwed up in terror, just because they have to cross the road. As usual there is a pack of television cameras and photographers hanging around – some Sarajevans criticize them as vultures, but they have saved people by using their armoured cars as shields. And if they didn't shoot the pictures, no one would know.'[49]

Photographers and TV cameramen undoubtedly felt deeply uncomfortable with their position, torn between the need to document what was clearly attacks on civilians but in the knowledge that they were, quite literally, waiting to capture images of someone being shot. Peter Maass of *The Washington Post* noted that this was in particular evidence in the vicinity of the Holiday Inn hotel, which itself was something of 'a grandstand from which you could watch the snipers at work'. He added that 'Watching them [snipers] at work was work, not voyeurism. Just ask any of the photographers who found safe spots near a sniper zone and waited for someone to be shot.'[50]

Yet while this may have been perceived as deeply cynical, the visual evidence captured by photographers did, ultimately, have an important role to play in providing evidence of the attacks. On 18 November 1994, Nermin Divović, a seven-year-old boy, was killed by a single shot fired from Bosnian Serb positions in Grbavica, despite the presence of UNPROFOR APC's providing some protection as civilians crossed the dangerous intersections near the Holiday Inn.[51]

Marti recounted how he was photographing civilians running across the intersection in front of the Zemaljski Muzej, one of the regular locations where photographers would go to, looking for 'the cliché photo of people running between one corner and another one with the UN tank in the background, the people running back and forth'.[52] He saw a group of civilians including a woman and her children walk past, and recounts what then happened:

Figure 6.1 The body of Nermin Divović lies on the ground as UNPROFOR peacekeepers attempt to get transport to take him to hospital, November 1995 (Enric Marti/AP).

I saw the kid that was lying in a pool of blood in the intersection in the exposed area. And then I saw that the UN Land Rover was going to get the kid. So, I ran out there before the car was there, out in sight of the sniper that just killed the kid. I remember being really nervous. Anyway, the car came and collected Nermin, put him in the car and went. I then took pictures of mother and the sister who were hiding in one of the UN cars, and I remember her face ... she had a particular face. I later sent the pictures and there was a discussion in the AP about if it. Was it too strong for Americans to see in the newspapers over breakfast? I had to fight for it. One of the editors pushed his weight to say: 'What are you doing sitting on these pictures, this has to go right away'. It got a lot of play, and it was a moment when there was a lot of discussion of intervention and non-intervention in Bosnia. It was one of those pictures that actually made it to many newspapers' front pages, more in Europe than the US, although it was in *Newsweek*. And it was used to illustrate the need for an intervention and what was happening in Sarajevo.[53]

Some of the incidents that journalists witnessed were so graphic that they left significant mental scars. In May 1992, the *Time* photographer Chris Morris was driving into Sarajevo when he was confronted with a scene of surreal horror. Along with a colleague, he was driving at high speed down Sniper Alley trying to reach the city centre when a car driving close to them came under fire. Morris described what subsequently happened:

> There was an explosion near the car, which does a 360-degree spin in the road ... I got out and ran towards that car because I saw it being hit. I was running like hell. I come around the passenger side towards the front of the car and as I came around I saw the driver of the car. He was a soldier. There were two passengers in the car but the driver's head was completely off, and it was sitting in the window and his eyes were open, like he's alive. He'd been decapitated but he looked at me with pure horror in his eyes ... I just saw his head staring at me and I didn't want that to be me, so I ran. It's probably the most poignant picture that seared in my mind that I did not take in this war. But I felt if I had tried to raise the camera I would be dead.[54]

Morris's experience was illustrative of those that journalists had to absorb and 'process' on a near daily basis in Sarajevo, which was particularly challenging for those with little experience, hitherto, of war. And even those who had experience of war found it difficult in the context of Sarajevo, where much of the suffering was borne by civilians, young and old, male and female. Indeed, the psychological strain of witnessing daily violence and the impact of that violence on civilians began to take its toll on the journalists; this was particularly acute in circumstances where children were victims. Chris Morris recounted another incident that had a profound effect on him, one that would force him to consider carefully the ethics of the visual documentation of death and violence. During a lull in shelling on 22 January 1994, a group of young children had left their homes in Alipašino polje - tempted by the clear, sunny but snowy day - to embark upon some sledging. They were playing in the snow when a mortar landed amongst them. Six children were killed and six seriously injured, the youngest among the dead a four-year-old girl called Jasmina Brković.[55] Morris recalls how along with another photographer, Enrico, he had gone to the site of the massacre, and then to the morgue to document the victims. It was, he said, 'kind of my breaking point', the beginning of a struggle with post-traumatic stress disorder (PTSD):

> They had literally scooped-up the children off the snow ... We jumped in our vehicles and we raced up to the hospital. There, we went into the morgue and we started photographing six children, two of them had their faces ripped off from the shrapnel. The shrapnel came and sliced the face off and the insides were gone - you could see the back of the skull. Pure horror. And because you shoot film you know nobody is going to see it. And we just stood back with respect, stopping in the corner. But I did shoot it. I did it like a forensic document ... wide, medium and then in-close and knowing no-one is ever going to publish it. You know, the soft tender ones you can publish, but I looked down over these two children's faces and looking in the back of their brains I was absolutely terrified. The mortician, the father and grandfather and some of the other children came in and just stood over. I was choking on tears ... the mortician had put the face of the boy on upside down, and just when the parents came to see him. I had pulled Enrico back, he was too close. We kind of backed off, but just the way the father and grandfather looked towards me it was like the Earth crying. And you're in that cold. The odour of that room from the long war. That just broke me.[56]

Morris was not the only one among the foreign press corps who had reached their limit with the senseless death of a child. The ITN cameraman Jon Steele had to acknowledge his own PTSD after the killing of a ten-year-old girl in Sarajevo in August 1992. Having been seriously injured by shrapnel, Steele had filmed her last moments of life, and he was wracked with guilt thereafter. The last thing she had seen, he said, 'was her own face reflected mirror-like in the lens of my camera – the camera I shoved in her face as she lay choking on her own blood'.[57] The impact of witnessing the death of a child under such circumstances also haunted Chris Morris. On 22 January 1994, after his return from the morgue, where he had photographed six dead children, he watched the TV news at the AP offices. The US President, Bill Clinton, gave a speech about the situation in Bosnia and Herzegovina and in Sarajevo:

> There was a press conference that night and I heard Clinton on TV. Somebody had asked him about the humanitarian crisis in Sarajevo. He was basically saying that 'We've examined it, there's plenty of aid getting in and there is no humanitarian crisis'. I lost it. I went to the PTT building to call *Time* on the sat-phone. I asked to be patched into the White House correspondent of the day and let them know that the humanitarian crisis is that children's faces were being ripped off by shrapnel ... At *Time* they said, 'Chris you've lost it', because I was screaming on the phone. I was so angry but the pictures I took, those forensic pictures, well, I knew the only person that would see them was my picture editor, Robert Stevens. I knew he was going to have to take them out of the envelope from a box of slides and he was going to have to lay it out on a light table. I wanted to punch him in the stomach and say: 'What the fuck? Look at this! Look at what I have seen!'[58]

How should a journalist react when they witness incidents such as those recounted by Morris and Steele? Another ethical challenge was whether to intervene or not; whether journalists should directly help people who had been injured or were in imminent danger. One of the most common was the question of whether it was appropriate to transport the wounded to hospital after an attack. Was this within their professional remit?

Regardless, for most this was a simple decision –- the saving of someone's life, many judged, was more important than journalistic impartiality. As John F. Burns noted, it was not enough to simply bear witness.

> If you had the potential, and we did have the potential to help, because we had armored cars, money, flak jackets, helmets and an ability to cross the siege lines. I came to the conclusion that we could help, we should help and we did help, where we could and however modest the contribution – not the Bosnian government but the ordinary citizens of Sarajevo.[59]

And while this position may have been regarded as problematic by some foreign correspondents, there were those for whom it was the only rational response. Chris Helgren, for example, recounted that when he sold the Range Rover that he had been using during the siege to Gary Knight in 1995, 'The car still had blood stains on the

Figure 6.2 Chris Morris photographing bodies in the Sarajevo morgue, Winter 1993 (Paul Lowe/VII).

back seat, and that is basically testimony to all the wounded people that I picked up along the way.' In addition, he added, 'We all used to do that, and I can pretty much say this is among all the journalists in the city, that if somebody was hurt then we did what we could to help.'[60] Likewise the BBC's Jeremy Bowen always gave lifts to those who needed it, even if only back to their homes. When leaving the TV station in the evening, having edited and sent their stories at the EBU transmission point, Bowen would often give those working there a lift home and would do so on many other occasions – 'we had, after all, cars and fuel, which most Sarajevans did not'.[61] Zoran Kusovac and the Sky News team also helped people where they could. This primarily involved bringing food into Sarajevo, taking parcels out and sometimes involved helping to get people out of the city:

> When I was initially asked to help people leave the city, I thought, 'well, this is not my job'. However, I did take dozens of people out of Sarajevo because I came around to thinking that if I was in a position to do that, I should. It's a question of how much involvement you can get into without compromising your positon as a journalist, but I don't consider that by doing this it impinged upon my reporting. It was simply that I could help as part of my daily routines. I had an armoured car and a large trailer attached and could cross lines with relative ease, several times a week. So, I felt I it was my obligation to help innocent people who were not participating in the war. I developed a system: on a quiet day, when I would normally leave Sarajevo to buy supplies, I started familiarising myself with the shift system at the checkpoints, and I soon knew these well. I would, therefore, go to the checkpoint very early in the morning with all the paperwork and an empty

armoured car. I would explain that I was going to buy supplies and normally I would be asked to purchase something for those manning the checkpoints. I would do so and then they would generally just wave me through the next time I crossed. This is how I managed to smuggle people out of the city.[62]

The reality, added Kusovac, is that journalists, because they had many connections in the city, became 'involved'.[63] So, when asked to take someone out he, and others, did their best to do so. 'We [journalists] all did it, to a greater or lesser extent', he said, 'and it's difficult to assess, when you are in the situation, whether this is befitting for journalists or not, but it was what many of us felt we had to do'.[64] This view was shared by Remy Ourdan, who stated that he always tried to help people if he could. 'I didn't care if whoever was injured was a civilian or a fighter, or for which side they were fighting for,' he said, 'because if you are the only one on the scene – and knowing that someone wounded should arrive at the hospital as soon as possible to have a chance to survive – journalism, at that moment, doesn't really matter.'[65]

On occasion, the role of journalists in highlighting certain stories – and driving them to the top of the news agenda – was key.[66] A mortar attack by the VRS on 30 July 1993 critically wounded five-year-old Irma Hadžimuratović and killed her mother. Irma had severe injuries to her spine, head and stomach and the scant resources of Koševo Hospital were overwhelmed by the complexity of her situation. She developed bacterial meningitis, and her surgeon, Doctor Edo Jaganjac,[67] tried unsuccessfully to have her evacuated on a UN relief flight.[68] In desperation, he called the BBC office at the Holiday Inn. Allan Little, the BBC's correspondent there, then went to the hospital and produced a radio report on Irma's condition for the Saturday evening news. His colleague Jeremy Bowen followed up the next day with a report for the BBC TV news. He saw in Irma's plight an opportunity to craft a powerful narrative around the story. As he later recalled, 'Children and war are a very profitable combination for journalists. The weakness and innocence of childhood and the power and might of warfare together make strong magic, and reporters who spend a lot of time in war zones should deploy it carefully.'[69] Bowen understood that Irma was a powerful symbol of the suffering of the citizens of the city, recalling that 'television news works best when a small story can symbolize something much bigger, and I knew I could do a very strong piece about young Irma and her father'.[70] Bowen and his team filmed an interview with Irma's father, Ramiz, going with him to the grave of his wife and to the site of the attack that had killed her and wounded Irma. The story was broadcast on the evening of Sunday 8 August 1993, but Bowen did not expect it to generate a significant response, at the time he recalled that 'I did not think that Irma's terrible experience was particularly exceptional. I had done similar stories in Sarajevo over more than two years about children who were gravely ill and usually they either stayed that way or they died. Telling their stories seemed to have made no difference at all. This time was different.'[71]

In the UK, the Sunday news bulletin typically drew a large audience, and by chance there were a significant number of British tabloid reporters in Sarajevo at the time – largely due to rumours of impending NATO airstrikes on the Bosnian Serbs. Fleet Street journalists, and their newspapers, picked up Allan Little's radio and Bowen's TV pieces and splashed the dramatic human-interest story in their papers. This drew

an almost immediate response from the British government, and on the Monday evening the foreign secretary Douglas Hurd announced that an RAF Hercules of No.47 Squadron would be sent to Sarajevo to airlift Irma out immediately to take her to London's Great Ormond Street Hospital. This sparked off a larger programme that was quickly dubbed 'Operation Irma' by the British press, that facilitated the evacuation of dozens of injured, with forty-one people taken out of Sarajevo in the week after Irma's rescue. Other countries joined the operation, with Sweden and Ireland organizing their own airlifts, and France, Italy, Norway, the Czech Republic, Finland and Poland offering hospital beds to treat the wounded.

Despite the extensive coverage of the evacuation in the media, many criticized the operation as ill conceived, a waste of precious resources, and morally questionable.[72] The UNHCR spokesperson, Sylvana Foa, questioned the selection process of the evacuees, feeling that it was based more on their photogenic nature than their actual medical need.[73] One of the medical advisers for the UN evacuation committee in Sarajevo, Dr Patrick Peillod, argued that the operation had turned into a cynical public relations exercise that paraded sick and wounded children like 'animals in a zoo'. He criticized the RAF doctor, Wing Commander Andy Mitchell, who had selected the patients, for adding four extra people to the original evacuation list in order to satisfy the media attention, claiming that 'There are two others who could have waited weeks or months but as – Mitchell – put it he could not evacuate so few children in order to please public opinion.'[74] Rescuers cynically commented that 'Operation IRMA was an acronym for *Instant Response to Media Attention*'.[75] Others maintained that the huge costs of the operation could have been better used to improve the ability of the hospitals in Sarajevo itself to care for the wounded. Sadly, despite the efforts of the medical team at Great Ormond Street, Irma's condition deteriorated even further, and she became paralysed from the neck down and required a ventilator to breathe. She eventually succumbed to septicaemia on 1 April 1995, aged seven, passing away after twenty months in intensive care.

Bowen made another intervention soon afterwards, when he encountered another sick child at the Koševo Hospital. Nine-month-old Eldar Kalamujić was considered as not suitable for evacuation as he needed a kidney transplant. Bowen recalled that 'It seemed outrageous to me what he was saying was logical, but it also felt wrong … So, for the only time in my life, I decided to manipulate a news story, to get Eldar and his family evacuated.'[76] He crafted a bulletin about 'the baby who was being left behind' that ran on the lunchtime news, provoking an immediate response. As Bowen remembers, 'someone in Downing Street must have been watching. By mid-afternoon Mrs. Kalamujić was smiling again. They were all going to London.'[77] Despite his central role in the evacuation, Bowen admitted that he felt a certain unease about the intervention, and the authenticity of the British government's motives for the operation. He posited that the 'festival of medical evacuation created a rosy glow, gave an impression of progress, and meant that the press would not be writing so much about the West's failure, once again, to end the killing'.[78] Reflecting on his own part in the process, Bowen was honest about his purpose, questioning what gave him the moral authority to intervene in favour of one individual, but finally concluding that in the face of such terrible suffering, taking a stand was the right thing to do:

Journalists' motives are never pure in these matters either. We also intervene in people's lives, telling ourselves that the upshot of it all will be positive. What right did I have to play God when I decided to use my platform on BBC News to make sure that Eldar Kalamujić was evacuated? The answer is that I thought I was doing good, that I was writing a wrong.[79]

The veteran ITN correspondent Michael Nicolson also made a dramatic personal intervention that was later dramatized in Michael Winterbottom's 1997 film *Welcome to Sarajevo*. Although he defended his actions they were not without controversy. He and his crew were filming a report on the situation in the Ljubica Ivezić orphanage in July 1992 when one of the children attracted his attention, as he recalled: 'We'd picked out some children, going for the faces as you do on television, and we'd got ourselves a nice little story and were just packing up, when suddenly a little girl came and stood by me, pushing herself on me ... Her name was Natasha.'[80] Nicolson completed his filming and left the orphanage, but soon after his thoughts turned back to Natasha's fate when he learned that a French charity was preparing to evacuate children from the city. Nicolson had been vocally campaigning on air for this to happen, recalling that 'the C-130s were coming in full of food and going out empty. Why? Put the kids on them and take them to safety till the war's over, I told them. The UN said no. The Bosnians said no.'[81] He felt that 'I thought, here I've been, shouting my mouth off on TV every night about how disgraceful it is, well, I can actually take one out myself this way.'[82] He realized that this was potentially a very risky enterprise, but felt compelled to try to bring Natasha out of the city with him and take her to London.[83] Unbeknown to his employers, crew and his family, he developed a plan:

> I knew that if I was going to get her out to England, I would have to do it illegally, so I had to keep it a secret from the crew. We left the convoy at Split and took a taxi to Zagreb – the driver was suspicious so I had to give him extra money. The night before the flight I had altered my passport and a few other documents - I'd put her on the ticket as Natasha Nicholson and bought two business-class tickets. We managed to get on to the plane – she was on cloud nine, but I tried to tell her not to talk. And then what happens is the pilot comes back – he had recognised me from television – and he said: 'Would your daughter like to come up in front?' and boom, she was out and up the front. My heart stopped. When she came back she was babbling to him in Serbo-Croat and I thought, it's finished. But he said to me, and whether he was having me on I'll never know, 'Your daughter speaks the most perfect Serbo-Croat; you must be very proud' and off he went.[84]

On arrival in the UK, he realized that he had to be honest with immigration authorities who were eventually sympathetic to his cause, and he returned to his home to explain to his wife and children what he had done.[85] The story was quickly broken by the British tabloid newspaper *The Sun* and followed up by most of its rivals. Nicolson's' decision came in for considerable criticism. Most of the aid agencies involved were supporting children in the conflict were against adoptions during wartime, which were illegal in the former Yugoslavian republics. Emma Daly, writing in *The Independent*,

described how other journalists at the time questioned Nicolson's motives, quoting a photographer as saying 'everyone was so cynical. It was just, he's doing that for a book and a film. I don't think that was the motivation, but that's how it was perceived … He could have just done it and not said a word.' She reported how another television colleague argued that 'he went for the sentimental "look at the baby" story … But there were plenty of people well able to care for children within Sarajevo. What the Bosnians needed, above all, was international intervention to stop the siege.'[86] Nicolson, however, defended his actions; as an evacuee in the Second World War himself he felt a sense of responsibility to help, recalling that 'It saved my life. And that's all I was trying to get the UN to do for these children. I resolved that when I left Bosnia, I would take one of those kids with me. It happened to be Natasha.'[87] He also claimed that good journalism demanded an emotional involvement with the story, claiming that 'you've got to get as close to a story as you can and sometimes that means becoming a casualty yourself, a physical casualty or, as I was in Sarajevo, an emotional casualty. But I see nothing wrong with that.'[88] Nicolson argued that the proximity of the reporters to the lives of the city's inhabitants meant that it was inevitable that they would begin to identify with their shared experiences:

> One of the things about Sarajevo was that it was one of the few instances … in which you were very much part of the scene because you couldn't get out of the place. You were under siege yourself … and therefore how could you be objective? No, I don't believe in this so-called objectivity. You can still report the facts. You can still be as close to the truth as any person can be and still show a commitment, an emotional anguish. I don't see them to be contradictory.[89]

Nicholson was not the only foreign journalist who made the decision to remove a vulnerable child from a dangerous situation. In January 1993, Dan Damon of Sky News, and his wife Sian – who was working as his camerawoman, were reporting from Koševo Hospital when he interviewed a woman who had given birth there. She had been the victim of a rape in Foča – in Eastern Bosnia – was deeply traumatized and told Damon that she 'might strangle' the child. Damon assessed that the nine-day-old girl was in danger and, with the blessing of the Bosnian authorities, procured the necessary papers to get the child, who was called Lejla, out of Sarajevo and to the UK – via Slovenia and Hungary.[90]

Such cases were rare. Foreign journalists did, however, provide whatever help they could to citizens, and there were moments when journalists intervened at a more political level, as Martin Dawes recounted when he was faced with the threat of military action from the UN forces against Bosnian government forces located within siege lines. Upon hearing this, he took the initiative to try to defuse the situation:

> I had probably slightly crossed the line … there was a mortar attack on the city but the UN said it had been provoked by the Bosnian government forces breaking a truce. A guy who was with the Scots Guards, who I had met a couple of times before, was the spokesman. He came to my office and he didn't go to any other

journalists, because it was the BBC and the British Army and they hadn't quite got that whole UN thing going. He gave me a statement, basically saying they blamed the Bosnian government forces and they were going to ask for NATO airstrikes on targets *within* Sarajevo. And I said to him, 'I'm going to ask you to take this away. I'm going to ask you to have a think and I'm going to ask you if President Clinton is ever going to initiate a strike on a besieged city ... You know, what the fuck do you think you're saying'? He looked at it, went away, and came back and said, 'All right, we're dropping it'.[91]

Such instances were, however, the exception rather than the rule. While many foreign correspondents acknowledged that their actions were sometimes beyond what would be regarded as the parameters of their profession, it was a question, primarily, of being in a position where they had the ability and the infrastructure to help. Working within a city that was besieged and witnessing at first hand, and to an extent sharing, the daily privations and dangers of the citizens of Sarajevo, they reported, in the main, with honesty and integrity. By reporting these privations and dangers, they naturally identified those responsible for organizing and executing the siege – the Bosnian Serb leadership and the VRS – as the primary aggressors. By so doing, they often stood accused of being biased, having lost all sense of objectivity or having acted as advocates for the Bosnian government by making the case, through their reporting, for military intervention by the West.

Conclusion

The war in Bosnia and Herzegovina, and in particular the siege of Sarajevo, played a pivotal role in the development of – and shifts in – journalistic practice in the last decade of the twentieth century. The lessons learnt during the siege would be applied to future conflicts, not least the use of armoured cars, safety gear – such as helmets and flak jackets – and the advent of 'hostile environment training courses'.[1] Sarajevo was a unique situation for foreign correspondents; operating in a besieged city in Europe that could be accessed, not without difficulty but without the need to be embedded with military forces – as would be the case in later conflicts in Afghanistan, Iraq and Syria. As the BBC's Martin Bell noted,

> The siege of Sarajevo was quite unique in that a large part of the story was the centrality of civilians, who were caught-up in an armed conflict fought with modern weapons in a modern industrial city. It was, additionally, probably the first time in the history of warfare where we, as journalists, had the technological means to show the effects of that conflict day by day.[2]

But reporting within such a context also required the building of an infrastructure that would allow for viable operations; and in an age when that required the movement of transportation – armoured cars – safety equipment, hardware such as satellite phones, editing equipment, television cameras, computers, cables, generators, fuel and other components in the telecommunications infrastructure that was developed gradually. It was a significant endeavour that required a range of expertise – logistics coordinators, mechanics, electricians, satellite engineers, television editors, correspondents, stringers, translators and fixers. Reporting the siege of Sarajevo was, therefore, not an uncomplicated process; it was a complex logistical undertaking in a particularly difficult and dangerous environment. Those foreign correspondents who operated in the city between April and September 1992 did so in exceptionally difficult and dangerous circumstances, reliant on a less-developed communications infrastructure – indeed, often relying on the existing and depleted local systems that frequently ceased functioning. They travelled in 'soft-skin' cars with little or no protection from the dangers surrounding them, stayed in small hotels or private apartments and moved around a city – that most were unfamiliar with – as best they could to report on a rapidly evolving situation while siege lines consolidated.

As the first summer of the siege came to an end, however, the media operation in Sarajevo became more organized and less fragmented. The reopening of the Holiday Inn hotel in late June 1992, which became the base for many of the foreign press corps – though by no means all – was vital in the consolidation of an infrastructure that also included the Sarajevo TV station – and the EBU transmission point – the PTT building and the city's airport. As the winter of 1992/93 closed in, those working for established agencies or newspapers became increasingly well equipped with armoured cars, flak jackets and the communications equipment that would allow them to file their stories or edit and send their footage. For freelancers and those that did not enjoy the luxury of the support of a large media organization, it was a different story. They could not afford to stay at the Holiday Inn, so often stayed with local families or rented private apartments where they suffered many of the same privations suffered by the citizens of Sarajevo.

Beyond the evolution of that infrastructure, the experience for many of the foreign correspondents based there, or operating from the city regularly, was a deeply personal one. Indeed, the experience of reporting from besieged Sarajevo also had a significant emotional impact on many of the journalists who reported from the city. As the *Il Giorno* correspondent Gigi Riva who has covered wars before and since, noted, 'Sarajevo is the city of my soul. The experience of reporting from the city during the siege will accompany me throughout my life because I shared it with people who looked like me, who had the same way of viewing the world, shared my values and the belief in the need for tolerance and coexistence.'[3] The BBC's Allan Little also regards his experience in Sarajevo as one that was career defining. Interviewed in Sarajevo in 2012, he recalled:

> I've reported from a lot of wars, but this one I stayed with for longer and committed myself to more fully than any other. So, this was a very defining experience for a lot of us. It shaped us; we grew up here. We were quite young and inexperienced. The more experienced guys in our newsrooms were focused on the Middle East, the aftermath of the Iraq war in 1991 or the Israel-Palestine conflict – those were the big stories of the day in the later 1980s and early 1990s. So, when trouble started in Yugoslavia, news desks didn't expect it to be very big. They thought, 'This is Europe, it will all be sorted out', and so some of the junior guys got to have a go, and I was one of those. And by the time it became big, we were the ones who had been here a lot and we knew it. We grew up here as correspondents and learnt not only about former Yugoslavia but about our trade and our business.[4]

Indeed, what made the siege of Sarajevo unique is that so many of the international press corps were young freelancers and they were operating *within* siege lines. 'We did not', said Remy Ourdan, 'report from the front lines during the day and return to our hotels far from the dangers in the evening. We lived permanently within the siege and that is a unique situation that has, thus far, never been repeated.'[5] This impacted the practice of journalism in numerous ways and created a generation of media professionals whose careers were deeply affected by their involvement in both reporting on and living through the shared experiences of the citizens of Sarajevo. The siege was formally lifted on 29 February 1996, exactly four years after the 'referendum

weekend' in 1992. With the signing of the Dayton Peace Agreement and the end of the siege, most – though not all – foreign journalists left the city, though some remained to cover the early days of the implementation of the agreement. In their stead, many of the local staff that were employed by them, their agencies or newspapers, continued to tell the story of post-siege Sarajevo, some as journalists for international media agencies – many of which retained a permanent presence in the city.

The period between 1992 and 1996 was also one marked by the emergence of a series of pressures and forces that impacted on almost every aspect of the work of reporters, photographers and TV crews, both in terms of how they operated in the field and how their work was disseminated. From the fall of the Berlin Wall in November 1989, through the upheavals in the former Soviet Union that it heralded, the disintegration of the Yugoslav state, the war in Chechnya, the genocide in Rwanda, to the destruction of the World Trade Centre on 11 September 2001, a whole series of economic, ethical, technological and aesthetic challenges combined to drive media professionals to actively engage with why, how and for whom they work – and to what effect. This was particularly the case for TV crews as the inexorable changes in cable and satellite technology changed the nature of television news.[6] Indeed, the pace of news-gathering accelerated dramatically during this decade, as the demands of the 24-hour rolling news environment, exemplified by CNN's coverage of the 'First Gulf War', were extended and amplified by the ongoing conflict in the SFRJ, with its frequent ceasefires, crises, breaking reports and news management. Similarly, photographers at the beginning of the conflict in 1990 were still very much in the analogue age, shooting film, developing it in hotel bathrooms and then transmitting it over phone lines on bulky and expensive wire machines. By the time of the 1998/99 conflict in Kosovo and the subsequent 78-day NATO bombing of the Federal Republic of Yugoslavia – Serbia and Montenegro – they were using new digital cameras with sensors of ten megapixels, and transmitting high-resolution images in a matter of seconds over mobile satellite telephones directly from the field.

Though the Bosnian war was predictive of later conflicts in Iraq, Syria and Afghanistan, it was also arguably the last of a certain type of conflict, in terms of how journalists were able to operate. As Sean Maguire noted, the Yugoslav wars saw the 'end of a certain type of journalism rather than the beginning of a new one.'[7] And, he continued, 'In Sarajevo, and throughout Bosnia, our non-combatant status was respected, we were able to cross front lines, we had the privilege of being able to come and go and we weren't, generally, targeted. In the majority of cases, we were allowed to get on with our jobs.'[8] Yet, they did so with growing levels of security and protection for journalists. The BBC's Martin Bell observed that at the start of the siege 'for the small but growing press corps in Sarajevo, the risks were far greater than any of us had imagined when we embarked on what had seemed at the time to be just another war', but that as the conflict progressed 'by acting cooperatively instead of competitively, we managed over the months and years to reduce the risks to a point where if not acceptable ... then at least calculable.'[9] Thus, as Sean Maguire explained, the senior management at news organizations 'had to be more responsible increasingly because the frequency of death and injury was getting higher and the costs were becoming untenable, so they invested in training, in better communications, and in more protection.'[10] As a consequence,

'hostile environment' training courses became the norm for journalists preparing for assignment in conflict zones.[11]

The results of this investment did mean that journalists were able to operate in situations where previously it would have been too dangerous, with Maguire noting that by the end of the conflict coming under fire had become so normalized that 'it became routine that an armoured car saved your life, it was unremarkable when the car got hit by a bullet'.[12] Chris Helgren took the operational lessons learnt by Reuters into other arenas, where they rapidly became standard practice. He recounted how the lessons learnt around the use of a radio network in Sarajevo were applied elsewhere:

> It was so successful that I carried that idea to Baghdad where, a few years later, I was Reuters' chief photographer. I made a point of installing a repeater on top of the tallest hotel in the city so that we would have network coverage all around the city. Every day I would have a big map, on which the city would be cut into quadrants just like police forces do. And we would have a photographer and a driver in each quadrant, and so, if anything happened they would hear about it first, and then people from other quadrants could race to them to help them out.[13]

The other innovation Helgren noted from Sarajevo was the 'importance of hiring and developing local talent, photographers and reporters'. They were, he added, 'more connected to what was going on than foreign journalists or photographers parachuting in from outside all the time. They were just more tied into the story than any travelling journalist could ever be'.[14] This practice has continued into the conflicts in Afghanistan, Iraq and Syria, with the bulk of the reporting from those countries coming from local reporters and citizen journalists. Indeed, many of the local stringers, translators and fixers employed by international media agencies went on to more permanent roles in Reuters, AP, CNN and other organizations.

For many of the journalists who covered the siege it was, doubtless, life changing. And they remained deeply connected to the city and its people thereafter. For the generation of reporters in their 20s and 30s, the war in Bosnia and Herzegovina was *their* war, their Vietnam, their Beirut. As Allan Little recalled in 2012 'we were all hungry and prepared to devote our lives to it completely. We took ownership of the story and it was the making of a generation of us.'[15] The shared experience of living under siege brought the press corps together in ways that formed powerful bonds between them. Chris Helgren felt that 'the comradery was something incredible – I've never really experienced that before or, really, since'.[16] Janine di Giovanni remarked that 'Those years, 1992 to 1995, were the most potent of my life: professionally, personally and emotionally.'[17] Charlotte Eagar also described the intimate relationship that she had built up with the city, recalling that 'By the time the war ended in 1995, I'd spent the better part of three years living in Sarajevo, chronicling how a medieval siege laid waste to a modern city, and I had fallen deeply, passionately in love: not with a person ... but with the city itself.'[18] Jeremy Bowen recalled how the extraordinary nature of the experience actually became the new normal for him, making the mundanities of everyday life seem strange, writing that he 'felt more at home in Sarajevo than London. Sarajevo was normal; London was strange. I didn't have to explain anything to my

friends at the Holiday Inn. I could not explain much to my friends in London. It was not good for my personal life. I was spending too much time at a war and the abnormal became routine.'[19] But he also admitted that though the intensity of the experience was incredibly fulfilling, it also took its toll:

> Being there stretched me enormously, and all the time, as a person as well as a reporter. I loved that feeling and being with people who understood what was in my head because the same stuff was in theirs. When I went home after a stint of four or five or six weeks in Bosnia, I was more or less catatonic. I'd sit in my flat and after a couple of days I could probably open the post and go down to the pub for lunch, but I was pretty speechless. I was knackered.[20]

Bowen's experience was shared by many of his colleagues, as the intensity of the experience was so extraordinary and emotionally draining that some adverse reaction was to be expected. In a piece reflecting on the war in 2008 entitled *My Five-Year Battle to Exorcise the Ghosts of Sarajevo*, Charlotte Eagar explained how she was still haunted by the memories of the siege more than a decade later:

> I often used to dream I was being machine-gunned, and, finding it hard to connect with my London life, desperately sought out people I knew in the war. I remember feeling that more than anything I wanted to be normal – to have the families and babies that were enveloping my friends. But I couldn't seem to work out how to change gear. The most overwhelming feeling, however, was that of guilt: unlike the trapped population of Sarajevo, I had been free to come and go, to eat and drink[21]

Martin Bell, too, shared this sense of guilt that he had been able to escape the trauma of the fighting with relative ease, even after being wounded. He recounted how he had felt that there had been 'a striking contrast between my treatment and that of the ordinary people of Sarajevo, injured on that day or any other':

> For a short while after what happened to me there were little features and articles in the press based on the total fiction of the reporter as hero. It was nonsense, of course. We were not heroes but journalists doing our job and sometimes in harm's way more than was good for us. But we had so many advantages that real people, facing equal dangers, did not. We were there of our own free will, they were not. We could escape, they could not. We had United Nations accreditation and the use of its best field hospitals, they did not. The lightness of my wound and the ease of the evacuation made me feel a bit of a fraud: all that care and attention for what really didn't amount to more than a puncture.[22]

Eager was brutally honest in her assessment of her own condition and sought counselling for several years to help alleviate the effects that post-traumatic stress disorder (PTSD) had on her life. Identifying it as a form of 'survivor's guilt', she recounted how she had been given a first-hand account of how the condition was likely to affect those who covered the siege as well as those who were trapped by it:

> The symptoms of PTSD are probably best described by Professor Slobodan Loga, Professor of Psychiatry at the University of Sarajevo. During the war, he told me that all the Sarajevans would go mad after it, as would the journalists; we would be cracked mirrors for the rest of our lives. I am certainly not the only journalist to suffer from it. It was the rank injustice of the siege which was so hard to bear. And, perhaps, our ability to nip in and out of the war on UN planes while the population had to hunker down, to be shot and starved. Many journalists were affected – some are now dead of drugs, drink or suicide. Some, like me, have retired from war reporting, or faced their demons in other ways. Others are just very weird. Almost the weirdest are those who say the war had no effect on them at all.[23]

Given the physical, emotional and psychological strain that covering the siege took on the reporters who experienced it, it is necessary to explore what their motivations were in staying committed to the story for so long. In a 2016 article on the lessons learnt from the siege of Sarajevo and how they might be applied to the crisis in Aleppo, Syria, Janine di Giovanni explained why she felt the journalists devoted themselves so fully to the story, writing that 'My colleagues and I vowed to stay until the end … we did this partly as committed journalists.' But she also identified another purpose that she regarded as far more significant:

> A siege isolates its inhabitants from the rest of the world. We wanted to show to people on the outside our Bosnian colleagues, as well as the fighters who were defending their city under a punishing arms embargo, and the ordinary people who were dodging snipers' rounds. There was little hope that anyone was coming to save them, but we felt that if we left, we would be giving them a clear sign: that they were truly abandoned.[24]

Similarly, Emma Daly, who worked for *The Independent* and later went on to work at Human Rights Watch (HRW) as communications director, believes that:

> Bosnia changed me. I think it changed a generation of journalists raised on 'objective' reporting (as if such a thing ever existed). We realized that we were seeing only a part of the war, and many of us travelled as widely as we could in the former Yugoslavia, though the Bosnian Serbs did their best to keep journalists out. How could we bear witness to war crimes, day in and day out, over not months, but years, without wanting something to change? Especially when anyone could fairly easily see how decisive UN action could make for such a change.[25]

Jeremy Bowen identified the importance of just being there, of being the eyes and ears of the world, arguing that 'in Sarajevo we specialized in bad news. But we thought that the effect of being there and bearing witness would change things, that our reporting would get the siege lifted and stop the killing.' Although in retrospect, he was uncertain as to the actual impact of the reporting of the conflict, he remained convinced of its moral value as evidence that the events actually happened and as a counter to the misinformation of the warring parties, maintaining that:

I don't think we really changed anything, though I suppose you could say that when the Americans and NATO finally intervened in 1995 it was because three years of stories dripping into the eyes and ears of voters just made it too embarrassing not to do anything anymore. But I do not think the fact that journalists do not often right the wrongs that they report matters at all. Being there is important enough on its own. Between us, we at least created a record of what was happening.[26]

Christiane Amanpour, however, maintained that reporting on Bosnia did have an effect on political policy, arguing that 'we did the right thing as journalists and eventually managed to be part of the reason that the world intervened. We led and we forced leadership in our international sphere at the highest levels of the U.S. and European governments.'[27] Martin Bell was also certain that their reporting did eventually have some impact on the policy of Western governments, arguing that:

Sometimes there are situations where a government doesn't have a clear policy, and Bosnia in 1992 was a particular example, when all these hundreds and thousands of people were suffering and being driven from their homes. The TV coverage, I believe, forced the government to develop a policy. And they did so only because people were, rightly, asking 'What are you doing about this?' Of course, I was accused by Douglas Hurd of being the founder of the so-called 'something-must-be-done club'. But what do you do? You are there to bear witness and people will either take notice or they won't, but I think they did ... the NATO intervention in Bosnia in 1995 actually brought the war to an end and saved a lot of lives.[28]

Perhaps the most significant feature of the foreign correspondents' experience in Sarajevo, and in Bosnia and Herzegovina more broadly, was that it forced journalists to question the traditions of 'neutral' reporting; and the lessons learnt in Sarajevo remain relevant today. Writing about the war in Syria in 2012, Christiane Amanpour referenced her experiences in Bosnia and Herzegovina, experiences which led her to believe that, 'Objectivity means giving all sides a fair hearing. It does not mean drawing a false moral equivalence.'[29] The ethical problems of reporting the conflict saw a shift in attitudes. As we have described, the Bosnian conflict and the siege of Sarajevo in particular, caused many journalists to question their roles as neutral observers; and the concept of the 'Journalism of Attachment' emerged – though not all are comfortable using that terminology – the basis of which was the argument that neutrality in the face of war crimes, genocide and attacks against civilians breached the Geneva Convention and were thus unacceptable. For Andrew Reid, this presented little in the way of a dilemma:

My motivation was to bear witness to the suffering of the people of Sarajevo, and throughout Bosnia & Herzegovina – to tell the story, to do my job. My own internal debate was common enough: how can one justify making a living out of the suffering of others? The answer, of course, is that sound reportage is crucial – people deserve to have their stories told and the world needs to know what injustice and cruelty look like. It was remarkable how the international press corps reacted ... I remain immensely proud of the work we did. And it was satisfying

that all that work and risk and toil did eventually contribute to some kind of peace for the innocent people who suffered so much. The Dayton Agreement was, and is, utterly flawed, but it did stop the shooting.[30]

In terms of reporting the wider dynamics of the siege of Sarajevo, Sean Maguire also considered that the pushback from reporters in the field about the realities of the conflict on the ground, and how that challenged the assumptions about who was to blame, led to a subtle but significant shift in the attitudes of the major news organizations to their staff. Maguire recounted how there was 'a real struggle, journalistically, to find a way to present the political reality of the combat. You could tell stories about people being killed, of course, but unless you put that in the context of the geopolitical realities that were perpetuating that violence you were presenting an insufficient and an incomplete story'.[31] Over time, those journalists who had established their credibility were able to articulate a deeper analysis and understanding of the forces that were shaping the conflict. Maguire explained how:

> Reuters pretended to itself that it was continuing with its age-old impartiality reporting but had to find new ways to articulate what was going on without the standard 'he said, she said' approach, so some of us were given the privilege of being able to observe more acutely than a wire reporter would have been ten to twenty years before. Those who had been there a while were given the authority to say this is the history of this conflict, this is the pattern of behaviour, these are the facts, this is what stacks up against sets of lies, and broken promises.[32]

This realignment of journalistic principles arguably became even more pronounced as some journalists and photographers aligned themselves with the processes of international law and the defence of human rights, shifting the focus of their practice away from mainstream media into one that more closely resembled an advocacy model. This led to a significant number of the reporters who covered the conflicts in the former Yugoslavia moving away from journalism and into the NGO sector, working for organizations such as Human Rights Watch (HRW) – both Emma Daly and Corrine Dufka worked for HRW – the Open Society Foundation (Laura Silber), and the UN as communications and policy officer (Arianne Quentier). In his coverage of the Kosovo emergency of 1999, Gary Knight explained the systematic way in which photographers collaborated with human rights organizations. Motivated partly by a sense that his coverage from the earlier [Bosnian] conflict had been a failure, he adopted a different strategy, arguing that 'It needed Bosnia for the transition in Kosovo to happen, because of a frustration and a feeling that I hadn't really done what I felt there was to be done there. We felt that surely there was more to it than just being a photojournalist'.[33] However, the work then entered another arena of human rights discourse as both had their images used on websites like HRW. Finally, by publishing their images in books several years after the events took place they form part of the discourse around bringing to justice the perpetrators of the crimes. For Knight, this experience of multiple outputs was very much a turning point in his career, moving him from a journalistic agenda to new territory:

> It has totally changed the way that I work since; I was no longer interested in being a journalist *per se*. I remain interested in using journalism and the media as part of my tool set but no longer interested in running around chasing lots of stories. I'm much less interested in creating beautiful photographs and more interested in using photography as a means to an end.[34]

As a consequence of the events that they witnessed, foreign journalists were called to give testimony to the International Criminal Tribunal for the Former Yugoslavia (ICTY),[35] which led to considerable and sometimes heated debates over whether journalists should testify or not. The BBC's Martin Bell and Jeremy Bowen, Aernout van Lynden of Sky News and Ed Vulliamy of *The Guardian* were among those that opted to give evidence, while others refused on the basis that they did not believe it was within their remit to do so. Evidence in the form of footage captured by TV crews and still photographs were, nevertheless, used as evidence, meaning that the work of these correspondents and photojournalists, even if they were not invited to give evidence or refused to do so, had an important utility beyond contributions to television and radio reports or images in newspapers.

The siege of Sarajevo was not just another story for those that were tasked with reporting from within the city during the siege. This was evidenced, in the aftermath, by the plethora of books and personal memoirs that were produced by foreign correspondents that describe in detail their personal experiences in Sarajevo, many of which have contributed significantly not only to our understanding of life within the besieged city but, more broadly, how journalists operated within such a context. A small number, among them Charlotte Eagar of *The Guardian*, Kevin Sullivan of UPI, John Fullerton of Reuters and Julio Fuentes of *El Mundo*, wrote novels based on their experiences of Sarajevo during the siege. A small number of foreign correspondents remained, or would regularly return to, Sarajevo after the lifting of the siege – for both professional and personal reasons. Close friendships, marriages, the adoption of children and a bond with the city and its people developed. Some remain committed to the city, lived there for long periods and have sought to contribute to the city. A greater number return to the city regularly. Kevin Sullivan, the journalist and writer who began working in Sarajevo for UPI in 1992, remained in Sarajevo and worked for both the Office of the High Representative (OHR), the body tasked with implementing the Dayton Peace Agreement and the International Commission on Missing Persons (ICMP). In 2012, Remy Ourdan organized a reunion of foreign correspondents in Sarajevo to mark the twentieth anniversary of the beginning of the siege.[36] In the same year he created the WARM Foundation, based in Sarajevo, which organizes the WARM Festival annually – which brings journalists, filmmakers and scholars from around the world to Sarajevo for lectures, roundtables and film screenings. The photographers Gary Knight and Ron Haviv founded the VII Agency and the VII Academy, with an office in Sarajevo, that provides tuition-free education in media practice and scholarships to aspiring photographers. Thus, for many of the foreign correspondents who reported from Sarajevo during the siege, the story did not end with the lifting of the siege on 29 February 1996 and their lives remained entwined with the city for decades thereafter.

Notes

Introduction

1. The precise date the siege began is one that is somewhat contested and open to interpretation. It is often defined as 5 April 1992, with the shootings of Suada Dilberović and Olga Sučić on the Vrbanja Bridge – see Chapter 1. We have defined the start of the siege as 6 April 1992, following the shootings from the Holiday Inn hotel. Thereafter, a state of war existed and the protests against the slide to conflict ended. However, throughout April, Sarajevans or those that had the contacts and the means to do so could still leave the city. From early May, however, it was impossible to leave the city. Thus, the siege was not fully consolidated until nearly a month after the events of 6 April 1992, though the parameters of it were already being established and siege lines crystallizing.
2. See Ewa Tabeau, Marcin Soltkowski and Jakub Bijak – Demographic Unit (LRT) – 'Population Losses in the Siege of Sarajevo', Research report prepared for the case of Stanislav Galić, UN-ICTY Case No. IT-98-29-I, May 2002.
3. For an extensive analysis of the daily events of the siege and equally extensive selection of interviews with ordinary citizens of Sarajevo and their experiences of the siege, see Suada Kapić (ed.), *The Siege of Sarajevo: 1992–1996*, Sarajevo: FAMA, 2000.
4. Suada Kapić estimated that '260 tanks, 120 mortars and many weapons of a smaller calibre' were actively used to attack the besieged parts of Sarajevo. See 11. See ibid., p. 143.
5. For the destruction of Bosnia's cultural heritage, see Helen Walasek, 'Destruction of Cultural Heritage in Bosnia-Herzegovina: An Overview', in Helen Walasek (ed.), *Bosnia and the Destruction of Cultural Heritage*, Farnham: Ashgate, 2015.
6. For an excellent analysis of the economic dynamics of the siege, see Peter Andreas, *Blue Helmets and Black Markets: The Business of Survival in the Siege of Sarajevo*, Ithaca and London: Cornell University Press, 2008, and – by the same author – 'The Clandestine Political Economy of War and Peace in Bosnia', *International Studies Quarterly*, No. 48, 2004, pp. 29–51.
7. Michael Nicholson, *Natasha's Story*, London: Macmillan, 1993, p. 7.
8. Interview with John Fisher Burns – *New York Times* – in 'Veillées d'armes: Histoire du Journalisme en temps du guerre' – 'The Troubles We've Seen: A History of Journalism in Wartime'), *First Journey*, Director: Marcel Ophuls, Little Bear Productions, 1993.
9. The following foreign journalists were killed in the Yugoslav wars: Nikolas Vogel and Norbert Werner in Slovenia; Peter Brysky, Pierre Blanchet, Paul Schofield, Paul Jenks, Viktor Nogin, Christian Wuertenberg, Damian Reudin, Gennadiy Kurinnoy and Egon Scotland in Croatia; Allesandro Ota, David Kaplan, Haris Karadza, Marco Luchetta, Mohammed Hussein Navab, Dario D'Angelo, Bryan Brinton, Georg Friderich Pfuhl, Guido Puletti, John Hasek, Dominique Lonneux, Tasar Omer and Jordi Pujol Puente in Bosnia and Herzegovina; Zhu Ying, Xu Xinghu and Shao

Yunhuan in Serbia. For a full list of the 142 journalists killed in the Yugoslav wars see Balkan Insight, 'Last Despatches', BIRN, Belgrade and Sarajevo, http://last-despatches.balkaninsight.com [last accessed 12 July 2019].

10 Peter Andreas, *Blue Helmets and Black Markets: The Business of Survival in the Siege of Sarajevo*, p. 72.

11 For a succinct analysis of the UN 'safe areas', see Charles Ingrao, 'Safe Areas', in Charles Ingrao and Thomas A. Emmert, *Confronting the Yugoslav Controversies*, West Lafayette: Purdue University Press, 2013, pp. 202–231.

12 Robert Fisk of *The Independent* noted in September 1992 that Sarajevo 'lends itself to a kind of grim romanticism, attractive to journalists ... so that while every bombardment is catalogued by correspondents, the equally vicious Serbian destruction of towns far to the east like Jajce, with its hordes of refugees amid Roman ruins and a fifteenth-century castle, remains largely unrecorded'. See *The Independent*, London, 26 September 1992, p. 26.

13 Ibid., p. 209.

14 Robert Donia, *Sarajevo: A Biography*, London: Hurst & Co., 2006, p. 287.

15 See Stathis Kalyvas, 'The Urban Bias in Research on Civil Wars', *Security Studies*, Vol. 13, No. 3, 2004, p. 160–190.

16 Peter Andreas, *Blue Helmets and Black Markets: The Business of Survival in the Siege of Sarajevo*, Ithaca and London: Cornell University Press, 2008, p. 3.

17 For more on 'hotel journalism' see John J., *Hotel Warriors: Covering the Gulf War*, Washington DC: Woodrow Wilson Center, 1992.

18 Peter Andreas, *Blue Helmets and Black Markets: The Business of Survival in the Siege of Sarajevo*, p. 73.

19 Stuart Hughes, 'The Class of '92 returns to Sarajevo', *BBC College of Journalism Blog*, 5 April 1992, https://www.bbc.co.uk/blogs/collegeofjournalism/entries/21c52c77-74a6-3915-9d98-0e6038d0edc7 [last accessed 2 September 2019].

20 Martin Bell, *War and the Death of News: Confessions of a Grade B Reporter*, London: Oneworld, 2017, p. 83.

21 Author's interview (KM) with Christiane Amanpour (CNN), September 2019.

22 For the work of *Oslobođenje* during the siege of Sarajevo see Tom Gjelten, *Sarajevo Daily: A City and Its Newspaper under Siege*, New York: HarperCollins, 1995, and Kemal Kurspahić, *As Long as Sarajevo Exists*, Stony Creek, CT: The Pamphleteers Press, 1997.

23 There have been a number of dramas – films – that have focused on foreign journalists during the siege of Sarajevo, the foremost among them Michael Winterbottom's 'Welcome to Sarajevo' and Gerardo Herrero's *Territorio Comanche*. The best of the documentary films – and they are few in number – about foreign correspondents in Sarajevo remains Marcel Ophuls' *Veillées d'armes: Histoire du Journalisme en Temps du Guerre* ('The Troubles We've Seen: A History of Journalism in Wartime').

24 Peter Andreas, *Blue Helmets and Black Markets: The Business of Survival in the Siege of Sarajevo*, p. 72.

25 Author's interview (KM) with Gigi Riva (*Il Giorno*), May 2020.

26 As Greg McLaughlin points out, advances in satellite and cable television technology had changed the nature of news, particularly television news, significantly during the early 1990s. See Greg McLaughlin, *The War Correspondent*, London: Pluto Press, 2016, p. 79.

27 Charles Ingrao, *Safe Areas*, p. 208.

Chapter 1

1. For a succinct overview of different factors that led to the disintegration of the SFRJ, see Dejan Jović, 'The Disintegration of Yugoslavia: A Critical Review of Explanatory Approaches', *European Journal of Social Theory*, Vol. 4, No. 1, 2001, pp. 101–120.
2. Branka Magaš, *The Destruction of Yugoslavia: Tracking the Break-Up, 1980–1992*, London: Verso Press, 1993, p. 170.
3. See Nebojša Vladisavljević, *Serbia's Antibureaucratic Revolution: Milošević, the Fall of Communism and Nationalist Mobilisation*, Basingstoke: Palgrave Macmillan: 2008 and – by the same author – 'The Break-up of Yugoslavia: The Role of Popular Politics', in D. Djokić and J. Ker-Lindsay (eds), *New Perspectives on Yugoslavia: Key Issues and Controversies*, Routledge: London and New York, 2011, pp. 143–160.
4. The demonstrations in Montenegro were primarily driven by economic discontent. They were, however, quickly manipulated by Milošević's supporters to replace the Montenegrin communist leadership with younger elites – within the party – who were more inclined towards Belgrade. See Kenneth Morrison, *Nationalism, Identity and Statehood in Post-Yugoslav Montenegro*, London: Bloomsbury, 2018. See also Srdjan Darmanović, 'The Peculiarities of Transition in Serbia and Montenegro', in Dragica Vujadinović et al. (eds), *Between Authoritarianism and Democracy: Serbia, Montenegro, Croatia*, Belgrade: CEDET, 2003.
5. Tanjug Domestic Service (Belgrade), 21 December 1990, FBIS, *Daily Report* – Eastern Europe), FBIS-EEU-90-250. The rebellion was staged by the Croatian branch of the Serbian Democratic Party (*Srpska demokratska stanka* – SDS) whose support was among rural Serbs. The majority of Serbs in Croatia inhabited cities beyond the Krajina.
6. Zavod za statistiku Republike Bosne i Hercegovine, 'Popis stanovništva, domaćinstava i poljoprivrednih gazdinstava 1991. godine: Etnička obilježja stanovništva rezultati po republikama i po opštinama 1991. godine'. Statistički bilten broj 233, Beograd, 1991.
7. Mirko Pejanović, *Essays on the Statehood and Political Development of Bosnia and Herzegovina*, Sarajevo: TKD Šahinpašić, 2016, pp. 71–72.
8. Neven Andjelić, *Bosnia-Herzegovina: The End of a Legacy*, p. 135.
9. Tanjug Domestic Service, Belgrade, FBIS – LD270323490, 27 March 1990. For an analysis of the formation of the SDA in the Sandžak region see Kenneth Morrison and Elizabeth Roberts, *The Sandžak: A History*, London: Hurst and Co., 2013, pp. 134–39.
10. See Kenneth Morrison, *Sarajevo's Holiday Inn on the Frontline of Politics and War*, London: Palgrave Macmillan, 2016.
11. For a detailed analysis of the trial see Rajko Danilović, *Sarajevski proces 1983*, Tuzla: Bosanska riječ, 2006.
12. Noel Malcolm, *Bosnia: A Short History*, London: Pan-Macmillan, 1994, p. 208. Malcolm goes on to note that 'The treatise, written in the late 1960s, is a general treatise on politics and Islam, addressed to the whole Muslim world; it is not about Bosnia and does not even mention Bosnia'. See ibid., p. 219.
13. For the full text of the SDA's 'Statement of the Forty', see Alija Izetbegović, *Inescapable Questions: Autobiographical Notes*, Leicester: The Islamic Foundation, 2003, pp. 66–74.
14. Alija Izetbegović, *Inescapable Questions: Autobiographical Notes*, p. 75.
15. Adil Zulfikarpašić (in dialogue with Milovan Djilas and Nadežda Gaće), *The Bosniak*, London: Hurst and Co., 1998, p. 130.

16 *Demokratija*, Belgrade, 13 October 1990, p. 4.
17 Born in Foča in the then Kingdom of Yugoslavia, Adil Zulfikarpašić was the descendant of a long line of prominent Muslim *beys* (lords). He was a member of the Yugoslav Communist Party during the Second World War and was, in 1942, arrested and jailed in Sarajevo by the Ustaše. Upon his release, he became a prominent member of the party, and was awarded the post of Deputy Minister for Trade. However, he gradually became disillusioned with Tito and fled Yugoslavia for exile in Switzerland in 1946. He returned to Bosnia in 1990 and was a key early member of the SDA. See Adil Zulfikarpašić, *The Bosniak*, London: Hurst and Co., 1998.
18 Tanjug Domestic Service, Belgrade, FBIS- LD2705131490, 26 May 1990. For Brozović's speech at the SDA meeting see also Neven Andjelić, *Bosnia-Herzegovina: The End of a Legacy*, p. 163.
19 During a meeting of the Assembly of the SDS on 24 October 1991, Dr Dragan Djukanović reminded the audience that 'The sufferings of Serbs in Bosnia were actually prepared when the HDZ-BiH was formed. What many assumed would happen was confirmed by Mr Brozović at the founding of the Party of Democratic Action, across the street from here in the Holiday Inn hotel in late May last year. You remember very well that he said that Croatia would be defended on the River Drina, and his speech received frenetic applause'. See 'Serbian Democratic Party of Bosnia and Herzegovina: Stenograph of the constituting session of the Assemble of the Serbian People in Bosnia and Herzegovina', 24 October 1991, UN-ICTY Doc No. SA02-2055-SA02-2164/SA01-2055-SA01-2164/MP, p. 28.
20 Mario Pejić, *HVO Sarajevo*, Sarajevo: Libertas, 2008, p. 17.
21 According to Stjepan Kljuić, he was replaced by Boban because he wouldn't execute 'this dirty mission of the partition of Bosnia and Herzegovina'. Speaking of Boban, he said, 'Boban, who was anonymous in the HDZ, never gave us a single speech at [HDZ] meetings. He was a deputy in our parliament [but] he was known for the fact that he was the only one who kept silent' – Kljuić suggests this was the case because Boban possessed an 'inferiority complex'. See transcript of interview with Stjepan Kljuić, in 'Death of Yugoslavia Archive', 3/39, UBIT, 035–038 p. 3.
22 For an excellent and detailed assessment of Radovan Karadžić's political life, see Robert Donia, *Radovan Karadžić: Architect of the Bosnian Genocide*, Cambridge: Cambridge University Press, 2014. See also Nick Hawton, *The Quest for Radovan Karadžić*, London: Hutchinson, 2009. For a more biased – essentially pro-Karadžić – assessment see Lijljana Bulatović (ed.), *Radovan*, Belgrade: EVRO, 2002.
23 Neven Andjelić, *Bosnia-Herzegovina: The End of a Legacy*, London: Frank Cass, 2003, p. 163.
24 *Naši Dani*, Sarajevo, 20 July 1990, p. 12. See also Neven Andjelić, *Bosnia-Herzegovina: The End of a Legacy*, p. 166.
25 Radovan Karadžić always played up to his family name, on occasion implying that he was directly related to the Serbian linguist who codified the Serbian language. Commenting on footage of Karadžić from a BBC documentary entitled 'Serbian Epics', the Serbian sociologist, Ivan Čolović noted that 'Karadžić can be seen in Vuk's house in his birthplace of Tršić [Serbia] demonstrating his skill in the playing the *gusle* [a traditional Serbian instrument – though it is played by other nations in the Balkans]. But the strongest part of this film is a scene in which the Karadžić of our day points to a portrait of the old Karadžić, asking us to note a detail which discloses the remarkable working of the genes: a dimple on the chin of the old Karadžić which

26 Robert Donia, *Radovan Karadžić: Architect of the Bosnian Genocide*, p. 27.
27 Ibid.
28 For the emergence and consolidation of the Montenegrin state in the nineteenth century see Elizabeth Roberts, *Realm of the Black Mountain: A History of Montenegro*, London: Hurst and Co., 2007, pp. 186–250.
29 For the poetry of Njegoš see Andrew Wachtel, *Making a Nation, Breaking a Nation: Literature and Cultural Politics in Yugoslavia*, Stanford: Stanford University Press, 1998 and Edward D. Goy, *The Sabre and the Song: Njegoš, the Mountain Wreath*, Belgrade: PEN Serbia, 1995. For a biography of Njegoš see Milovan Djilas, *Njegoš*, London: Harcourt, 1966.
30 *Monitor*, Podgorica, 23 August 2008, p. 14.
31 Robert Donia, *Radovan Karadžić: Architect of the Bosnian Genocide*, p. 32.
32 Ibid., p. 40.
33 In a 1994 interview, the SDP leader, Zlatko Lagumdžija, claimed that Karadžić, while the symbolic head of the SDS, was not the real power within it. According to Lagumdžija, that honour belonged to the historian and head of the SDS Political Council, Milorad Ekmečić. 'We knew', said Lagumdžija, 'that Ekmečić was the man behind the strategy of the [SDS] project. At one moment he said [to] forget about what Karadžić is saying, because he has no right to say it … it was quite an unusual situation.' See transcript of interview with Zlatko Lagumdžija, in 'Death of Yugoslavia Archive', 3/47, UBIT 046–048-297, p. 2.
34 See, for example, an early interview given to the Belgrade weekly *NIN* in July 1990. The nationalist tone is certainly present, but the language is rather moderate in comparison to many of his later interviews. See *NIN*, Belgrade, 17 September 1990, pp. 10–16.
35 *NIN*, Belgrade, 17 September 1990, p. 14.
36 Edina Bećirević, *Genocide on the Drina River*, New Haven and London: Yale University Press, 2014, p. 52.
37 For an overview of the pre-election campaigns and the predictions in advance of the elections see Neven Andjelić, *Bosnia-Herzegovina: The End of a Legacy*, pp. 156–184.
38 Suad Arnautović, *Izbori u Bosni i Hercegovini '90: Analaiza izborni procesa*, Sarajevo: Promocult, 1996, p. 112. The victory of the nationalist parties came [as] a shock to many observers, though Zoran Pajić noted that 'After so many years of a comfortable collective identity within the [Yugoslav] system, the common man was simply unprepared to take on the responsibility to exercise his individual freedom. The easiest option was therefore to seek another form of collective identity, another protective shield against the confusion. This was nationalism. Many politicians quickly realized that the nationalist ticket was a lifeboat for them also. It was an instrument for the homogenization of people and the creation of the constituency that, in the one-party system, they had never had.' See Zoran Pajić, 'Bosnia-Herzegovina: From Multi-ethnic Co-existence to "Apartheid … and Back"', in Payam Akhavan (ed.), *Yugoslavia: The Former and the Future – Reflections by Scholars from the Region*, The Brookings Institute, Washington, and the United Nations Research Institute for Social Development, Geneva, 1995, p. 153.
39 Mirko Pejanović, *Essays on the Statehood and Political Development of Bosnia and Herzegovina*, p. 74.

40 According to Zlatko Lagumdžija, the then leader of the SDP, the three ruling parties were very antagonistic in their differing perception of the future of Bosnia and Herzegovina and that this required the opposition to act as moderators. 'I must admit', he said, 'it sounds ridiculous that the opposition party is a moderator between the ruling parties, but we tried exactly that.' See transcript of interview with Zlatko Lagumdžija, in 'Death of Yugoslavia Archive', 3/47, UBIT 046-048-297, p. 1.
41 Vahid Karavelić and Zijad Rujanac, *Sarajevo: Opsada i odbrana, 1992-1995*, Sarajevo: Udruženje za zaštitu tekovima borbe za Bosnu i Hercegovinu, 2009, p. 83.
42 Ibid., p. 55.
43 Thereafter, the SDS leadership made purposeful and tangible moves towards scenario-planning in the event of a referendum on – and possible declaration of – Bosnia and Herzegovina's independence. Indeed, on 19 December 1991, with SDS municipal chiefs and SDS parliamentary deputies present, a document was circulated which included detailed information about how the SDS should respond in the event of a declaration of independence. These documents – so-called 'Variant A' – areas where Serbs were a majority – and 'Variant B' – areas in which Serbs were a minority – contained instructions on how to seize power in the towns – whether the Serbs were a majority there or not – with the help of the JNA and from *dobrovolci* (volunteers) from Serbia. For a detailed analysis of the creation of SAO's and the SDS encirclement of Sarajevo see Robert Donia, *Sarajevo: A Biography*, pp. 264-274.
44 *The Times*, London, 24 December 1991, p. 6.
45 Central Intelligence Agency (CIA), CIA Directorate of Intelligence Memorandum: Bosnia and Herzegovina on the Edge of the Abyss', 19 December 1991, Document No. (FOIA)/ESDN (CREST): 5235e50c9329405d174d7.
46 Geert Hinrich Ahrens, *Diplomacy on the Edge: Containment of Ethnic Conflict and the Minorities Working Group of the Conferences on Yugoslavia*, Washington: Wilson Centre Press, 2008, p. 203.
47 Edina Bećirević, *Genocide on the Drina River*, p. 53.
48 The event was covered widely in the Bosnian media, though not all journalists were welcome. Gordana Knežević, the then editor of the 'political pages' of Oslobođenje was forbidden from entering the building by SDS bodyguards on 9 January 1992. This was typical of the way the SDS dealt with journalists who did not meet their approval. 'We did not choose', she said, 'who covered the SDS – it was the party who chose who could cover them. The only journalist from Oslobođenje that could attend these SDS press conferences was Snežena Rakočević. I raised this with my editor, Kemal Kurspahić, because I felt we should not allow the SDS to dictate who could and could not write about them, but Kemal was keen to ensure that we did not give them any reason to declare that Oslobođenje had lost objectivity and was anti-Serb. He was, in essence, protecting the newspaper.' Author's interview (KM) with Gordana Knežević (*Oslobođenje*), March 2018.
49 Quote by Radovan Karadžić in *Borba*, Belgrade, 31 January 1992, in Helsinški odbor za ljudska prava u Srbiji, *Jezgro velikosrpskog projekta*, p. 22.
50 For the full transcript of the meeting see UN-ICTY Case No. IT-95-5/18-T, 'The Prosecutor v. Radovan Karadžić' (ET SA01-1505-SA01-1571.doc), Club of Parliament Representatives, Serb Democratic Party, Bosnia and Herzegovina: Transcript from the meeting of the Club, Sarajevo, 28 February 1992.
51 *Oslobođenje*, Sarajevo, 1 March 1992, p. 1.
52 *Oslobođenje*, Sarajevo, 3 March 1992, p. 3.
53 Author's interview (KM) with Senada Kreso, April 2014.

54 *Oslobođenje*, Sarajevo, 3 March 1992, p. 3.
55 Author's interview (KM) with Joel Brand (*The Times/Newsweek*), November 2013.
56 Ibid.
57 Author's interview (KM) with Samir Krilić (Associated Press), October 2018.
58 The Good Vibrations office was badly damaged at the end of April 1992. Good Vibrations ceased to operate after that, though they captured some important images of the events of 5 and 6 April 1992. The owner, Slobodan Svrzo, remained in Sarajevo – in Grbavica – but left for Belgrade soon after. He ended his career in the United States, working for Voice of America in Washington DC Hayat TV subsequently took over the frequency used by Good Vibrations.
59 For an analysis of events in the Sandžak region during this period see Kenneth Morrison and Elizabeth Roberts, *The Sandžak: A History*, London: Hurst and Co.: 2013, pp. 132–145. Ramiz Delalić remained a powerful figure throughout the Bosnian war. Unlike a number of Sarajevo's criminals – such as Jusuf 'Juka' Prazina – he remained loyal to the Bosnian government throughout. He was charged with the murder of Nikola Gardović though the court found that the accusations against him were not proven. He was murdered in what appeared to be a 'gangland hit' in Sarajevo in June 2007. For the events that led to his court case see *Slobodna Bosna*, Sarajevo, 3 February 2005, pp. 20–23.
60 Robert Donia, *Sarajevo: A Biography*, p. 278. According to Karavelić and Rujanac, the narrative of Serbs being endangered was part of a wider SDS strategy to mobilize support and radicalize the Serb population of Bosnia. See Vahid Karavelić and Zijad Rujanac, *Sarajevo: Opsada i odbrana, 1992–1995*, p. 63.
61 *Slobodna Bosna*, Sarajevo, 28 November 1998, p. 16. According to a witness statement of Miroslav Deronjić – the one-time Chairman of the Executive Committee of the SDS and later member of the Main Board of the party – given to the ICTY in 2003, Dukić was 'A highly influential figure, both politically and economically, a man well known even before the war, who maintained good relations with former communist and economic officialdom. He was a man who enjoyed extensive political prestige both in Belgrade and in the SDS leadership.' ICTY Doc. No. 0344-7914-0344-7981, November 2003.
62 Transcript of interview with Šefer Halilović, in 'Death of Yugoslavia Archive', 3/28, UBIT 295-297, p. 4. In May 1992 Halilović became the Commander of the Bosnian Territorial Defence (*Teritorijalna odbrana* – TO), which was later incorporated in the Army of Bosnia and Herzegovina (ARBiH).
63 Author's interview (KM) with Gigi Riva (*Il Giorno*), May 2020.
64 According to Karavelić and Rujanac, the SDS's placement of barricades following the referendum 'was aimed to test the [SDS] plan to blockade and take over the city'. They were, the authors claim, a 'general dress rehearsal of the Sarajevo siege, and how to cut main communication routes, both road and railroad'. See Vahid Karavelić and Zijad Rujanac, *Sarajevo: Opsada i odbrana, 1992–1995*, p. 55.
65 CSCE, 'The Referendum on Independence of Bosnia-Herzegovina, February 29–1 March 1992', CSCE Report, March 1992, p. 19.
66 UN-ICTY Document, 'Socialist Republic of Bosnia and Herzegovina: Ministry of the Interior State Security Service, Sarajevo, Security Information in Relation to the Events of 01.03/02.03 and 303.03/04.03.1992 in Sarajevo', 6 March 1992, ET 0323-7746-0323-7757, p. 4.
67 *Slobodna Bosna*, Sarajevo, 28 November 1998, p. 16.
68 UN-ICTY Document, 'Socialist Republic of Bosnia and Herzegovina: Ministry of the Interior State Security Service, Sarajevo, Security Information in Relation to the

Events of 01.03/02.03 and 303.03/04.03.1992 in Sarajevo', 6 March 1992, ET 0323–7746-0323-7757, p. 3.

69 Kemal Kurspahić, *As Long as Sarajevo Exists*, Stony Creek, CT: The Pamphleteers Press, 1997, p. 121.

70 Transcript of interview with Alija Izetbegović, in 'Death of Yugoslavia Archive', 3/32, UBIT 286–288, p. 7.

71 Robert Donia, *Sarajevo: A Biography*, p. 280.

72 *Belgrade RTB Television Network*, 2 March 1992, FBIS AU0203222093.

73 According to Joel Brand – later of *The Times* and *Newsweek* – 'when the group entered the hotel there was an immediate increase in tension before what I think was a shotgun blast – one of the SDS gunmen had fired straight into the ceiling, sending broken glass flying'. Author's interview (KM) with Joel Brand (*The Times/Newsweek*), April 2014.

74 On the evening of the 1 March, Ejup Ganić spoke by telephone to Karadžić. The SDS leader claimed that he did not have information about who ordered the erection of the barricades, but that the problem should be resolved by senior members of the SDS in Sarajevo. See Ejup Ganić, *Razgovori i svjedočenja 1990–1994*, Sarajevo: Svjetlost, 2007, p. 260.

75 In a 1998 interview for the Bosnian weekly *Slobodan Bosna*, Rajko Dukić – the director of the 'Boksit' company which had an office in the Holiday Inn and was seen as a cover for channelling SDS funds – claimed that the atmosphere in the hotel during 1 March had darkened significantly. 'I came to the party office [at the Holiday Inn] and found three priests and another man there who were very agitated. They told me they had been shot at near the church ... Party [SDS] members started gathering. Information circulated that Green Berets had been seen, and that an attack was imminent. People spontaneously started to volunteer for defence. They informed me that they had put up barricades; it was a spontaneous event. That night, we wrote a proclamation which we sent to the Presidency and to the government. I could not get in touch with Karadžić and the people in Belgrade until the following morning. At first, I did not know where they were. The Holiday Inn was full of people ... we were all afraid of what might happen.' See *Slobodna Bosna*, Sarajevo, 28 November 1998, p. 16.

76 According to Hartmann, the SDS members were being treated well in the hotel and were provided with three course dinners while the group she was with had to make do with cheese and bread. 'I was horrified. After all, we were paying guests, but it became clear that we were not the most important guests in the hotel.' Author's interview (KM) with Florence Hartmann (*Le Monde*), April 2015.

77 Author's interviews (KM) with Joel Brand (*The Times/Newsweek*) and Michael Montgomery (*Daily Telegraph*), April 2014.

78 Author's interview (KM) with Florence Hartmann (*Le Monde*), April 2015.

79 *Oslobođenje*, Sarajevo, 5 March 1992, p. 3.

80 Author's interview (KM) with Gigi Riva (*Il Giorno*), May 2020.

81 Kreso also noted that while the terrified EC monitors were having breakfast in the hotel, 'the manager was in the restaurant hurriedly making lunch packets for the [SDS] people on the barricades'. See interview with Senada Kreso in Suada Kapić, *The Siege of Sarajevo: 1992–1996*, Sarajevo: FAMA, 2000, p. 144. A report in *Oslobođenje* also makes this claim, stating that a white van was parked in front of the hotel and was being used to take food to the 'boys on the barricades'. See *Oslobođenje*, Sarajevo, 3 March 1992, p. 3.

82 See UN-ICTY, 'The Prosecutor v. Ratko Mladić, Prosecution 92 TER MOTION: RM 114(Colm Doyle)', Case No. IT-09-92-T, 23 July 2012, p. 25.
83 Colm Doyle, *A Witness to War Crimes: The Memoirs of a Peacekeeper in Bosnia*, Barnsley: Pen and Sword, 2018, p. 99.
84 Ibid., p. 101.
85 CSCE, 'The Referendum on Independence of Bosnia-Herzegovina, February 29–1 March 1992', CSCE Report, March 1992, pp. 19–20.
86 Robert Donia, *Radovan Karadžić: Architect of the Bosnian Genocide*, p. 164.
87 *Oslobođenje*, Sarajevo, 3 March 1992, p. 12.
88 *Valter brani Sarajevo* was made in 1972 and directed by the Sarajevo-born Hajrudin 'Šiba' Krvavac, who was notable for a number of 'partisan films'. He died of a heart attack in Sarajevo in July 1992. For a fascinating overview of the 'partisan genre' and the work of AVALA Films – the studio that created most of the partisan films – see the documentary film 'Cinema Komunisto', Director: Mila Turajlić, Dribbling Pictures, Belgrade, 2010.
89 Author's interview (KM) with Neven Andjelić (Radio Sarajevo), June 2018.
90 Robert Donia, *Sarajevo: A Biography*, p. 281.
91 *Monitor*, Podgorica, 6 March 1992, p. 18.
92 *Dani*, Sarajevo, April 2008, p. 87.
93 *Oslobođenje*, Sarajevo, 6 March 1992, p. 1.
94 *Oslobođenje*, Sarajevo, 14 March 1992, p. 3.
95 *Oslobođenje*, Sarajevo, 21 March 1992, p. 1. For Colm Doyle's assessment of the situation in Sarajevo during March 1992, see UN-ICTY, 'The Prosecutor v. Ratko Mladić, Prosecution 92 TER MOTION: RM114 (Colm Doyle)', Case No. IT-09-92-T, 23 July 2012, p. 25. See also Colm Doyle, *A Witness to War Crimes: The Memoirs of a Peacekeeper in Bosnia*, Barnsley: Pen and Sword Books, 2018.
96 Lewis MacKenzie, *Peacekeeper: The Road to Sarajevo*, Vancouver and Toronto: Douglas and McIntyre, 1993, p. 120.
97 Transcript of interview with General Lewis MacKenzie in 'Death of Yugoslavia Archive', UBIT, p. 1.
98 *Oslobođenje*, Sarajevo, 21 March 1992, p. 3.
99 Ibid. According to MacKenzie, Nambiar was delighted when he was eventually relocated to a hotel complex called Stojčevac two kilometres southwest of Sarajevo. 'General Nambiar' he said, 'could not wait to move in. He hated living in the Holiday Inn.' See Lewis MacKenzie, *Peacekeeper: The Road to Sarajevo*, p. 125.
100 Transcript of interview with General Lewis MacKenzie in 'Death of Yugoslavia Archive', UBIT, p. 1. In a speech published in the *Canadian Journal of Military and Strategic Studies*, MacKenzie said, 'One of my Majors won 1200 bucks US for picking 2:30 p.m. on the afternoon of the 6th of April when snipers opened up at the Holiday Inn at the crowd in front of the Presidency. I had 2:32 p.m., others had 2:31, 2:28. It didn't take 20 years in the diplomatic corps or a PhD in Political Science to see it coming.' See Lewis MacKenzie, 'Canada's Army – Post Peacekeeping', *The Canadian Journal of Military and Strategic Studies*, Vol. 12, No. 1, Fall 2009, p. 8.
101 See Kenneth Morrison, *Sarajevo's Holiday Inn on the Frontline of Politics and War*, London: Palgrave Macmillan, 2016, p. 60.
102 *The Spectator*, London, 18 July 1992, p. 10.
103 *The Guardian*, London, 10 August 1992, p. 19.
104 For more detail on the Lisbon negotiations see Stephen L. Burg and Paul Shoup, *The War in Bosnia-Herzegovina: Ethnic Conflict and International Intervention*, New York: M.E. Sharpe, 2000, pp. 108–117.

105 See *Oslobođenje*, Sarajevo, March 19, p. 1.
106 *Oslobođenje*, Sarajevo, 1 April 1992, p. 10. Novi Grad comprises the following areas: Otoka, Švrakino selo (1–3), Alipašino polje, Saraj polje, Vojničko polje, Mojmilo, Dobrinja (1–4), Buća potok, Alipašin Most, Briješće, Sokolje and Dobroševć – essentially most of the far western parts of the city of Sarajevo.
107 *Oslobođenje*, Sarajevo, 4 April 1992, p. 13.
108 Author's interview (KM) with Gordana Knežević (*Oslobođenje*), March 2018.
109 *Oslobođenje*, Sarajevo, 3 April 1992, p. 1. For a detailed analysis of the ethnic cleansing of eastern Bosnia in 1992 see Edina Bećirević, *Na Drini genocid: istraživanje organiziranog zločina u istočnoj Bosni*, Sarajevo: Buybook, 2009. For a succinct analysis of the period between 1 and 10 April – in Bijeljina, Foča, Višegrad, Vlasenica and Zvornik – see *Dani*, Sarajevo, 12 December 2010, pp. 38–41.
110 Kemal Kurspahić, *As Long as Sarajevo Exists*, Stony Creek, CT: The Pamphleteers Press, 1997, p. 119.
111 Though Mrkić and Rifatbegović were fortunate, other *Oslobođenje* reporters were less so. In Zvornik, on 8 April 1992, the local correspondent for the newspaper, Kjašif Smajlović, was murdered in his office by 'Arkan's men', having reported on the arrival of Arkan's Tigers in the town. See Kemal Kurspahić, *As Long as Sarajevo Exists*, p. 119.
112 Author's interview (PL) with Ron Haviv (AFP/*Time Magazine*), August 2018.
113 *Oslobođenje*, Sarajevo, 5 April 1992, p. 3.
114 Transcript of interview with Radovan Karadžić in 'Death of Yugoslavia Archive', UBIT 177, p. 6.
115 The plans for creating an exclusively Serb MUP had been ongoing for over six months. In an SDS document entitled *Mogućnosti organizovanja Srpskog ministarstva za unutrašnje poslove* (Possibilities of Organising a Serbian Ministry of the Interior) from October 1991, basic plans were drawn up that envisaged its creation, which involved either a Bosnian Serb MUP being incorporated into the Serbian MUP – in Serbia proper – or an independent Bosnian Serb MUP being established. At the time of the report being circulated to SDS members the former option was judged most desirable. See SDS document SA02/3707, Sarajevo, 17 oktobra 1991. godine, p. 2. See also Robert Donia, *Iz Skupštine Republike Srpske 1991–1996*, Sarajevo: Sarajevo University Press, 2012, pp. 141–143. For the SDS perspective on the ethnic division of MUP see the English translation of the interview with Momčilo Mandić in *Slobodna Bosna*, Sarajevo, 10 April 1994. UN-ICTY Doc No. ET ERN 0215-5771 0215-5576 Doc.
116 *Oslobođenje*, Sarajevo, 5 April 1992, p. 2.
117 Transcript of interview with Radovan Karadžić in 'Death of Yugoslavia Archive', UBIT 177, p. 7.
118 *Oslobođenje*, Sarajevo, 6 April 1992, p. 1.
119 Transcript of interview with Radovan Karadžić in 'Death of Yugoslavia Archive', UBIT 177, pp. 7–8. In a 1995 interview, Karadžić stated, 'I could not go there … because he [Izetbegović] wanted to humiliate me. His idea was probably to sit there on some sort of a platform, so that his seat would be elevated in relation to mine, and I, being a Christian slave, would have to salute to him as if he were a [Ottoman] vizier.' Karadžić, despite expressing an aversion to meeting in the Konak, had in fact attended numerous meetings there in February 1992 as part of an SDS delegation during EC-sponsored negotiations. See Steven L. Burg, and Paul Shoup, *The War in Bosnia-Herzegovina: Ethnic Conflict and International Intervention*, p. 108.
120 *Oslobođenje*, Sarajevo, 6 April 1992, p. 3.

121 Ibid.
122 See *Oslobođenje*, Sarajevo, 7 April 1992, p. 1 and *Oslobođenje*, Sarajevo, 8 April 1992, p. 1.
123 Author's interview (KM) with Edina Bećirević, April 2019.
124 Author's interview (KM) with Neven Andjelić (Radio Sarajevo), June 2018.
125 Transcript of interview with Radovan Karadžić in 'Death of Yugoslavia Archive', UBIT 177, p. 7.
126 *Oslobođenje*, Sarajevo, 8 April 1992, p. 3.
127 Author's interview (KM) with Neven Andjelić (Radio Sarajevo), June 2018.
128 Robert Donia, *Radovan Karadžić: Architect of the Bosnian Genocide*, p. 189.
129 Transcript of interview with Radovan Karadžić in 'Death of Yugoslavia Archive', UBIT 177, p. 7. In his testimony to the ICTY, the former chief of Yugoslav Military Counter-Intelligence, Aleksandar Vasiljević, claimed that the shots had not been fired by SDS snipers, but by Muslim snipers in the nearby adjacent Secondary Technical School. 'There were a number of [SDS] people there [in the Holiday Inn] at the time, working on the archives. According to our information, the firing positions of the Muslim paramilitary formations at the Technical School near the Holiday Inn were held by Juka Prazina. These positions were behind the mass of people, facing in the direction of the Government of Bosnia and Herzegovina, across from the Holiday Inn. From there they opened fire at the people, wounding one or two and after that they spread misinformation that the Chetniks were opening fire from the Holiday Inn. At the same time, a special unit of the Bosnia and Herzegovina MUP, led by Mirza Jamaković, whose members were dressed in workers' overalls, was on stand-by. They burst into the premises of the SDS at the Holiday Inn, capturing four or five persons who were packing things at the time, and declared that the Chetniks had fired at the people. This was a planned operation to radicalise the situation, to be used as an excuse to take over the BH territorial defence headquarters.' See UN-ICTY Case No. IT-95-5/18-T, 'The Prosecutor V. Radovan Karadžić: Revised Notification of Submission of Written Evidence Pursuant to Rule 92 *ter*: Aleksandar Vasiljević' (KW527), p. 69.
130 Transcript of interview with Momčilo Krajišnik in 'Death of Yugoslavia Archive', UBIT 050, p. 4.
131 According to the Sarajevo daily *Oslobođenje*, the protestors who approached the Holiday Inn were unarmed and were later brave enough to 'take on the snipers with their bare hands'. See *Oslobođenje*, 7 April 1992, p. 24.
132 Kemal Kurspahić, *As Long as Sarajevo Exists*, p. 121.
133 Author's interview (PL) with Ron Haviv (AFP/*Time Magazine*), August 2018.
134 Robert Donia, *Sarajevo: A Biography*, p. 285. See also Silber and Little, *The Death of Yugoslavia*, London: Penguin Books, p. 229. A 'Radio Sarajevo' report from 6 April (by Zdenko Jendruh), provided a succinct description of the atmosphere in Sarajevo on 6 April. 'Few cars and passers-by can be seen in the streets of Sarajevo today ... Firms in the city are not working today and schools are closed. The shops are also closed and as of this morning all supplies have stopped. The medical centre has sent an appeal to enable the supply of food for the patients and the supply of hospitals with medical materials, of which there are less and less. There were no daily papers in Sarajevo today. Many shops and tobacco shops have been looted. Postal and telephone links with Sarajevo are interrupted. Trains arrive and leave with delays and the inter-city bus service has been interrupted.' See *Sarajevo Radio Network*, 6 April 1992, FBIS OU604143092.

135 Author's interview (KM) with Gordana Knežević (*Oslobođenje*), March 2018.
136 Interview with Ibro Spahić in Suada Kapić, *The Siege of Sarajevo: 1992–1996*, p. 153. See also *The Guardian*, London, 7 April 1992, p. 1.
137 Final Report of the United Nations Commission of Experts, 'Study of the Battle and Siege of Sarajevo', Part 1/10, S/1994/674/Add. 2 (Vol. II), 27 May 1994, p. 16.
138 *The Independent*, London, 7 April 1992, p. 1.
139 Author's interview (KM) with Tim Judah, London (*The Times*), April 2014.
140 *The Times*, London, 9 April 1992, p. 28.
141 Author's interview (KM) with Holiday Inn (Sarajevo) employee, May 2014. See also Tom Gjelten, *Sarajevo Daily: A City and Its Newspaper under Siege*, New York: HarperCollins, 1995, p. 23.
142 *Oslobođenje*, Sarajevo, 8 April 1992, p. 1. For the role of Dragan Vikić and his 'Specials' in these events see *Oslobođenje*, Sarajevo, 8 April 1992, p. 3.
143 Lewis MacKenzie, *Peacekeeper: The Road to Sarajevo*, p. 140. See also *Oslobođenje*, Sarajevo, 7 April 1992, p. 3.
144 Laura Silber and Allan Little, *The Death of Yugoslavia*, BBC/Penguin Books (2nd edn), London, 1996, p. 229.
145 Author's interview (PL) with Ron Haviv (*Time Magazine*), August 2018.
146 According to Kemal Kurspahić, the editor-in-chief of *Oslobođenje*, one of the snipers arrested was Rajko Kušić, the personal bodyguard of Radovan Karadžić's close associate of Nikola Koljević. See Kemal Kurspahić, *As Long as Sarajevo Exists*, p. 136 and *Oslobođenje*, Sarajevo, 18 April 1992, p. 3. Hasan Efendić claims that one of the snipers was 'the deputy secretary for national defence of Sarajevo, Branko Kovačević, previously Radovan Karadžić's personal secretary'. See Hasan Efendić, *Ko je branio Bosnu*, Sarajevo: Udruženje gradjana plemićkog porijekla BiH, 1999, p. 103. According to Smail Čekić, the eventual evacuation of the snipers was organized by the 'Security Department of the Command of the second District' of the JNA. See Smail Čekić, *The Aggression against the Republic of Bosnia and Herzegovina: Planning, Preparation, Execution* (Book One), Institute for the Research of Crimes against Humanity and International Law: Sarajevo, 2005, p. 929. See also *Vreme News Digest Agency*, No. 29, 13 April 1992. For the SDS's precise demands see *Oslobođenje*, Sarajevo, 8 April 1992, p. 8.
147 Author's interview (KM) with Jonathan Landay (UPI), August 2018.
148 The Ilidža hotel and spa complex had been built by the Austro-Hungarians in 1910. It comprised three hotels – 'Austria', 'Hungary' and 'Bosnia' – that were considered some of the finest in Bosnia. It was here that the Archduke Franz Ferdinand and his wife Sophie had stayed the night before their fateful assassination on 28 June 1914. See James Lyon, 'Habsburg Sarajevo 1914: A Social Picture', pp. 36–38.
149 Transcript of interview with Radovan Karadžić in 'Death of Yugoslavia Archive', UBIT 177, p. 7.
150 Robert Donia, *Radovan Karadžić: Architect of the Bosnian Genocide*, p. 189.
151 *Oslobođenje*, Sarajevo, 8 April 1992, p. 5. According to Donia, 'Responsibility for the killing of demonstrators on the afternoon of April 6 remains contested. Serb apologists point to reports of shots coming from buildings to the east, suggesting that Muslim gunmen may have fired on the crowd. The possibility of shooting from other locations cannot be excluded, but, as recorded by television cameras, those in the crowd reacted to gunfire from the Holiday Inn's top floor.' See Robert Donia, *Sarajevo: A Biography*, pp. 285–286.

152 Transcript of interview with Milutin Kukanjac in 'Death of Yugoslavia Archive', UBIT 166 (2), p. 15.
153 BSA (Bosnian Serb Assembly), 17th Session, 24–26 July 1992, Nedeljko Prstojević, BCS 0214-9561, quoted in Robert Donia, *Radovan Karadžić: Architect of the Bosnian Genocide*, p. 190.
154 Author's interview (KM) with Marcus Tanner (*The Independent*), November 2019.
155 *The Independent*, London, 18 April 1992, p. 16. Tanner would later admit that he 'should have seen it coming' when he saw Radovan Karadžić's wife Ljilijana, and daughter Sonja, dragging their suitcases down to the hotel reception and checking out just prior to the shootings. See *The Independent*, London, 15 October 1995, p. 12.
156 Author's interview with Tim Judah (*The Times*), April 2014. See also *The Times*, London, 9 April 1992, p. 28.
157 Built in 1882, the Hotel Europa was completely destroyed during the siege of Sarajevo. The building was targeted in July and August 1992 – the Bosnian Serbs claimed that the hotel was the headquarters of the 'Green Berets' – and was nothing more than a shell thereafter, despite the best efforts of the Sarajevo Fire Service. Its cellar was used as a shelter during the subsequent three and a half years of the siege. The Europa was reconstructed after the siege and remains one of Sarajevo's finest hostelries. See also interview with Huso Ćesko (Sarajevo Fire Service) in Sauda Kapić, *The Siege of Sarajevo 1992–1996*, Sarajevo: FAMA, 2000, p. 224.
158 Author's interview (PL) with Ron Haviv (AFP/*Time Magazine*), August 2018.
159 Haviv had every reason to be concerned. Though he returned to Bosnia, and to the Serb-held parts of the country – to photograph both Trnopolje and Manjača camps – he was, unbeknown to him at the time, on a list of 'enemies' of the Bosnian Serbs. On one occasion a French journalist who, according to Haviv, 'had similar physical characteristics' was arrested while in Pale, the Bosnian Serb wartime capital – he was later released when it was confirmed that this journalist was not Ron Haviv. Author's interview (PL) with Ron Haviv (*Time Magazine*), August 2018.
160 *Oslobođenje*, Sarajevo, 8 April 1992, p. 5. See also *Monitor*, Podgorica, 10 April 1992, p. 6.
161 Recalling conversations over Sarajevo with Radovan Karadžić in the Spring of 1992, the then US Ambassador to the SFRJ, Warren Zimmermann, said that 'Karadžić told me ... that Sarajevo was going to be the Serbian capital, and I expressed some surprise, since it's largely a Moslem city. He said "Well, we're going to divide it up" and that "We will have the Serbian area, and that will be part of the Serbian Republic, we will have a Moslem area, and we will have a Croatian area, so nobody will have to live next to another ethnic group. There will be divisions". I asked him about [these] divisions. He said 'Yes, we are going to build walls that will separate all of these areas.' I said, 'Well that means Serbs can't see Croats – what if they're in a mixed marriage, or something? And he said, 'Oh yes, they can go through the checkpoints in the walls, with permission of course, to go to the other side and see members of other ethnic groups.' 'Transcript of interview with Warren Zimmermann, in 'Death of Yugoslavia Archive', 3/87 UBIT 677–678, pp. 9–10.
162 Transcript of interview with Momčilo Krajišnik in 'Death of Yugoslavia Archive', UBIT 050, p. 5.
163 Mirko Pejanović, *Essays on the Statehood and Political Development of Bosnia and Herzegovina*, p. 74.
164 *Oslobođenje*, Sarajevo, 9 April 1992, p. 6. A section of the newspaper – anything between one and three pages daily – called *Sarajevska hronika* (Sarajevo chronicle) provided detailed information on events within Sarajevo – from information about

where bread and milk could be purchased to equally detailed information about where in the city had been attacked.
165 Kemal Kurspahić, *As Long as Sarajevo Exists*, p. 105.
166 See Mile Jovičić, *Two Days till Peace: A Sarajevo Airport Story*, Bloomington, IN: Author House, 2011. See also *The Guardian*, London, 14 April 1992, p. 8.
167 See, for example, *Oslobođenje*, Sarajevo, 21 May, pp. 1–2 and *Oslobođenje*, Sarajevo, 22 May 1992, p. 1.

Chapter 2

1 Final Report of the United Nations Commission of Experts, 'Study of the Battle and Siege of Sarajevo', p. 18. See also *Monitor*, Podgorica, 17 April 1992, p. 6.
2 *Oslobođenje*, Sarajevo, 17 April 1992, p. 6.
3 Peter Andreas, *Blue Helmets and Black Markets: The Business of Survival in the Siege of Sarajevo*, p. 27.
4 *The Times*, London, 9 April 1992, p. 10.
5 Peter Andreas, *Blue Helmets and Black Markets: The Business of Survival in the Siege of Sarajevo*, p. 27.
6 *New York Review of Books*, New York, 13 August 1992, p. 6.
7 Robert Donia, *Sarajevo: A Biography*, p. 291.
8 Ibid.
9 Ibid.
10 According to Kerim Lučarević, one of the key organizers of the defence of Sarajevo, 'Anyone going from Vratnik to the city centre need[s] at least two hours. He had to get past all the sentries. He had to say the same thing to each of the sentries if he wanted to keep going on his way. So, the city was covered as if by a spider's web.' See Kerim Lučarević, *The Battle for Sarajevo: Sentenced to Victory*, Sarajevo, FKV, 2000, p. 52.
11 *The Independent*, London, 18 April 1992, p. 11.
12 Author's interview (KM) with Jean Hatzfeld (*Libération*), September 2019.
13 Author's interview (PL) with Chris Morris (Time VII Photo), November 2019.
14 Author's interview (KM) with Jonathan Landay (UPI), August 2018.
15 *The Times*, London, 26 April 1992, p. 18.
16 The Klas bakery and flour mill continued to function, albeit at limited capacity, during the siege – despite the fact the building was shelled on a few occasions during the siege – the first attack being on 19 May 1992. They produced bread, rolls, buns, cookies, waffles and pasta while also successfully processing over 24,000 tons of wheat. For more on how the enterprise functioned throughout the siege see Irfan Mehičić (ed.), *Privreda u opkoljenom Sarajevu*, Sarajevo: OKO, 1999, p. 130. See also Miroslav Prstojević, *Sarajevo: ranjeni grad*, Sarajevo: Ideja, 1994, p. 38 and Suada Kapić (ed.), *The Siege of Sarajevo 1992–1996*, Sarajevo: FAMA, p. 142.
17 Author's interview (KM) with Jonathan Landay (UPI), August 2018.
18 Kerim Lučarević, *The Battle for Sarajevo: Sentenced to Victory*, p. 77.
19 Robert Donia, *Sarajevo: A Biography*, p. 295. As Donia further notes, 'In 1992 the world was on the cusp of a communications revolution ushered in by the Internet, but only a few devotees were using e-mail when the war began.' The destruction of Sarajevo's Post Office determined that telephone capacity – which supported the early internet – was almost wholly destroyed. See ibid., p. 320. See also *Monitor*, Podgorica, 8 May 1992, p. 6.

20 Robert Donia, *Sarajevo: A Biography*, p. 293.
21 For more on the development of the Ilidža spa and hotel complex see Mary Sparks, *The Development of Austro-Hungarian Sarajevo*, London: Bloomsbury, 2014, pp. 173–177.
22 Doyle forged a good relationship with the journalists and because 'there were almost no tabloid reporters in Bosnia', he did 'not have to deal with the seekers of sensationalist news or be asked to give soundbites'. Author's interview (KM) with Colm Doyle (ECMM), August 2017.
23 *The Times*, London, 15 May 1992, p. 12.
24 Author's interview (KM) with Joel Brand (*The Times/Newsweek*), April 2014.
25 Mark Thompson, *Forging War: The Media in Serbia, Croatia and Bosnia-Hercegovina*, London: Article 19, 1994, p. 207.
26 Interview with Dragan Miovčić (RTBiH) in Suada Kapić (ed.), *The Siege of Sarajevo 1992–1996*, Sarajevo: FAMA, p. 147.
27 *Oslobođenje*, Sarajevo, 15 April 1992, p. 12. See also Mark Thompson, *Forging War: The Media in Serbia, Croatia and Bosnia-Hercegovina*, p. 207.
28 During the seizure of the Vlasić transmitter, a Sarajevo TV engineer, Bajram Zenuni was killed and his crew taken prisoner. See Kemal Kurspahić, *Prime Time Crime: Balkan Media in War and Peace*, Washington DC: United States Institute for Peace, 2003, p. 98.
29 Mark Thompson further noted that the situation deteriorated immediately after the outbreak of war. 'When the onslaught began', he stated, 'three more transmitters were seized' – Velež, near Mostar, covering Herzegovina, was redirected at the end of April 1992, while Vlasić in central Bosnia was seized and redirected just days after. The Leotar transmitter – in eastern Herzegovina – was taken in June 1992. See Mark Thompson, *Forging War: The Media in Serbia, Croatia and Bosnia-Hercegovina*, p. 207.
30 Ibid., p. 208.
31 Founded in 1950, the EBU emerged from the International Broadcasting Union – which had been co-opted by the Nazis during the Second World War. The EBU is essentially an alliance of public service broadcasters throughout Europe – and beyond. They do produce content – such as the Eurovision Song Contest – but, in the main, act as a facilitator for exchange between members. In 1992, Yugoslavia ceased to be a member. The successor states of Croatia, Slovenia, Bosnia and Herzegovina and Macedonia – now North Macedonia – became members in 1993, while the Federal Republic of Yugoslavia – later the Joint State of Serbia & Montenegro – did not become a member until 2001. Both Serbia and Montenegro became members separately after Montenegro's independence, following a referendum, in 2006.
32 JRT was decentralized into eight regional 'centres' – one for each of Yugoslavia's six republics and named after the capital cities of each of those republics – Radio Television Zagreb (1956–1990), Radio Television Belgrade (1958–1992), Radio Television Ljubljana (1958–1990), Radio Television Skopje (1964–1991), Radio Television Sarajevo (1969–1991) and Radio Television Titograd (1971–1991). Two further 'centres' were created after the 1974 constitutional revisions in the country's two autonomous regions (Vojvodina and Kosovo) – Radio Television Novi Sad (1975–1992) and Radio Television Priština (1975–1992).
33 Letter from Aleksandar Todorović (Managing Director, TV Sarajevo) to the European Broadcasting Union, TLX 01:12158 Yurate YU, No. 4/225, 6 April 1992.
34 Author's interview (KM) with Myriam Schmaus (European Broadcasting Union), June 2019.

35 See *Oslobođenje*, Sarajevo, 10 April 1992, p. 1.
36 Final Report of the United Nations Commission of Experts, 'Study of the Battle and Siege of Sarajevo', p. 29. See also *The Guardian*, London, 23 April 1992, p. 24.
37 Author's interview (KM) with Myriam Schmaus (European Broadcasting Union), June 2019.
38 Ibid.
39 Ibid.
40 The Bosnian daily *Oslobođenje* claimed in an article published on 23 May 1992 that the Serbian paramilitary group *Beli orlovi* (White Eagles) had arrived in Ilidža to help consolidate the Serb stronghold on the area. See *Oslobođenje*, Sarajevo, 23 May 1992, p. 4.
41 Author's interview (KM) with Martin Bell (BBC), October 2018.
42 Author's interview (KM) with Nigel Bateson (BBC), March 2018.
43 *The Guardian*, London, 23 April 1992, p. 24.
44 For a detailed account of the defence of Sarajevo, the myriad groups who were involved and the eventual creation of the Army of Bosnia and Herzegovina, see Marko Attila Hoare, *How Bosnia Armed*, London: Saqi Books, 2004.
45 Robert Donia, *Sarajevo: A Biography*, p. 294.
46 The republics of Serbia and Montenegro remained united in the 'Federal Republic of Yugoslavia', a successor state comprising only these two republics. The creation of the state was not without controversy. A referendum was held in Montenegro – on 1 March 1992 – but not in Serbia. Despite a boycott by Montenegrin opposition parties and their members, 95.7 per cent of Montenegrins who voted – the turnout was approximately 66 per cent – approved the creation of the new state. The new constitution of the SRJ was scornfully referred to as 'The Žabljak Constitution' by Montenegrin opposition, after the town where the *nomenklatura* from Serbia and Montenegro wrote a new constitution with little or no public consultation. See Kenneth Morrison, 'Montenegro: A Polity in Flux, 1989–2000' in Charles Ingrao and Thomas Emmert, *Confronting the Yugoslav Controversies: A Scholars' Initiative*, West Lafayette, Indiana: Purdue University Press, 2013, pp. 437–438 and – by the same author – *Nationalism, Statehood and Identity in Post-Yugoslav Montenegro*, London: Bloomsbury Academic, 2018, pp. 52–53.
47 The VRS incorporated forces from Knin, Bihać, Tuzla, Sarajevo and Banja Luka and was created on 22 May 1992 under the command of General Ratko Mladić. The commanders – of the Romanija-Sarajevo corps – who directed the siege of Sarajevo were Stanislav Galić (1992–1994) and Dragomir Milošević (1994–1995). Both were later convicted by the International Criminal Tribunal for the Former Yugoslavia (ICTY) for the responsibility of targeting civilians and civilian infrastructure in Sarajevo.
48 For a transcript of these exchanges see Senad Hadžifejzović, *Rat užvo: ratni teevizijski dnevnik*, pp. 74–98.
49 For a succinct overview of the battle see Marko Attila Hoare, 'Civil-Military Relations in Bosnia-Herzegovina 1992–95' in Branka Magaš and Ivo Žanić, *The War in Croatia and Bosnia-Herzegovina 1991–1995*, London: Frank Cass, 2001, pp. 186–188.
50 See *Oslobođenje*, Sarajevo, 3 May 1992, pp. 1–4.
51 The small group of defenders located between Baščaršija and Skenderija succeeded in holding back the advance largely because they had access to weapons acquired from the PRETIS military plant in Vogošća – which was being guarded by SDS volunteer units. On the night of 17 April 1992, mobile combat groups loyal to the

Bosnian government gained access to the plant in a well-planned raid. They took anti-armour missiles and other ordinance. The acquisition of these weapons proved pivotal in stemming the JNA attack on 2 May 1922. See Vahid Karavelić and Zijad Rujanac, *Sarajevo: Opsada i odbrana, 1992–1995*, pp. 133–134.

52 According to Martin Bell, there was a 'heated argument among journalists caught up in it about whether it was better to stay where we were or to flee'. He added, in a rather self-deprecating manner, that he 'led the escape artists'. See Martin Bell, *In Harm's Way*, p. 39.

53 The BBC TV crew was a typical three-man operation, with the correspondent, soundman and cameraman all working in concert and all tied together with electrical cables. This *troika* system had been typical of TV news crews since the Vietnam War. See Greg McLaughlin, *The War Correspondent*, p. 80.

54 Mile Jovičić, *Two Days till Peace: A Sarajevo Airport Story*, p. 189.

55 For more detail on the complex negotiations surrounding the exchange see Colm Doyle, *A Witness to War Crimes*, pp. 165–177.

56 'Background, Politics and Strategy of the Sarajevo Siege, 1991–95', Statement of Expert Witness in the case IT-09-92, 'The Prosecutor v. Ratko Mladić', 18 February 2013, p. 73.

57 Marko Attila Hoare, *How Bosnia Armed*, London: Saqi Books, 2004, p. 73.

58 Marrack Goulding, *Peacemonger*, London: John Murray, 2002, p. 312.

59 *The Independent*, London, 6 May 1992, p. 10.

60 Robert Donia, *Iz Skupštine Republike Srpske 1991–1996*, Sarajevo: Sarajevo University Press, 2012, p. 171.

61 Misha Glenny, *The Fall of Yugoslavia* (3rd edn), Penguin Books, London, 1996, p. 178.

62 Author's interview (KM) with Jean Hatzfeld (*Libération*), October 2019.

63 Author's interview (KM) with Edina Bećirević (WTN), April 2019.

64 Author's interview (KM) with Joel Brand (*The Times/Newsweek*), October 2019.

65 Author's interview (KM) with Martin Bell (BBC), February 2018 and author's interview (KM) with Myriam Schmaus (EBU), June 2019. See also Tim Judah, *The Serbs: History, Myth and the Destruction of Yugoslavia*, p. 220.

66 Author's interview (KM) with Martin Bell (BBC), February 2018. See also Martin Bell, *In Harm's Way*, p. 150. According to Bell, the BBC's editing equipment was 'liberated by the grateful Serbs, together with a great quantity of videotape, and became the foundation of their TV service in Pale'. See ibid., pp. 150–151.

67 The Bosnian daily *Oslobođenje* had already reported, on 28 April 1992, that the Serbian paramilitary group *Beli orlovi* (White Eagles) were already in Ilidža. See *Oslobođenje*, 28 April 1992, p. 6.

68 Author's interview (KM) with Edina Bećirević (WTN), April 2019.

69 *Oslobođenje*, Sarajevo, 16 May 1992, p. 1.

70 *The Times*, London, 15 May 1992, p. 11.

71 *The Independent*, London, 18 May 1992, p. 1. See also *Borba*, Belgrade, 23 May 1992, p. 2.

72 For more detail on the 'Battle for Pofalići', see Vahid Karavelić and Zijad Rujanac, *Sarajevo: Opsada i odbrana, 1992–1995*, pp. 159–170.

73 Author's interview (KM) with Edina Bećirević (WTN), April 2019.

74 Quoted in David Brauchli's 'Sarajevo Diary', which can be accessed at http://hovasse.tripod.com/diaries/bosnia/bosnia.htm [last accessed 29 June 2018].

75 Author's interview (KM) with David Brauchli (Associated Press), September 2019.

76 Author's interview (KM) with Tony Smith (Associated Press), October 2019.

77 Author's interview (KM) with David Brauchli (Associated Press), September 2019.
78 Author's interview (KM) with Tony Smith (Associated Press), October 2019.
79 Kerim Lučarević, *The Battle for Sarajevo: Sentenced to Victory*, p. 137.
80 Author's interview (KM) with David Brauchli (Associated Press), September 2019.
81 Ibid.
82 *The Guardian*, London, 21 May 1992, p. 1.
83 *The Independent*, London, 19 June 1992, p. 27. See also Roger Cohen, *Hearts Grown Brutal*, New York: Random House, 1998, p. 216; for an analysis of the work of the ICRC and the UNHCR in Bosnia and Herzegovina, see Kirsten Young, 'UNHCR AND ICRC in the former Yugoslavia: Bosnia-Herzegovina', *International Review of the Red Cross*, Vol. 83, No. 843, September 2001, pp. 781–805.
84 *The Guardian/Observer* journalist Maggie O'Kane described her escape from Sarajevo with the body of Jordi Pujol in a piece published in *The Observer* in a special supplement of the paper in December 1999. See *The Observer*, London, 18 December 1999, p. C-5. Mirko Čarić, the Sarajevo correspondent for the Belgrade daily *Politika* was arrested by 'Green Berets' in an Ilidža apartment on 15 May 1992 but was released soon after. See Tanjug, Belgrade, 16 May 1992, in Daily Report East Europe (FBIS-EEU-92-006), 18 May 1992.
85 Author's interview (KM) with Tony Smith (Associated Press), October 2019.
86 *The Guardian*, London, 21 May 1992, p. 1.
87 Author's interview (KM) with David Brauchli (Associated Press), September 2019.
88 Atka Reid and Hana Schofield, *Goodbye Sarajevo: A True Story of Courage, Love and Survival*, London: Bloomsbury, 2011, p. 129.
89 Author's interview (KM) with Tony Smith (Associated Press), October 2019.
90 See *Dani*, Sarajevo, 19 July 2002, p. 7.
91 Author's interview (KM) with Tony Smith (Associated Press), October 2019.
92 Ibid.
93 Author's interview (KM) with Samir Krilić (Associated Press), October 2019.
94 Author's interview (KM) with Aernout van Lynden (Sky News), March 2018 and author's interview (KM) with Zoran Kusovac (Sky News), March 2020.
95 The Volkswagen Golf was, according to van Lynden, their car of choice. Spare parts could, after all, be found relatively easily in Sarajevo – given that the large Volkswagen factory – which manufactured the Golf – was based in the Sarajevo suburb of Vogošća. In addition, recalled Zoran Kusovac, 'Having anything other than a Golf meant you were fucked if you needed spare parts. If I needed, say, a new wheel or tyre for our Golf, I would just pay some local "alley cats" to find one for me – they probably stole it from another car – and I would pay them fifty Deutschmarks for it; but getting parts was not too problematic.' Author's interview (KM) with Aernout van Lynden (Sky News), March 2018 and Author's interview (KM) with Zoran Kusovac (Sky News), March 2020.
96 Author's interview (KM) with Aernout van Lynden (Sky News), March 2018.
97 Ibid.
98 Author's interview (KM) with Zoran Kusovac (Sky News), March 2020.
99 Author's interview (KM) with Aernout van Lynden (Sky News), March 2018.
100 This proved problematic on more than one occasion. In September 1992, the Sky News team would attempt to report from behind Bosnian Serb lines, meaning they had to use the Pale TV building more regularly. By then, some staff there made their feelings explicit. Having made a short piece about Jusuf 'Juka' Prazina and his unit in June 1992, van Lynden returned to Pale to send the story by satellite – which

went from Pale to Belgrade and then by satellite uplink to London. However, staff at the Pale TV station were annoyed by what they regarded as a 'puff piece' about an individual they regarded as a criminal and a warlord. 'It was clear', said van Lynden, 'that there were difficulties, not only with that particular piece of reportage, but my coverage of what was happening in Sarajevo more broadly'. Author's interview (KM) with Aernout van Lynden (Sky News), March 2018.
101 Author's interview (KM) with Zoran Kusovac (Sky News), March 2020.
102 According to Kusovac, 'They were always pleased to see me when I arrived, as I frequently brought chicken sandwiches with me that I had bought in Pale.' Author's interview (KM) with Zoran Kusovac (Sky News), March 2020.
103 Author's interview (KM) with Aernout van Lynden (Sky News), March 2018.
104 Ibid.
105 Martin Bell acknowledged that Sky News 'scooped' the BBC for the remainder of April, while other TV crews were out of town. See Martin Bell, *War and the Death of News: Reflections of a Grade B Reporter*, London: Oneworld, 2017, p. 195.
106 *The Guardian*, London, 30 May 1992, p. 1.
107 Author's interview (KM) with John F. Burns (*New York Times*), September 2013.
108 Ibid.
109 Ibid.
110 Ibid.
111 *Oslobođenje*, Sarajevo, 16 April 1992, pp. 1–2.
112 Author's interview (KM) with John F. Burns (*New York Times*), July 2015.
113 Author's interview (KM) with Andrew Reid (Gamma Photo Agency), March 2020.
114 Author's interview (KM) with John F. Burns (*New York Times*), July 2015.
115 Author's interview (KM) with Martin Bell (BBC), February 2018.
116 Martin Bell, *War and the Death of News: Reflections of a Grade B Reporter*, p. 195.
117 Author's interview (KM) with Martin Bell (BBC), February 2018.
118 Ibid.
119 Despite travelling relatively 'light', Bateson noted that his BBC issue Sony BVW-200 camera – and Fujinon lens with X2 extender – was heavy by contemporary standards and was powered by weighty nickel-cadmium rechargeable batteries that worked fairly well in heat but would drain quickly in the cold weather. Author's interview (KM) with Nigel Bateson (BBC), March 2018.
120 By the end of May 1992, Bosnia and Herzegovina had been dismembered and there were myriad armed groups operating all over the country. The Bosnian Serbs had already taken control of areas they coveted in the Bosnka Krajina, Eastern Herzegovina and the Drina Valley. Zdravko Grebo, a Professor of Law at the University of Sarajevo stated in an interview for the Zagreb-based daily *Danas* that 'At the moment we do not have any authority here … it is clear that BiH *de facto* no longer exists … it is not excessively ironic to say that Bosnia and Herzegovina extends at the moment from Marindvor to Baščaršija, [so] the government of Bosnia and Herzegovina has some kind of power over that stretch of one and half kilometres [of Sarajevo].' *Danas*, Zagreb, 26 May 1992, p. 16.
121 Author's interview (KM) with Allan Little (BBC), September 2019.
122 Author's interview (KM) with Allan Little (BBC), September 2019.
123 Ibid.
124 The Delegates Club became an increasingly inconvenient location for the UNPROFOR senior staff to reside after the outbreak of war on 6 April 1992. From their base in the PTT Engineering building – most of the UNPROFOR staff were

based in the 'Hotel Rainbow' – they would have to drive through sniper attacks along what was rapidly becoming known as 'Sniper Alley' to get back to the Delegates Club. According to Lewis MacKenzie, this involved waiting for firing to subside before 'making a break' and 'embarking on a high-speed run back to the Delegates Club'. See Lewis MacKenzie, *Peacekeeper: The Road to Sarajevo*, p. 149.
125 Author's interview (KM) with Allan Little (BBC), September 2019.
126 Ibid.
127 Lewis MacKenzie noted in his memoirs that by mid-June 1992, 'I noticed that the media pool surrounding us was growing exponentially every day.' See Lewis MacKenzie, *Peacekeeper: The Road to Sarajevo*, p. 215.
128 *The Guardian*, London, 12 June 1992, p. 22.
129 *The Guardian*, London, 30 June 1992, p. 35.
130 Helsinki Watch, *War Crimes in Bosnia and Herzegovina*, New York: Human Rights Watch, 1992, pp. 126–127.
131 Author's interview (KM) with Remy Ourdan (RTL/*Le Monde*), March 2020.
132 *New York Times*, New York, 30 June 1992, p. 12.
133 Author's interview (KM) with Kevin Weaver (*The Guardian/The Independent*), October 2019.
134 Ibid.
135 When Hatzfeld arrived in mid-April 1992, a small group of journalists had already 'checked in' at the Hotel Beograd – which had, before the war, also been a popular Sarajevo nightspot. Others, primarily photojournalists, were based in the Hotel Europe in Baščaršija – until that hotel was destroyed by incendiary shells in May 1992. Author's interview (KM) with Jean Hatzfeld (*Libération*), October 2019.
136 Author's interview (KM) with Kevin Weaver (*The Guardian/The Independent*), October 2019.
137 Ibid.
138 Ibid.
139 Martin Bell, *In Harm's Way: Bosnia: A War Reporter's Story*, London: Penguin, 1996, p. 114.

Chapter 3

1 See *Oslobođenje*, Sarajevo, 22 June 1992, p. 1.
2 Peter Andreas, *Blue Helmets and Black Markets: The Business of Survival in the Siege of Sarajevo*, p. 73.
3 Getting though the checkpoints was not always straightforward. As Kevin Weaver recalled, 'It felt quite dangerous. You had to talk your way into the city and that sometimes involved drinking with those manning the checkpoint or going through the rather unpleasant experience of being asked to hand over coveted items such as flak jackets – the threat was always there.' Author's interview (KM) with Kevin Weaver (*The Guardian/The Independent*), October 2019. Indeed, numerous journalists were robbed at checkpoints. In March 1993, Joel Brand of The Times, Janine di Giovanni of *The Sunday Times* and Brian Green of WTN were arrested by 'Serb rebels' at a checkpoint twenty miles west of Sarajevo and all their cash – around £4,000 – taken from them. See *The Times*, London, 25 March 1993, p. 16.
4 Author's interview (KM) with Allan Little (BBC), March 2015.

5 Author's interview (KM) with Marcus Tanner (*The Independent*), November 2019.
6 Peter Andreas, *Blue Helmets and Black Markets: The Business of Survival in the Siege of Sarajevo*, p. 33. For an excellent overview of this visit see Chris Jones, 'François Mitterrand's Visit to Sarajevo, June 1992', *Diplomacy and Statecraft*, Vol. 28, No. 2, 2017, pp. 296–319.
7 Author's interview (KM) with Zrinka Bralo (European Broadcasting Union), November 2018.
8 Peter Andreas, *Blue Helmets and Black Markets: The Business of Survival in the Siege of Sarajevo*, p. 35.
9 Author's interview (KM) with Cees van der Laan (*De Telegraaf*), September 2018.
10 The former Head of the ECMM, Colm Doyle, who was now Lord Peter Carrington's special envoy, recalled his first 'Khe Sanh' landing in late July 1992: 'As the aircraft's nose suddenly dropped I felt a dramatic pull upwards, my ears became blocked, blood rushed to my head and my stomach began to hurt. I was sure we would plummet into the ground, but at the last moment we seemed to ease up and I felt myself being pulled downwards as if the floor was giving way. As the aircraft mercifully came to a halt and my stomach returned to its normal position, the smiling loadmaster came over and congratulated me on my first Khe Sanh landing.' See Colm Doyle, *Witness to War Crimes*, p. 223.
11 United Nations (Sarajevo): 'Notice to Correspondents Arriving on Aid Flights', UNPROFOR, Sarajevo, August 1992 (courtesy of the Reuters Archive, London).
12 Ibid.
13 Ibid.
14 Author's interview (KM) with Cees van der Laan (*De Telegraaf*), September 2018.
15 Michael Nicholson, *Natasha's Story*, London: Macmillan, 1993, p. 12.
16 *The Independent*, London, 2 April 2010, p. 29.
17 The street has had a number of names throughout the twentieth century. During the period of the KSHS it was known as *Vojvode Putnika* – after the Serbian military leader, Radomir Putnik. During the occupation by the Ustaše (1941–45) it was known as *Ante Strarčević* street – after the Croatian nationalist philosopher, writer and politician – before being changed to the *Bulevar Crvene armije* (Soviet Red Army) in 1946. In 1952 its former name of *Vojvoda Putnik* was reinstated and remained in place until 1994, when it was renamed *Zmaja od Bosne*, after Husein-kapetan Gradaščević – the leader of the uprising against the Ottoman Empire in the 1830s. See Behija Zlatar et al., *Sarajevo: Ulice, trgovi, mostovi, parkovi i spomenici*, Sarajevo: Mediapress, 2007, p. 121.
18 *Rolling Stone*, New York, 18 March 1993, p. 24.
19 A total of ten journalists from the former Yugoslavia were killed in Sarajevo during the siege. Among them were two *Oslobođenje* journalists, Salko Hondo and Karmela Sojanović; the Sarajevo correspondent for the Slovenian magazine *Mladina* (Ivo Štandeker); Saša Lazarević, Željko Filipović and Amir Begić from RTV-BiH; Željko Ružičić from Radio Sarajevo; Karim Zaimović from *Dani*; and Miloš Vulović from Serbian Radio. One high-profile case – outside Sarajevo – involved the hardline editor-in-chief of Pale-based Bosnian Serb Television (Kanal-S), Risto Djogo, who was, allegedly, murdered at the Hotel Vidikovac – later the Hotel Sveti Stefan – in Zvornik. See *Vreme News Digest Agency*, No. 156, 19 September 1994 and the Organization for Security and Cooperation in Europe (OSCE), 'List of Killed Journalists in the OSCE region 1992–2017', OSCE: Vienna, 17 December 2017.

20 Margaret Moth worked as a photojournalist/camerawoman for CNN when she was injured in Sarajevo. She was a remarkable woman, who continued to cover conflicts around the world – including returning to Sarajevo in 1994 – despite the horrific injuries she sustained in Sarajevo. She died of cancer in March 2010 at the age of fifty-nine. For an overview of her work and life see 'Margaret Moth: Fearless', CNN Documentary, broadcast on CNN, 22 September 2009.

21 According to Sarah Helm and Emma Daly in an article for *The Independent*, 'Many reporters have been shot, very deliberately, by snipers while driving cars clearly marked with "TV" – the sign of a press car. There has been much debate over whether to mark cars or not: large agencies also use white armoured Land Rovers, which are often mistaken for UN vehicles.' See *The Independent*, London, 11 August 1995, p. 9.

22 Author's interview (KM) with David Rust (CNN), May 2019.

23 Interview with Margaret Moth in 'Margaret Moth: Fearless', CNN Documentary, broadcast on CNN, 22 September 2009.

24 Milan Panić, *Prime Minster for Peace: My Struggle for Serbian Democracy*, London: Rowman & Littlefield, 2015, p. 65.

25 Interview with Sam Donaldson (ABC) in BBC Television's 'The Late Show Special: Tales from Sarajevo'. First broadcast 21 January 1993. This information is, however, questionable. The TVSA drivers did not generally have flak jackets at this point in the siege – though it is possible that this particular driver may have privately owned one.

26 Author's interview (KM) with Christiane Amanpour (CNN), September 2019.

27 Author's interview (KM) with David Rust (CNN), May 2019.

28 Eddie Maalouf, 'European Broadcasting Union: Unpublished Memoirs from Sarajevo, 1992–95', p. 14. The authors would like to thank Eddie Maalouf for providing access to these memoirs which, though yet unpublished, are a unique and important insight into the operations of the EBU in Sarajevo.

29 Interview with Sam Donaldson (ABC) in BBC Television's 'The Late Show Special: Tales from Sarajevo'. First broadcast 21 January 1993.

30 Milan Panić, *Prime Minster for Peace: My Struggle for Serbian Democracy*, p. 65.

31 Author's interview (KM) with Pierre Peyrot (EBU), August 2018.

32 Eddie Maalouf, 'European Broadcasting Union: Unpublished Memoirs from Sarajevo, 1992–95', p. 14.

33 Ibid., p. 17.

34 The *El Pais* journalist, Hermann Tertsch was saved at a checkpoint after he had been arrested by members of the Bosnian TO as the night time curfew in Sarajevo approached. There had been heavy fighting that evening when he was arrested and thrown into the back seat of a waiting car. 'They were out of control', he said, 'but, thank God, we came to a checkpoint where there were some official regular militias, among them an officer who was a friend of mine … he took me out of the car, but they [the four members of the TO] had taken all of my identification papers away and they were [when they stopped at the checkpoint] taking me somewhere out of the city. I thought I was going to be floating on the river Miljacka very soon.' Interview with Hermann Tertsch (*El Pais*) in BBC Television's 'The Late Show Special: Tales from Sarajevo', Director: Roland Keating. First broadcast 21 January 1993.

35 Ibid., p. 17.

36 Ibid., p. 18.

37 Dejan Anastasijević, 'Death in the Eye', *Vreme News Digest*, Belgrade, 22 August 1994.

38 *Oslobođenje*, Sarajevo, 2 May 1995, p. 11. See also Suada Kapić (ed.), *The Siege of Sarajevo 1992–1996*, Sarajevo: FAMA, 2000, p. 127.

39 Peter Maass, *Love Thy Neighbour*, p. 145.
40 Author's interview (KM) with Marcus Tanner (*The Independent*), November 2019.
41 Author's interview (KM) with Tony Smith (Associated Press), October 2019.
42 The late Hugh Pain was reporting for Reuters in the west-central Bosnian town of Gornji Vakuf in January 1993 when the armoured Land Rover he was driving ran over an anti-tank mine. The vehicle and its passengers – the Reuters photojournalist Corinne Dufka, and the UPI correspondent Kevin Sullivan – were then pinned down by sniper fire before they were rescued by Bosnian militia before being handed over to the British UNPROFOR contingent. All survived but were lucky to do so.
43 Hugh Pain, 'Elegy for Yugoslavia', in Nicholas Moore and Sidney Weiland (eds), *Frontlines: Snapshots of History*, London: Reuters/The Tangman Press, 2001, p. 274.
44 Author's interview (KM) with John Sweeney (*The Observer*), July 2014.
45 Giving evidence in the trial of Ratko Mladić in September 2013, the BBC journalist, Jeremy Bowen, described the approach to the hotel along 'Sniper's Alley'. It was, he said 'Very dangerous because you could be shot by at by snipers from the Serb side. I would drive down it from the TV station to the [Holiday Inn] hotel and into the town in an armoured Land Rover. Before we had an armoured Land Rover, we had to take the roundabout route that avoided Sniper Alley. Even with the armour, I would drive fast because it is much harder to hit a moving target. During the siege many civilians were killed on the road by snipers. One sniper position overlooked the Holiday Inn.' UN-ICTY, Case No. IT-09-92-T, 'The Prosecutor v. Ratko Mladić' (Witness Statement: D70033-D69927), 13 September 2013, p. 5.
46 Author's interview (KM) with David Rust (CNN), May 2019.
47 Author's interview (KM) with Zoran Stevanović (Reuters TV), August 2015.
48 Author's interview (KM) with Dina Neretljak (AFP), October 2018.
49 Author's interview (KM) with Joel Brand (*The Times/Newsweek*), April 2014.
50 Author's interview (KM) with Colin Smith (*The Observer*), May 2014.
51 *New York Times*, New York, 26 September 1992, p. 7.
52 John Simpson, *Strange Places, Questionable People*, London: Pan/Macmillan, 1999, p. 435.
53 Author's interview (KM) with John Simpson (BBC), June 2019.
54 Ibid.
55 Author's interview (KM) with Vaughan Smith (Frontline News), June 2015.
56 Robert Donia, *Sarajevo: A Biography*, p. 287.
57 *Dani*, Sarajevo, April 2008, p. 87.
58 Robert Donia, *Sarajevo: A Biography*, p. 314.
59 After a chance meeting with Jonathan Landay (UPI, later the *Christian Science Monitor*) and Blaine Harden (*The Washington Post*), Džemal Bećirević, who would be hired as a fixer and translator. He recalled that 'In the first weeks of the siege, people just carried on with their routines, going to work. There was nothing to do when they got there, but people held on to their normal routines nevertheless. I lived day by day, as much as normal, going to town to meet friends. I even went to the bank to pay off my overdraft! We thought it would all be over in days or weeks and that we would soon be down on the coast having our regular summer holiday – we never imagined then that it would last over three years.' Author's interview (KM) with Džemal Bećirević (UPI/Washington Post), April 2015.
60 Towards the end of the Bosnian war, Danilo Dursun would become the 'acting director' of the Republika Srpska Bureau in Serbia, which was based in Moše Pijade Street in Belgrade. He would later (in 1997) be on the SDS's list of

proposed ambassadors in the (post-Dayton) Bosnian state. See Onasa, Sarajevo, 3 August 1997.

61 The premises of many of Sarajevo's largest firms were targeted throughout the siege, thereby destroying much of the commercial infrastructure of the city. For an overview of the impact of the siege on these businesses see Kemal Grebo, *Privreda u opkoljenom Sarajevu*, Sarajevo: OKO, 1998. For an overview of how some of these firms endeavoured to function and provide basic services for citizens during the siege see Muhamed Kreševljaković (ed.), *I oni brane Sarajevo*, Sarajevo: Zlatni ljiljani, 1998.
62 *The Independent*, London, 11 July 1992, p. 10.
63 Robert Donia, *Sarajevo: A Biography*, p. 294. For a personal account of the fighting around Sarajevo Airport and how it impacted on operational aspects, see Mile Jovičić, *Two Days till Peace: A Sarajevo Airport Story*.
64 *The New York Times*, New York, 27 September 1992, p. 3.
65 Robert Donia, *Sarajevo: A Biography*, p. 290.
66 *The Observer*, London, 27 December 1992, p. 27. For a detailed analysis of the 'Green Lines' and impact of division on both Beirut and Nicosia see Jon Calame and Esther Charlesworth, *Divided Cities: Belfast, Beirut, Jerusalem, Mostar and Nicosia*, Philadelphia: University of Pennsylvania Press, 2009.
67 In Sarajevo, the citizens of the 'old town' – Baščaršija, Bistrik, Vratnik, Kovači and much of Marindvor – were referred to by their fellow Sarajevans as *avlijaneri* – or sometimes merely *mahalci* – while those from the newer parts of the city – those areas constructed after the Second World War, such as Čengić Vila, Dolac Malta, Alipašino polje and west towards Dobrinja – were referred to as *haustorčad*. Even within the former, however, there is a distinction between those who live on the *sunčani strana* (sunny side), such as Vratnik, and the *memli strana* (humid side), such as Bistrik.
68 ICTY Case No. IT-98-29/1-T, 'The Prosecutor vs. Dragomir Milošević', Doc. No. 5765, 12 December 2007, p. 77.
69 *The Guardian*, London, 14 July 1992, p. 21.
70 Jeremy Bowen, *War Stories*, p. 136.
71 *The Los Angeles Times*, Los Angeles, 22 March 1994, p. 21.
72 Author's interview (KM) with Malcolm Brabant (BBC), August 2015.
73 Martin Bell, *In Harm's Way*, p. 63.
74 *The Independent*, London, 11 July 1992, p. 10.
75 Author's interview (KM) with Remy Ourdan (*Le Monde*), 5 November 2013.
76 Miroslav Prstojević, *Sarajevo: ranjeni grad*, Sarajevo: Ideja, 1994, p. 110.
77 *The Guardian*, London, 14 July 1992, p. 21.
78 Author's interview (KM) with Joel Brand (*The Times/Newsweek*), April 2014.
79 Michael Nicholson, *Natasha's Story*, p. 12.
80 Ibid., p. 12.
81 Ibid., p. 13.
82 Miroslav Prstojević, *Sarajevo: ranjeni grad*, p. 110.
83 Paul Harris, *More Thrills than Skills: Adventures in Journalism, War and Terrorism*, p. 183.
84 Author's interview (KM) with Džemal Bećirević (UPI/*Washington Post*), April 2015.
85 When Sullivan arrived in Sarajevo in October 1992, UPI's equipment consisted only of 'a Volkswagen Golf with no windows and a satellite phone with no consistent access to electricity', so he opted to move to the Holiday Inn where there were

distinct advantages. 'Being in the loop,' he said, 'was the primary benefit. Information circulated, and people were generally collaborative.' Author's interview (KM) with Kevin Sullivan (UPI), April 2015.

86 Author's interview (KM) with Kevin Sullivan (UPI), April 2015. On Kevin Sullivan's first evening at the Holiday Inn, he was introduced to an *Oslobođenje* journalist, Marija Fekete, whom he later married. And despite being a distinctly unromantic place to meet a prospective partner, Sullivan wasn't alone. The CNN correspondent, Christian Amanpour, met her – now former – husband, James Rubin, then the US State Department spokesman, in the Holiday Inn. See *The Times*, London, 13 June 1998, p. 16.
87 UN-ICTY, Case No. IT-98-29/-T, 'The Prosecutor v. Dragomir Milošević': (D70033-D69927), 12 December 2007, p. 53.
88 UN-ICTY, Case No. IT-09-92-T, 'The Prosecutor v. Ratko Mladić' (Witness Statement: D70033-D69927), 13 September 2013, p. 9.
89 Author's interview (KM) with Jeremy Bowen (BBC), March 2014.
90 Author's interview (KM) with Vaughan Smith (Frontline News), June 2015.
91 Author's interview (KM) with Peter Maass (*The Washington Post*), April 2015.
92 Peter Maass, *Love Thy Neighbour*, p. 148. Maass is not suggesting here that cameramen simply set up their equipment and waited for something to happen, but images could be captured from the confines of the Holiday Inn. This is not entirely novel – some of the most striking images of war or conflict have been captured from hotel balconies. Perhaps the most famous image of 'Tank Man' during the events was captured by the American photographer Jeff Widener who worked for AP – and was published in a number of European newspapers. Images were also captured by Charlie Cole of *Newsweek*, Stuart Franklin of Magnum Photos and Arthur Tsang Hin Wah of Reuters. All the images were captured from balconies at the Hotel Beijing.
93 Author's interview (KM) with Malcolm Brabant (BBC), August 2015.
94 Author's interview (KM) with Gigi Riva (*Il Giorno*), May 2020.
95 Peter Andreas, *Blue Helmets and Black Markets: The Business of Survival in the Siege of Sarajevo*, p. 75.
96 Robert Donia, *Sarajevo: A Biography*, p. 287.
97 Author's interview (KM) with Zoran Kusovac (Sky News), March 2015.
98 Author's interview (KM) with Remy Ourdan (RTL/*Le Monde*), March 2020.
99 Author's interview (KM) with Vaughan Smith (Frontline News), June 2015.
100 Author's interview (KM) with Christiane Amanpour, September 2019.
101 Author's interview (KM) with Jeremy Bowen (BBC), May 2019.
102 Ibid.
103 Ibid.
104 Jeremy Bowen, *War Stories*, p. 130.
105 Author's interview (KM) with Jeremy Bowen (BBC), March 2014. The Holiday Inn was, strictly speaking, not the only hotel that functioned during the siege. Both the Belvedere on Višnjik 2 and the nearby Hondo on Zaima Šarca – which opened in 1993 – were among the very few functioning hotels in Sarajevo. They were, of course, smaller and cheaper, but could not provide the same facilities as the Holiday Inn. Nevertheless, both continued to function in difficult circumstances, though they were far less exposed – particularly to sniper fire – than the Holiday Inn.
106 Ibid.
107 *The Independent*, London, 11 July 1992, p. 16.
108 Jeremy Bowen, *War Stories*, p. 131.

109 Author's interview (KM) with Jeremy Bowen (BBC), March 2014. Bowen also stated that he had made the mistake of using the lifts – which almost never functioned – on one of this first visits to the Holiday Inn. 'Before I knew better, I got into the lift, which was at the front of the hotel facing the Serb positions. The moment the doors opened at my floor and I stepped out ... two shots came in and hit the doorframe where I was standing. They missed. A sniper on the Serb side of the frontline must have been aiming at the light as the doors opened. After that, the lift stopped working most of the time, and I used the stairs at the back.' See ibid., p. 131.
110 Miroslav Prstojević, *Sarajevo Survival Guide*, Sarajevo: FAMA, p. 84.
111 Author's interview (KM) with Remy Ourdan (*Le Monde*), London, 5 November 2013.
112 Author's interview (KM) with Joel Brand (*The Times/Newsweek*), May 2015.
113 Author's interview (KM) with Vaughan Smith (Frontline News), June 2015.
114 Author's interview (KM) with Sean Maguire (Reuters), September 2013.
115 *The Scotsman*, Edinburgh, 29 May 2000, p. 16.
116 Author's interview (KM) with Vaughan Smith (Frontline News), June 2015.
117 Author's interview (KM) with Kevin Weaver (*The Guardian/The Independent*), October 2019.
118 Author's interview (KM) with Paul Harris (*The Scotsman/Scotland on Sunday*), August 2015.
119 Author's interview (KM) with Robert King (Freelance photographer, JB Pictures), June 2015.
120 Ibid.
121 See *Killer Image: Shooting Robert King*, Director: Richard Parry, Trinity Films, London, 2008.
122 Jeremy Bowen, *War Stories*, p. 133.
123 *Soldier of Fortune* (SOF), known also as *The Journal of Professional Adventurers* was a monthly magazine published in the US, which was widely read by soldiers, both by professionals and by mercenaries. The magazine became notorious in the 1970s when it launched a recruitment drive for mercenaries to fight for the Rhodesian Security Forces during the Rhodesian War of 1964–79. The magazine was known to be popular among 'war tourists' and other amateurs with an interest in warfare.
124 *The Scotsman*, Edinburgh, 15 June 1998, p. 9.
125 *The American Spectator*, Summer Reading issue, June 2000, p. 115.
126 *Rolling Stone*, New York, 18 March 1993, p. 24.
127 Ivana Maček, *Sarajevo under Siege: Anthropology in Wartime*, p. 133.
128 *Dani*, Sarajevo, April 2008, p. 87.
129 Ibid.
130 *Vreme News Digest Agency*, Belgrade, No. 154, 5 September 1994, p. 6.
131 Anthony Loyd, *My War Gone By, I Miss it So*, p. 179.
132 *Oslobođenje*, Sarajevo, 14 November 1994, p. 1.
133 Author's interview (KM) with Samir Korić (Reuters), October 2018.
134 Peter Andreas, *Blue Helmets and Black Markets: The Business of Survival in the Siege of Sarajevo*, p. 74. See also Paul Harris, *More Thrills than Skills: Adventures in Journalism, War and Terrorism*, p. 182.
135 Peter Maass, *Love Thy Neighbour*, p. 122.
136 Anthony Loyd, *My War Gone By, I Miss it So*, p. 179.
137 Author's interview (KM) with Kevin Sullivan (UPI), April 2015.

138 Author's interview (KM) with Džemal Bećirević (UPI/*Washington Post*), April 2015.
139 Author's interview (KM) with Sabina Ćosić (Reuters), June 2014.
140 Suada Kapić (ed.), *The Siege of Sarajevo 1992–1996*, Sarajevo: FAMA, 2000, p. 127.
141 The Sarajevo TV building was completed in two phases. The first phase of the building began in the early 1970s and the second phase, which significantly upgraded the building, was completed in 1983 as part of the wider process of building Sarajevo's Olympic infrastructure in the early 1980s. See Ivan Štraus, 'Savremena arhitektura Bosne i Hercegovine, 1918–1984. godine' in Zoran Menević et al., *Arhitektura XX vijeka*, Beograd: Prosveta, 1986, pp. 57–65.
142 See Amro Čusto, 'Urbanizacija na kraju grada – 'Obećao si da ćemo živjeti u neboderu', in *Zbornik radova Historijskog Muzej BiH*, Sarajevo, broj. 13, 2019, pp. 26–30.
143 Peter Andreas, *Blue Helmets and Black Markets: The Business of Survival in the Siege of Sarajevo*, p. 76.
144 TV Sarajevo formally merged into RTBiH in 1992, though it continued to function as a separate channel. See *Oslobođenje*, 10 May 1992, p. 1. YUTEL's Deputy Director, Milan Trivić, subsequently found himself attempting to document events in the Sarajevo district of Dobrinja, which was isolated from the rest of the city and was under a separate siege by the VRS. Trivić also played a key role in organizing the Dobrinja Press Centre and in smuggling images out of the area – that would be transmitted by RTBiH. For an insider's account of the defence of Dobrinja, see Muharem Hamzić, *Dobrinjska tvrđava*, Sarajevo: Općina Novi Grad, 2004.
145 For more on US broadcasters in Sarajevo during the Winter Olympics, see Jason Vuić, *The Sarajevo Olympics: The Story of the 1984 Winter Games*, Amherst and Boston: University of Massachusetts Press, 2015.
146 Robert Donia, *Sarajevo: A Biography*, pp. 292–293. The TV station was, according to Kerim Lučarević, also the target for an attempt by *Beli orlovi* (White Eagles), a Serb paramilitary force, to occupy the building in April 1992. See Kerim Lučarević, *The Battle for Sarajevo: Sentenced to Victory*, p. 42.
147 Author's interview (KM) with Colm Doyle (ECMM), August 2017.
148 Author's interview (KM) with Myriam Schmaus (European Broadcasting Union), June 2019.
149 Author's interview (KM) with Zrinka Bralo (EBU), November 2018.
150 Ibid.
151 Ibid.
152 Author's interview (KM) with Myriam Schmaus (EBU), June 2019. The EBU did, however, establish a separate transmission point in Pale, the Bosnian Serb wartime capital, in February 1994, though the rate of journalists using their facilities was relatively small in comparison to the numbers using the Sarajevo TV station transmission point. They also established a second transmission point at the Hotel Bosna – where they had originally located the first EBU transmission point – in early 1996. Author's interview (KM) with Steve Ward (EBU), October 2019.
153 Author's interview (KM) with Pierre Peyrot (EBU), August 2018.
154 Eddie Maalouf, 'European Broadcasting Union: Unpublished Memoirs from Sarajevo, 1992–95', p. 20.
155 Ibid.
156 Author's interview (KM) with Pierre Peyrot (EBU), August 2018.
157 Author's interview (KM) with Steve Ward (EBU), October 2019.
158 Author's interview (KM) with Zrinka Bralo (EBU), November 2018.

159 Author's interview (KM) with Steve Ward (EBU), October 2019.
160 Peter Andreas, *Blue Helmets and Black Markets*, p. 76.
161 The satellite phones that were used by most of the foreign crews in 1992/93 were primarily for voice though they could transmit data very, very slowly – and if contact was lost the process would have to begin again. According to Pierre Bairin of CNN, 'You had to dial it in and it was a very slow process. We were moving slowly from analogue to digital hardware but what we had in Sarajevo at that time was, by today's standards, quite primitive.' Author's interview (KM) with Pierre Bairin (CNN), August 2018.
162 Author's interview (KM) with David Rust (CNN), May 2019.
163 Eddie Maalouf, 'European Broadcasting Union: Unpublished Memoirs from Sarajevo, 1992–95', p. 21.
164 Author's interview (KM) with Pierre Peyrot (EBU), August 2018.
165 Ibid.
166 Author's interview (KM) with Zrinka Bralo (EBU), November 2018.
167 Peter Andreas, *Blue Helmets and Black Markets: The Business of Survival in the Siege of Sarajevo*, p. 76.
168 Author's interview (KM) with Steve Ward (EBU), October 2019.
169 *Oslobođenje*, Sarajevo, 30 June 1995, p. 5.
170 *Oslobođenje*, Sarajevo, 29 June 1995, p. 1.
171 Author's interview (KM) with Eldar Emrić (APTV), July 2020.
172 Ibid.
173 Ibid.
174 *Oslobođenje*, Sarajevo, 29 June 1995, p. 3.
175 Author's interview (KM) with Steve Ward (EBU), October 2019.
176 Author's interview (KM) with Eldina Jašarević (ARD), September 2019.
177 *Oslobođenje*, Sarajevo, 30 June 1995, p. 5.
178 Author's interview (KM) with Eldar Emrić (APTV), July 2020.
179 *Oslobođenje*, Sarajevo, 30 June 1995, p. 5.
180 Suada Kapić (ed.), *The Siege of Sarajevo 1992–1996*, Sarajevo: FAMA, 2000, p. 125.
181 Interview with Corporal Greg Alkerton, Royal Canadian Regiment (UNPROFOR) in 'Sector Sarajevo', History Channel, Director: Berry Stevens, 2017.
182 Lewis MacKenzie, *Peacekeeper: The Road to Sarajevo*, Vancouver/Toronto: Douglas & McIntyre, 1993, p. 226.
183 Peter Maass, *Love Thy Neighbour*, pp. 166–167.
184 Author's interview (KM) with Jeremy Bowen (BBC), May 2019. Bowen's colleague, John Simpson, also noted that 'Many of the journalists who turned up at the morning briefings at UN headquarters regarded the UN virtually as an enemy.' See John Simpson, *Strange Places, Questionable People*, p. 445.
185 Author's interview (KM) with Christiane Amanpour, September 2019.
186 Author's interview (KM) with John Simpson (BBC), June 2019. See also *The Guardian*, London, 9 January 1993, p. 10.
187 Author's interview (KM) with Christiane Amanpour, September 2019.
188 *New York Times*, New York, 17 August 1993, p. 6. See also Adam Le Bor, *Complicity with Evil: The United Nations in the Age of Modern Genocide*, New Haven and London: Yale University Press, 2006, p. 36.
189 Documentation provided for Amra Abadžić (Reuters), UN Accreditation No. 10112, from UN Civilian Police (UNCIVPOL), Sarajevo, 22 June 1993.
190 Author's interview (KM) with Allan Little (BBC), September 2019.
191 Atka Reid and Hana Schofield, *Goodbye Sarajevo*, p. 53.

192 Interview with Senad Pečanin (*Ratni Dani*) in Suada Kapić (ed.), *The Siege of Sarajevo 1992–1996*, 2000, p. 405.
193 Peter Andreas, *Blue Helmets and Black Markets: The Business of Survival in the Siege of Sarajevo*, p. 49.
194 Author's interview (KM) with Kevin Weaver (*The Guardian/The Independent*), October 2019.
195 Author's interview (KM) with Gigi Riva (*Il Giorno*), May 2020.
196 Peter Andreas, *Blue Helmets and Black Markets: The Business of Survival in the Siege of Sarajevo*, p. 82.
197 Ibid.

Chapter 4

1 Author's interview (PL) with Martin Dawes (BBC), November 2019.
2 Author's interview (PL) with Charlotte Eagar (*The Observer*), November 2019.
3 Ibid.
4 Ibid.
5 Ibid.
6 Howard Tumber and Frank Webster, *Journalists under Fire: Information War and Journalistic Practices*, London: Sage Publications, 2006, p. 62.
7 Martin Bell, *In Harm's Way*, p. 57.
8 Author's interview (KM) with Cees van der Laan (*De Telegraaf*), September 2018.
9 Author's interviews (KM) with Amra Abadžić-Lowe (Reuters), May 2014, Sabina Ćosić (Reuters), June 2014, Džemal Bećirević (UPI/*Washington Post*), April 2015 and Samir Korić (Reuters), April 2015.
10 Leslie Fratkin, *Sarajevo Self-portrait: The View from the Inside*, New York: Umbrage Editions, 2000, p. 63.
11 Ibid.
12 Ibid.
13 Author's interview with Amra Abadžić-Lowe (Reuters), May 2014.
14 Author's interview (KM) with Džemal Bećirević (UPI/*Washington Post*), April 2015
15 Author's interview (KM) with Dina Neretljak (AFP), October 2018.
16 Ibid.
17 Ibid.
18 Ibid.
19 Ibid.
20 Ibid.
21 Author's interview (KM) with Boba Lizdek (*Libération/El Pais/El Mundo*), July 2018. Julio Fuentes was killed in Nangarhar Province in Afghanistan on 19 November 2001. He was travelling with Azizullah Haidari – a photographer for Reuters; Harry Burton – an Australian cameraman for Reuters – and Maria Grazia Cutuli – an Italian correspondent for the Milan-based daily *Corriere della Serra* – when they were killed by a group of gunmen who ambushed the convoy they were in.
22 Ibid.
23 Lizdek worked with a large number of press agencies and newspapers including *El Pais, La Vanguarda, El Mundo*, RFI, *Le Figaro*, France 3, *Radio Suisse*, Radio Canada, RTL, RAI, RAI Radio, *Libération, Corriere Della Serra* and *La Republica*.

24 Author's interview (KM) with Boba Lizdek (*Libération/El Pais/El Mundo*), July 2018.
25 Author's interview (KM) with Samir Krilić (Associated Press), October 2018.
26 Author's interview (KM) with John Simpson (BBC), June 2019.
27 Author's interview (KM) with Martin Bell (BBC), December 2013.
28 Author's interview (KM) with Allan Little (BBC), September 2019.
29 Author's interview (KM) with David Rust (CNN), May 2019.
30 Martin Bell, *War and the Death of News*, p. 189.
31 Author's interview (KM) with David Rust (CNN), May 2019.
32 Ibid.
33 Author's interview (KM) with Christiane Amanpour (CNN), September 2019.
34 Martin Bell, *War and the Death of News*, p. 199.
35 Martin Bell, *In Harm's Way*, p. 77. The SAP was eventually disbanded in 1995.
36 Author's interview (KM) with Martin Bell (BBC), December 2013.
37 Author's interview (KM) with Zrinka Bralo (European Broadcasting Union), November 2018.
38 Author's interview (KM) with Christiane Amanpour, September 2019. Writing in *The Independent*, Sarah Helm and Emma Daly noted that 'Troops often object to television crews filming what they see as sensitive areas and have threatened many reporters. But it is more usual to steal or confiscate videotape, film or camera equipment, or to shoot to frighten than actually kill reporters in cold blood.' See *The Independent*, London, 11 August 1995, p. 9.
39 Author's interview (KM) with Zoran Kusovac (Sky News), March 2015.
40 *The Guardian*, London, 25 March 1996, Features, p. T 10.
41 Author's interview (PL) with Ron Haviv (AFP/*Time Magazine*), August 2018.
42 Author's interview (KM) with Jeremy Bowen (BBC), May 2019.
43 Bell, *In Harm's Way*, p. 71.
44 Ibid.
45 Author's interview (PL) with Allan Little (BBC), January 2020.
46 Author's interview (KM) with Zoran Kusovac (Sky News), March 2020.
47 Ibid.
48 *The Washington Post*, 15 September, 1992, p. 16.
49 Author's interview (KM) with Tony Winning (Reuters), October 2019.
50 Author's interview (KM) with Sean Maguire (Visnews/Reuters), October 2019.
51 Author's interview (KM) with Tony Winning (Reuters), October 2019.
52 Author's interview (KM) with Sean Maguire (Visnews/Reuters), October 2019.
53 Author's interview (PL) with Chris Morris (*Time*/VII Photo), November 2019.
54 See *New York Times*, New York, 19 June 1994, p. 14.
55 Author's interview (KM) with Pierre Bairin (CNN), August 2018.
56 Peter Maass, *Love Thy Neighbour*, p. 34.
57 Ibid.
58 Ibid., p. 145.
59 Author's interview (KM) with David Brauchli (Associated Press), September 2019.
60 Author's interview (KM) with Joel Brand (*The Times/Newsweek*), May 2015.
61 Jeremy Bowen, *War Stories*, pp. 142–143.
62 Author's interview (KM) with Christiane Amanpour (CNN), September 2019.
63 Author's interview (KM) with David Rust (CNN), May 2019.
64 Tanner also noted that 'Sarajevo was a place in which you needed to be able to run, not waddle, and flak jackets virtually immobilised you.' He added that 'they offered

no real protection as your face was still uncovered'. Author's interview (KM) with Marcus Tanner (*The Independent*), November 2019.
65 Author's interview (KM) with Allan Little (BBC), September 2019.
66 Interview with Bob Simon (CBS) in 'Reporters at War' (Episode 1), Director: Jon Blair, True Vision Productions, 2003.
67 Author's interview (KM) with Samir Krilić (Associated Press), October 2018.
68 Author's interview (KM) with Boba Lizdek (*Libération/El Pais/El Mundo*), July 2018.
69 Author's interview (PL) with Amra Abadžić Lowe (Reuters), January 2020.
70 Martin Bell, *In Harm's Way*, pp. 85–86. See also Jeremy Bowen, *War Stories*, p. 130.
71 Authors interview (KM) with Martin Bell (BBC), December 2013.
72 Bell, *In Harm's Way*, pp. 92–93. See also *The Times*, London, 26 August 1992, p. 8.
73 Author's interview (KM) with Martin Bell (BBC), December 2013.
74 Author's interview (KM) with Martin Bell (BBC), October 2018.
75 Martin Bell, *War and the Death of News*, p. 197.
76 Author's interview (KM) with Remy Ourdan (RTL/*Le Monde*), March 2020.
77 For Paul Marchand's personal account of his journalistic endeavours in Beirut and Sarajevo see Paul Marchand, *Sympathie pour le diable*, Outremont: Lancot, 1997.
78 Paul Marchand, *Sympathie pour le diable*, p. 95.
79 *New York Times*, New York, 26 September 1992, p. 7.
80 *New York Times*, New York, 21 June 1994, p. 24.
81 Interview with Paul Marchand in 'Veillées d'armes: Histoire du Journalisme en temps du guerre' ('The Troubles We've Seen: A History of Journalism in Wartime'), Second Journey, Director: Marcel Ophuls, Little Bear Productions, 1994.
82 Author's interview (KM) with Boba Lizdek (*Libération/El Pais/El Mundo*), July 2018.
83 A biopic based loosely on Marchand's book *Sympathie pour le diable* – and with the same title – was made in 2019. The film, directed by Guillaume de Fontenay, focused mainly on Marchand's experiences in Sarajevo during the siege.
84 Author's interview (PL) with Gary Knight (Saba/*Newsweek*), August 2018.
85 Ibid.
86 Ibid.
87 Ibid.
88 Ibid.
89 Ibid.
90 Author's interview (KM) with Joel Brand (*Newsweek*), October 2019.
91 Ibid.
92 Ivana Maček, *Sarajevo under Siege: Anthropology in Wartime*, p. 71. For an overview of the ingenious ways in which Sarajevans collected water see Armina Pilav, 'Before the War, War, after the War: Urban Imageries for Urban Resilience', *International Journal of Disaster Risk Science*, Vol. 3, No. 1, 2012, p. 29.
93 Peter Andreas, *Blue Helmets and Black Markets: The Business of Survival in the Siege of Sarajevo*, p. 102.
94 Ibid. Andreas underpins this argument by illustrating the case of Fred Cuny's water treatment system, which would channel water from the Miljacka River through the underground water system. Although he had the system rigorously tested by the World Health Organization (WHO), among others, the Bosnian government were reluctant to allow the system to become operational, claiming that the water was not safe for consumption. They later allowed the system to be used for 'non-drinking purposes' but then – in April 1995 – allowed the system to become fully operational – used for drinking water – and it remained so until the end of the siege.

95 Author's interview (KM) with Kevin Sullivan (UPI), April 2015.
96 Author's interview (KM) with Jeremy Bowen (BBC), March 2014.
97 Author's interview (KM) with Allan Little (BBC), March 2015.
98 Author's interview (KM) with Joel Brand (*The Times/Newsweek*), May 2015.
99 Author's interview (KM) with Hajrudin Rovčanin (Holiday Inn), May 2018.
100 Author's interview (KM) with Džemal Bećirević (UPI/*Washington Post*), April 2015.
101 Author's interview (KM) with Kevin Sullivan (UPI), April 2015.
102 Author's interview (KM) with Christiane Amanpour (CNN), September 2019.
103 Hamza Bakšić, *Sarajevo kojeg više nema*, Sarajevo: Oslobođenje, 1997, p. 17.
104 John Simpson, *Strange Places, Questionable People*, p. 441.
105 Author's interview (KM) with Amra Abadžić-Lowe (Reuters), May 2014.
106 Author's interview (KM) with Amra Abadžić-Lowe (Reuters), May 2014.
107 Author's interview (KM) with Paul Harris (*The Scotsman/Scotland on Sunday*), August 2015.
108 John Simpson, *Strange Places, Questionable People*, p. 441.
109 Author's interview (KM) with Joel Brand (*The Times/Newsweek*), May 2015.
110 Author's interview (KM) with Stéphane Manier (France 2), April 2015.
111 According to John Burns, the journalists' own stock of fuel was kept under lock and key in the basement garage. What became evident, however – after several incidents in which cars did not function effectively after filling with fuel – was that the fuel was being watered down. A group of journalists went to the hotel management to complain and request that they be given control over access to the fuel store. When this was refused, many simply stored it in their rooms. 'I had', said Burns, '2000 litres of fuel – both gasoline and diesel – stored in one of my rooms. AP and CNN did the same thing. We all feared that the staff would have them removed, given the possible impact if the hotel was to be hit, but they did not.' Author's interview (KM) with John F. Burns (*New York Times*), September 2013.
112 Author's interview (KM) with Vaughan Smith (Frontline News), June 2015.
113 Ivana Maček, *Sarajevo under Siege: Anthropology in Wartime*, p. 65.
114 Interview with Kurt Schork (Reuters) in 'Hotel na prvoj liniji', SAGA Films, Sarajevo, 1993.
115 Author's interview (KM) with Sabina Ćosić (Reuters), June 2014.
116 On occasion, fuel acquired by the Holiday Inn would be 'donated' to the Bosnian Army. A Bosnian Army (ARBiH) document from 15 June 1993, signed by Mušan Topalović 'Caco' states that the Holiday Inn donated 50 litres of oil to the Bosnian Army's 'Tenth Mountain Brigade'. Ref: Armija Republike Bosne i Hercegovine (10 Brdska 'Caco'), Inv. br. 1189/93, Sarajevo, 15 June 1993 godine.
117 A range of primary materials relating to the VOPP can be found in David Owen (ed.) *Bosnia-Herzegovina: The Vance/Owen Peace Plan*, Liverpool: Liverpool University Press, 2013.
118 Author's interview (KM) with Kevin Weaver (*The Guardian/The Independent*), October 2019.
119 Author's interview (KM) with Samir Korić (Reuters), October 2018.
120 Author's interview (KM) with Christiane Amanpour, September 2019.
121 Author's interview (KM) with Kevin Sullivan (UPI), April 2015.
122 The desire to appear 'normal' and to continue with daily life as much as possible was not limited to the staff at the Holiday Inn but was common across Sarajevo. According to Ivana Maček, 'Making an effort to appear normal was important to Sarajevans,

enabling them to feel less defeated by their circumstances than they may otherwise have done.' See Ivana Maček, *Sarajevo under Siege: Anthropology in Wartime*, p. 63.
123 Interview with Allan Little (BBC Radio) in BBC Television 'The Late Show Special: Tales from Sarajevo', First broadcast 21 January 1993.
124 Author's interview (KM) with Sabina Ćosić (Reuters), June 2014.
125 Author's interview (KM) with John Sweeney (*The Observer*), July 2014.
126 Kate Adie, *The Kindness of Strangers: The Autobiography*, Headline Books, London, 2002, p. 314.
127 John Simpson, *A Mad World, My Masters*, London: Macmillan Press, 2000, p. 23.
128 Interview with John Simpson (BBC) in 'Veillées d'armes: Histoire du Journalisme en temps du guerre' ('The Troubles We've Seen: A History of Journalism in Wartime'), First Journey, Director: Marcel Ophuls, Little Bear Productions, 1993.
129 *The Spectator*, London, 23 January 1993, p. 12. Citing a 1992 article from *MacLeans*, Andreas notes that some of the best of the 'highest quality humanitarian aid items were showing up on the tables at the Holiday Inn'. See Peter Andreas, *Blue Helmets and Black Markets: The Business of Survival in the Siege of Sarajevo*, p. 183 fn. 178.
130 See Peter Andreas, 'The Clandestine Political Economy of War and Peace in Bosnia', *International Studies Quarterly*, 2000, Vol. 48, No.1, pp. 29–51.
131 Andreas, *Blue Helmets and Black Markets: The Business of Survival in the Siege of Sarajevo*, p. 73.
132 Author's interview (KM) with Janine di Giovanni (*Harpers Magazine*), 11 July 2013.
133 Matthew McAllister, *Eating Mud Crabs in Kandahar: Stories of Food during Wartime by the World's Leading Correspondents*, Berkeley: University of California Press, 2011, p. 3.
134 Ivana Maček, *Sarajevo under Siege: Anthropology in Wartime*, Philadelphia: University of Pennsylvania Press, 2009, p. 64.
135 Larry Hollingworth, *Merry Christmas, Mr Larry*, p. 15. By 1993, there were other places in which food and drink could be found in Sarajevo. There was a bar/restaurant called *Jež* (hedgehog) in a basement near the Orthodox Cathedral. Hot food and alcoholic drinks were served, but only foreigners – with hard currency – and war profiteers could afford to dine or drink there.
136 *NIN*, Belgrade, 27 November 1992, p. 23. According to Peter Andreas, 'The murkier reality on the ground in Sarajevo included a less visible internal siege (made possible by the external siege conditions) – ranging from theft and looting by criminals-turned-combatants within the city, to profiteering by unit commanders on the frontline, to the political power grab by the SDA leadership in sacking competent officials and replacing them with party loyalists.' See Peter Andreas 'The Longest Siege: Humanitarians and Profiteers in the Battle for Sarajevo', in Benedek Wolfgang (et al.), *Transnational Terrorism, Organized Crime and Peace Building: Human Security in the Western Balkans*, London: Palgrave Macmillan, 2010, p. 180.
137 *NIN*, Belgrade, 27 November 1992, p. 23.
138 Zlatko Dizdarević, *Sarajevo: A War Journal*, New York: Fromm International, 1994, p. 104. Dizdarević was also shocked to see a notice board giving details of the Sarajevo itinerary of a UNHCR delegation that were due to arrive that evening, which included a meeting with Radovan Karadžić in Serb-held Lukavica. 'I must admit' he wrote, 'that I felt faint when I saw, in black and white, on a notice board in the centre of Sarajevo, that certain gentlemen have arranged a meeting with a criminal who has thrown the operation of this very hotel into disarray, who has killed people who have stayed in it, and who is personally responsible for demolishing the side of the hotel that faces the hills'. Ibid,. p. 105.

139 Most Sarajevans, with little or no access to gas or electricity, cooked on a *Sarajevska konzerva* (Sarajevo tin can), which was constructed from a five-litre tin can of humanitarian aid. This implement would be used to boil water, heat coffee or small foodstuffs. See Ivana Maček, *Sarajevo under Siege: Anthropology in Wartime*, p. 73.
140 *Ajvar* is a relish made from garlic and red bell peppers – and sometimes chilli peppers – and can be used as a spread or as a dip/side-dish. Often quite hot, it is a very popular condiment in the Balkan region.
141 Author's (KM) interview with Kevin Sullivan (UPI), April 2015.
142 Janine di Giovanni, 'Siege Food: Bosnia', p. 34.
143 Ibid.
144 Andreas, *Blue Helmets and Black Markets: The Business of Survival in the Siege of Sarajevo*, p. 74.
145 For a history of the Frontline Televison News Agency, see David Loyn, *Frontline: The True Story of the British Mavericks Who Changed the Face of War Reporting*, London: Penguin/ Michael Joseph, 2005.
146 Author's interview (KM) with Vaughan Smith (Frontline News), June 2015.
147 SAGA Films Sarajevo, 'Hotel na prvoj liniji', Director: Antonije 'Nino' Žalica, Sarajevo, 1993. For a succinct but powerful description of the quantities of humanitarian aid provided per citizen of Sarajevo see Sulejman Grozdanić, *Bosna nije san*, Sarajevo; Svjetlost, 1995, pp. 146–151.
148 Peter Maass, *Love Thy Neighbour*, p. 118.
149 Kate Adie, *The Kindness of Strangers*, p. 303.
150 Peter Maass, *Love Thy Neighbour*, p. 119.
151 Zoran Stevanović, 'Sarajevo Agency Pool, Mediacentar, Sarajevo', 25 April 2012, https://www.media.ba/en/journalism-investigative-journalism/sarajevo-agency-pool-0 [last accessed 26 June 2018].
152 Janine di Giovanni, 'Siege Food: Bosnia', p. 35. According to di Giovanni one – unnamed – American correspondent came down for breakfast one morning at the Holiday Inn with two eggs – a very rare and valuable commodity in Sarajevo – in his pocket. 'He removed them and asked the waiter to cook them. He did this in front of the rest of us, who probably had not tasted an egg for some time … Shamelessly, he ate the fried eggs, dipping hard bread into the yolk.' See ibid., p. 35.
153 Interview with Jean-Jacques Le Garrec (France 2) in 'Veillées d'armes: Histoire du Journalisme en temps du guerre' ('The Troubles We've Seen: A History of Journalism in Wartime'), First Journey, Director: Marcel Ophuls, Little Bear Productions, 1993.
154 *The Spectator*, London, 23 January 1993, p. 13. In the same article di Giovanni noted that the hotel management 'followed the same rule of thumb as the French journalists, though using *Systeme D* to the highest level'.
155 Author's interview (KM) with Stéphane Manier (France 2), April 2015.
156 Ibid.
157 *NIN*, Belgrade, 27 November 1992, p. 23.
158 Peter Andreas, 'The Clandestine Political Economy of War and Peace in Bosnia', p. 39.
159 Author's interview (KM) with Remy Ourdan (*Le Monde*), 5 November 2013.
160 *The Guardian*, London, August 1993, p. 1.
161 Jeremy Bowen, *War Stories*, pp. 144–145.
162 Author's interview (KM) with Jeremy Bowen (BBC), London, March 2014.
163 Author's interview (KM) with Džemal Bećirević (UPI/*Washington Post*), April 2015.

164 According to Peter Andreas, cigarettes were so valued in Sarajevo during the siege that the city's tobacco factory 'essentially played the role of a government mint. Well stocked before the siege with tobacco meant to supply the entire region, the factory was officially designated a priority building and managed to operate throughout the war, maintaining about 20 per cent of its pre-war production capacity.' See Peter Andreas, *Blue Helmets and Black Markets: The Business of Survival in the Siege of Sarajevo*, p. 85.

Chapter 5

1 Author's interview (KM) with Christiane Amanpour (CNN), September 2019.
2 Author's interview (PL) with Martin Dawes (BBC), November 2019.
3 Author's interview (PL) with Enric Marti (AP) November 2019.
4 Author's interview (KM) with Gigi Riva (*Il Giorno*), May 2020.
5 Author's interview (PL) with Martin Dawes (BBC), November 2019
6 *The Times* (London), 24 July 1994, p. 12.
7 See Tim Ripley, *Operation Deliberate Force: The UN and NATO Campaign in Bosnia, 1995*, Lancaster: Centre for Defence and International Security Studies, 1999.
8 Author's interview (PL) with Martin Dawes (BBC), November 2019.
9 Ibid.
10 Sean Maguire, 'In Sarajevo', *London Review of Books*, Vol. 15, No. 2, 28 January 1993, https://www.lrb.co.uk/the-paper/v15/n02/sean-maguire/diary [last accessed 4 December 2018].
11 Author's interview (PL) with Amra Abadžić Lowe (Reuters), January 2020.
12 Ibid.
13 Sean Maguire, 'In Sarajevo', *London Review of Books*, Vol. 15 No. 2, 28 January 1993, https://www.lrb.co.uk/the-paper/v15/n02/sean-maguire/diary [last accessed 4 December 2018].
14 Author's interview (PL) with Amra Abadžić-Lowe (Reuters), January 2020.
15 Ibid.
16 Author's interview (PL) with Chris Helgren (Reuters), November 2019.
17 Author's interview (PL) with Amra Abadžić Lowe (Reuters), January 2020.
18 Author's interview (PL) with Chris Helgren (Reuters), November 2019.
19 Ibid.
20 Leslie Fratkin, *Sarajevo Self-portrait: The View from the Inside*, p. 63.
21 For an account of the development of wire service technology, see Mia Tramz (2015) 'Time Magazine's Celebrating 80 Years of Associated Press' Wirephoto, *Time*, 1 January 2015, https://time.com/3650882/associated-press-photowire-80th-anniversary/[last accessed 21 December 2019].
22 Author's interview (PL) with Ron Haviv (AFP/*Time Magazine*), November 2019.
23 Martin Dawes recalled that the BBC Radio reporters initially used Marantz tape recorders but switched to a more compact Sony model towards the end of the war.
24 Author's interview (PL) with Martin Dawes (BBC), November 2019.
25 Author's interview (PL) with Charlotte Eagar (*The Observer*), November 2019.
26 Ibid.
27 Author's interview (KM) with John F. Burns (*New York Times*), July 2015.
28 Author's interview (KM) with Jonathan Landay (UPI/*Washington Post*), August 2018.

29 Human-interest stories were often more popular with readers of newspapers, but that wasn't the only reason that foreign journalists would often invest so much time and effort in them. According to Gigi Riva, 'We were party to a lot of information – even too much. It became difficult to distinguish between what was true and what was false. Things happened in remote places and we had to rely on sources that were difficult to control and rely on our experience. All the warring parties used propaganda. In addition, within the siege there were difficulties of movement due to the bombing, the curfew. And there were no cell phones yet. However, I often decided that it was better to write only about things I could see. In fact, I wrote many reports on how people lived in the besieged city, so as not to run the risk of giving false information.' Author's interview with Gigi Riva (*Il Giorno*), May 2020.
30 Author's interview (PL) with Charlotte Eagar (*The Observer*), November 2019.
31 Ibid.
32 Ibid.
33 Ibid.
34 Ibid.
35 Ibid.
36 The Books Interview: Barbara Demick, *The New Statesman*, 4 April 2012, https://www.newstatesman.com/culture/2012/04/books-interview-barbara-demick [last accessed 9 November 2019]. See also Barbara Demick, *Besieged: Life under Fire on a Sarajevo Street*, London: Granta, 2012.
37 The book was later published under the title *Besieged: Besieged: Life under Fire on a Sarajevo Street*.
38 *Los Angeles Times*, Los Angeles, 6 May 2012, p. 17.
39 Author's interview (PL) with Roger Hutchings (*The Observer*/Network Photographers), February 2018.
40 Ibid.
41 Ibid.
42 Ibid.
43 Predrag Matvejević, 'War and Memory', in Tom Stoddart and Predrag Matvejević (eds), *Sarajevo*, Washington DC: Smithsonian Institution Press, 1998.
44 Author's interview (KM) with Remy Ourdan (RTL/*Le Monde*), March 2020.
45 *New York Times*, New York, 18 September 1997, p. 16.
46 Quoted in Danica Kirka, Haris Pašović, 'Ensuring Culture Survives amid the Horrors of Sarajevo', *Los Angeles Times*, 17 April 1994, https://www.latimes.com/archives/la-xpm-1994-04-17-op-46915-story.html [last accessed 28 September 2019].
47 Ibid.
48 *The Independent*, London, 2 April 1994, p. 12.
49 Ibid.
50 Edin Numankadić, 'It's important to be yourself', *VisitBiH.ba*, 5 January 2018, https://visitbih.ba/en/edin-edo-numankadic-its-important-to-be-yourself/ [last accessed 25 June 2019].
51 Phillip Hammond, *Media, War and Postmodernity*, New York: Routledge, 2007, p. 50.
52 Peter Andreas, *Blue Helmets and Black Markets: The Business of Survival in the Siege of Sarajevo*, 2008, pp. 71–72. With celebrity engagement risking trivialization of the conflict, there existed a distinct unease at the celebrity endorsement of a 'Bosnian cause', of which many of the celebrity advocates knew very little, and they were derided as gimmicks by some. In an article in *The Guardian* in September 1993 entitled *Sarajevo? Been there. Done it*, Peter Beaumont caustically commented that

'Whatever the good intentions of all these stunts or exercises in consciousness-raising—call them what you will—a fundamental sense of uneasiness remains about the motivation.' See *The Guardian*, London, 20 September 1993 (Supplement), p. 4.

53 Author's interview (KM) with John F. Burns (*New York Times*), July 2015.
54 Author's interview (KM) with Džemal Bećirević (UPI/*Washington Post*), April 2015.
55 Author's interview (KM) with Allan Little (BBC), March 2015.
56 Quoted in Benjamin Moser, 'Sontag in Sarajevo', *New York Review of Books*, 9 September 2019, https://www.nybooks.com/daily/2019/09/09/sontag-in-sarajevo/[last accessed 10 November 2019].
57 Ibid.
58 Ibid.
59 Author's interview (KM) with Tony Smith (Associated Press), October 2019. Likewise, the *Oslobođenje* journalist, Zlatko Dizdarević was sceptical about those well-known celebrities that came to Sarajevo. 'At the time, we were very excited about their arrival', he said, 'Because it appeared to us that they brought with them some kind of peace. Later, we realized that these types of guests were much more abundant than hopes of peace and an end to the war. Sarajevo turned out to be a destination point for a great safari. They were coming because of themselves, not because of us. We were not aware of this at the time.' Interview with Zlatko Dizdarević (*Oslobođenje*) in Suada Kapić (ed.), *The Siege of Sarajevo 1992–1996*, p. 262.
60 See Susan Sontag, 'Waiting for Godot in Sarajevo' *Performing Arts Journal*, Vol. 6, No. 2, 1994, pp. 87–106.
61 Quoted in Benjamin Moser, 'Sontag in Sarajevo', *New York Review of Books*, 9 September 2019, https://www.nybooks.com/daily/2019/09/09/sontag-in-sarajevo/[last accessed 10 November 2019].
62 Radio Free Europe, Prague, 5 April 2017, https://www.rferl.org/a/susan-sontag-siege-sarajevo- waiting-for-godot/28412155.html [last accessed 29 June 2019].
63 *New York Times*, New York, 18 September 1997, p. 18.
64 *The Guardian*, London, 25 July 1993, p. 13.
65 Susan Sontag, 'Godot Comes to Sarajevo', *The New York Review of Books*, 21 October 1993. See also Janine di Giovanni, 'Siege Food: Bosnia', in Matthew McAllister, *Eating Mud Crabs in Kandahar: Stories of Food during Wartime by the World's Leading Correspondents*, Berkeley: University of California Press, 2011, p. 34.
66 Quoted in Moser, Benjamin Sontag in Sarajevo, *New York Review of Books*, 9 September 2019, https://www.nybooks.com/daily/2019/09/09/sontag-in-sarajevo/ [last accessed 10 November 2019].
67 See *The Guardian*, London, 20 September 1993 (Supplement), p. 4.
68 Author's interview (KM) with Marcel Ophuls, June 2019.
69 Ibid.
70 Author's interview (KM) with John Simpson (BBC), June 2019.
71 Author's interview (KM) with Marcel Ophuls, June 2019.
72 See 'Veillées d'armes: Histoire du Journalisme en temps du guerre' ('The Troubles We've Seen: A History of Journalism in Wartime'), First Journey, Director: Marcel Ophuls, Little Bear Productions, 1993. See also John Simpson, *Strange Places, Questionable People*, London: Macmillan, 1999, pp. 451–157.
73 Author's interview (KM) with Stéphane Manier (France 2), April 2015.
74 See 'Veillées d'armes: Histoire du Journalisme en temps du guerre' ('The Troubles We've Seen: A History of Journalism in Wartime'), Second Journey, Director: Marcel Ophuls, Little Bear Productions, 1994.

75 See *Christian Science Monitor*, Massachusetts, 27 June 1994, p. 16.
76 Author's interview (KM) with Marcel Ophuls, June 2019.
77 See 'A Sarajevo Diary: From Bad to Worse', Director: Dom Rotheroe, W.O.W Productions, 1993.
78 *The Independent*, London, 4 September 1993, p. 13.
79 Larisa Kurtović, 'The Paradoxes of Wartime "Freedom": Alternative Culture during the Siege of Sarajevo', in Bojan Bilić and Vesna Janović (eds), *Resisting the Evil: (Post-) Yugoslav Anti-war Contention)*, Baden-Baden: Nomos, 2012. p. 221.
80 *Los Angeles Times*, Los Angeles, 17 April 1994, p. 23.

Chapter 6

1 *Prospect*, London, 20 February 2004, p. 14.
2 See Greg McLaughlin, *The War Correspondent*, p. 33.
3 There were significant 'Save Sarajevo' campaigns in British newspapers such as *The Daily Mail* and *The Independent* in 1993. See, for example, *The Daily Mail*, London, 21 August 1993 and *The Independent*, London, 14 August 1993, p. 8.
4 Robert Donia, *Sarajevo: A Biography*, p. 299.
5 *Monitor*, Podgorica, 24 July 1992, p. 15.
6 Sherry Ricchiardi, 'Exposing Genocide … For What?', *American Journalism Review*, Vol. 15, No. 5, June 1993, p. 36.
7 For more see Edina Bećirević, *Genocide on the Drina River*.
8 Allan Little, 'Return to Sarajevo'. *Bosnia Report*, Jan–Feb 1998, http://www.bosnia.org.uk/bosrep/report_format.cfm?articleID=2810&reportid=120 [last accessed 24 July 2018].
9 Ibid.
10 CNN, 'Global Forum with President Clinton', broadcast on 4 March 1994.
11 See, for example, Peter Brock, *Media Cleansing, Dirty Reporting: Journalism and Tragedy in Yugoslavia*, Los Angeles: GM Books, 2006.
12 Martin Bell, *In Harm's Way*, pp. 148–149.
13 See Brendan Simms, *Unfinest Hour: Britain and the Destruction of Bosnia*, London: Penguin Books, 2001, p. 46. See also Stewart Purvis and Jeff Hulbert, *When Reporters Cross the Line: The Heroes, The Villains, the Hackers and the Spies*, p. 219–220.
14 Giving evidence during the trial of Ratko Mladić at the ICTY in 2013, Martin Bell did acknowledge that the foreign media in Sarajevo were 'unconsciously biased'. 'It's not that they consciously took sides but they didn't go anywhere outside the territory under the control of the government in Sarajevo and they couldn't see the war from any other perspective.' See Sense Agency, 'The Media Were "Unconsciously" Biased', 1 February 2013, https://www.sense-agency.com/icty/media-were-unconsciously-biased.29.html?cat_id=1&news_id=14614 [last accessed 24 September 2019].
15 Emma Daly, 'Dateline in the 1990s: In Sarajevo, Scant Rations but Abundant Black Humour', Overseas Press Club of America, 24 April 2014, https://www.opcofamerica.org/news/dateline-1990s-sarajevo-scant-rations-abundant-black-humor [last accessed 2 June 2015].
16 Peter Brock, *Media Cleansing, Dirty Reporting: Journalism and Tragedy in Yugoslavia*, p. 133.
17 John Simpson, *Strange Places, Questionable People*, p. 445.

18 Simpson added that, 'Those of us who didn't join the claque were much criticized. I overheard one of the translators hired by the BBC telling someone else that I was pro-Serb; not a good thing to be in Sarajevo at that time. In fact, I was very far from being pro-Serb. It was perfectly clear to me that it was the Bosnian Serbs, with the support of their puppet-master, Slobodan Milošević, the President of the rump Yugoslav Federation, who were guilty of the war crimes we saw enacted in front of us.' See ibid., p. 446.
19 Ibid., p. 445.
20 Interview with Phil Davison (*The Independent*) in 'Tales from Sarajevo: A Late Show Special' Director: Roland Keating, BBC TV, London, 1993.
21 Ljiljana Smajlović, 'Okrutno šminkanje krvavog rata', *Vrene*, Belgrade, 8 February 1993, in Helsinški odbor za ljudska prava u Srbiji, *Jezgro velikosrpskog projekta*, pp. 634–635.
22 Ljiljana Smajlović, 'The Cruel Touching Up of the Bloody War', *Vreme News Digest Agency*, Belgrade, 8 February 1993.
23 Ibid.
24 Ljiljana Smajlović, 'Dva "Pulicera" za jedan sat', *Vreme*, Belgrade, 5 April 1993 in ibid., pp. 641–642.
25 Author's interview (PL) with Gary Knight (Saba/*Newsweek*), November 2012.
26 *UK Press Gazette*, London, 13 November 2006, p. 11.
27 Martin Bell, 'Farewell to War', in Tony Grant (ed.), *From Our Own Correspondent: A Celebration of Fifty Years of the BBC Radio Programme*, London: Profile Books, 2005, p. 19.
28 John F. Burns, 'Neutrality isn't the Same as Being Fair', *The British Journalism Review*, London, Vol. 21, No. 3, 2010, p. 30.
29 Author's interview (KM) with Zoran Kusovac (Sky News), March 2020.
30 One of the first journalistic uses of the phrase was in a report by John Burns for *The New York Times* in July 1992, where he described the movement for a 'Greater Serbia', noting that 'the precondition for its creation lies in the purging – "ethnic cleansing" in the perpetrators' lexicon – of wide areas of Bosnia of all but like-minded Serbs'. See *The New York Times*, New York, 26 July 1992, p. 8.
31 Author's interview (KM) with Christiane Amanpour (CNN), September 2019.
32 Jeremy Bowen, *War Stories*, p. 157.
33 Robert Donia, *Sarajevo: A Biography*, p. 310.
34 As Donia further notes, 'After the war, the secrecy surrounding the ARBiH operations vanished in a rush for public acclaim' and that 'In a spate of interviews, memoirs, leading commanders boasted of their roles in military operations, and several commanders competed in claiming primary credit for having saved the city.' See Robert Donia, *Sarajevo: A Biography*, p. 310. For insider accounts see, for example, Nedžad Ajnadžić, *Odbrana Sarajeva*, Sarajevo: Sedam, 2002; Vahid Karavelić and Zijad Rujanac, *Sarajevo: opsada i odbrana, 1992–1995*, Sarajevo: Udruženje za zaštitu tekovina borber za Bosnu i Herzegovinu, 2009; Muhamed Gafić, *Sarajevski rulet*, Sarajevo: CPU, 2005; and Kerim Lučarević, *The Battle for Sarajevo: Sentenced to Victory*, Sarajevo: TZU, 2000.
35 Author's interview (KM) with Remy Ourdan (RTL/*Le Monde*), March 2020.
36 United Nations Security Council Resolution 819 of 16 April 1993, declared that the Srebrenica enclave was a 'safe area'. On 6 May 1993, United Nations Security Council Resolution 824 further extended the status to Sarajevo, Žepa, Goražde, Tuzla and Bihać. These cities and territories were placed under the protection of the UN peacekeeping units UNPROFOR.

37 *Le Monde*, Paris, 28 September 1994, p. 1.
38 Author's interview (KM) with Remy Ourdan (RTL/*Le Monde*), March 2020.
39 Jeremy Bowen *War Stories*, p. 164.
40 Ibid., p. 165
41 Author's interview (PL) with Enric Marti (Associated Press), November 2019.
42 Peter Andrews, 'Welcome to Sarajevo, again', *Reuters Photographers' Blog*, 31 May 2011, http://blogs.reuters.com/photographers-blog/2011/05/31/welcome-to-sarajevo-again/ [last accessed 29 December 2019].
43 Leslie Fratkin, *Sarajevo Self-portrait: The View from the Inside*, p. 65.
44 Author's interview (PL) with Enric Marti (Associated Press), November 2019.
45 Author's interview (PL) with Chris Helgren (Reuters), November 2019.
46 Ibid.
47 Author's interview (PL) with Martin Dawes (BBC), November 2019.
48 Ibid.
49 *The Independent*, London, 11 June 1995, p. 8.
50 Peter Maass, *Love Thy Neighbour*, p. 146.
51 For the UNPROFOR efforts in the area around the Holiday Inn and the Zemaljski Muzej see *Oslobođenje*, Sarajevo, 11 October 1995, p. 11.
52 Author's interview (PL) with Enric Marti (Associated Press), November 2019.
53 Ibid.
54 Author's interview (PL) with Chris Morris (*Time*/VII Photo), November 2019.
55 For a detailed account of the events of 22 January 1994 see Džana Brkanić, 'Memories of Snow and Blood in Sarajevo', 9 February 2015, https://balkaninsight.com/2015/02/09/sarajevo-memories-of-snow-and-blood/ [last accessed 21 September 2019].
56 Author's interview (PL) with Chris Morris (*Time*/VII Photo), November 2019.
57 Jon Steele, *War Junkie: One Man's Addiction to the Worst Places on Earth*, London: Corgi Books, 2003, p. 524.
58 Author's interview (PL) with Chris Morris (*Time*/VII Photo), November 2019.
59 Author's interview (KM) with John F. Burns (*New York Times*), July 2015.
60 Author's interview (PL) with Chris Helgren (Reuters), November 2019.
61 Author's interview (KM) with Jeremy Bowen (BBC), May 2019.
62 Author's interview (KM) with Zoran Kusovac (Sky News), March 2020.
63 Ibid.
64 Ibid.
65 Author's interview (KM) with Remy Ourdan (RTL/*Le Monde*), March 2020.
66 See, for example, *The Guardian*, London, 13 August 1993, p. A2.
67 Edo Jaganjac later published a book about his experiences in Sarajevo and the efforts to evacuate Imra Hadžimuratović from besieged Sarajevo. See Edo Jaganjac, *Sarajevska princeza*, Sarajevo: Carobna knjiga, 2015.
68 *The Independent*, London, 12 August 1993, p. 8.
69 Ibid., p. 165.
70 Ibid.
71 Jeremy Bowen, *War Stories*, p. 166.
72 Jeremy Bowen, who played a significant role in bringing the story of Irma Hadžimuratović to the attention of the public, noted that the subsequent 'festival of medical evacuation' merely 'created a rosy glow, gave an impression of progress, and meant the press would not be writing so much about the West's failure, once again, to end the killing'. See Jeremy Bowen, *War Stories*, p. 169.

73 *The Independent*, London, 17 August 1993, p. 12, and *The Guardian*, London, 15 August 1993, p. 1.
74 *The Independent*, London, 16 August 1993, p. 13.
75 Philip Taylor, 'Television: Force Multiplier or Town Crier in the Global Village?' *Corporate Communications: An International Journal*, June 1999, https://www.emerald.com/insight/content/doi/10.1108/13563289910268089/full/html [last accessed 26 June 2018].
76 Jeremy Bowen, *War Stories*, p. 169.
77 Ibid.
78 Ibid.
79 Ibid.
80 *The Independent* (Sunday Review), London, 3 October 1993, p. 93.
81 Rod Dreher, 'A Child of Sarajevo', *Sun Sentinel*, Miami, 15 March 1998, https://www.sun-sentinel.com/news/fl-xpm-1998-03-15-9803120201-story.html [last accessed 29 June 2019].
82 *The Independent* (Sunday Review), London, 3 October 1993, p. 93.
83 Michael Nicholson, *Natasha's Story*, p. 36.
84 *The Independent* (Sunday Review), London, 3 October 1993, p. 93.
85 For more detail see Michael Nicholson, *Natasha's Story*, pp. 68–79.
86 *The Independent*, London, 2 November 1997, p. 18.
87 Rod Dreher, 'A Child of Sarajevo', *Sun Sentinel*, Miami, 15 March 1998, https://www.sun-sentinel.com/news/fl-xpm-1998-03-15-9803120201-story.html [last accessed 29 June 2019].
88 Greg McLaughlin, *The War Correspondent*, p. 44.
89 Ibid.
90 See Balkan Insight, 'Wartime Rape in Bosnia: A Daughter's Search for Truth', BIRN, Belgrade/Sarajevo, https://balkaninsight.com/2018/07/19/wartime-rape-in-bosnia-a-daughter-s-search-for-truth-07-17-2018/[last accessed 23 June 2019].
91 Author's interview (PL) with Martin Dawes (BBC), November 2019.

Conclusion

1 The British company AKE, for example, developed short training hostile environment courses for journalists that were led by former Special Air Service (SAS) personnel. See Greg McLaughlin, *The War Correspondent*, p. 17.
2 Author's interview (KM) with Martin Bell (BBC), October 2018.
3 Author's interview (KM) with Gigi Riva (*Il Giorno*), May 2020.
4 Mediacentar Sarajevo, 'Allan Little o ratnom izvještavanju iz BiH', 10 September 2012, https://www.youtube.com/watch?v=PAGselv8ebU [last accessed 26 March 2020].
5 Author's interview (KM) with Remy Ourdan (RTL/*Le Monde*), March 2020.
6 Greg McLaughlin, *The War Correspondent*, p. 79.
7 Author's interview (PL) with Sean Maguire (Reuters), January 2020.
8 Ibid.
9 Martin Bell, *In Harm's Way*, p. 72.
10 Author's interview (PL) with Sean Maguire (Reuters), January 2020.
11 See Greg McLaughlin, *The War Correspondent*, pp. 17–18. McLaughlin points out, however, that 'the prohibitive costs of safety training and equipment as

Notes

 well as insurance cover are unaffordable for all but the larger international news organisations and agencies'. See ibid., p. 17.
12 Author's interview (PL) with Sean Maguire (Reuters), January 2020.
13 Author's interview (PL) with Chris Helgren (Reuters), November 2019.
14 Ibid.
15 Stuart Hughes, 'The class of '92 returns to Sarajevo', *BBC College of Journalism Blog*, 5 April 2012, https://www.bbc.co.uk/blogs/collegeofjournalism/entries/21c52c77-74a6-3915-9d98-0e6038d0edc7 [last accessed 2 February 2020].
16 Author's interview (PL) with Chris Helgren (Reuters), November 2019.
17 Janine Di Giovanni, 'From Sarajevo to Aleppo: Lessons on Surviving a Siege', *The Atlantic*, 12 October 2016, https://www.theatlantic.com/international/archive/2016/10/sarajevo-aleppo-daraya-syria/503843/ [last accessed 21 January 2020].
18 Authors interview (PL) with Charlotte Eagar (*The Observer*), November 2019.
19 Jeremy Bowen, *War Stories*, pp. 146–147.
20 Ibid., p. 146.
21 Charlotte Eagar, 'My Five-year Battle to Exorcise the Ghosts of Sarajevo', *Evening Standard*, 29 July 2008, https://www.standard.co.uk/news/my-five-year-battle-to-exorcise-the-ghosts-of-sarajevo-6933279.html [last accessed 29 January 2020].
22 Martin Bell, *In Harm's Way*, p. 82.
23 Charlotte Eagar, 'My Five-year Battle to Exorcise the Ghosts of Sarajevo', *Evening Standard*, 29 July 2008, https://www.standard.co.uk/news/my-five-year-battle-to-exorcise-the-ghosts-of-sarajevo-6933279.html [last accessed 29 January 2020].
24 Janine Di Giovanni, 'From Sarajevo to Aleppo: Lessons on Surviving a Siege', *The Atlantic*, 12 October 2016, https://www.theatlantic.com/international/archive/2016/10/sarajevo-aleppo-daraya-syria/503843/ [last accessed 21 January 2020].
25 Author's interview (PL) with Emma Daly (*The Independent*), September 2014.
26 Jeremy Bowen, *War Stories*, p. 149.
27 Author's interview (KM) with Christiane Amanpour (CNN), September 2019.
28 Author's interview (KM) with Martin Bell (BBC), October 2018.
29 Author's interview (KM) with Christiane Amanpour (CNN), September 2019.
30 Author's interview (KM) with Andrew Reid (Gamma), March 2020.
31 Ibid.
32 Author's interview (PL) with Sean Maguire (Reuters), January 2020.
33 Author's interview (PL) with Gary Knight (Saba/Charlotte Eagar), August 2018.
34 Ibid.
35 The Tribunal was established by the United Nations in May 1993 in response to mass atrocities then taking place in Croatia and Bosnia and Herzegovina. The ICTY was the first war crimes court created by the UN and the first international war crimes tribunal since the Nuremberg and Tokyo tribunals. It was established by the Security Council in accordance with Chapter VII of the UN Charter.
36 See Radio Free Europe/Radio Liberty, 'Sarajevo Notebook: For Journalists, the Story of Their Lives', RFE, Prague, 6 April 2012, https://www.rferl.org/a/sarajevo_siege_anniversary_reporters_notebook/24540320.html [last accessed 14 March 2020].

Bibliography

Adie, Kate, *The Kindness of Strangers: The Autobiography*, London: Headline Books, 2002.
Ahrens, Geert Hinrich, *Diplomacy on the Edge: Containment of Ethnic Conflict and the Minorities Working Group of the Conferences on Yugoslavia*, Washington DC: Wilson Centre Press, 2008.
Ajnadžić, Nedžad, *Odbrana Sarajeva*, Sarajevo: Sedam, 2002.
Akhavan, Payam (ed.), *Yugoslavia: The Former and the Future – Reflections by Scholars from the Region*, Geneva: The Brookings Institute, Washington, and the United Nations Research Institute for Social Development, 1995.
Alibabić-Munja, Munir, *Tajni rat za Bosnu: izemdu službe državne bezbjednosti RbiH i KOS-a JNA*, Sarajevo: Print line, 2014.
Alić, Dijana and Gusheh, Maryam, 'Reconciling Nationalist Narratives in Socialist Bosnia & Herzegovina: The Baščaršija Project, 1948–1953', *Journal of the Society of Architectural Historians*, Vol. 58, No. 1, March 1999, pp. 6–25.
Allcock, John B., *Explaining Yugoslavia*, London: Hurst & Co., 2000.
Anderson, Scott, *The Man Who Tried to Save the World: The Dangerous Life and Mysterious Disappearance of Fred Cuny*, New York: Doubleday, 1999.
Andjelić, Neven, *Bosnia-Herzegovina: The End of a Legacy*, London: Frank Cass, 2003.
Andreas, Peter, 'The Clandestine Political Economy of War and Peace in Bosnia', *International Studies Quarterly*, Vol. 48, No. 1, 2004, pp. 29–51.
Andreas, Peter, *Blue Helmets and Black Markets: The Business of Survival in the Siege of Sarajevo*, Ithaca and London: Cornell University Press, 2008.
Andreas, Peter, 'The Longest Siege: Humanitarians and Profiteers in the Battle for Sarajevo', in Wolfgang Benedik et al. (eds), *Transnational Terrorism, Organized Crime and Peace Building: Human Security in the Western Balkans*, New York: Palgrave Macmillan, 2010, pp. 169–189.
Arnautović, Suad, *Izbori u Bosni i Hercegovini '90: Analaiza izborni procesa*, Sarajevo: Promocult, 1996.
Arsenijević, Damir, *Forgotten Future: The Politics of Poetry in Bosnia & Herzegovina*, Baden-Baden: Nomos, 2010.
Arsenijević, Damir, *Unbribable Bosnia & Herzegovina: The Fight for the Commons*, Baden-Baden: Nomos, 2014.
Ashdown, Paddy, *The Ashdown Diaries: Volume One, 1988–1997*, London: Allen Lane, 2000.
Ashdown, Paddy, *Swords and Ploughshares: Building Peace in the 21st Century*, London: Phoenix Press, 2008.
Avdić, Senad, 'Karadžićev obavještajni stožer', *Slobodna Bosna*, 7 August 2008, pp. 18–21.
Bačanović, Vuk, 'Strategija istrebljenja', *Dani*, Sarajevo, 25 February 2011, pp. 30–31.
Badsey, Stephen, *The Media and International Security*, London: Frank Cass Publishers, 2000.
Bakšić, Hamza, *Sarajevo kojeg više nema*, Sarajevo: Oslobođenje, 1997.
Banac, Ivo, *The National Question in Yugoslavia; Origins, History, Politics*, Ithaca and London: Cornell University Press, 1984.

Banac, Ivo, *With Stalin against Tito: Cominformist Splits in Yugoslav Communism*, Ithaca and London: Cornell University Press, 1987.
Bećirević, Edina, *Na Drini genocid: istraživanje organiziranog zločina u istočnoj Bosni*, Sarajevo: Buybook, 2009.
Bećirević, Hajriz (ed.), *Opsada i odbrana Sarajeva, 1992–1995: referati Okruglog stola održanog 23. novembra 2005. godine*, Sarajevo: Institut za istraživanje zločina protiv čovječnosti i medjunarodnog prava Univerziteta, 2008.
Bell, Martin, *In Harm's Way: Bosnia: A War Reporter's Story*, London: Penguin, 1996.
Bell, Martin, *War and the Death of News: Reflections of a Grade B Reporter*, London: Oneworld, 2017.
Benedek, Wolfgang et al., *Transnational Terrorism, Organized Crime and Peace Building: Human Security in the Western Balkans*, London: Palgrave Macmillan, 2010.
Bennett, Christopher, *Yugoslavia's Bloody Collapse*, London: Hurst & Co., 1995.
Bennett, Christopher, *Bosnia's Paralysed Peace*, London: Hurst & Co., 2015.
Berić, Gojko, *Sarajevo: Na kraju svijeta*, Sarajevo: Oslobođenje, 1994.
Bilić, Bojan and Janović, Vesna (eds), *Resisting the Evil: (Post-)Yugoslav Anti-war Contention*, Baden-Baden: Nomos, 2012.
Bogdanović, Bogdan, 'Murder of the City', *New York Review of Books*, Vol. 40, No. 10, 27 May 1993, pp. 22–23.
Bogdanović, Bogdan, *Glib i krv*, Beograd: Zagorac, 2001.
Bojić, Mehmedalija, *Historija Bosne i Bošnjaka (VII-XX vijek)*, Sarajevo: TKD Šahinpašić, 2001.
Bose, Sumantra, *Bosnia after Dayton: Nationalist Partition and International Intervention*, London: Hurst & Co., 2002.
Bougarel, Xavier, 'Bosnia and Hercegovina – State and Communitarianism', in D. Dyker and I. Vejvoda (eds), *Yugoslavia and After: A Study in Fragmentation, Despair and Rebirth*, London: Pearson Education, 1996.
Bougarel, Xavier, 'Bosnian Muslims and the Yugoslav Idea', in D. Djokić (ed.), *Yugoslavism: Histories of a Failed Idea*, London: Hurst & Co., 2003.
Bougarel, Xavier, 'Urban Exile: Locals, Newcomers and the Transformation of Sarajevo', in X. Bougarel, E. Helms and G. Duijzings (eds), *The New Bosnian Mosaic*, Aldershot: Ashgate Publishing, 2007, pp. 72–73.
Bowen, Jeremy, *War Stories*, London: Simon & Schuster, 2006.
Bringa, Tone, *Being Muslim the Bosnian Way: Identity and Community in a Central Bosnian Village*, New Jersey: Princeton University Press, 1995.
Brock, Peter and Binder, David, *Media Cleansing, Dirty Reporting: Journalism and Tragedy in Yugoslavia*, Los Angeles: GM Books, 2006.
Bučuk, Esad, *Sarajlija protiv agresije na Bosnu: svjedočanstvo, 1992–1993*, Sarajevo: Muzej genocida, 1998.
Bulatović, Lijlijana (ed.), *Radovan*, Belgrade: EVRO, 2002.
Burić, Ahmed, 'Casablanca pored snajperske raskrsnice', *Dani* (specialno izdanje), Sarajevo, April 2008, p. 14.
Burns, John F., 'Neutrality isn't the same as being fair', *The British Journalism Review*, London, Vol. 21, No. 3, 2010, pp. 27–31.
Buturović, Adnan, 'Godišnjica prvog zasejdanja Karadžićevih Srba', *Slobodna Bosna*, 12 May 2005, pp. 22–25.
Campbell, David, 'Apartheid Cartography: The Political Anthropology and Spatial Effects of International Diplomacy in Bosnia', *Political Geography*, Vol. 18, No. 4, pp. 395–435.
Carter, Bill, *Fools Rush In*, London: Corgi Books, 2005.

Cataldi, Anna, *Letters from Sarajevo: Voices from a Besieged City*, London: Element Books, 1994.
Čekić, Smail, *The Aggression against the Republic of Bosnia & Herzegovina: Planning, Preparation, Execution* (Book One), Sarajevo: Institute for the Research of Crimes Against Humanity and International Law, 2005.
Čekić, Smail, *The Aggression against the Republic of Bosnia & Herzegovina: Planning, Preparation, Execution* (Book Two), Sarajevo: Institute for the Research of Crimes Against Humanity and International Law, 2005.
Central Intelligence Agency (CIA), Directorate of Intelligence, 'Yugoslavia: Key Questions and Answers on the Debt Crisis: An Intelligence Assessment', January 1984, Document No. (FOIA)/ESDN (CREST): 0005361799.
Central Intelligence Agency (CIA), Intelligence Report, DCI Interagency Balkan Task Force, 'Bosnia & Croatia: The Costs of Reconstruction', 20 November 1995, Document No. (FOIA)/ESDN (CREST): 5235e00d93294098d517537.
Central Intelligence Agency (CIA), Letter: Karadžić to President Clinton Accepting the Dayton Agreement, 2 December 1995, Document No. No. (FOIA)/ESDN (CREST): 5235e00d935294098d5174.
Central Intelligence Agency (CIA), Intelligence Report, DCI Interagency Balkan Task Force, 'Sarajevo: Serbs More Likely to Flee Than Fight', 17 December 1995, Document No. (FOIA)/ESDN (CREST): 5235e50c99324093d517406.
Central Intelligence Agency (CIA), CIA Directorate of Intelligence Memorandum: Bosnia & Herzegovina on the Edge of the Abyss', 19 December 1991, Document No. (FOIA)/ESDN (CREST): 5235e50c9329405d174d7.
Cohen, Lenard. J. and Dragović-Soso, Jasna, *State Collapse in South-Eastern Europe: New Perspectives on Yugoslavia's Disintegration*, West Lafayette: Purdue University Press, 2008.
Cohen, Lenard J. and Lampe, John R., *Embracing Democracy in the Western Balkans: From Postconflict Struggles toward European Integration*, Washington DC: Woodrow Wilson Center Press / Johns Hopkins University Press, 2011.
Cohen, Roger, *Hearts Grown Brutal: Sagas of Sarajevo*, New York: Random House, 1998.
Collings, Anthony, *Capturing the News: Three Decades of Reporting Crisis and Conflict*, Missouri: University of Missouri Press, 2010.
Čolović, Ivan, *The Politics of Symbol in Serbia*, London: Hurst & Co., 2002.
Cooper, Anderson, *Dispatches from the Edge*, New York: Harper Collins, 2006.
Coward, Martin, *Urbicide: The Politics of Urban Destruction*, New York: Routledge, 2009.
Crnobrnja, Mihailo, *The Yugoslav Drama*, London: I.B.Tauris, 1996.
CSCE, 'The Referendum on Independence in Bosnia-Herzegovina, February 29–March 1, 1992', CSCE Report, March 1992.
Čusto, Amro, 'Urbanizacija na kraju grada – 'Obećao si da ćemo živjeti u neboderu', in *Zbornik radova Historijskog Muzej BiH*, Sarajevo, broj. 13, 2019, pp. 12–35.
Daadler, Ivo, *Getting to Dayton*, Washington DC: Brookings Institute, 2000.
Death of Yugoslavia Archive, transcript of interview with General Lewis MacKenzie, UBIT, 1995.
Death of Yugoslavia Archive, transcript of interview with Momčilo Krajišnik (SDS), UBIT 050, 1996.
Death of Yugoslavia Archive, transcript of interview with Milutin Kukanjac (JNA), UBIT 166 (2), 1996.
Death of Yugoslavia Archive, transcript of interview with Radovan Karadžić (SDS), UBIT 177, 1996.

Demick, Barbara, *Besieged: Life under Fire on a Sarajevo Street*, London: Granta, 2012.
Di Giovanni, Janine, 'All Systeme D at the Holiday Inn', *The Spectator*, London, 23 January 1993.
Di Giovanni, Janine, *The Quick and the Dead: under Siege in Sarajevo*, London: Phoenix House, 1994.
Di Giovanni, Janine, *Madness Visible: A Memoir of War*, London: Bloomsbury, 2004.
Dizdarević, Zlatko, *Portraits of Sarajevo*, New York: Fromm International, 1994.
Dizdarević, Zlatko, *Sarajevo: A War Journal*, New York: Fromm International, 1994.
Djokić, Dejan and Ker-Lindsay, James, *New Perspectives on Yugoslavia: Key Issues and Controversies*, New York and London: Routledge, 2011.
Donia, Robert J., *Islam under the Double-Headed Eagle: The Muslims of Bosnia and Hercegovina 1878-1914*, Boulder: Eastern European Monographs, 1981.
Donia, Robert J., *Sarajevo: A Biography*, Hurst & Co., London, 2006.
Donia, Robert J., *Iz Skupštine Republike Srpske 1991-1996: Izvodi iz izlaganja poslanika skupštine Republike Srpske kao dokazni material ns medjunarodnom kriviĉnom tribunal u Hagu* Sarajevo: Sarajevo University Press, 2012.
Donia, Robert J., *Radovan Karadžić: Architect of the Bosnian Genocide*, Cambridge: Cambridge University Press, 2015.
Donia, Robert J. and Fine, John V. A., *Bosnia and Herzegovina: A Tradition Betrayed*, London: Hurst & Co., 1994.
Dowdall, Alex and Horne, John (eds), *Civilians under Siege from Sarajevo to Troy*, London: Palgrave Macmillan, 2018.
Doyle, Colm, *Witness to War Crimes: The Memoirs of a Peacekeeper in Bosnia* (edited by Kenneth Morrison), Barnsley: Pen & Sword, 2018.
Dragović-Soso, Jasna, *Saviours of the Nation: Serbia's Intellectual Opposition and the Revival of Nationalism*, London: Hurst & Co., 2002.
Du Preez Bezrob, Anne Marie, *Sarajevo Roses: War Memoir of a Peacekeeper*, Paarl: Oshun Books, 2004.
Dyker, David A. and Vejvoda, Ivan, *Yugoslavia and After: A Study in Fragmentation, Despair and Rebirth*, London: Pearson Education, 1996.
Efendić, Hasan, *Ko je branio Bosnu*, Sarajevo: Udruženje gradjana plemićkog porijekla BiH, 1999.
Fialka, John J., *Hotel Warriors: Covering the Gulf War*, Washington DC: Woodrow Wilson Center, 1992.
Fichter, Madigan, 'Yugoslav Protest: Student Rebellion in Belgrade, Zagreb and Sarajevo', *Slavic Review*, Vol. 75, No. 1, 2016, pp. 99–121.
Fratkin, Leslie, *Sarajevo Self-portrait: The View from the Inside*, New York: Umbrage Editions, 2000.
Frei, Matt, 'The Mafia Move In', *The Spectator*, London, 15 October 1993.
Friedman, Francine, 'The Muslim Slavs of Bosnia and Herzegovina (with reference to the Sandžak of Novi Pazar): Islam as National Identity', *Nationalities Papers*, Vol. 28, No. 1, 2000, pp. 165–180.
Gafić, Muhamed, *Sarajevski rulet*, Sarajevo: CPU, 2005.
Ganić, Ejup, *Razgovori i svjedočenja 1990-1994*, Sarajevo: Svjetlost, 2007.
Garcia, Sofia and Kotzen, Bronwyn, 'Re-Constructing Sarajevo: Negotiating Socio-Political Complexity', LSE Cities/The Ove Arp Foundation, 2014.
Gjelten, Tom, *Sarajevo Daily: A City and Its Newspaper under Siege*, New York: HarperCollins, 1995.

Glenny, Misha, 'Yugoslavia: The Revenger's Tragedy', *The New York Review of Books*, 13 August 1992.
Glenny, Misha, 'What is to be Done?', *The New York Review of Books*, 27 May 1993.
Glenny, Misha, 'Bosnia: The Tragic Prospect', *The New York Review of Books*, 4 November 1993.
Glenny, Misha, *The Fall of Yugoslavia* (3rd edn), London: Penguin, 1996.
Glenny, Misha, *The Balkans 1804–1999*, London: Granta Books, 1999.
Gow, James, *The Serbian Project and Its Adversaries*, London: Hurst & Co., 2003.
Gow, James et al. (eds), *Bosnia by Television*, London: British Film Institute/BFI Publishing, 1996.
Goytisolo, Juan, *Landscapes of War: From Sarajevo to Chechnya*, Oregon: City Lights Books, 1996.
Grandits, Hannes and Leutloff, Carolin, 'Discourses, Actors, Violence: The Organisation of War-escalation in the Krajina region of Croatia, 1990–91', in J. Koehler and C. Zürcher (eds), *Potentials of Disorder*, Manchester and New York: Manchester University Press, 2003, pp. 23–45.
Grant, Tony (ed.), *From Our Own Correspondent: A Celebration of Fifty Years of the BBC Radio Programme*, London: Profile Books, 2005.
Greble, Emily, *Sarajevo, 1941–45: Muslims, Christians and Jews in Hitler's Europe*, Ithaca and London: Cornell University Press, 2011.
Grebo, Kemal, *Privreda u opkoljenom Sarajevu*, Sarajevo: OKO, 1998.
Grebo, Zdravko, *100 & 1 noć: Sarajevske price*, Sarajevo: Zid, 1994.
Grozdanić, Sulejman, *Bosna nije san*, Sarajevo: Svjetlost, 1995.
Gül, Murat and Dee, John, 'Sarajevo – A City profile', *Cities*, No. 43, 2015, pp. 152–166.
Gunić, Vehid, *Evropo, stidi se!*, Tešanj: PLANJAX, 1999.
Hadžić, Kemal, *Sarajevo '94*, Sarajevo: Medjunarodni centar za mir, 1998.
Hadžifejzović, Senad, *Rat užvo: ratni teevizijski dnevnik*, Ljubljana: Mladinska kniga, 2002.
Hadžihasanović, Aziz, *1984: Olimpijada trijumfa i šansi*, Sarajevo: Rabic, 2010.
Hammond, Phillip, *Media, War and Postmodernity*, New York: Routledge, 2007.
Harper, Stephen, *Screening Bosnia*, London: Bloomsbury Academic, 2017.
Harris, Paul, *More Thrills than Skills: Adventures in Journalism, War and Terrorism*, Glasgow: Kennedy & Boyd, 2009.
Hawton, Nick, *The Quest for Radovan Karadžić*, London: Hutchinson, 2009.
Helsinki Watch, *War Crimes in Bosnia & Herzegovina*, New York: Human Rights Watch, 1992.
Helsinški odbor za ljudska prava u Srbiji, *Izbeglice – žrtve etničkog inženinga*, Svedočanstva Br. 21, Knjiga 1, Beograd: Zagorac, 2004.
Helsinški odbor za ljudska prava u Srbiji, *Kovane antijugoslovenske zavere*, Svedočanstva Br. 26, Knjiga 1, Beograd: Zagorac, 2006.
Helsinški odbor za ljudska prava u Srbiji, *Jezgro velikosrpskog projekta*, Svedočanstva Br. 27, Beograd: Zagorac, 2006.
Hewitt, Dawn M., *From Ottawa to Sarajevo: Canadian Peacekeepers in the Balkans*, Martello Papers No. 8, Centre for International Relations, Queen's University, Kingston, Ontario, Canada, 1998.
Hitchens, Christopher, *Hitch-22: A Memoir*, London: Atlantic Book, 2010.
Hoare, Marko Attila, *How Bosnia Armed*, London: Saqi Books, 2004.
Hoare, Marko Attila, *The History of Bosnia*, London: Saqi Books, 2007.
Holbrooke, Richard, *To End a War*, New York: Random House, 1998.
Hollingworth, Larry, *Merry Christmas, Mr Larry*, London: William Heinemann, 2006.

Hozić, Edo, *Biografija Sarajeva*, Bemust: Sarajevo, 2008.
Ingrao, Charles and Emmert, Thomas (eds), *Confronting the Yugoslav Controversies: A Scholars' Initiative* (2nd edn), West Lafayette: Purdue University Press, 2013.
Ivanković, Željko, *700 dana opsade*, Zagreb: Durieux, 1995.
Izetbegović, Alija, *Inescapable Questions: Autobiographical Notes*, Leicester: The Islamic Foundation, 2003.
Jančić, Miroslav, *Sarajevo 92/93: izvještava portparol pakla*, Ljubljana: ČZP Enotnost, 1994.
Jergović, Miljenko, *Sarajevo Marlboro*, London: Penguin Books, 1997.
Jergović, Miljenko, *Sarajevo, plan grada*, Zagreb: Fraktura, 2017.
Jestrović, Silvija, *Performances, Space, Utopia: Cities of War, Cities of Exile*, Basingstoke: Palgrave Macmillan, 2013.
Jones, Chris, 'François Mitterrand's Visit to Sarajevo, June 1992', *Diplomacy and Statecraft*, Vol. 28, No. 2, 2017, pp. 296–319.
Jović, Borisav, *Poslednji dani SFRJ*, Beograd: Prizma, 1996.
Jović, Dejan, 'The Disintegration of Yugoslavia: A Critical Review of Explanatory Approaches', *European Journal of Social Theory*, Vol. 4, No.1, 2001, pp. 101–120.
Jović, Dejan, *Yugoslavia: A State that Withered Away*, West Lafayette: Purdue University Press, 2009.
Jovičić, Mile, *Two Days till Peace: A Sarajevo Airport Story*, Bloomington: Author House, 2011.
Judah, Tim, *The Serbs: History, Myth and the Destruction of Yugoslavia* (3rd ed.), New Haven: Yale University Press, 2009.
Jukić, Ilija, *The Fall of Yugoslavia*, New York and London: Harcourt Brace Jovanovich, 1974.
Kalyvas, Stathis, 'The Urban Bias in Research on Civil Wars', *Security Studies*, Vol. 13, No. 3, 2004, pp. 160–190.
Kapić, Suada (ed.), *The Siege of Sarajevo: 1992–1996*, Sarajevo: FAMA, 2000.
Karahasan, Dževad, *Sarajevo, Exodus of a City*, Tokyo and London: Kodansha International, 1994.
Karavelić, Vahid and Rujanac, Zijad, *Sarajevo: opsada i odbrana, 1992–1995*, Sarajevo: Udruženje za zaštitu tekovina borber za Bosnu i Hercegovinu, 2009.
Karup-Druško, Dženana, 'Rat nije počeo u Sarajevu', *Dani*, Sarajevo, 12 March 2010, pp. 39–41.
Kecmanović, Dušan, *Ethnic Times: Exploring Ethno-nationalism in the Former Yugoslavia*, London: Praeger, 2002.
Knightley, Phillip, *The First Casualty of War: The War Correspondent as Hero, Propagandist and Myth Maker from Crimea to the Gulf War II* (3rd edn), London: Carlton Books, 2003.
Komesarjat za izbeglice Republike Srbije, *Stradanja Srba u Sarajevu: Knjiga dokumenata*, Beograd, 1995.
Koštović, Nijazija, *Sarajevo između dobrotvorstva i zla*, Sarajevo: Rijaset Islamske zajednice i Mladi Muslimani 39, 1998.
Kreševljaković, Muhamed (ed.), *I oni brane Sarajevo*, Sarajevo: Zlatni ljiljani, 1998.
Kulić, Vladimir et al., *Modernism In-Between: The Mediatory Architectures of Socialist Yugoslavia*, Zagreb and Vienna: Jovis, 2013.
Kurspahić, Kemal, *As Long as Sarajevo Exists*, Stony Creek, CT: The Pamphleteers Press, 1997.
Kurspahić, Nermina, *Sarajevski ratni pogledi*, Sarajevo: OKO, 1996.
Lampe, John R. *Yugoslavia as History: Twice There was a Country* (2nd edn), Cambridge: Cambridge University Press, 2000.

Lampe, John R., *Balkans into Southeastern Europe: A Century of War and Transition*, London: Palgrave Macmillan, 2005.
Le Bor, Adam, *'Complicity with Evil': The United Nations in the Age of Modern Genocide*, New Haven and London: Yale University Press, 2006.
Le Normand, Brigette, *Designing Tito's Capital: Urban Planning, Modernism, and Socialism in Belgrade*, Pittsburgh: University of Pittsburgh Press, 2014.
Little, Allan and Silber, Laura, *The Death of Yugoslavia*, London: Penguin Books, 1997.
Lodge, Robin, 'Changing Guard at the Holiday Inn', *The Spectator*, London, 18 July 1992.
Lowe, Paul, *The Siege of Sarajevo*, Sarajevo: Galerija 11/07/95, 2014.
Lowe, Paul, 'Portfolio: The Siege of Sarajevo', *Photography and Culture*, Vol. 8, No. 1, March 2015, pp. 135–142.
Loyd, Anthony, *My War Gone By, I Miss it So*, London: Random House, 1999.
Loyn, David, *Frontline: The True Story of the British Mavericks Who Changed the Face of War Reporting*, Penguin/Michael Joseph: London, 2005.
Lučarević, Kerim, *The Battle for Sarajevo: Sentenced to Victory*, Sarajevo: TZU, 2000.
Lyon, James, 'Habsburg Sarajevo 1914: A Social Picture', *Prilozi/Contributions*, Institut za istoriju u Sarajevu, Vol. 43, Sarajevo, 2014, pp. 23–40.
Maalouf, Eddie, 'European Broadcasting Union: Unpublished Memoirs from Sarajevo, 1992-95', unpublished, 2004.
Maass, Peter, *Love Thy Neighbour: A Story of War*, London: Papermac, 1996.
Maček, Ivana, *Sarajevo under Siege: Anthropology in Wartime*, Philadelphia: University of Pennsylvania Press, 2009.
MacKenzie, Lewis, *Peacekeeper: The Road to Sarajevo*, Vancouver and Toronto: Douglas & McIntyre, 1993.
MacKenzie, Lewis, 'Canada's Army – Post Peacekeeping', *The Canadian Journal of Military and Strategic Studies*, Vol. 12, No. 1, Fall 2009, pp. 2–16.
Magaš, Branka, *The Destruction of Yugoslavia*, London: Verso Press, 1993.
Magaš, Branka and Žanić, Ivo (eds), *The War in Croatia and Bosnia-Herzegovina 1991–1995*, London: Frank Cass, 2001.
Mahmutćehajić, Rusmir, 'The War against Bosnia-Herzegovina', *East European Quarterly*, Vol. 33, No. 2, June 1999, pp. 219–233.
Mahmutćehajić, Rusmir, *Bosnia the Good: Tolerance and Tradition*. Budapest and New York: Central European University Press, 2000.
Malcolm, Noel, *Bosnia: A Short History*, London: Macmillan Press, 1994.
Marchand, Paul M., *Sympathie Pour le Diable*, Outremont: Lancot, 1997.
Markowitz, Fran, *Sarajevo: A Bosnian Kaleidoscope*, Chicago: University of Illinois Press, 2010.
Matvejević, Predrag, 'War and Memory', in T. Stoddart and P. Matvejević (eds), *Sarajevo*, Washington DC: Smithsonian Institution Press, 1998, pp. v–xi.
McAllister, Matthew, *Eating Mud Crabs in Kandahar: Stories of Food during Wartime by the World's Leading Correspondents*, Berkeley: University of California Press, 2011.
McLaughlin, G., *The War Correspondent* (2nd ed.), London: Pluto Press, 2016.
Mehičić, Irfan (ed.), *Privreda u opkoljenom Sarajevu*, Sarajevo: OKO, 1999.
Mehmedinović, Semezdin, *Sarajevo Blues*, New York: City Lights, 1999.
Milašin, Tihomir, *Iz dana u dan: Medijsko izveštavanje o ratu u BiH (1992-1996)*, Sarajevo: Mediacentar, 2002.
Moll, Nicholas, 'An Integrative Symbol for a Divided Country? Commemorating the 1984 Sarajevo Winter Olympics in Bosnia and Herzegovina from the 1995 War until Today', *Croatian Political Science Review*, Vol. 1, No. 5, 2014, pp. 127–156.

Moore, Nicholas and Weiland, Sidney (eds), *Frontlines: Snapshots of History*, London: Reuters/The Tangman Press, 2001.
Morrison, Kenneth, 'The State-Criminal Symbiosis in the Yugoslav Wars of Succession', in A. Colas and C. Mabee (eds), *Mercenaries, Pirates, Bandits and Empires: Private Violence in Historical Context*, London: Hurst & Co., 2010.
Morrison, Kenneth, *Sarajevo's Holiday Inn on the Frontline of Politics and War*, London: Palgrave Macmillan, 2016.
Morrison, Kenneth, *Nationalism, Statehood and Identity in Post-Yugoslav Montenegro*, London: Bloomsbury, 2018.
Morrison, Kenneth, 'The "June Events": The 1968 Student Protests in Yugoslavia', in K. McDermott and S. Stibbe (eds), *Eastern Europe in 1968: Responses to the Prague Spring and Warsaw Pact Invasion*, London: Palgrave Macmillan, 2018, pp. 215–234.
Morrison, Kenneth and Roberts, Elizabeth, *The Sandžak: A History*, London: Hurst & Co, 2013.
Moser, Benjamin, *Sontag: Her Life*, London: Allen Lane, 2019.
Neidhardt, Tatjana, *Sarajevo through Time*, Sarajevo: Bosanska riječ, 2004.
Neuffer, Elizabeth, *The Key to my Neighbour's House: Seeking Justice in Bosnia and Rwanda*, London: Bloomsbury Press, 2002.
Nicholson, Michael, *Natasha's Story*, London: Macmillan, 1993.
Nicholson, Michael, *A State of War Exits: Reporters in the Line of Fire*, London: Biteback, 2012.
Olbina, Dane, *Dani i godine opsade (Zabilješke 'Dan za danom' od 3. marta 1992. do 13 januara 1996)*, Sarajevo: FAMA, 2002.
Organisation for Security and Cooperation in Europe (OSCE), 'List of Killed Journalists in the OSCE region 1992–2017', OSCE: Vienna, 17 December 2017.
Organizacionog komiteta XIV zimskih olimpijskih igara Sarajevo, 'Završni izvještaj – Organizacionog komiteta XIV zimskih olimpijskih igara Sarajevo, 1984', Sarajevo: Oslobođenje, 1984.
Owen, David, *Balkan Odyssey*, London: Victor Gollancz, 1995.
Owen, David (ed.) *Bosnia-Herzegovina: The Vance/Owen Peace Plan*, Liverpool: Liverpool University Press, 2013.
Owen, John (ed.), *International News Reporting: Frontlines and Deadlines*, Chichester: Wiley-Blackwell, 2009.
Palavestra, Vlajko, *Legends of Old Sarajevo*, Zemun: Most Art, 2003.
Panić, Milan, *Prime Minster for Peace: My Struggle for Serbian Democracy*, London: Rowman & Littlefield, 2015.
Pavlović, Srdja and Živković, Marko (eds), *Transcending Fratricide: Political Mythologies, Reconciliations, and the Uncertain Future in the Former Yugoslavia*, Baden-Baden: Nomos, 2013.
Pečanin, Senad, 'Skandirao sam: Bosna, Bosna!', *Dani*, Sarajevo, 28 December 2007.
Pedelty, Mark, *War Stories: The Culture of Foreign Correspondents*, Abingdon: Routledge, 1995.
Pejanović, Mirko, *Essays on the Statehood and Political Development of Bosnia & Herzegovina*, Sarajevo: TKD Šahinpašić, 2016.
Pejić, Mario, *HVO Sarajevo*, Sarajevo: Libertas, 2008.
Petrović, Ruža and Blagojević, Marina, *The Migration of Serbs and Montenegrins from Kosovo and Metohija: Results of the Survey Conducted in 1985–1986*, Belgrade: Serbian Academy of Arts and Sciences (SANU), Demographic Studies, Vol. 3 (English translation), 1992.

Pinson, Mark, *The Muslims of Bosnia-Herzegovina: Their Historic Development from the Middle Ages to the Dissolution of Yugoslavia*, Cambridge, MA: Harvard University Press, 1993.
Plavšić, Biljana, *Svedočim: Knjiga pisana u zatvoru*, Banja Luka: Trioprint, 2005.
Prstojević, Miroslav, *Sarajevo: Ranjeni grad*, Sarajevo: Ideja, 1992.
Prstojević, Miroslav (ed.), *Sarajevo Survival Guide*, Sarajevo: FAMA, 1992.
Prstojević, Miroslav, *Zaboravljeno Sarajevo*, Sarajevo: Ideja, 1992.
Prstojević, Miroslav, Razović, Maja and Wagner, Aleksandra (eds), *Sarajevo Survival Guide*, Sarajevo: FAMA, 1993.
Purves, Stewart and Hulbert, Jeff, *When Reporters Cross the Line: The Heroes, the Villains, the Hackers and the Spies*, London: Biteback Publishing, 2013.
Radević, Maja, 'Štraus: Bosansko-Srpski akademik', *Slobodna Bosna*, Sarajevo, 25 April 2013, pp. 62–65.
Ragaru, Nadège, 'Missed Encounters: Engaged French Intellectuals and the Yugoslav Wars', *Südosteuropa*, Vol. 4, No. 61, 2013, pp. 498–521.
Ramet, Sabrina, *Balkan Babel: The Disintegration of Yugoslavia from the Death of Tito to the Fall of Milošević*, Boulder, CO: Westview Press, 2002.
Reid, Atka and Schofield, H., *Goodbye Sarajevo: A True Story of Courage, Love and Survival*, London: Bloomsbury, 2011.
Rešidbegović, Neždad, *BH Telekom, Sarajevo 2015*, Sarajevo, 2005.
Ricchiardi, Sherry, 'Exposing Genocide … For What?', *American Journalism Review*, Vol. 15, No. 5, June 1993, pp. 32–43.
Ripley, Tim, *Operation Deliberate Force: The UN and NATO Campaign in Bosnia, 1995*, Lancaster: Centre for Defence and International Security Studies, 1999.
Ristić, Mirjana, 'Sarajevo Warscapes: Architecture, Urban Spaces and Ethnic Nationalism', unpublished PhD thesis, University of Melbourne, Australia, September 2011.
Rose, Michael, *Fighting for Peace: Lessons from Bosnia*. London: Harvill Press, 1998.
Rohde, David, *A Safe Area, Srebrenica: Europe's Worst Massacre since the Second World War*, London: Simon & Schuster, 1997.
Rujanac, Zijad, et al., *Stari grad Sarajevo: Agresija i odbrana*, Tešanj: Planjax, 2016.
Rusinow, Dennison, *The Yugoslav Experiment 1948–1974*, London: Hurst & Co., 1977.
Rusinow, Dennison, *Yugoslavia: Oblique Insights and Observations*, Pittsburgh: Pittsburgh University Press, 2008.
Sadikovich, James, *The U.S. Media and Yugoslavia, 1991–1995*, Westport, CT: Praeger, 1998.
Šarkinović, Hamdija, *Bošnjaci od nacertanije do memorandums*, Podgorica: MNVS, 1997.
Serotta, Edward, *Survival in Sarajevo: How a Jewish Community Came to the Aid of its City*, Budapest: CECRD, 1994.
Silber, Laura and Little, Allan, *The Death of Yugoslavia*, London: Penguin Books, 1996.
Simpson, John, *Strange Places, Questionable People*, London: Pan/Macmillan, 1999.
Simpson, John, *A Mad World, My Masters*, London: Macmillan, 2000.
Sobel, Richard and Shiraev, Eric (eds), *International Public Opinion and the Bosnia Crisis*, New York: Lexington Books, 2003.
Softić, Elma, *Sarajevo Days, Sarajevo Nights*, Saint Paul, MN: Hungry Mind Press, 1996.
Sontag, Susan, 'Godot Comes to Sarajevo', *The New York Review of Books*, 21 October 1993, pp. 32–37.
Sontag, Susan, 'Waiting for Godot in Sarajevo', *Performing Arts Journal*, Vol. 6, No. 2, 1994, pp. 87–106.

Sparks, Mary, *The Development of Austro-Hungarian Sarajevo, 1878–1918: An Urban History*, London: Bloomsbury Press, 2014.
Steele, Jon, *War Junkie: One Man's Addiction to the Worst Places on Earth*, London: Corgi Books, 2003.
Stewart, Christopher S., *Hunting the Tiger: The Fast Life and Violent Death of the Balkans' Most Dangerous Man*, New York: St Martin's Press, 2007.
Sučić, Anton et al., *Sarajevo '84*, Sarajevo: Oslobođenje, 1984.
Sudetić, Chuck, *Blood and Vengeance*, London and New York: Penguin Books, 1999.
Štraus, Ivan, *Arhitektura Bosne i Hercegovine, 1945–1995*, Sarajevo: Oko, 1991.
Štraus, Ivan, *Arhitekt i barbari*, Sarajevo: Medjunarodni centar za mir, 1995.
Tabeau, Ewa et al., 'Death Toll in the Siege of Sarajevo, April 1992 to December 1995: A Study of Mortality Based on Eight Large Data Sources', Expert report prepared for the case of Slobodan Milošević – Bosnia and Herzegovina ICTY Case No. IT-02-54.
Tanner, Marcus, *Croatia: A Nation Forged in War* (3rd edn), New Haven: Yale University Press, 2010.
Thompson, Mark, *A Paper House: The Ending of Yugoslavia*, London: Vintage Books, 1992.
Thompson, Mark, *Forging War: The Media in Serbia, Croatia and Bosnia-Herzegovina*, London: Article 19, 1994.
Tomašević, Bato, *Life and Death in the Balkans: A Family Saga in a Century of Conflict*, London: Hurst & Co., 2008.
Trifunovska, Snežana, *Yugoslavia through Documents: From its Creation to its Dissolution*, Dordrecht and London: Martinus Nijhoff, 1994.
Tumber, Howard and Webster, Frank, *Journalists under Fire: Information War and Journalistic Practices*, London: Sage Publications, 2006
Udovički, Jasminka and Ridgeway, James, *Burn This House: The Making and Unmaking of Yugoslavia*, Durham, NC: Duke University Press, 2000.
UN Final Report of the United Nations Commission of Experts, 'Study of the Battle and Siege of Sarajevo', Part 1/10, S/1994/674/Add. 2 (Vol. II), 27 May 1994.
UN-ICTY Case No. IT-95-5/18-T, 'The Prosecutor v. Radovan Karadžić (ET SA01-1505-SA01-1571.doc)', Club of Parliament Representatives, Serb Democratic Party, Bosnia and Herzegovina: Transcript from the meeting of the Club, Sarajevo, 28 February 1992.
UN-ICTY Document, 'Socialist Republic of Bosnia & Herzegovina: Ministry of the Interior State Security Service, Sarajevo', Security Information in Relation to the Events of 01.03/02.03 and 303.03/04.03.1992 in Sarajevo, 6 March 1992, ET 0323-7746-0323-7757.
UN-ICTY, 'Death Toll in the Siege of Sarajevo, April 1992 to December 1995: A Study of Mortality Based on Eight Large Data Sources', Expert report prepared for the Case of Slobodan Milošević – Bosnia & Herzegovina, Case No. IT-02-54, August 2003.
UN-ICTY: Robert Donia, 'From Election to Stalemate: The Making of the Siege of Sarajevo, 1990–1994', Statement of Expert Witness in Case IT-98-29-1, The Prosecutor V. Dragomir Milošević, December 2006.
UN-ICTY, Case No. IT-04-79, 'Mićo Stanišić and the Bosnian Serb Leadership 1990-1992 (Addendum to the Bosnian Serb Leadership, 1990-1992)', Patrick J. Treanor, Research report prepared for the case of Mićo Stanišić (IT-04-79), 21 February 2008.
UN-ICTY Case No. IT-95-5/18-T, 'The Prosecutor v. Radovan Karadžić' (ET SA03-0331-SA03-03311.doc), 27 February 2009.

UN-ICTY Case No. IT-95-5/18-T, 'The Prosecutor v. Radovan Karadžić' Revised Notification of Submission of Written Evidence Pursuant to Rule 92 *ter*: Aleksandar Vasiljević (KW527), 14 March 2012.
UN-ICTY Case No. IT-09-92-T, 'The Prosecutor v. Ratko Mladić', Prosecution 92 *TER* MOTION: RM114 (Colm Doyle), 23 July 2012.
UN-ICTY Case No. IT-09-92-T, 'The Prosecutor v. Ratko Mladić' (Witness Statement: D70033-D69927), 13 September 2013.
UNPROFOR (Zagreb) Daily Sitrep, 14 August 1994, File Ref: SR151100.
UNPROFOR (Zagreb) Daily Sitrep, 8 October 1994, File Ref: SR091100.
UNPROFOR (Zagreb) Daily Sitrep, 26 October 1994, File Ref: SR271100.
UNPROFOR (Zagreb) Daily Sitrep, 24 November 1994, File Ref: SR251100.
UNPROFOR (Zagreb) Daily Sitrep, 6 December 1994, File Ref: SR071100.
UNPROFOR (Zagreb) Daily Sitrep, 10 December 1994, File Ref: SR111100.
UNPROFOR (Zagreb), 'Outgoing Code Cable: Violations of the Sarajevo Anti-Sniping Agreement', 12 September 1994, Number: UNPROFOR Z-1398.
UNPROFOR Office of Civil Affairs (Zagreb), 'Subject: Meeting with General Mladić in Jahorina', 10 October 1994, File Ref: CCA-BHC-363.
UNPROFOR (SMO Sector Sarajevo), 'Senior Military Observer's End Month Report: November 1992', 1 December 1992, File Ref: 11008965.
UNPROFOR (SMO Sector Sarajevo), 'Senior Military Observer's End Month Report: November 1992', 1 January 1993, File Ref: 11008977.
UNPROFOR (SMO Sector Sarajevo), 'Senior Military Observer's End Month Report: November 1992', 2 February 1992, File Ref: 11008990.
Vladisavljević, Nebojša, *Serbia's Antibureaucratic Revolution: Milošević, the Fall of Communism and Nationalist Mobilisation*, Basingstoke: Palgrave Macmillan, 2008.
Vuić, Jason, *The Sarajevo Olympics: A History of the 1984 Winter Games*, Amherst and Boston: University of Massachusetts Press, 2015.
Vujadinović, Dragica (ed.), *Between Authoritarianism and Democracy: Serbia, Montenegro, Croatia*, Belgrade: CEDET, 2003.
Vuksanović, Mladen, *From Enemy Territory: Pale Diary*, London: Saqi Books, 2004.
Vulliamy, Ed, *Seasons in Hell: Understanding Bosnia's War*, New York: St. Martin's Press, 1994.
Vulliamy, Ed, *The War is Dead, Long Live the War – Bosnia: A Reckoning*, London: Vintage, 2013.
Walasek, Helen (ed.), *Bosnia and the Destruction of Cultural Heritage*, Farnham: Ashgate, 2015.
Wessenlingh, Isabelle and Valerin, Arnaud, *Raw Memory: Prijedor, Laboratory of Ethnic Cleansing*, London: Saqi Books/The Bosnian Institute, 2005.
Woodward, Susan, *Balkan Tragedy: Chaos and Dissolution after the Cold War*, Washington DC: Brookings Institute, 1995.
Young, Kirsten, 'UNHCR AND ICRC in the former Yugoslavia: Bosnia-Herzegovina', *International Review of the Red Cross*, September 2001, Vol. 83, No. 843, pp. 781–805.
Žanić, Ivo, *Flag on the Mountain: A Political Anthropology of War in Croatia and Bosnia*, London: Saqi Books, 2007.
Zimmermann, Warren, *The Origins of a Catastrophe*, New York: Random House, 1996.
Zlatar, Behija et al., *Sarajevo: Ulice, trgovi, mostovi, parkovi i spomenici*, Sarajevo: Mediapress, 2007.
Zulfikarpašić, Adil (in dialogue with Milovan Djilas and Nadežda Gaće), *The Bosniak: Adil Zulfikarpašić*, London: Hurst & Co., 1998.

Newspapers, periodicals and news agencies

Oslobođenje (Sarajevo), *Naši dani* (Sarajevo), *Ratni dani* (Sarajevo), *Dani* (Sarajevo), *Dnevni avaz* (Sarajevo), *Start* (Sarajevo), *Danas* (Belgrade), *Danas* (Zagreb), *Vreme* (Belgrade), *Vreme News Digest* (Belgrade) *NIN* (Belgrade), *Borba* (Belgrade), *Feral Tribune* (Zagreb), *Slobodna Dalmacija* (Split), *Tanjug* (Belgrade), *Novi Tednik* (Ljubljana), *Monitor* (Podgorica), *Pobjeda* (Podgorica), *The Guardian* (London), *The Times* (London), *The Independent* (London), *The Daily Mail* (London), *The European* (London), *The Daily Telegraph* (London), *The Spectator* (London), *The Observer* (London), *The Scotsman* (Edinburgh), *Il Giorno* (Milan), *The New York Times* (New York), *The Washington Post* (Washington DC), *The Philadelphia Enquirer* (Philadelphia), *The San Francisco Chronicle* (San Francisco), *Newsweek* (New York), *Time Magazine* (New York), *New York Review of Books* (New York), *Reuters* (London), *Associated Press* (New York), *Balkan Insight* (Belgrade), *Osservatorio Balcani e Caucuso* (Trento), *AIM Press* (Paris/Zurich), *Le Monde* (Paris), *Libération* (Paris), *Rolling Stone* (New York).

Documentary films

'A Sarajevo Diary: From Bad to Worse', Director: Dom Rotheroe, W.O.W. Productions, London, 1993.
'Bosna!', Director: Alain Ferrari and Bernard-Henri Lévy, Radio Television Bosnia-Herzegovina, Canal+, Centre National de la Cinématographie (CNC), 1994.
'Cinema Komunisto', Director: Mila Turajlić, Dribbling Pictures, Belgrade, 2010.
'Godot-Sarajevo', Director: Pjer Žalica, SAGA Films Sarajevo, 1993.
'Hotel na prvoj liniji' (Hotel on the Front Line), Director: Antonije 'Nino' Žalica, SAGA Films Sarajevo, 1993.
'Killer Image: Shooting Robert King', Director: Richard Parry, Trinity Films, London, 2008.
'Margaret Moth: Fearless', CNN Documentary, 22 September 2009.
'Reporters at War' (Episodes 1–3), Director: Jon Blair, True Vision Productions, 2003.
'Sarajevo: The Living and the Dead', Director: Radovan Tadić Archipel 33, Paris, 1994.
'Sector Sarajevo', History Channel, Director: Berry Stevens, 2017.
'Serbian Epics', Director: Paul Pawlokowski, BBC TV, London, 1992.
'Tales from Sarajevo: A Late Show Special', Director: Roland Keating, BBC TV, London, 1993.
'The Reckoning', Director: Kevin Sim, Channel 4 'True Stories', 1998.
'The Siege', Directors: Remy Ourdan and Patrick Chauvel, Agat Films, 2016.
'Veillées d'armes: Histoire du Journalisme en temps du guerre' ('The Troubles We've Seen: A History of Journalism in Wartime'), First Journey, Director: Marcel Ophuls, Little Bear Productions, 1993.
'Veillées d'armes: Histoire du Journalisme en temps du guerre' ('The Troubles We've Seen: A History of Journalism in Wartime'), Second Journey, Director: Marcel Ophuls, Little Bear Productions, 1994.
'War Hotels: The Holiday Inn, Sarajevo', Director: Abdallah El Binni, Al Jazeera, Doha, 2018.

Interviews

Amra Abadžić-Lowe (Reuters), Christiane Amanpour (CNN), Neven Andjelić (Radio Sarajevo), Nigel Bateson (BBC), Džemal Bećirević (UPI/*Washington Post*), Edina Bećirević (WTN), Martin Bell (BBC), Pierre Biaran (CNN), Jeremy Bowen (BBC), Malcolm Brabant (BBC), Zrinka Bralo (EBU), Joel Brand (*Newsweek*), David Brauchli (Associated Press), John F. Burns (*New York Times*), Sabina Ćosić (Reuters), Janine di Giovanni (*The Times/Harpers Magazine*), Colm Doyle (ECMM), Jelena Grujić (*Vreme*), Dina Hamdžić (BBC), Paul Harris (*Scotland on Sunday/Scotsman*), Ron Haviv (*Time*/VII Agency), Florence Hartmann (*Le Monde*), Roger Hutchings (*The Observer*/Network Photographers), Eldina Jašarević (ARD), Tim Judah (*The Times*), Robert King (Freelance), Gordana Knežević (*Oslobođenje*), Gary Knight (VII Agency), Samir Krilić (Associated Press), Kemal Kurspahić (*Oslobođenje*), Zoran Kusovac (Sky News), Jonathan Landay (UPI), Allan Little (BBC), Boba Lizdek (*Libération/El Pais/El Mundo*), Srečko Latal (Associated Press), Sean Maguire (Reuters), Christopher Morris (Associated Press) Stéphane Manier (France 2), Dina Neretljak (France 2), Peter Maass (*Washington Post*), Marcel Ophuls (Filmmaker/Little Bear), Samir Korić (Reuters), Eldar Emrić (APTV), Remy Ourdan (RTL/*Le Monde*), Pierre Peyrot (EBU), Charlotte Eagar (*The Observer*), Ariane Quentier (RTL), Nic Robertson (CNN), Hajrudin Rovčanin (Holiday Inn), David Rust (CNN), Myriam Schmaus (EBU), John Simpson (BBC), Vaughan Smith (Frontline News), Tony Smith (Associated Press), Zoran Stefanović (WTN), Kevin Sullivan (UPI), John Sweeney (*The Observer*), Milan Trivić (YUTEL), Cees van der Laan (*De Telegraaf*), Aernout van Lynden (Sky News), Tony Winning (Reuters), Steven Ward (EBU), Kevin Weaver (*The Guardian/The Independent*), Jean Hatzfeld (*Libération*), Martin Dawes (BBC), Marcus Tanner (*The Guardian*), Chris Helgren (Reuters), Gigi Riva (*Il Giorno*) Andrew Reid (Gamma), Senada Kreso (Bosnian government liaison with foreign press).

Index

Abadžić, Amra 93, 103-4, 110, 121-4
Abdić, Fikret 14
accreditation of journalists 57, 75, 85-6, 165
Adie, Kate 90, 112-13, 115
adoption of children 157
advocacy journalism 142-3, 168
Ageto, Jospeh 69
Ahrens, Geert Hinrich 15
airlifts 56, 156
Akashi, Yasushi xxiii
Albright, Madeleine xxi
Alpiton, David 83
Amanpour, Christiane 5, 59, 71, 85, 97-8, 102, 110, 112, 119, 143-6, 167
Andjelić, Neven 12, 21, 27
Andreas, Peter 3-5, 33, 56, 78, 88, 134
Andrews, Peter 148
Anne, Princess 69
armoured cars 59, 98-108, 164
'armourization' of the press corps 6, 89, 98
Arslanagić, Sabina 83
art and culture during the siege 132-40

Baez, Joan 134-6
Bagnulo, Ron 95
Bairin, Pierre 101-2
Bajramović, Ismet 33-4
Bajrović, Izudin 136
Bakšić, Hamza 110
Barbie, Klaus 136
Baščaršija 17-18, 21, 33
Bateson, Nigel 50-1, 138
'Battle for Sarajevo' (1992) xv, 39-41
Bećirević, Džemal 77, 93, 109, 135
Bećirević, Edina 13, 15, 26, 42-4
beer 117
Bell, Martin 5, 39-42, 50-4, 68, 71, 92-3, 96-9, 104, 144-5, 161-9
 and journalism as a 'moral profession' 141

Ben Achour, Salem 38
Bhoutros-Ghali, Bhoutros xvii, 85
bias in reportng 143-5, 159
'big footing' 91
black market operations 2-4, 82, 111-17
Blue Cards 86-8
Boban, Mate 12, 23-4
'Body Armour Level II' 102
book-burning 110
Bosnia and Herzegovina, elections in (1990) 10-14
Bosnian war 3, 119, 132, 139, 141-5, 161, 163
Bowen, Jeremy 67, 70-2, 75-6, 85, 98, 102-3, 109, 117, 146-7, 154-7, 164-9
Brabant, Malcolm 68, 70
Bralo, Zrinka 56, 79-82, 97
Brand, Joel 16-17, 42, 58, 63, 68, 76, 102, 108-10
Brauchli, David 44-5
British Broadcasting Corporation (BBC) 4, 39-44, 51-2, 89-90, 98-100, 120, 138
 World Service 120
Brković, Jasmina 152
Brock, Peter 144
Brozović, Dalibor 11 -12
Bulatović, Momir 9
Bulić, Branko 78
Burns, John Fisher 2, 49-50, 63-4, 72-3, 105, 127, 135, 138-9, 144-5, 153

Cable News Network (CNN) 4, 100, 103, 119, 163
camaraderie among journalists 143, 164
čarapari 18
Carax, Leos 133
Carter, Jimmy xxii-xxiii
Columbia Broadcasting System (CBS) 107-8

Celliers, Rob 42
Central Intelligence Agency (CIA) 15
Chazan, Yigal 40
children as victims 152–6
cigarettes 117
civic values in Sarajevo 140
Clinton, Bill 143, 153, 159
cold conditions 109–10, 116–17
communal identity, sense of 140
Ćosić, Dobrica 13
Ćosić, Sabina 77, 111–12
Crawshaw, Steve 34
criminal activity 33, 113–14
criticism of reporting from Sarajevo 143, 150
Croatian Democratic Community of Bosnia (HDZ-BiH) 9, 12, 14–15, 25
Cuaron, Alfonso 133
Cutileiro, Jose 22

Daly, Emma 143, 150, 157–8, 166, 168
Damon, Dan 47, 158
Davis, George 47–8, 100
Davison, Phil 52, 144
Dawes, Martin 72, 119–21, 126–7, 149–50, 158–9
Dayton Peace Agreement (1995) xxv–xxvi, 2, 163, 168–9
decapitation 152
Delegates Club 52–3, 68
Delimustafić, Alija 69
Demick, Barbara 129–30
Deshpal, Walter xxiii
Diebert, Kevin 79
di Giovanni, Janine 113–16, 135, 164, 166
digital technology 6, 163
Dilberović, Suada xiv, 25
dilemmas faced by journalists 6, 141, 149
Divjak, Jovan 50
Divović, Nermin 148, 150–1
Dizdarević, Zlatko 71, 114
Djukanović, Milo 9
Donaldson, Sam 59–60
Donia, Robert 3, 30, 33, 36, 40, 65, 141, 146
'double trucks' 91–2
Doyle, Colm 20–2, 36–7, 78–9
Drew, Nelson xxv
Druškić, Sulejman 46

Dubrovnik 10
Duchamp, Marcel 134
Dufka, Corrine 96, 122–3, 168
Dukakis, Michael 74
Dukić, Rajko 18, 21
Dulmage, Mark 58–9
Duraković, Nijaz 10, 14
Dursun, Danilo 65

Eagar, Charlotte 91, 127–30, 164–6, 169
Eckhard, Fred 57
electricity and water supplies 2, 75, 81–2, 108–13, 116
'embedding' of journalists 3, 161
Emrić, Eldar 82–3
English, Greg 107–8
Erickson, Anna 42, 61, 80
Espanoza, Xavier 53
ethical and moral issues 141, 145, 149, 166–7
ethnic cleansing 37, 142, 145
European Broadcasting Union (EBU) 37–8, 42, 48, 55–6, 60, 79–83, 162
European Community (EC) xiv, 16, 20, 26
 Monitoring Mission (ECMM) xv, 36, 40
'exclusives' 97

Filipović, Benjamin 44
Filipović, Muhamed 11
flak jackets 102–5, 108
Fleiner, Thomas 15
Foa, Sylvana 156
food supplies 112–17
foreign correspondents 4–7, 17, 32–7, 46, 49, 54–6, 71, 76, 86, 89–92, 95, 102, 115, 130, 146–7, 153, 159, 164, 167, 169
Franz Ferdinand, Archduke 1
Fraser, Nicholas 120
Frasure, Robert xxv
freelance journalists 90, 92, 162
French journalists 115–17, 138
Frewer, Barry 85
fuel supplies 111
Fuentes, Julio 95, 169
Fullerton, John 169
funerals 149
Fyfe, Anthony 48

Gardović, Nikola xiv, 17–18
Geneva Convention 167
genocide 145
geopolitical realities 168
Glenny, Misha 33, 41–2
Gobet, George 53
Good Vibrations studio 17
Goulding, Marrack 41
Goupil, Romain 138
guilt, sense of 165
Gulf War, First (1991) 3–4, 163
Gutman, Roy 142, 144

Hadžić, Harun 11
Hadžifejzović, Senad 40
Hadžimuratović, Irma xix, 155–6
Hafizović, Alija 21
Halilović, Šefer 18
Hamdžić, Dina 93–4
Harden, Blaine 93, 99
Harris, Paul 69, 75–6, 110
Hartmann, Florence 19–20
Hatzfeld, Jean 34–5, 42, 44, 53–4
Hauck, Erick 42, 44
Haviv, Ron 24–5, 28–31, 92, 98, 126, 169
Hayman, Allan 99, 107
Hedgehog restaurant 117
Helac, Mirsad 83
Helgren, Chris 72, 121–5, 149, 153–4, 164
helmets, wearing of 104
Hitchens, Christopher 76
Hodžić, Alija 123–4
Holiday Inn, Sarajevo 11, 14–30, 39, 46, 50, 52, 55, 63–78, 93, 95, 108–16, 134–8, 144, 150, 162
 as a communications hub 71–8
 relative safety and possible 'deal' for protection of 77–8
Holland, John 52
Hotel Belvedere 54
Hotel Beograd 34, 37, 46–7, 53–4
Hotel Bosna 36–54
 evacuation of 42–54
Hotel Bristol 44–5
Hotel Europa, Belfast 64–5
Hotel on the Front Line (film) 114–15
'hotel journalism' 3
'hotel roof dish monkeys' 96
Hulls, Brian 41

human-interest stories 129, 155
humanitarian aid xix, xxiv, 2, 51, 113–17, 141, 153
Hume, Mick 141
Hurd, Douglas xxi, 143, 156, 167
Hutchings, Roger 131–2
Huxley, Aldous 93

independence referendum 17
infrastructure needed by journalists 1, 4–6, 37, 39, 54–6, 80, 84, 89, 92, 161–2
Ingrao, Charles 3
innovation resulting from the siege 164
International Commission on Missing Persons (ICMP) 169
International Criminal Tribunal for the Former Yugoslavia (ICTY) xviii, 169
international law 168
International Monetary Fund (IMF) 8
Iraq 4
Ivanko, Alexander xxiii
Izetbegović, Alija xv, xviii, xix, 11, 14, 19–31, 41, 56, 147
Izetbegović, Bakir 46

Jaganjac, Edo 155
Jašarević, Eldina 83
Jergović, Miljenko 21, 142
Jones, Colin 41
Jones, Jon 52, 54
'journalism of attachment' 6, 145–6, 167
'journalism by consensus' 143
journalistic principles and practices 161, 163, 168
journalists
 accommodation for 36–7, 46, 65–75
 acting as letter couriers 88
 changing nature of work 3, 6, 55
 commitment of 144
 cooperation between 5, 65, 89, 97, 100, 163
 creating a record of events 167
 daily routine of 35, 119, 125–31
 deaths of 3, 45, 58, 98, 103, 105, 166; *see also* Kaplan, David
 difficulties and dangers faced by 6, 34, 37, 51, 54, 61–9, 72–5, 84, 96–7, 100, 120, 161

honesty and integrity of 159
inexperienced or *well-established* 4–5, 74–5, 89, 91, 97, 100, 144–5, 152, 162
involvement in saving lives 153–9
relations with citizens of Sarajevo 76–7, 139, 143–4, 150
relative freedom of 4
Sarajevo as a life-changing experience for 162–9
types of 89–92
Jovičić, Mile 41
Judah, Tim 29–31, 37
Juppe, Alain xxi
Jurić, Ante 134
Juričić, Željko 65

Kalamujić, Eldar 156–7
Kaplan, David, death of 58–61, 89, 98, 102
Karadžić, Radovan xvi, xix, xxv, 1, 12–13, 16–27, 30, 39, 41, 66, 78, 138–9
 business interests of 13
 upbringing of 12
Kecmanović, Nenad 12, 14
Kienoel, Volkmar 83
Killer Image (film) 75
King, Robert 75
Kiseljak 115
Kljuić, Stjepan 12, 30
Knežević, Gordana 24, 28, 136
Knežević, Milan 66
Knight, Gary 106–8, 145, 168–9
Koljević, Nikola 16, 19, 31, 138–9
Kontić, Boro 79–80
Kordić, Vera 138
Korić, Samir 76–7, 112
Kosovo 8–9, 168
Kotsonis, Stefan 58
Kovač, 'Tomo' 43
Krajina region 9–10
Krajišnik, Momčilo 13, 19, 27, 31
Krilić, Samir 46, 95, 103
Krstanović, Danilo 92, 148
Krushelnycky, Askold 63
Kruzel, Joseph xxv
Kukanjac, Milutin 30
Kurspahić, Kemal 18–19, 28, 31–2
Kurtović, Larisa 139–40

Kušan, Milan 78
Kusovac, Zoran 47–8, 71, 98, 100, 145, 154–5

Lagumdžija, Zlatko 41
Landay, Jonathan 30, 35–6, 72, 93, 127–8
Laroche-Joubert, Martine 138
League of Communists of Bosnia and Herzegovina (SK-BiH) 10, 14
League of Communists of Serbia (SKS) 8
League of Communists of Yugoslavia (SKJ) 8–9
Le Garrec, Jean-Jacques 115, 138
Lévy, Bernard-Henri 134
Libero (fanzine) 95
Liebowitz, Annie 108, 136
Lisbon Agreement 23–4
Little, Allan 52, 86, 96, 99, 103, 109, 112, 142, 144, 155, 164
Lizdek, 'Boba' 94–5, 103–6
Lloyd, John 141
Lobjois, Phillipe 105–6
local journalistic staff 92, 95, 97, 164
Lodge, Robin 23
Loga, Slobodan 166
logistical challenges 6, 102, 106, 161
looting 65
Loyd, Anthony 76–7
Lyon, Santiago 44

Maalouf, Eddie 59–60, 80–1
Maass, Peter 61–2, 70, 77, 84, 102, 115, 150
MacKenzie, Lewis 22, 29, 47, 51, 56
Maguire, Sean 96, 101, 121–2, 163–4, 168
Manier, Stéphane 116, 138
Marchand, Paul 105–6, 111, 138
 eccentric behaviour 105
Marjanović, Vladimir 50
Markale marketplace massacres (1994 and 1995) xix, 148–9
Marović, Svetozar, 9
Marti, Enric 119–20, 148–50
Massey, Anthony 100
Matvejević, Predrag 132
Maurice, Frederic 45
Mehta, Zubin xxi
Meller, Paul 98

military intervention in Bosnia 141–3, 147–53, 167
Milošević, Slobodan xxii, 8–9, 19, 138, 142, 144
Miovčić, Dragan 37
Mirović, Radenko 18
'Miss Besieged Sarajevo' contest (1993) 132–3
'Miss Piggy' 98–9
Miss Sarajevo (song and film) 132
Mitchell, Andy 156
Mitterrand, François xv, 51, 56
Mladić, Ratko xxv
Mole, Richard 122
Monday, Alan 38
Montenegro 8–9, 12–13
Montgomery, Michael 35–6
morality *see* ethical and moral issues
morgue visits 123–4
Morillion, Phillipe xvii, 47
Morris, Chris 35, 92, 101, 151–4
mortar fire 62
Moth, Margaret 58–9, 102
motivation of reporters 166, 168
Mrkić, Vlado 24
Myers, Kevin 66–8

Nakaš, Abdulah 47, 83
Nambar, Vijay 22–3
Nambiar, Satish 22
nationalism 8–14
Nelson, Willy 104
Neretljak, Dina 63, 93–4
'neutral' reporting 145–6, 167
New York Times 49–50
news agenda 90, 119
Nicholson, Michael 2, 58, 69, 157–8
Nogić, Inela 132–3
non-government organizations (NGOs) 168
Noriega, Manuel 24
norms, cultural 94
North Atlantic Treaty Organization (NATO) 121, 141, 148, 155, 159, 167
Northall, Peter 44
Numankadić, Edin 134

Obala xviii, 117, 134
objectivity in reporting 144, 146, 159, 166–7

The Observer 129, 131
Office of the High Representative (OHR) 169
O'Kane, Maggie 23, 117
Olivier, Laurence 139
Olympic Games 1, 3–4, 23, 69, 78, 141
Ophuls, Marcel 2, 105, 136–9
Ophuls, Max 139
Osborne, Nigel 134
Oslobođenje (newspaper) xviii, 22, 27, 29, 37, 78, 82, 84, 136
Osmanagić, 'Hare' 97
Ostojić, Velibor 21
Otes xvii, 122–3
Ourdan, Remy 53, 68, 71, 73, 104–5, 117, 132, 146–7, 155, 162, 169

Pain, Hugh 62
Pajić, Zoran 48
Pale 30
Panić, Milan 58–60
partisanship amongst journalists 144
Party of Democratic Action (SDA) 10–12, 14–15, 18–19, 21, 25, 27, 147
Pašović, Haris 133, 135, 140
Paunović, Mladen 28
Pečanin, Senad 86–7
Peillod, Patrick 158
Perinović, Davorin 12
Persson, Michael 28
Peyrot, Pierre 60, 80–1
photography 75, 91, 125, 148–50, 163–4, 168–9
 as a means to an end 169
'Piglet' 99
Plavšić, Biljana 31, 66
policy impact of reporting from Sarajevo 142–3, 166–7
post-traumatic stress disorder (PTSD) 148, 152–3, 165–6
Postal, Telegraph and Telephone (PTT) building xxiv, 84–5, 162
press briefings 84, 86, 120
Prguda, Hana 42, 45
print journalism 89, 127
Prstojević, Miroslav 73
psychological strain 152
Pujol Puente, Jordi 42–5
Pulitzer Prizes 50, 135, 144

Purivatra, 'Miro' 133–5
PX Store 87, 111–12

Quentier, Arianne 168

Rajak, Miodrag 69
Rasavac, Asja 83
Ražnatović, Željko (Arkan) 24–5, 31
Red Cross 45
referendum weekend (1992) xiv, 7, 16, 21, 162–3
Reid, Andrew 49–50, 167–8
Renier, Hugues 105
renting of armoured cars 107–8
Republika Srpska (RS) xviii, 1
repurposing of journalists' stories 91
Reuters 73, 93, 97, 101, 103, 120–4, 168
Rich, Sebastian 69
Rieff, David 135
Rifatbegović, Halid 24
Riva, Gigi 6, 18, 20, 71, 88, 119, 162
Rojo, Alfonso 53
Rust, David 59, 63, 81, 96–7, 102–3

'safe havens' xviii, xxiv, 3, 147
Samaranch, Juan Antonio xxi, 23
Sarajevo
 airport 4, 32, 39–40, 51–8, 66, 85, 162
 division of the city into two parts 66
 evacuation of the city 32
 failure to reach an agreement on the future of (1992) 31
 journalists' continuing links with 169
 post-war development of 10
 as primary focus of media attention 2–3
 see also siege of Sarajevo
Sarajevo Agency Pool (SAP) 5, 89, 96–7, 143
'Sarajevo Agreement' 7
A Sarajevo Diary (film) 139
Sarajevo International Journalists Association (SIJA) 86
satellite technology 37–8, 81, 120, 126–7, 163
Schmaus, Myriam 38–9, 42, 79–80
Schneider, Jana 53
Schork, Kurt 73–4, 96, 103, 111
Sekerez, Una 135

sensitive issues 94
Serbian Democratic Party (SDS) xiv, 1, 11–15, 18–21, 37–41, 57, 66, 78, 142
VII Agency and VII Academy 169
Sherwood, David 59
Shopliak, Mustafa 134
Sarajevo Survivors' Club 42
siege of Sarajevo
 aftermath of 169
 dates of 1, 7, 162–3, 169
 deaths in 1
 early stages of 33–54, 162
 later stages of 117, 141
 lessons learnt from 164–7
 military aspects of 146
 uniqueness of 161–2
Silajdžić, Haris 15
Silber, Laura 168
Simon, Bob 103
Simpson, John 64, 85, 96, 110, 113, 138, 144
Sky News 47–50, 100
Slovenia xvii, 9
Smajlović, Ljiljana 144
Smajlović, Vedran 50
Smale, Alison 46
Smith, Colin 63
Smith, Tony 44–6, 62, 95, 135
Smith, Vaughan 70–1, 74, 114
smuggling of people 155
sniper fire 2, 18, 59–62, 70, 139
Social Democratic Party (SDP) 9–10, 12
social life in Yugoslavia multi-ethnic character of 140, 147
Solana, Javier xxvi
'something-must-be-done club' 143, 167
Sontag, Susan xix, 135–7
Srevanović, Steven 42
Stambolić, Ivan 8
Štandeker, Ivo 53
Stanislas, Marc 38
Steele, Jon 153
Stephen, Chris 91
Stevanović, Zoran 115
Stevens, Eddie 138
Stevens, Robert 153
Stiglemayer, Alexandra 108
stringers 90–1, 103
Sučić, Olga xiv, 25

Sudetić, Chuck 35–6
suffering, representation of 147–50
Sullivan, Kevin 69–70, 77, 109, 112, 114, 169
Sunday newspapers 128–9
super-stringers 90
Šuvalija, Merdijana 79
Svrzo, Slobodan 17
Sweeney, John 62–3, 112
Syria 5, 166
'Systeme D' 115–16

Tanner, Marcus 28, 30, 55, 62, 103
targeting of journalists 98, 146, 163
Tasić, Slobodan 69
telephone lines, access to 36–7, 40, 52, 127
television crews 96
television stations in Sarajevo 17, 30–1, 37–40, 62, 78–84, 162–3
tensions, political 15, 21–3, 26, 29, 31
Thomson, Mark 37–8
Thornberry, Cedric 22, 28–9
Time magazine 25, 31, 101
Tito, Josip Broz 7–8
Todorović, Aleksandar 38
training courses for journalists 6, 163–4
Tribe, Bill 93, 139–40
Tuđman, Franjo 9
Tunel spasa 117, 146–7
Turner, Fiona 107
2-way links 120

Ugljanin, Sulejman 11
United Nations (UN) 2, 4, 15, 22, 56–7, 69, 83–7, 113, 116, 120, 150, 155–8, 166
 arms embargo 117, 142
United Nations High Commissioner for Refugees (UNHCR) 75, 85–7, 111
United Nations Protection Force (UNPROFOR) 4, 7, 22–3, 28, 41–4, 51–3, 55–9, 62, 69, 78–9, 83–6, 95, 100, 111, 117, 120, 138–9, 150–1
United Nations Security Council xvi, xviii, 51

United States (US) xiv, 26
Urbicide (film) 139
urine used as a photographic chemical 125

Valter, Vladimir Perić 21–2
Vance–Owen Peace Plan (1993) xviii, 111–12
Vanderhoop, Charlie 38, 79
van der Laan, Cees 56–8, 92
van Lynden, Aernout 47–8, 169
Vešović, Marko 13
Vikić, Dragan 28, 95
Visnews 100–1
Vojyodina 8–9
Vukovar 10
Vulliamy, Ed 169

war crimes 166
Ward, Steve 82–3
war hotels 68, 114–15
WARM Foundation and WARM Festival 169
war reporting 5, 16, 73, 139
'war tourists' 75–6
washing 109
Weaver, Kevin 53–4, 74–5, 87–8
weekly newspapers and magazines 128
Welcome to Sarajevo (film) 157
'Winnie the Pooh' 99
Winning, Tony 100
Winterbottom, Michael 157
wire services 89–92, 125–7, 163
Wong, Deborah 74
Wright, Robbie 107

Yugoslav People's Army (JNA) 2, 7–9, 14–15, 19–21, 25, 30, 32–3, 35–7, 39–41, 47, 50, 52, 55, 142
Yugoslavia, Federal Republic of
 Constitution (1974) 7–8
 disintegration of 10, 14, 140
 economic crisis and drastic measures in 8

Zulfikarpašić, Adil 11